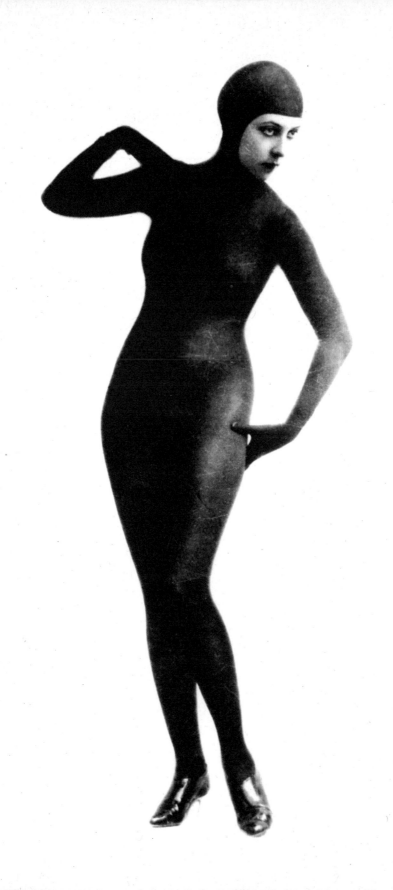

© 2008 Contributors, Fashion in Film Festival
and Koenig Books, London

Editor: Marketa Uhlirova
Design: Seán O'Mara
Print: Tadberry Evedale LTD.

(Co-Editor)
Koenig Books Ltd
At the Serpentine Gallery
Kensington Gardens
London W2 3XA
www.koenigbooks.co.uk

Library of Congress Cataloguing in Publication Data

If Looks Could Kill: Cinema's Images of Fashion,
Crime and Violence / edited by Marketa Uhlirova

Includes bibliographical references and index

1. Film—History. Costume—Symbolic Aspects—History

Printed in UK

Distribution
Buchhandlung Walther König, Köln
Ehrenstr. 4, 50672 Köln
T: +49 (0) 221 / 20 59 6-53
F: +49 (0) 221 / 20 59 6-60
verlag@buchhandlung-walther-koenig.de

UK & Eire
Cornerhouse Publications
70 Oxford Street
GB-Manchester M1 5NH
T: +44 (0) 161 200 15 03
F: +44 (0) 161 200 15 04
publications@cornerhouse.org

Outside Europe
D.A.P. / Distributed Art Publishers, Inc.
155 6th Avenue, 2nd Floor
New York, NY 10013
T: +1 212-627-1999
F: +1 212-627-9484
eleshowitz@dapinc.com

ISBN 978-3-86560-462-0

Fashion in Film Festival: 10.05.-31.05.2008

Film Stills Details (front section):
P.1 Mannequin in Red, dir. Arne Mattsson, 1958.
Courtesy the Alan Y. Upchurch Collection
P.2 Mannequin in Red, dir. Arne Mattsson, 1958. Courtesy
The Swedish Film Institute Stills Archive © Sandrew Metronome AB
P.3 Office Killer, dir. Cindy Sherman, 1997.
Courtesy The Cinema Museum

Film Stills Details (front section):
P.262 The 10th Victim, dir. Elio Petri, 1965. Courtesy BFI
P.263 Asphalt, dir. Joe May, 1929. Courtesy Deutsche Kinemathek
P.264 Blood and Black Lace, dir. Mario Bava, 1964.
Courtesy the Alan Y. Upchurch Collection

Contents

Acknowledgments — 010

Preface: If Looks Could Kill — 012
Marketa Uhlirova

Introduction: Dressed to Kill: Notes on Dress and Costume in Crime Literature and Film — 014
Elizabeth Wilson

The Masks of Villains

Making Fashion out of Nothing: The Invisible Criminal — 022
Tom Gunning

The Face of Fear — 032
Roger Sabin

The Killing Game: Glamorous Masks and Murderous Styles in Elio Petri's *La decima vittima* — 040
Anna Battista

The Eyes are Trapped: Dario Argento's *The Bird with the Crystal Plumage* — 052
Betti Marenko

Criminal Gestures, Transformations, Signatures

Looking Sharp — 062
Claire Pajaczkowska and Barry Curtis

Stained Clothing, Guilty Hearts — 068
Kitty Hauser

A Question of Silence: Revisited — 076
Karen Alexander

The Virgin-Whore Complex: *Ms .45* and 1970s Feminism — 082
Jenni Sorkin

Working Girl Turned *Office Killer*: The Onscreen Politics of Office Dressing Takes a Gothic Spin — 086
Gilda Williams

Inside Out: Living Costumes in Brice Dellsperger's *Body Double (X)* — 094
Drake Stutesman

Criminal Desire, Possession and Transgression

Fashioning Silent Film's Thieves and Detectives — 100
Christel Tsilibaris

Scandal, Satire and Vampirism in *The Kidnapping of Fux the Banker* — 108
Marketa Uhlirova

Twenties Fashion, Ivor Novello and *The Rat* 118
Bryony Dixon

Asphalt, Theft and Seduction 126
Werner Sudendorf

The Economy of *Desire* 132
Caroline Evans

I Want That Mink! *Film Noir* and Fashion 138
Petra Dominková

The Red Shoes 144
Hilary Davidson

Peeling the Groomed Surface

Models Murdered 154
Charlie T. Porter

Sometimes the Truth is Wicked: Fashion, Violence and Obsession in *Leave Her to Heaven* 158
Rebecca Arnold and Adrian Garvey

Plein soleil: Style and Perversity on the Neapolitan Riviera 164
Stella Bruzzi and Pamela Church Gibson

Death on the Runway: Mario Bava's *Blood and Black Lace* and Arne Mattsson's *Mannequin in Red* 170
Tim Lucas

Mannequin in Red: Death and Desire in a Couture House 182
Louise Wallenberg

Desire and Death before the Apocalypse 194
Román Gubern

Delinquency, Dress and Power

"So What!" Two Tales of Juvenile Delinquency 204
Roger K. Burton

Smell of Female 210
Cathi Unsworth

On Gangster Suits and Silhouettes 218
Lorraine Gamman

Co-Conspirators

Fingerprint on Lens — 232
Laura McLean-Ferris

Eloise Fornieles: *Carrion* — 234

Elizabeth McAlpine: *Slap* — 236

Paulette Phillips: *Marnie's Handbag* — 238

Derrick Santini: *Frottage* — 240

Boudicca: *Still Framed* — 242

Dino Dinco: *El Abuelo* — 244

Wendy Bevan: *Untitled* — 246

Shannon Plumb: *The Corner* — 248

Notes on Contributors — 253
Selected Bibliography — 256
Index — 258

Acknowledgments

I would like to extend grateful thanks to the contributing writers, artists and illustrators, all of whom embraced the project with excitement and great generosity of spirit, delivering pieces packed with sharp observations, and peppered with wit and attitude. I am particularly indebted to the following individuals who played crucial roles in the preparations of this publication and provided invaluable assistance: Christel Tsilibaris, the festival's Associate Curator, for her major contribution to the planning and programming of "If Looks Could Kill", of which this catalogue is part and parcel; Dorcas Brown for co-ordinating the picture research and for her absolute enthusiasm for the job which involved many an extra hour; Eve Dawoud, who also contributed much of the picture research, and really shone when it came to fact-checking; Rita Revez and Felice McDowell for providing astute comments on all texts, and for their able assistance with numerous tasks on this publication; the Art Director Seán O'Mara for his incredible dedication and excitement for anything visual; Marco Pirroni for his pithy commentaries, ideas and humour in the early stages, and for nailing the project's title; Louise Clarke for her passion and for giving the curation of "Co-conspirators" a name and a much-needed initial push; Laura McLean-Ferris for her many talents, excellent advice, soothing voice, and high standards; Susie Cole, Francesca Coombs, Nathaniel Dafydd Beard and Joanne Kernan for their valuable research assistance; Stuart Comer, Cathy John, James Bell and Karen Alexander for their encouragements and belief in the project; Emma Pettit, Katy Louis and Alyn Horton, for working so hard and so creatively behind the scenes; Jane Rapley, Peter Close, Anne Smith, Jane Gibb, Monica Hundal, Alistair O'Neill, Caroline Evans, Frances Corner, Dani Salvadori, Sabita Kumari-dass, Steve Murray, Alison Church, Joan Ingram and other friends and colleagues at the University of the Arts London for their help and patience. Huge thanks also to Sharon O'Connor, Caroline Bradley and other Oasis staff, and to Arts Council England, Arts and Business, Kirin, BFI Library and Koenig Books without whom this catalogue wouldn't have been possible.

I am most indebted to Ruth Massey for copy-editing the entire volume and making so many helpful suggestions, and Sarah Waterfall for additional editorial work and for tirelessly proofreading all texts under pressing deadlines. Finally, love to my partner Joe Hunter for his support and an endless supply of pasta with pesto.

Illustration © Amélie Labarthe

Preface: If Looks Could Kill / Marketa Uhlirova

If the hero join combat with the night and conquer it, may shreds of it remain upon him!
Jean Genet, *The Thief's Journal*, 1949 (trans. Bernard Frechman)

Soon after its invention in the 19th century, photography became an essential part of the criminal investigation process. Due to its *indexical* relationship with reality, photography offered highly reliable evidence, mapping and freezing scenes of crime with precision and "objectivity". Film, a medium born from the same technological impulse, has followed a completely different path – not documenting but, instead, *imagining* crime. While forensic photographers and photojournalists have made it their business (with different aims, of course) to harvest evidence and capture macabre details of crime or disaster scenes, filmmakers have been fabricating such scenes, planting clues to be deciphered by their audiences.

Cinema's images of crime are both seductive and haunting. The darkness and menace of villains, the nerve and calm assurance of detectives, the chilling vulnerability of unknowing victims (not to mention their anxieties and neuroses): all have a distinct cinematic allure. They all exert their own kind of onscreen magnetism. Cinema, it seems, has a tendency to portray criminality and evil as lethally stylish. It often turns to fashion for elegance, sharpness and frisson (the drop-dead effect), but also mines it as a subject – be it a dream-like world of pleasure and sumptuousness, or a ghostly labyrinth of surfaces, mirrors and illusions. Being so obsessive, so out of reach, so decadent, fashion's touch of glamour makes crime more captivating in its insensitivity, cruelty, even brutality. But it can also render crime poignant in such a way that it becomes almost sensual.

So what role does fashion assume in criminal narratives? Film shows great inventiveness in putting fashion to work in all kinds of plots. Fashion seems an ideal environment for crime because it has an excessive preoccupation with dress and grooming – an insistence with the surface – which often signals something sinister lurking underneath. Film also often singles out specific garments and accessories, such as hats, gloves, shoes, handbags or jewellery, to turn them into objects of desire, murderous weapons, clues, evidence...

At the core of much crime narrative is the problem of identification – and this is where film really comes into its own. One fundamental quality both villains and their pursuers trade on is anonymity. In order to infiltrate environments unnoticed, they must conceal their true identities behind masks and disguises. For masks render their wearers mysterious and their identities fluid, making them unpredictable, impossible to capture. And these highly expressive extra layers are never merely devices of concealment – they visualise anonymity, giving it a distinct and forceful image.

If Looks Could Kill is a collection of newly-commissioned articles which savour these links between fashion, crime and cinema, getting to grips with why they continue to fascinate. Meandering through history and cultures, these articles make a case for a variety of sartorial practices, rituals, gestures and even mistakes that have helped define genres and movements from early crime and detective film to melodrama, gangster film, thriller, *film noir* and horror.

If Looks Could Kill grows out of, and mirrors the 2nd edition of the Fashion in Film Festival of the same title (10-31 May 2008), exhibited at London's BFI Southbank, Tate Modern, Ciné lumière, Institute of Contemporary Arts and The Horse Hospital, to which many of the authors contributed as guest curators.

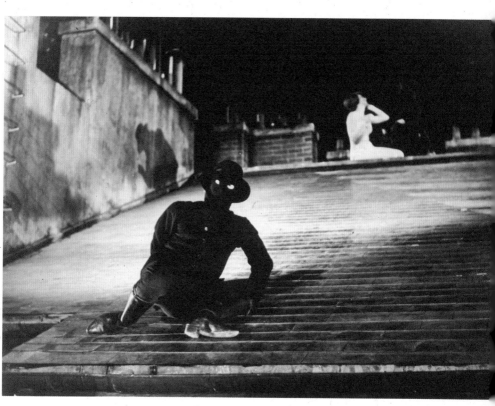

Judex, dir. Georges Franju, 1963. Courtesy BFI

Introduction: Dressed to Kill: Notes on Dress and Costume in Crime Literature and Film / Elizabeth Wilson

A perennial hostility to fashion has long thwarted all attempts to have it taken seriously. Today's fashion industry, obsessed with glamour and celebrity, may have made matters worse, but, at least in the English-speaking world, fashion has always been viewed with suspicion. Fashion seems trivial and superficial by reason of its obsessive attention to detail and style and its continual thirst for change. What makes it even more infuriating is that we can't do without it. The fiction that fashion is unimportant and indeed despicable is a disavowal of its centrality to our Western – to any – culture.

One consequence of this disavowal is that fashion in literature has not been much researched, and this certainly also applies to crime fiction, which, at least until recently, has been little studied at all. It too, of course, is another aspect of popular culture habitually judged trivial and worthless. Yet, from Little Red Riding Hood's cloak to Scarlett O'Hara's gown made from green velvet drawing room curtains in *Gone With the Wind* (Victor Fleming, 1939), dress is inescapably important in the telling of any story. If anything, it is crucial in crime fiction.

At its most prosaic (and perhaps least interesting), clothes can function as forensic clues. In Paul Willetts' book *North Soho 999* (2007), for example, an abandoned raincoat is the item that eventually nails the murderers – an archival photo of a member of the forensic science team using "a modified vacuum cleaner to collect dust and fibres from a jacket"[1] illustrates the point.

More usually, dress functions to add realism to the setting. Ruth Rendell is good at suggesting period through details of dress, for example in *A Dark Adapted Eye* (1986) where the 1940s are succinctly pinned down with "Vera in a dress made out of two dresses, brown sleeves set into brown and orange-spotted bodice, surely in 1941 the prototype of such a fashion",[2] but in 1986, when the book was published (under the pen name of Barbara Vine), it was an unthinkable colour combination. Dress provides a reality effect, whether the setting be past or present.

More than that, it represents social codes and indicates class, group subdivisions, regional difference and individual personality. Agatha Christie uses dress, often unsubtly, as a shorthand method of indicating character. When a new client visits Hercule Poirot, he asks his manservant to describe her:

> She would be aged between forty and fifty, I should say, sir. Untidy and somewhat artistic in appearance. Good walking shoes, brogues. A tweed coat and skirt – but a lace blouse. Some questionable Egyptian beads and a blue chiffon scarf.[3]

This tells us much of what we need to know about the lady in question: that she is upper-middle class, and addicted to spiritualism. The get-up may be stereotyped, but it works. Alison Light has commented that there is a "significant ambivalence" in Christie's use of types or "cardboard characters", something for which she has often been attacked. In fact, she subverts stereotypes. They ought, points out Light, "to represent known and fixed qualities"; although "her stories are indeed peopled with instantly recognisable types – the 'acidulated' spinster, the mild-mannered doctor, the dyspeptic colonel", in fact they are not embodiments of unchanging virtue or villainy. They no longer carry any reliable moral cargo, but signify the possible untrustworthiness of values rather than their security. Christie is here as clearly "post-realist" as any other modernist, deliberately playing with the assumptions of an earlier literary form and working in pastiche.[4]

Dress plays an indispensable role in the creation of a stereotype. The "language" of clothes – although it is not really a language but more like music in suggesting mood, as Fred Davis has pointed out[5] – makes visible social assumptions, social codes and collective understandings.

It can also "speak" the individual, as in *A Dark Adapted Eye*, in which Jamie, the boy whose life has been ruined by the murder of which he was the cause, in adult life dresses twenty years too young for his age. And here the detail *is* subtle, an unexplained and mysterious indicator of how psychic trauma can work its way through to the surface of the individual.

So dress can stand in for character, straightforwardly or ambiguously. It can also draw on a culturally understood system of signs – when white represents purity and innocence, for example (at least in Western societies).

Yet Claire Hughes, who has studied dress in literary fiction, tells us that, at least in the nineteenth century fiction, dress is seldom described in detail, or directly.[6] This surprises me.

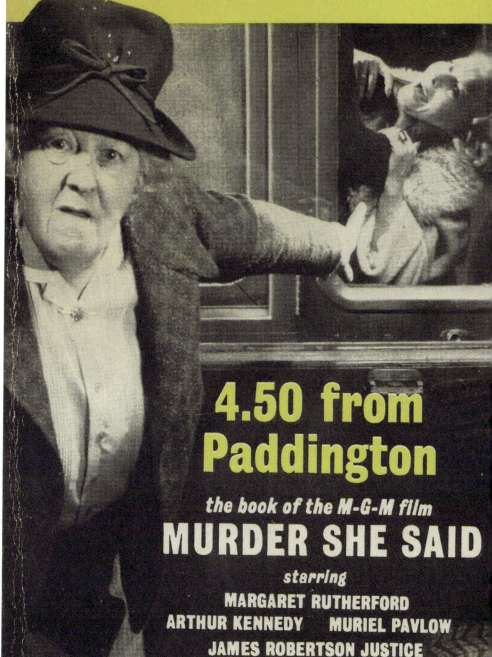

Agatha Christie, 4:50 from Paddington, 1963 (book cover)

My memory seems littered with fragments from all sorts of nineteenth and twentieth century novels of dress described – the miniature elephants on the dress of Michael Arlen's tragic heroine in *The Green Hat* (1924), for example – and Marcel Proust was certainly lavish in his sartorial description, devoting pages, for example, to an analysis of the Duchesse de Guermantes' Fortuny gowns. For Proust, dress can also provide a moral compass, as when the Duc de Guermantes is more preoccupied with his wife's sartorial crime of wearing black shoes with a red dress, than with the fact that their old friend Charles Swann has just informed them he is dying.[7]

Whether or not fiction operates through suggestion rather than direct description, films necessarily differ, since when we watch a film we *have to* see the clothes. This might be an advantage, but might also take away the subtler possibilities of suggestion and inference. In a film, what you see is what you get.

It is perhaps not surprising that dress in film, and television too (although not particularly or specifically in crime films other than *film noir*), has been studied more than dress in fiction, for no-one can deny that costume is a central component of the whole cinematic or televisual experience. One reason for the popularity of the endless proliferation of period dramatisations on TV – Jane Austen, Charles Dickens, Elizabeth Gaskell – is probably the pure pleasure experienced in the rich detail of the costumes. Clad in the sober, casual and, it must be said, dreary uniform of early twenty-first century quasi-sportswear, we can revel vicariously in corsets, bustles, crinolines, top hats, and cravats high and tight enough to choke you: so uncomfortable but so glamorous, so vulgar but so exuberant, so different from our own inhibited, restricted minimalism.

The minutely detailed realism of today's productions contrasts, for the most part, with some of the earlier Hollywood – and French – efforts, those films in which, rather poignantly, Danielle Darrieux and Bette Davis were dressed and made up more in the style of the 1940s than the 1790s or 1830s, and although Anne Hollander concedes that even before the Second World War historical costume in Hollywood film was often accurate, she maintains that a whole fake history of costume also grew up, functioning primarily as a series of signals – powdered hair and silk breeches signifying the eighteenth century or a ruff the Elizabethan period.[8]

The most recent series of Agatha Christie adaptations of the *Miss Marple* novels for British television seemed nevertheless to signal a move away from meticulous realism once more. Whereas the series filmed in the 1980s produced painstaking reproductions of the 1930s, 40s and 50s, we were treated in 2006 and 2007 to a "postmodern" version in which not only were the plots reworked and a romance for Miss Marple invented, but the period dress became parodic – two respectable spinsters whose lesbianism is clear but never actually named in the original *A Murder is Announced* (1950) becoming in the new version a youthful dyke couple straight out of *Diva* magazine, complete with butch suits and gelled hair. On the other hand, the recent crime series set in wartime Britain, *Foyle's War* (Anthony Horowitz, 2002-), has maintained the tradition of hyper-realist accuracy, with crepe frocks, red lipstick, permed hair, peasant blouses and tweed "slacks" in satisfactory profusion.

And, if period films in the 1940s were not always strictly accurate when it came to dress, some were. *The Man in Grey* (Leslie Arliss, 1943), starring Margaret Lockwood, Phyllis Calvert, James Mason and Stewart Granger, the first of the Gainsborough Studios period productions, was produced in austere conditions during the Second World War. Location shooting was banned and the whole film was produced on a shoestring. Yet the costumes managed to look both lavish and accurate, with the transition from 1790s to the full flowering of the Regency style carefully observed.

The significance of dress is not confined to spectacle. In the opening and closing scenes of *The Man in Grey* the wicked Hesther (Margaret Lockwood) wears black, which, overtly a sign of poverty at the beginning and of mourning at the end, symbolically represents her villainy. And in *film noir*, the evil woman is almost always signalled by her manner of dressing. In the famous early scene in *Double Indemnity* (Billy Wilder, 1944), when the hapless insurance salesman (Fred MacMurray) meets his doom in the shape of Barbara Stanwyck, she first appears wrapped only in a towel. As she gazes down at him from the first floor landing, her power over him is already visually in place, and his nervous, joking innuendo can't undermine her dominance. Later, dressed, as she descends the stairs from the landing the camera focuses on her legs, anklet and high-heeled shoes – the fatal approach of the phallic woman.

The enjoyment of dress on screen, like the enjoyment of its description in literature, may link seductively with a taste for crime fiction, for both involve an encounter with the forbidden. Even today,

to take too much pleasure in dress is transgressive, and one reason for the contempt heaped on celebrities – especially WAGs – may be their excessive and blatant enjoyment of self-adornment and very expensive clothes. Likewise, one reason for the way in which crime fiction is often dismissed as an inferior genre may be that the reader's enjoyment in the unlawful and usually lethal is also illicit. This is not to deny that celebrity culture is tedious and vacuous, nor that crime fiction is often badly written with clumsy plots and crude characterisation. The fascination notwithstanding testifies to the existence of the secret pleasures to be derived from them.

It is easy to see why historic and retro fashions are more readily drawn into this conspiracy of forbidden desire than the utilitarian fashions of the early twenty-first century. What film today could be compared, for example, with Michelangelo Antonioni's *Story of a Love Affair* (*Cronaca di un amore,* 1950), in which romantic passion, murder and *haute couture* mix to make an intoxicating cocktail?

Filmed in the empty and rain-sodden streets of Milan in winter, at a time when automobiles were only for the rich, Antonioni's first feature film tells the story of Paola and Guido. In their youth, in Ferrara, Guido was engaged to Paola's best friend, Giovanna, who mysteriously fell to her death in a lift shaft two days before their wedding. Some years later, a private investigator appears on the scene and we discover that Paola has married a rich industrialist, Enrico. Warned by an old acquaintance from Ferrara, Guido renews contact with Paola and their passion reignites. We learn that both were in some sense guilty for Giovanna's death, since they knew the lift was defective, but allowed Giovanna to step into it. Now, Paola seems still to be consumed with desire for her lover, whereas Guido's motives and feelings are ambiguous. More in love, she is also more imprisoned, since she cannot imagine renouncing her husband's wealth. Her solution is to persuade Guido to murder Enrico, but the event of his death mirrors Giovanna's, in that he kills himself in a car accident. For the second time, Paola and Guido have not exactly committed a murder, yet they are again both united and separated by their sense of guilt.

Paola's wardrobe is fabulous. She totters across the wet streets in sumptuously sculpted furs, prowls the bourgeois bars and salons in body hugging dresses and fantastic hats (a phallic leopard skin hat and huge matching muff are particularly outrageous) and in the last scenes, flees panic-stricken through the night in an evening dress composed of multiple layers of organza ruching – a kind of dying swan in the drab, post-war city. Her fashionable dress functions on the surface to denote the icy world of bourgeois wealth she inhabits; on a more subtle level, it suggests the frozen quality of the passion between the lovers, so that to her lover, who is a mere car salesman, she will always be slightly unreal, spiritually imprisoned by the jealous Enrico (who initiated the investigation that propels the plot), but equally by her strangling skirts and preposterous headgear.

Alain Resnais' *Last Year in Marienbad* (*L'année dernière à Marienbad,* 1961) would also link the frigid perfection of haute couture to psychological imprisonment and deathliness. In *Marienbad* Resnais paid homage to Alfred Hitchcock's *Vertigo* (1958), and there can be no mystery film in which dress plays a more crucial role than in the latter.

Scottie, a detective, has retired from the police force after his vertigo led to a colleague's death. He is nevertheless hired by an old friend, Gavin Elster, to follow Elster's wife Madeleine (Kim Novak), who has been behaving strangely and might be suicidal. As Scottie follows Madeleine in her wanderings through San Francisco, he becomes obsessed with her and they seem to be falling in love; but his vertigo again leads to death – he fails to prevent her from throwing herself off a bell tower.

This event bisects the film. In the second half, Scottie finds Judy, Madeleine's double. At this point, Hitchcock prematurely reveals what should have been the denouement of the mystery: Judy actually *is* Madeleine, and her masquerade was part of a plot to conceal the murder of the "real" Madeleine. Scottie, still obsessed, forces Judy to become the dead woman once more, by transforming the way she dresses and by bleaching her hair, so that she becomes the fetishised, petrified object of his gaze. With her platinum blonde French plait and pale grey post-New Look suit, she exemplifies the death by dress described by Simone de Beauvoir: "She is, like the picture or statue … an agent through which is suggested someone who is not there … this identification with something unreal, fixed, perfect."[9]

That Hitchcock gives away the plot in the middle of the movie suggests that the real subject of *Vertigo* is not the mystery, but rather the oppressive possession of women by men and the lethal nature of the "male gaze". In a curious early scene, Scottie visits an artist girl friend, Marjorie "Midge" Wood, who is actually hopelessly in love with him. Her glasses, neat twinsets and pencil skirts position

her as the "plain" foil to the beauty of Madeleine. As she chats with Scottie, she sketches a brassiere. When Scottie comments on it, she tells him it works without straps; it was designed by an aeronautics engineer "in his spare time" and its principle is the same as that of a cantilevered bridge. Hitchcock here slyly prefigures in comedy the tragedy that will unfurl, by referencing the fetish garment through which men create an "idealised" version of womanhood.

By contrast with "plain" Midge's practical clothing, Madeleine appears in luxurious yards of fabric: a black dress with rivers of emerald green in the form of a satin stole; a voluminous white coat; a perfect pale grey suit to underline her ethereal, ghostly existence. But although in the first half of the film her look seems ravishing, exquisite and precious, when Judy is forced by Scottie to re-inhabit it, the audience sees the sinister twist whereby the woman is created by a man in love with an unreal image; her very appearance no longer belongs to her, and, as de Beauvoir suggested, she has been objectified and turned to stone by the basilisk male stare. The feminist critic Tania Modleski takes a more nuanced view, arguing from a psychoanalytical point of view that in *Vertigo*, femininity may be "a matter of external trappings, of roles and masquerade, without essence". And she continues, "if a woman who is posited as she whom man must know and possess in order to guarantee his truth and his identity, does not exist, then in some important sense he does not exist either, but ... is faced with the possibility of his own nothingness".[10]

Vertigo bears witness to the idea that appearance — women's in particular — is artificial, a cultural creation that has nothing to do with the natural. Fashionable dress — and the structured, stiff, elaborate post-New Look fashions of the 1950s are perfect for this — represents this idea. There is also the further disturbing idea, developed by the sociologist René König that fashion's obsession with change is a kind of death wish in its desire to preserve the fleeting moment eternally, or a defence against the human reality of the changing body.[11] Paradoxically, its manic obsession with change is the very thing that protects us against the recognition of change in the shape of ageing and mortality — another reason for its potency when linked to the idea of crime, for crime too occurs when individuals refuse to face reality.

Yet there may also be a redemptive, Utopian aspect to fashion's attempt to stop time and shore up the human body against its decay. There are resemblances to the legend of Orpheus and Eurydice in *Vertigo*. The attempt by Orpheus to bring his lover back from the dead — an assertion of hope in the face of the inevitable — is imagined in the scene in which Judy finally "becomes" Madeleine, appearing to Scottie bathed in ghostly light and as if through a mist.

And if, in focusing on the link between fashion and crime, I have necessarily emphasised its dark potential, and even if the endless, repetitive search for the lost object of desire is doomed to failure, there remains a ray of hope in the continual renewal offered by fashion. In fashion, tomorrow is always another day and the quest for the beauty of perfection is eternal.

For that reason the greatest crime films force us to side with the criminal; for the criminal pursues his or her dream and flies in the face of reality. Which in its own way is heroic, as is the tragic farce of fashion.

Notes
1. Paul Willetts, *North Soho 999: A True Story of Gangs and Gun Crime* (Stockport: Dewi-Lewis, 2007), p.114.
2. Ruth Rendell (Barbara Vine), *A Dark Adapted Eye* (Harmondsworth: Penguin, 1986), p.105.
3. Agatha Christie, *Taken at the Flood* (London: HarperCollins, 1993 [1948]), p.11.
4. Alison Light, *Forever England: Femininity, Literature and Conservatism Between the Wars* (London: Routledge, 1999), pp.95-96.
5. Fred Davis, *Fashion, Culture and Identity* (Chicago: Chicago University Press, 1992).
6. Claire Hughes, *Dressed in Fiction* (Oxford: Berg, 2006).
7. Marcel Proust, *Le Côté de Guermantes: à la recherche du temps perdu III (The Guermantes Way: In Search of Lost Time III)* (Paris: Gallimard, 1988) [1920/21], p.578.
8. Anne Hollander, *Seeing Through Clothes* (New York: Avon Books, 1975), p.304.
9. Simone de Beauvoir, *The Second Sex* (London: Jonathan Cape, 1953), p.509.
10. Tania Modleski, *The Women Who Knew Too Much: Hitchcock and Feminist Theory* (London: Routledge, 1988), p.91.
11. René König, *The Restless Image* (London: Allen and Unwin, 1973).

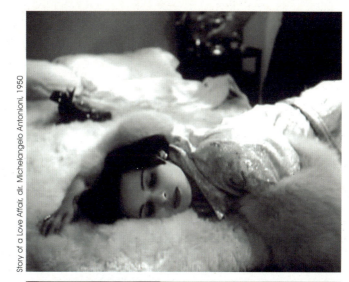

Story of a Love Affair, dir. Michelangelo Antonioni, 1950

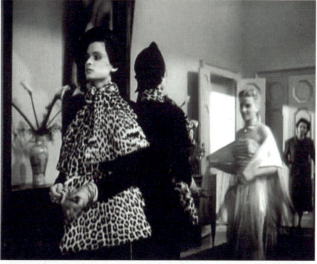

Story of a Love Affair, dir. Michelangelo Antonioni, 1950

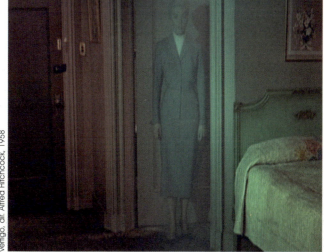

Vertigo, dir. Alfred Hitchcock, 1958

The Masks of Villains

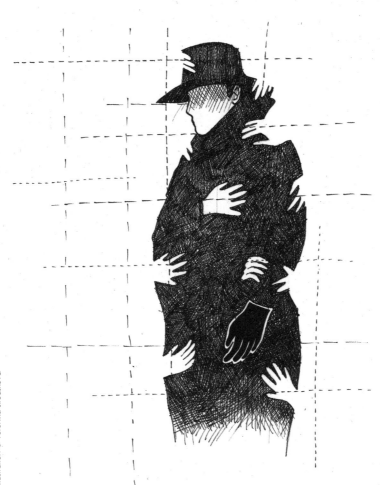

Illustration © Veronika Jirousková

Making Fashion out of Nothing: The Invisible Criminal
Tom Gunning

> If you could imagine any one obtaining this power of becoming invisible, and never doing any wrong or touching what was another's, he would be thought by the lookers-on to be a most wretched idiot.
>
> Plato, *The Republic* (Book II, 360, Jowett translation)

In *American Gangster* (Ridley Scott, 2007), gang boss Frank Lucas (Denzel Washington) approaches his brother and member of his gang Huey (Chiwetel Ejiofor) at a disco party. Gesturing at his new stylish clothes, Frank asks him what he's wearing. Huey responds: "A bad, bad, bad, nice suit," to which Frank counters angrily, "That's a clown suit, that's a costume, with a big sign on it that says: 'Arrest me'." The scene articulates a dichotomy in the relation between crime and fashion in film. On the one hand, success in the gangster film is often marked by the purchase of flashy, expensive clothes. Rico (Edward G. Robinson) in *Little Caesar* (Mervyn LeRoy, 1931) is measured for a dress suit as a sure sign of his rise to dominance over the city's mobs, while Scarface (Paul Muni), after moving through the ranks, displays his shirts to Poppy (Karen Morley), bragging about how expensive they are (*Scarface,* Howard Hawks and Richard Rosson, 1932). On the other hand, the business of crime relies on remaining unnoticed, on becoming, in effect, invisible. Thus Frank Lucas's downfall in *American Gangster* begins with his acceptance of a $50,000 chinchilla coat from his girlfriend, which he wears publicly to the Muhammad Ali/Joe Frazer championship fight, drawing the attention of special investigators previously unaware of him. Frank recognises his fatal fashion error and burns the expensive coat when his honeymoon is interrupted by corrupt police demanding their cut of his illicit profits.

 Frankly, I know very little about fashion, either as a historian or as a person (I often refer to myself as "sartorially challenged"). But as a historian of cinema, I know that fashion in film serves as a transfer point between issues of great importance to the medium: visuality and the body. In film, fashion – modes of costume and clothing – reveals character traits and displays the bodies of stars. However, in cinema, visibility and the body appear in an often paradoxical relation to the invisible, especially when we are dealing with crime. Traditionally, the movie gangster – from D.W. Griffith's 1912 *The Musketeers of Pig Alley* to both versions of *Scarface* (1932; and Brian de Palma, 1983) – dresses in flashy clothes. But as *American Gangster* shows, fashion statements can yield criminal sentences. As much as style, the criminal also seeks invisibility, and his professional costume attempts to shield him from legal surveillance. The ideal criminal, from Plato's Gyges who owns the ring of invisibility to H.G. Wells' criminal genius Griffin, aspires to the condition of the "Invisible Man".

 Can we imagine a costume of invisibility, as contradictory as that term might seem to be? For Plato, invisibility relies on a fashion accessory, but the cinematic criminals of the silent era donned an actual costume with a consistent and specific cut and hue. Replacing the more romantic cloak of figures like Rocambole, it appeared in French cinema in the film directed by Victorin Jasset of the phantom bandit Zigomar in 1911, and passed to perhaps its most famous appearances with Louis Feuillade's films of *Fantômas* (1913-14) and, perhaps most gloriously, in the figure of Irma Vep in his 1915-16 serial *Les Vampires*. This cloak of invisibility clings to the body, sheathing it in obscurity like a second skin. And its colour is generally black. The body-hugging design contrasts with certain traditions of fashion, especially in cinema – clothes that are ornamental, creating a nearly independent architecture which houses the body in spectacular display and often inhibits movement. In contrast, the silent film criminal wears a bodysuit, which facilitates rapid or even athletic movement. This bodysuit anticipates basic principles of modern clothing design, valorising the freedom of the body, and making form follow body shape rather than being imposed on or independent of it. The criminal bodysuit derives from clothing designed for acrobats and athletes, such as the leotard (which takes its name from the 19th century trapeze artist Jules Léotard who popularised it) or the early 20th century body-hugging swimsuit, known in France as maillot de bain. The leotard and *maillot* generally used flexible knit material, jersey, that rendered them skintight yet unconfining. If this design originally sought to make movement comfortable, it also revealed the wearer's body, and thus guaranteed these costumes a place in spectacular performances.

 Colour, especially uniformity of hue, also plays a key, but ambivalent, role in this costume's display of the body. While its cut and shape reveal the body, its colour can blot it out – or seem to reveal it. The black criminal bodysuit relates ambivalently to its closely related opposite, the flesh-coloured

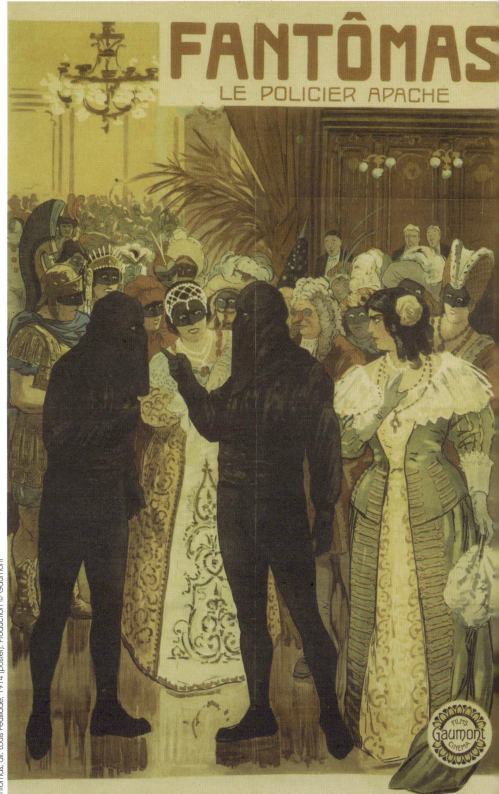

Fantômas, dir. Louis Feuillade, 1914 (poster). Production © Gaumont

bodystocking. Tights, as part of the costume of the ballet dancer and the burlesque performer, allow display of female anatomy without risking the actual nudity found in the more scandalous performances of *poses plastiques*, in which nude women posed to resemble classical sculptures in the 19th century, or the strip show of the 20th century. As part of 19th century masculine sporting culture, "leg shows" relied on pink fabric to shield the viewer from complete debauchery (as ballet did for more socially respectable audiences).[1] The scandalous performer Adah Isaacs Menken was famous for her burlesque (referring not to modern shows featuring striptease, but *transvesti* performances in which women played male roles) portrayal of Byron's hero Mazeppa, especially the scene in which the hero is tied, naked, to a horse (with Menken wearing a cloak and a flesh-coloured close-fitting bodystocking).[2] Flesh or light-coloured bodystockings appeared not only in burlesque, but in variety theatre, early cinema Mutoscope peepshows, and semi-pornographic cabinet photographs. Such costumes played hide and seek with revelation and imagination, a thin fabric standing between permitted sights and illicit possibilities. This neutral, artificial second skin provided a screen for fantastic and transgressive projections, bringing the bodystocking closer to criminal garb, even if colour and apparent visual effect remained opposed. Feuillade's *femme fatale* leader of the Vampire gang, Irma Vep, fused the associations of crime and sexuality as she slipped her dark maillot and cagoule over her voluptuous body, revealing every *fin de siècle* curve while cloaking them in a sinister black. Irma Vep's luxurious *maillot de soie* became (as Monica D'Asta and Vicki Callahan have shown[3]) the trademark of the fascinating actress Musidora, who played her. The surrealist Louis Aragon later claimed that Vep's dark bodysuit inspired the youth of France with fantasies of revolt.[4] If one associates this costume simply with recherché eroticism, seeing Maggie Cheung's slightly updated version in Olivier Assayas' 1996 filmic homage to Feuillade, *Irma Vep*, would demonstrate to anyone who can get one eye open that it still packs a wallop.

If the cut of the criminal bodysuit reveals the body within, the role of concealment comes primarily from its colour. The choice of black is not surprising: it is the colour of non-existence, the shade of night. The criminal is the brother (and sister) of night and obscurity, identifying with, and dwelling in, its shadows. But is it possible for clothes to render a body invisible? Black becomes unnoticed only in an environment of darkness. This effect of the criminal bodysuit finds its closest parallel in unexpected contexts that also blend costume with background: science and magic. The genre of "black-box" magic evolved within the highly optical theatre of magical illusion that was popular at the turn of the 20th century. In black-box magic, brightly focused electrical light sharply illuminated the foreground of the stage, while the background remained shrouded in shadow.[5] The back of the stage set was further obscured by being covered in light-absorbing dark material. With bright light poured onto the action in the foreground, the background darkness eliminated cues of depth. Serving as an optical black hole reflecting no light, this black background blended with dark-garbed figures moving within it so as to erase them from the visual field. A black-cloaked stagehand could manipulate light-coloured objects without being seen, and thus created the illusion of levitating props or invisible beings.

This trick from the theatre of illusions transferred easily to photographic media, perhaps most famously the trick films pioneered by the French entrepreneur of theatrical magic, Georges Méliès. The same basic principle can be applied to digital media and (with a switch in hue) underlies both video "blue screen" effects and the principles of motion capture. A dark figure against a dark background can become invisible photographically – not registered on the negative. Such visual erasure stretched beyond entertainment to the scientific study of movement by physiologists such as Étienne-Jules Marey. Marey's assistant Georges Demenÿ shrouded his body in a black bodysuit and hood, while white strings attached to the costume marked out the basic limbs and joints that Marey wanted to observe. As in black-box magic, the black costume photographed against a black background erased the superfluous physical details of the body. Plotting vectors with the white strings, Marey's images of motion yielded abstract arrays of information, resembling self-generating graphs. These *chronophotographs* used the body as a stylus inscribing its own mobile track, even as it erased its own visible physicality.[6]

The imaginary of the modern era draws together the modes of magic, science and criminality, kept separate in rational discourse. The modern environment confronts its denizens with a hyper-visual, yet deeply ambiguous world. Invisible forces such as electricity, radio waves and magnetism dissolve traditional concepts of materiality and tangibility and put pressure on the nature of visual experience. Fashion shows this pressure as well, probing a realm of visibility between nakedness and sartorial extravagance. What if nothingness dwells beneath the clothes?

In the fantasy (or, in the case of H.G. Wells, scientifically grounded speculation)

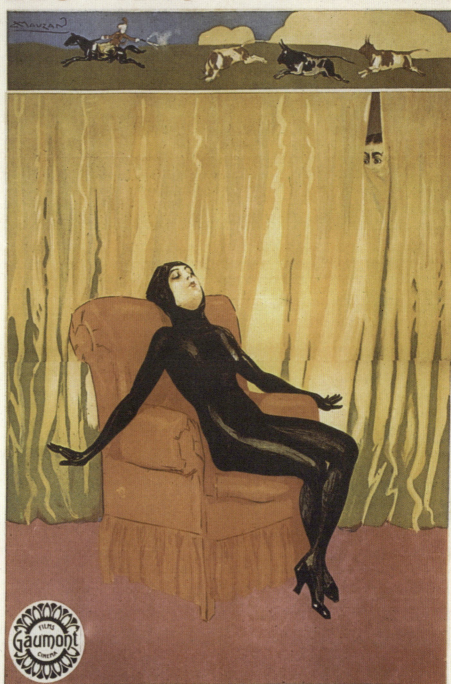

Les Vampires, dir. Louis Feuillade, 1915 (poster). Production © Gaumont

of an invisible man, the body itself disappears and clothes literally seem to make the man. When Griffin, Wells' invisible criminal genius, lets his costume slip, a character expresses alarm: "'Why!' said [he] suddenly, 'that's not a man at all. It's just empty clothes.'"[7] Griffin's uncanny quality of insubstantiality – no body, only clothes – triggers the reign of terror he inaugurates as much as the difficulty in apprehending him. Wells describes the reaction to Griffin removing his mask:

> It was worse than anything … They were prepared for scars, disfiguration, tangible horrors, but *nothing*! … For the man who stood there shouting some incoherent explanations, was a solid gesticulating figure up to the coat-collar of him, and then – nothingness, no visible thing at all![8]

This invisible body terrifies the population by threatening fundamental concepts of identity, existence and even ethnicity. A bystander describes an unguarded glimpse of Griffin's apparent body after a dog tears his trouser leg in racial terms:

> This chap you're speaking of, what my dog bit. Well – he's black. Leastways, his legs are. I seed through the tear of his trousers and the tar of his glove. You'd have expected a sort of pinky to show, wouldn't you? Well – there wasn't none. Just blackness. I tell you, he's as black as my hat.[9]

Although Wells' 1897 novella, with its chase, pursuits, thefts and murders, reads like a crime thriller, it is usually thought of as science fiction, due to its speculation, in the wake of Roentgen's discovery of the X-ray in 1895, about the possibility of the human body becoming more transparent than glass, disappearing from view. But even without introducing Wells' scientific speculation, the modern crime novel increasingly describes a conflict between visibility and invisibility. The modern detective perceives evidence where others see nothing significant, while the criminal seeks the shelter of obscurity, seeking to evade surveillance. Costuming plays an essential role in this duel of the gaze and the shadow. Clothing hides Griffin's eerie invisibility and becomes a pseudo-body, but the master criminals of turn-of-the-century crime fiction primarily used clothing to make their bodies blend into their surroundings, to conceal them.

The traditional account of the modern detective story traces a trajectory from Edgar Allan Poe through to Arthur Conan Doyle (often skipping the essential authors Anna Katherine Greene, Paul Féval and Emile Gaboriau), based primarily on the genre's use of the empirical gathering of evidence and the process of ratiocination. But even in the work of Poe and Doyle, not to mention a host of other mystery authors, disguise (involving costumes, as well as make-up and basic acting skills) often plays a more central role than deduction and the gathering of evidence. Mastery of disguise allows both criminals and detectives to manipulate identity. But clothing also offers clues. French historians of detective fiction Régis Messac and Roger Caillois relate the detective story to the rise of empirical natural science, and Sherlock Holmes's expertise with test tubes and chemical analysis support this connection.[10] But more fundamentally, the detective operates as a social scientist, able to read fashion as signs not only of personal behaviour but also of profession and social class.

Poe demonstrates this at the very beginning of the genre, in his short story detailing "the type and the genius of deep crime",[11] "The Man of the Crowd". More than a quarter of this short tale is taken up by the observations made by its protagonist as he observes the "figure, dress, air, gait, visage, and the expression of countenance" of the passing urban crowd.[12] Based on these observations, he describes, with precision, their social class and professions, moving from the "decent" noblemen, merchants and attorneys, through "the tribe of clerks", to pickpockets, gamblers and "women of the town".[13] But the eponymous figure of the tale, the "genius of deep crime" terrifies the protagonist by his lack of legibility, a quality that is described by Poe as a book that "does not permit itself to be read".[14]

The criminal aspires to this terrifying illegibility and the power of obscurity that it entails. To quote the famous prologue to Pierre Souvestre and Marcel Allain's first novel of the *Fantômas* series:

> "Fantômas."
> "What did you say?"

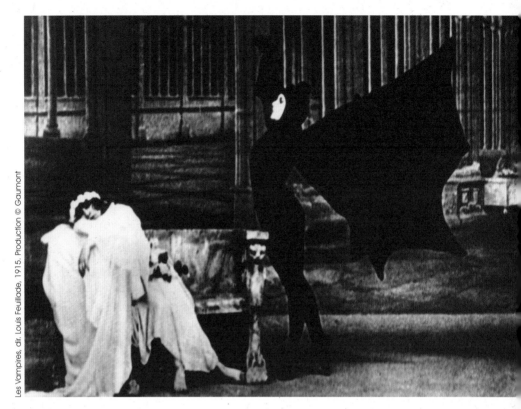

Les Vampires, dir. Louis Feuillade, 1915. Production © Gaumont

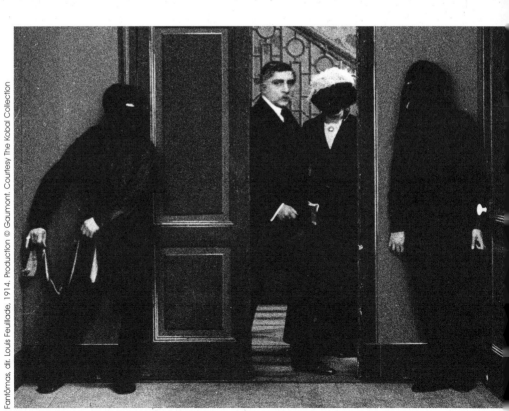

Fantômas, dir. Louis Feuillade, 1914. Production © Gaumont. Courtesy The Kobal Collection

"I said: Fantômas."
"And what does that mean?"
"Nothing... Everything!"
"But what is it?"
"Nobody... And yet, yes, it is somebody!"
"And what does the somebody do?"
"Spreads terror!"[15]

Fantômas, the ultimate master criminal, appeared in thirty-two novels written by Souvestre and Allain between 1909-13, and in the five *Fantômas* films made by Louis Feuillade between 1913-14. Like most criminals and detectives, he employed a variety of avatars, identities with varied social classes and appropriate costumes. In *Les voleurs des visages*, a study of false identities assumed in crime fiction by such mysterious criminals as Arsène Lupin, Rocambole and Fantômas, Didier Blonde lists over fifty identities taken on by Fantômas.[16] But the core underlying these personae remained hollow, as Fantômas' most enduring identity lay in erasing all visible traits as "The Man in Black". Like Milton's Pandemonium, this avatar is darkness visible.

As "The Man in Black", Fantômas wears perhaps the archetypal criminal bodysuit. Most often he appears disguised in the costumes of his various avatars. But he also occasionally wears a black mask and (somewhat anachronistically) a dark cloak. In the second *Fantômas* novel the mask is described as clinging to his face as if moulded to his features.[17] By the fourth novel of the series, *L'Agent secret*, this rather traditional dark mask becomes less a means of disguise than an emblem of the radical eradication of identity that Fantômas embodies (or disembodies). Bobinette, the mistress of a government attaché, beholds a mysterious figure as he removes his disguise as an old beggar: "He was dressed, or rather sheathed, in a clinging bodysuit (*maillot collant*) of dark knit from neck to toe, fitting him tightly."[18] The figure also wears a *cagoule*, a hooded mask that reveals only his eyes, which dart savagely with a fiery glare. The novel describes the figure as a man without a face, an apparition, an anonymous mask, with a body like a statue, a figure rendered unrecognisable, yet paradoxically precise in its mystery. Bobinette realised that this dark phantom could only be Fantômas.

Fantômas responds to this identification with a speech that crystallises the way his identity – or lack of it – merges with his costume:

> Yes indeed, I am Fantômas! ... I am he that the entire world seeks, but whom no one has seen and no one can ever recognize! I am Crime! I am Night! I have no face, because the night, because crime has no face ... I am unlimited power ... I am Death.[19]

Through the combination of costume and optics Fantômas merges with his surroundings, pushing (as one novel claims) the science of camouflage to its extreme limits.[20] Fantômas reduces his figure to a silhouette, described this way in *Le policier apache*:

> Silhouette of horror, silhouette simultaneously precise and indistinct, which merges with the night, disappearing momentarily, then reappearing as a dark blot on the surface of a light wall ... the silhouette of Fantômas![21]

Fantômas terrifies by disappearing and by appearing suddenly. He is the master not simply of invisibility, like Wells' mad scientist Griffin, but of the terror spawned by uncertain vision and unreliable identity, the product of the play of light and shadow. Rather than clothing that marks and fixes social identity, or even disguise that confuses and obfuscates recognition, Fantômas and his cloak of invisibility reveal the background against which identities are projected – or obscured. He moulds the nothingness that lies beneath Griffin's clothes into a protean force, able to take on – or to shake off – the identity he chooses. Fantômas' ultimate fashion statement comes in *Le fiacre de nuit*, which is set largely in one of the great Parisian department stores. Juve, Fantômas' policeman nemesis, and his companion Fandor chase the criminal through the galleries of the *grand magasin*, only to find that he seems suddenly to have vanished. Seeing him already outside the store, the detectives realise that Fantômas evaded them by jumping on a display counter and taking the pose of a mannequin as they

029

Stage setting for Black Art in: Albert Hopkins, Magic, Stage Illusions, Special Effects and Trick Photography, 1898

Méliès's Spiritism. In: Pierre Jenn, Georges Méliès Cinéaste: le montage cinématographique chez Georges Méliès, 1984

rushed past without noticing him.[22]

The mysterious criminal appears as a clotheshorse, as the unnoticed mannequin blending in with the store's commercial display. Such visually ambiguous figures propel narratives of power and escape, the substance of a new modern, popular mythology. Fashion may belong most obviously to the spectacle side of cinema, dazzling viewers with displays of erotic power, personal grace and taste, or even comic absurdity. But for the cinematic criminal, fashion alternates between flash and obscurity, recalling the primal flicker of the cinema itself, as it projects shadows on a screen with light. Like a shadow, Irma Vep still prowls the corridors in the cinema of the imagination.

Notes

1. See Robert C. Allen, *Horrible Prettiness: Burlesque and American Culture* (Chapel Hill: University of North Carolina Press, 1991).
2. On Menken, in *ibid.*, pp.96-101.
3. Monica Dall'Asta, "Il costume nero da Zigomar a Musidora" in *Il colore nel cinema muto,* ed. Monica Dall'Asta, Guglielmo Pescatore and Leonardo Quaresima (Bologna: Mano Edizioni, 1996), pp.164-81; Vicki Callahan, *Zones of Anxiety: Movement, Musidora and the Crime Serials of Louis Feuillade* (Detroit: Wayne State University Press, 2005). See also Marina Dahlquist's excellent dissertation "The Invisible Seen in French Cinema before 1917", University of Stockholm, 2001.
4. Louis Aragon, "Les Vampires" (1923), in *Projet d'histoire littéraire contemporaine,* (Paris: Gallimard, 1994).
5. See the discussion of black-box magic (also known as "Black Art") in Albert A. Hopkins, *Magic, Stage Illusions, Special Effects and Trick Photography* (New York: Dover Publications, 1990 [1898]), pp.64-68.
6. The best description of Marey is in English is Marta Braun, *Picturing Time: The Work of Étienne-Jules Marey (1830-1904)* (Chicago: University of Chicago Press, 1994).
7. H.G. Wells, *The Invisible Man* (New York: Bantam Classics, 1987), p.34.
8. *Ibid.*, p.31.
9. *Ibid.*, p.16.
10. Régis Messac, *Le "Detective Novel" et l'influence de la pensée scientifique* (Paris: Librairie Ancienne Honore Champion, 1929); Roger Caillois, *Le roman policier* (Buenos Aires: Editions des letters Francais/Sur, 1941).
11. Edgar Allan Poe, "The Man of the Crowd" in *Poe: Poetry and Tales,* ed. Patrick F. Quinn (New York: The Library of America, 1984), p.396.
12. *Ibid.*, p.389.
13. *Ibid.*, pp.389-92.
14. *Ibid.*, p.388.
15. Pierre Souvestre and Marcel Allain, *Fantômas* (New York: William Morrow and Company, 1986), p.11.
16. Didier Blonde, *Les voleurs des visages* (Paris: Métailié, 1992), pp.140-44.
17. Souvestre and Allain, *The Silent Executioner* (New York: William Morrow, 1987), p.235.
18. Souvestre and Allain, *Une ruse de Fantômas* [*L'agent secret*] (Paris: Edition Robert Laffont, n.d.), p.302 (my translation).
19. *Ibid.*, pp.302-03 (my translation).
20. Souvestre and Allain, *Un roi prisonnier de Fantômas* (Paris: Presses Pocket, 1972), p.175.
21. Souvestre and Allain, *Le policier apache* (Paris: Presses Pocket, 1974), p.74 (my translation).
22. Souvestre and Allain, *Le fiacre de nuit* (Paris: Presses Pocket, 1972), p.128.

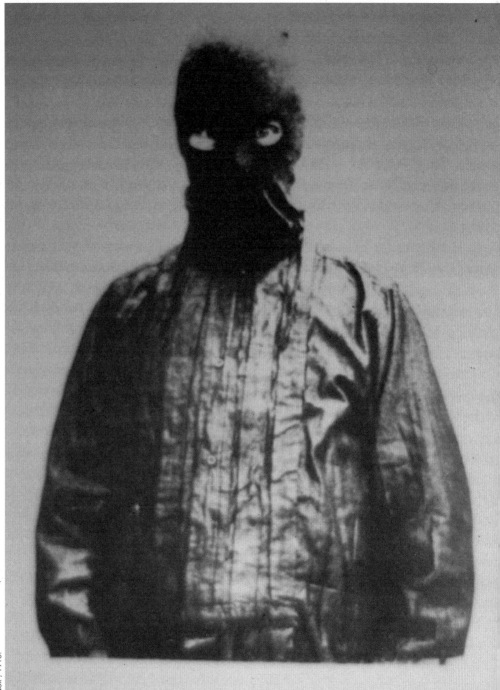

René Navarre as "The Man in Black", 1913.

M. NAVARRE

DANS LE RÔLE DE L'HOMME NOIR

The Face of Fear / Roger Sabin

Two of the movies showing at the 2008 Fashion in Film Festival are serial killer suspensers that feature a "faceless" psychopath. *Follow Me Quietly* (1949) concerns a strangler whose face we only see in the last reel, and whose identity is revealed solely with the aid of a replica dummy constructed out of clues – a dummy that is fully clothed, but without a face. *Blood and Black Lace* (*Sei donne per l'assassino*, 1964) is about a series of fashion models being bumped off by a killer who veils his features with a white stocking. Both films draw their power from the idea that an anonymous killer is more frightening than any other option, and that in particular the obscuring of the face is something guaranteed to "give us the willies" (to use a phrase from the earlier film).

But why should this faceless motif be so unsettling? And what were the inspirations? It's worth noting that the two movie killers look more or less the same – they both wear a fedora hat, with a suit or trench coat. Both are assumed to be male – though in *Blood and Black Lace* this remains ambiguous.[1] They also share other aspects. Both claim six victims, all female, leading to the deduction that they are sex killers. Both have a twisted agenda: in *Follow Me Quietly*, the killer's aim is to wipe out sinners (he calls himself "The Judge"), while in *Blood and Black Lace*, he has to punish the models for their guilty secrets (or at least that's the assumption made by the police). Finally, both are thought to be "triggered" into action: in *Follow Me Quietly*, it's the advent of a downpour of rain; in *Blood and Black Lace*, a cop speculates: "Perhaps it's the sight of beauty [that sets him off]."

It should be reiterated that in the earlier film, *Follow Me Quietly*, an American thriller in the *noir* tradition directed by Richard Fleischer, the killer is not actually faceless. It's the dummy that is. But the trick of the film is to make audiences half-believe that the killer has no features. This is confirmed in one amazing scene when the dummy actually moves. What has happened is that the killer has snuck into a cop's apartment, where the dummy had been taken, removed the dummy and sat in its place. This is an eerie moment, and takes the movie from being a straight policier into the realm of horror – more on which in a moment. In this way, by sleight of hand, the dummy becomes a sort of voodoo doll, or Golem.[2] The French titled the movie *L'assassin sans visage*, perhaps not too misleading a moniker.

Blood and Black Lace is more straightforwardly a horror film, made in Italy by the cult director Mario Bava, and this status is confirmed by the fact that the killer is a sadistic monster. He dispatches the models in a variety of horrific ways that usually involve ruining their good looks – thrusting a spiked metal claw into the face of one, pushing another's against a glowing stove, and so on. Here, his anonymity is key to the terror: his black and white appearance contrasts with the bright colours of the models' clothes, and with the cinematography in general; his sadism lends an extra psychosexual element to the drama (all the victims are left partially clothed following their ordeal). When one witness says "It looked like he didn't have a face", the idea of the killer being some kind of supernatural fiend is implanted in the viewer's mind.

This partly explains why such a character (in both films) should be so terrifying. The viewer is free to fill in the blank space below that hat brim with any demon their imagination may care to conjure. The killer becomes an empty canvas upon which we project our deepest fears. With no face how can he see, breathe, etc? How can he be human? With the obvious association with death masks, and with the drained pallor of a corpse, perhaps he is the very embodiment of Death. Here, "the mask is the meaning", in Roland Barthes' famous phrase:[3] a conceit well known to horror writers over the centuries (in Edgar Allan Poe's *The Masque of the Red Death*, 1842), the mysterious guest at a costume ball removes his mask to reveal… nothing, no face at all.

Less poetically, but no less disturbingly, the face of the killer may not be so blank. It might, indeed, be a face, but without the symmetry our brains are hardwired to comprehend. Beneath the covering, it could be scarred beyond recognition, or deformed, or mutilated in some grotesque way. After all, in *Follow Me Quietly* he strangles the women from behind so they never see him; and in *Blood and Black Lace*, his obsession is with damaging faces – perhaps his own is similarly deformed?

The scholar David J. Skal has shown how such fears of injury can be related to reality. In particular, he offers examples of horror movies in which the make-up imitates real kinds of mutilation. The face of "The Phantom of the Opera" (in the Rupert Julian classic from 1925), is revealed when he takes off his mask, and is very similar to the kind of maiming that resulted from shell bursts on the Western Front during the First World War. Wounded men in this condition, often patched together using primitive plastic surgery, would have been a common sight in the streets

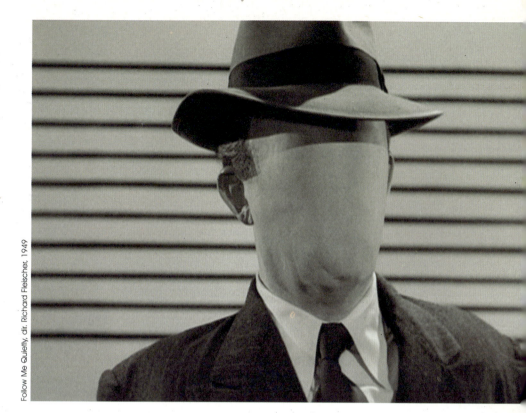
Follow Me Quietly, dir. Richard Fleischer, 1949

Follow Me Quietly, dir. Richard Fleischer, 1949

of Europe and, to a lesser extent, in the USA in the 1920s and 30s. Skal goes on to speculate that some of the other great horror films of the 1930s and 40s that involved disfigured faces might have been influenced by fine art, and in particular the disturbing portraits by the Cubists and the nightmarish visions of painter Francis Bacon.[4]

On a more subtle level, a psychoanalytical approach can offer hints about the sexual elements in the two movies, and especially the fact that the killers are male, preying on less powerful female victims. Alfred Adler has theorised that personality may be best understood as the "tool" used in striving for power. It is "constructed" to conceal inferiorities so that, for example, children with locomotion difficulties "construct an ideal for themselves that is permeated by power and speed".[5] So, too, adults construct a personality for themselves that is about feeling superior, despite the reality of their situation – thus, in literature, the disabled Byron stands in contrast to his "Byronic personality". Extrapolating from this idea, the act of putting on a mask becomes a part of the (re)construction. By erasing his face, the killer can become somebody else – bolder and less inhibited. It is instructive that in both films, he is eventually revealed to be a slightly weedy looking guy, in stark contrast to the terrifying appearance of the faceless killer/dummy.

Finally, we shouldn't forget that the violence of these movies was rooted in reality. If we follow writer Alan Moore's often-quoted line that the murders of Jack the Ripper (for Moore, the original sex killer) "prefigure a lot of the horrors of the 20th century",[6] then by the time our movies were released, those horrors were routinely acknowledged. In the case of *Follow Me Quietly*, the "Black Dahlia Killing" (1947) would only just have disappeared from the front pages of the American newspapers,[7] while *Blood and Black Lace* could be read as referring to several sex killings in Italy in the late 1950s and early 60s.[8] Both films, in the end, are about violence against women, and their politics and motivations – including blatant titillation in the case of the latter – deserve to be interrogated (though not here).

But what of the fictional antecedents to these faceless protagonists? Certainly they were not the first of their kind, and we can point to two predecessors in particular that more than likely would have had an influence – though there is no direct evidence. The first is *The Invisible Man* (James Whale, 1933), in his incarnation in the classic movie version of H. G. Wells' novella from 1897. Here, the character looks very similar to our killers – swathed in white bandages about the face, but with a suit and/or coat and occasional hat (plus the neat addition of a pair of sunglasses for extra creepiness).

In the story, he's not a psychopath as such (though he is driven to murder), and is more of a victim than a perpetrator, yet the film is definitely positioned in the horror genre. It was one of the Universal Studios stable – part of the same line as *Dracula* (Tod Browning, 1931), *Frankenstein* (James Whale, 1931), *The Mummy* (Karl Freund, 1932) and the aforementioned *Phantom of the Opera* – and, as such, H. G. Wells' story made the subtle but important switch from science fiction to horror. If the "faceless horror icon" was not established before this point in history, it was now here to stay.

Would the makers of *Follow Me Quietly* and *Blood and Black Lace* have been aware of Whale's film? It's difficult to imagine that they would not have been. *The Invisible Man* was an international success, spawning many sequels, and *Follow Me Quietly* was made only a few years after the last of these (*The Invisible Man's Revenge*, Ford Beebe, 1944). As for *Blood and Black Lace*, by the time it was released, Mario Bava was being hailed as a master of horror, and as a European successor to the Universal Pictures legacy. He had made a series of striking horror films, all of which put a spin on the American model, and was riding high on the success of his latest shocker *Black Sabbath* (*I tre volti della paura* with Salvatore Billitteri, 1963). Although Bava ventured into other genres, *Blood and Black Lace* was another addition to the horror category that he would return to, again and again, throughout his career.

The second major antecedent to the faceless murderer came from the world of comic strips. "The Blank" (aka "Faceless Redrum") was a character from the *Dick Tracy* strip, who made his debut in 1937. This figure is a former gang leader whose face has been horribly mutilated in a shoot-out, which he covers with a stocking while he goes about killing off his former wiseguy sidekicks. Again, he wears the fedora hat and coat, and looks very similar to our killers (as well as playing on Skal's fears of mutilation).[9] He was one of a number of grotesques characters that populated the *Dick Tracy* stories: always a strip that transcended being a mere crime soap opera, and which reportedly attracted more adult readers than children.

Again, we should ask whether the makers of our two films would have been aware of the character: and, again, the answer is almost certainly. *Follow Me Quietly* is interesting because one of the

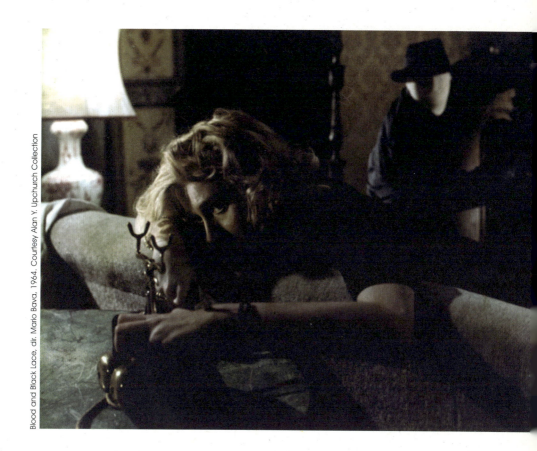
Blood and Black Lace, dir. Mario Bava, 1964. Courtesy Alan Y. Upchurch Collection

subplots involves the way in which trash culture (supposedly) leads to aberrant behaviour – specifically, the killer reads *True Crime* magazines. As such, the movie was commenting on a moral panic prevalent in the late 1940s about "crime" fiction, variously defined. This involved magazines, for sure, but also comic books and strips (indeed, in some parts of America, crime comics were destroyed on public bonfires). *Dick Tracy* was more stylised than most examples, and therefore largely avoided the censure that followed in the 1950s.[10] But being a crime story, and an often very violent one at that, it was part of the same generic continuum. The film was therefore connecting with "The Blank" in an oblique manner – but, without doubt, the character would have been known to many viewers, and the overall message of the film would have been much more salient than it seems today.

As for the makers of *Blood and Black Lace*, they too would likely have been aware of "The Blank", even though they were Italian. The *Dick Tracy* strip was widely syndicated throughout Europe, and in Italy in particular there was a growing respect for American cartooning. In the 1950s and 60s, appreciation societies were formed, and the first attempts by academics and scholarly writers to analyse the comic form stem from this period. The first serious history of comic art was published in 1961 (Carlo Della Corte's *I Fumetti*), and Umberto Eco's groundbreaking collection about mass communication, *Apocalittici e integrati: Communicazione di massa e teorie della communicazione di massa*, which included three essays about American comics (on Steve Canyon, Superman and Charlie Brown), appeared in 1964 – the same year as Bava's film.[11]

This trend in Italy would blossom in the late 1960s and 70s, with comics studies being co-opted into the universities, and the Lucca Comics festival becoming the focus of interest in the form. (Lucca established a prize for the best comics, and named it after an American character – The Yellow Kid.) Mario Bava himself was surely aware of these developments, and two years after *Blood and Black Lace*, he was given the job of directing a comic strip-based movie. This was *Danger: Diabolik* (1968) and centred around an urbane criminal; again, the protagonist was a masked character, but in a quite different mould from before. The movie is now seen as a landmark in 1960s "camp" cinema.

These are just two examples of possible influences on the look of the faceless killer. There may be others. From the world of literature, for instance, books had been trading in similar bogeymen for years, a trend given a fillip by the thriller and science fiction pulp boom of the 1920s-40s (eg Edgar Wallace's *White Face*, 1930, and Philip Wylie's *The Murderer Invisible*, 1931). Other movies may also have been influential. It is known, for example, that Mario Bava was an admirer of the French director Georges Franju, whose *Eyes Without a Face* (1960) featured a character who wears a white mask to conceal a face ravaged by radical plastic surgery (the movie poster was particularly striking for its use of the menacing visage).

It's clear, therefore, that our films were part of a tradition of such characters, and today we can look back on how this tradition evolved after they'd been premiered. Lack of space forbids a thorough analysis, but it is striking, for example, how popular culture built upon each psychological component of the faceless killer that we have so far identified – his bogeyman status, his role as an avenger, and his fetishistic mystique – and took them towards their logical conclusions.

Most obviously, the masked or "faceless" psychopath became a cliché in horror cinema after the 1960s. The three most famous franchises in this respect are "Michael Myers" in the *Halloween* series (original, John Carpenter, 1978), "Jason" in the *Friday the 13th* films (original, Sean S. Cunningham, 1980), and "Leatherface" in the *Texas Chainsaw Massacre* movies (original, Tobe Hooper, 1974).[12] Each features an unknown/unknowable killer in a white or flesh-coloured mask, and each has spawned massive amounts of merchandise, including countless Halloween masks, fancy dress costumes, toys, models, comic books, websites and fan magazines – not to mention the many "homages" posted by fans on YouTube. In fact, the subgenre was such a cliché by 1996 that the Wes Craven movie *Scream* set out to parody it – and in so doing came up with the same "split identity" solution to "who was under the mask" as in *Blood and Black Lace*.

The "avenger" motif is undoubtedly evident as a plot device in some of these movies, but is not their central concern. In other evocations of the "faceless man", it has been theorised more deeply, as in the case of comic book character "The Question", created by Steve Ditko, one of the great comic book artists and the co-creator of *Spider-Man*. "The Question" made his debut in 1967, and was a cult hit rather than a smash like some of Ditko's other characters. Here, again, we have a figure with a masked face (no eyes, nose or mouth), wearing a suit or trenchcoat and fedora hat. Only this time he's not a psychopath but a "righter of wrongs", in the tradition of the American superhero genre.

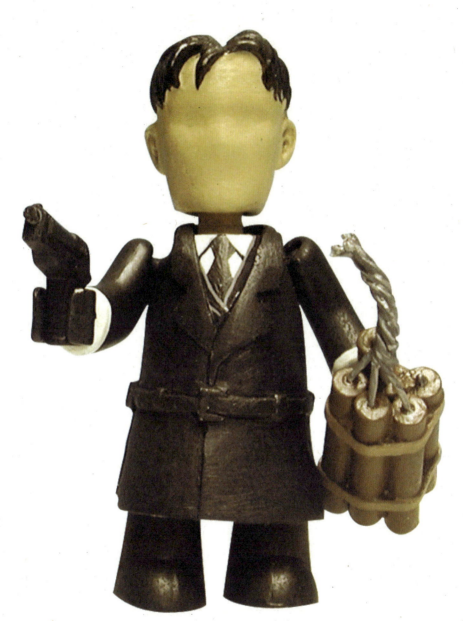

The Blank (promotional photograph). Courtesy Mezco Toyz

The links with the agendas espoused by the Bava/Fleischer killers are therefore tenuous, but the idea is the same.

Ditko's aim was to put heroic retribution into a more philosophical context, and he was deeply influenced by Ayn Rand's take on "Objectivism". Thus, "The Question" was more complex than "The Blank" and other creations in that mould. The character was paid homage to by the aforementioned Alan Moore in the 1987 graphic novel *Watchmen*, with the character Rorschach, who went even further than "The Question" in his obsession with moral absolutism, and who was depicted as a merciless vigilante, dispatching "justice" dressed in – you guessed it – a mask, trenchcoat and fedora. *Watchmen* is currently being turned into a blockbuster movie, due for release in 2009.

Finally, the fetishistic aspects of the "assassin sans visage" are certainly present in these examples of psychos and avengers, but perhaps have been played out with the most wit in the world of fashion, a world where, of course, facelessness is nothing new – think of shop mannequins and fashion photography. In particular the creations of Leigh Bowery, designer and night-club diva, in the 1980s-90s drew on the fascination with masks then evident in London's fetish clubs. His fashion designs built on the Malcolm McLaren "Cambridge Rapist" T-shirt/look (based on the rubber hood worn by a wanted rapist), by focusing less on un-PC nastiness and more on outrageous post-New Romantic fun. The effect of Bowery's numerous mask creations was still unsettling, but imbued with a knowing humour, and he went on to influence designers including Gareth Pugh and Yu-Shin "Mue" Kim, who became known for using masked catwalk models.

Follow Me Quietly and *Blood and Black Lace* were movies ahead of their time. In the 1990s, the serial killer became *de rigueur*, on the back of the success of the "Hannibal Lecter" books and films (another character, incidentally, in a mask). Such killers came to be seen as "symptoms of the postmodern age", and in an atmosphere of intense interest in them on the part of movie critics (and especially movie fanzine critics), *Follow Me Quietly* and *Blood and Black Lace* were rediscovered. Now, for the first time, it could be seen that *Follow Me Quietly* set the template for a particular kind of serial killer movie, starring a cop who is obsessed with catching the killer (à la *The Silence of the Lambs*, Jonathan Demme, 1991), while *Blood and Black Lace*, with its then shocking sexualised attitude to killing, could be re-assessed as essentially inventing the modern "body count" horror film. For both movies, the faceless killer was key to the suspense – as we have seen, a mix of bogeyman, avenger and fetish-nightmare. He will no doubt live again, continuing to "give us the willies", and provoking deeper thoughts about what it might mean to be de-faced.

Notes

1. See Tim Lucas's essay in this catalogue for a thorough account of the film. Mid-way through, it's hinted that the killer could be a middle-aged female house servant, and at the end we discover that two of the murders were perpetrated by the female owner of the fashion house (Eva Bartok) who is the main psycho's (Cameron Mitchell) lover.
2. There are other points in the film in which the dummy is treated as "real". In a demonstration to his assembled team, the police chief voices responses from the dummy through a microphone: "What's your name?" "I am The Judge," etc.
3. Roland Barthes, *Camera Lucida: Reflections on Photography* (London: Vintage, 1993), p.34.
4. See David J. Skal, *The Monster Show: A Cultural History of Horror* (London: Plexus, 1994; revised edition, 2001).
5. Alfred Adler, *Understanding Human Nature* (Oxford: Oneworld Publications, 1992), p.47. I am grateful to Dr Julia Round for this information. See her excellent article on masking in relation to superhero comics: "Fragmented Identity: The Superhero Condition", *International Journal of Comic Art* (Vol.7, No.2, Fall/Winter 2005), pp.358-69.
6. Gary Groth, "Last Big Words – Alan Moore on *Marvelman, From Hell, A Small Killing,* and being published", *The Comics Journal* (140, February 1991). Moore's graphic novel *From Hell*, illustrated by Eddie Campbell, is a version of the Ripper story, in which connections are made with several later killers – including Peter Sutcliffe and Ian Brady.
7. Interestingly, Fleischer returned to the story of a killer who strangles in his most celebrated film *The Boston Strangler* (1968), based on a true story.
8. In his recent book on Mario Bava, Tim Lucas quotes Luigi Barzini's non-fiction study *The Italians* (New York: Bantam Books, 1965), pp.112-13: "Italy is a blood-stained country … Streetwalkers are found dead with silk stockings wound tight around their necks …" Lucas, *Mario Bava: All the Colors of the Dark* (Video Watchdog, 2007), p.542
9. The Blank was just one of a number of similarly attired characters in the comics. For example, an early *Batman* number featured Charles Maire, the victim of a villain who used a laser beam to cut away his face. In Europe, a tradition of such masked characters also existed, the most famous of whom was Fantômas.
10. See Amy Nyberg, *Seal of Approval: The History of the Comics Code* (Jackson: University Press of Mississippi, 1998).
11. For a personal account of the early days of comics scholarship in Italy, see Giulio Cuccolini, "In Search of Lost Time or Time Regained", *International Journal of Comic Art* (Vol.4, No.1, Spring 2002), pp.26-39.
12. We could add to this list the many movie re-hashes of *The Invisible Man* that have appeared over the years – though these were never as popular as the *Halloweens*, etc. The look of the character hardly ever changes (bandaged, in a coat, with a fedora hat).

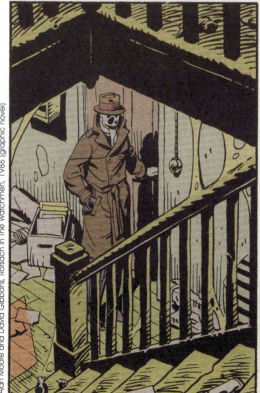

Alan Moore and David Gibbons, Rorsach in The Watchmen, 1986 (graphic novel)

The Killing Game: Glamorous Masks and Murderous Styles in Elio Petri's *La decima vittima*[1] / Anna Battista

> I'm a fan of Italian early '60s and late '70s art-house films, such as Antonioni, Fellini, Petri and Bava's. There are in particular two films which have extraordinary visual quality that still manage to thrill me, *The 10th Victim* and *Diabolik*.
>
> Roman Coppola, March 2004[2]

The 1960s opened in a gloriously stylish way for Italian cinema-goers: Federico Fellini's *La dolce vita* (1960) caused a major scandal with its portrayal of the decadent, orgiastic and debauched lives of Rome's glamorous inhabitants, Michelangelo Antonioni chronicled the boredom of his chic characters in his existential trilogy about alienation and loneliness that started with *The Adventure* (*L'avventura*, 1960), and Elio Petri debuted on the big screen with *The Assassin* (*L'assassino*, 1961), a psychological thriller that turned the reversible tweed paletot with raincoat lining (designed by the excellent menswear tailor Bruno Piattelli and worn by Marcello Mastroianni) into the "must-have" coat of the decade.[3] A few years later, Mario Bava officially started the Italian *giallo* (thriller) trend, with his deadly glamorous *Blood and Black Lace* (*Sei donne per l'assassino*, 1964) characterised by vibrantly garish colours.

The economic boom that began in the late '50s and which was marked by important changes – mainly a structural shift from an agriculture-based economy to an industrial one and the diffusion of new lifestyles and behaviours – continued through the early years of the following decade. Television also started its revolution in technology and communications and brought into the homes of Italians new and superfluous goods via the advertising program "Carosello".[4]

The future held great promise, encouraged by man's ventures into outer space. In America, the conquest of outer space inspired the science fiction genre in literature and film, whereas in Italy, space discoveries were more influential in interior design, art and, above all, fashion. The Italian designer Emilio Pucci became famous in the mid-60s for producing hostess uniforms for Braniff International Airways. His 1965 "Gemini 4" comprised a reversible coat with print hat and scarf, lime gloves, two-colour stitched boots in the André Courrèges style and a helmet dubbed "Space Bubble". Highlights of the collection for the Autumn/Winter 1966-67 season were Antonelli's space-age plastic jacket and beret, and capes and evening pyjamas made of see-through plastic and vitrified aluminium.[5] A few years later, in 1969, journalists reviewing Rome Fashion Week claimed that "lunar fashion" had landed on the catwalk. Among the many designers influenced by the moon landing was the Rome-based *haute couture* house, Sorelle Fontana.[6]

The future excited and inspired, but science fiction was destined to remain a secondary genre in literature and on the big screen. Bava paid homage to it with his low-budget science-fiction-meets-horror *Planet of the Vampires* (*Terrore nello spazio*, 1965), while with *The 10th Victim* (*La decima vittima*, 1965) Elio Petri created a highly underrated pop art masterpiece with a sci-fi plot.

The film was based on a story by Robert Sheckley[7] and adapted for the screen by Petri, Tonino Guerra, Giorgio Salvioni and Ennio Flaiano. Set in the future, *The 10th Victim* introduces the viewer to a dystopian world that has turned the human race's hunger for violence into a game called "The Big Hunt". Hunters and victims compete against each other for cash prizes, but only the tenth victim entitles the murderer to a fabulous prize and global fame. Shortly after the film begins, we see the American Caroline Meredith (Ursula Andress) travel to Rome to look for her tenth victim, Marcello Poletti (Mastroianni). Killing is easy for this eager and clever hunter and an advertiser has even paid her to turn the murder into a sensational television ad for his product. But she hasn't reckoned with the possibility of falling in love with her victim.

Most critics tend to divide Petri's filmography into three stages: the early era, which opens with *The Assassin* and closes with *The 10th Victim*; the mature phase, during which he shot his first political films; and the final phase, including films characterised by complex and dark plots. Writer and journalist Alfredo Rossi suggests a different method for analysing his works: according to Rossi, in all Petri's films his characters wear a sort of invisible mask that they use to hide their identity.[8] He therefore examines Petri's filmography by investigating the meaning of the different masks that the characters wear in the director's most political films. Yet, this "masking game" is also widely used in *The 10th Victim*.

Here it is not only the characters that put on a mask, but also the environments in which they move. It is only superficially that the Rome of *The 10th Victim* looks like the Italian capital that we all

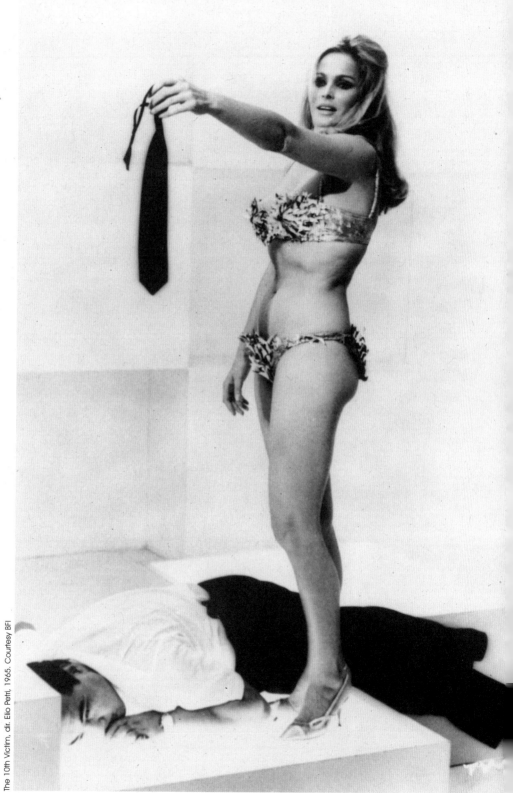

The 10th Victim, dir. Elio Petri, 1965. Courtesy BFI

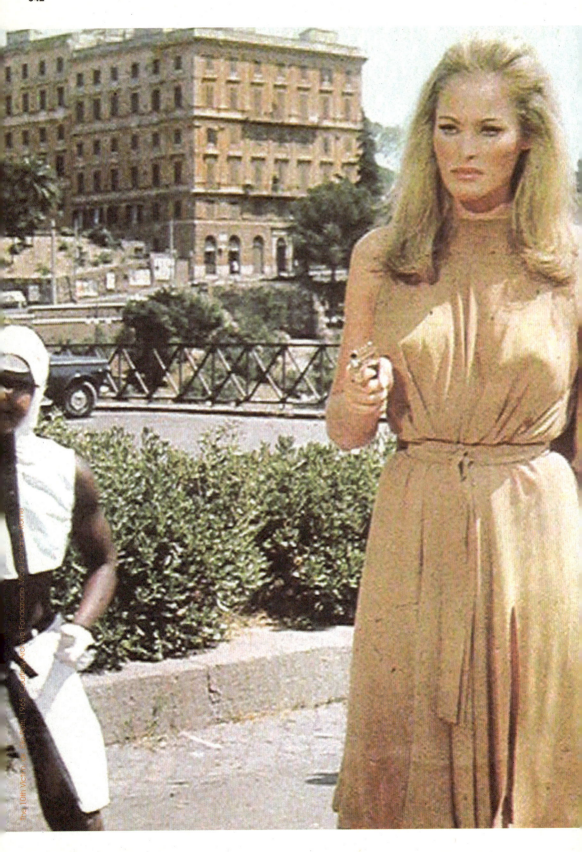

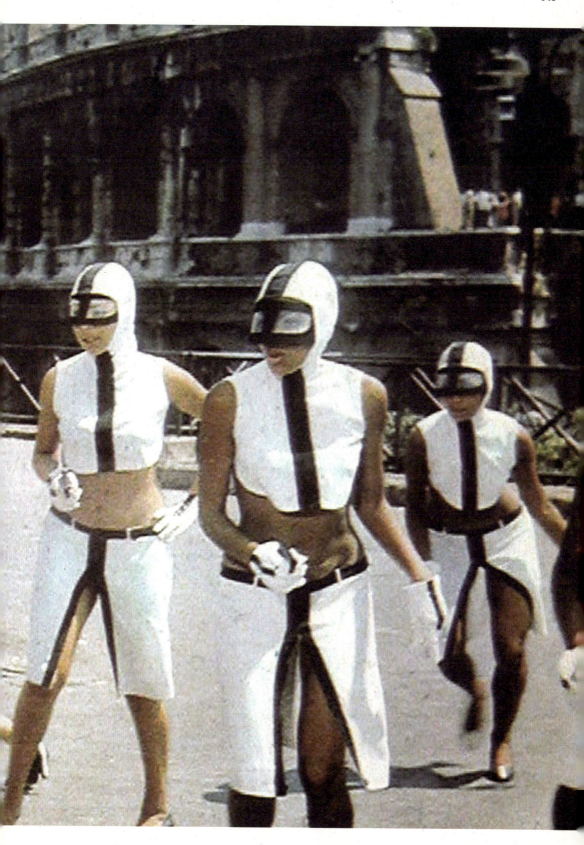

know, with its timeless monuments and locations. When the camera focuses on the interiors and the clothes of the various characters, we discover that this is a futuristic version of the city. The dietetic snack bar where Marcello meets Caroline for the first time is very different from the cafes in Via Veneto made famous by *La dolce vita*. Indeed, it is an abstract space furnished with low tables and inflatable square stools that evokes in its architecture the formalist abstractions of the painter Richard Smith.[9]

Marcello's flat in Lungotevere Fellini 149[10] is located, like the snack bar, on the top floor of a building. White curtains divide the various spaces, allowing anybody – from his lover Olga to the officer serving the order of attachment – to get in and out freely. A mobile painting that resembles Joe Tilson's *Look!* (1964) hangs on a wall, emphasising Marcello's status of a victim, constantly watched by his hunter.

While Marcello's flat is mostly an open-plan space, his ex-wife Lidia's house is full of mobile walls that lead to other rooms or ones that hide and "mask" secret spaces. One of these is a room that can only be accessed by hitting mysterious optical art-like targets resembling op-artist Victor Vasarely's "Vonal KSZ", and in which Marcello's elderly parents are hidden.[11] Lidia's space is cluttered with objects: multicoloured lamps, cushions, sofas, and life-size figures that imitate George Segal's monochromatic plaster-cast sculptures are scattered all over the place. Glamorous but bizarre photographs portraying women's body parts are used to cover up a piece of furniture or a safe, whilst also symbolising the reduction of the human body to an object that hides inside itself another object.

Petri scatters all these little clues throughout the film with the aim of satirising contemporary society. Superfluous objects – from televisions and Ericofon telephones[12] to furniture that recalls Joe Colombo's space-age compact pieces as well as Verner Panton and Vito Magistretti's chairs and lamps – fill up the various environments, almost dominating the screen.[13]

It is clear that one of the main "masks" of *The 10th Victim* is art: Petri loved paintings[14] and this film shows indepth knowledge of contemporary art. Director of photography Gianni Di Venanzo's "gorgeous pop art miscellany of colours"[15] echoes Barnett Newman and Kenneth Noland's vivid shades; the props for the Ming Tea ad are reminiscent of Andy Warhol's pop art paintings based on ads, and its giant cups of tea evoke Claes Oldenburg's three-dimensional plaster objects such as ice-cream cones, hamburgers and toothpaste tubes; Jasper Johns' paintings of targets are masked, transformed into real targets in "The Professor's" gym – a cross between the boxing clubs popular in Italy in the '60s and a technologically advanced James Bond-esque training space. Actor Salvo Randone, who stars as "The Professor", the gym's owner and trainer, is a grotesque mask himself. He is indeed a sort of comical half-man, half-cyborg creature, with various artificial appendages replacing missing body parts. While The Professor uses leather and stainless steel prostheses to mask his body, Caroline uses her dresses.

In the masking game of *The 10th Victim*, the costumes worn by the characters are a manifestation of the social and political climate in which they live; outfits are indeed used to make a fashion statement, but also to serve the criminal purposes of the hunters and victims. Caroline's stunning dresses and suits make her feel confident, while allowing her to move comfortably. They are beautifully cut and highly practical, intended to flatter her figure and make her feel young and carefree. They are purposely designed for action – running, travelling, driving and, above all, killing. The flawless outfits and their style mirror the perfection of Caroline's killing skills, but they also give her a distinctive look and influence her behaviour.

The costumes for this film were designed by Giulio Coltellacci and made by the Sorelle Fontana fashion house (Andress's costumes) and the tailor Bruno Piattelli (Mastroianni's). Coltellacci worked as a cover designer for French *Vogue* after the Second World War, and after a few years returned to Italy where he became famous for his work for the stage and film. His costumes for Petri's film marked a change in fashion and actually anticipated future trends on the big screen.[16] The main inspiration for the costumes came directly from André Courrèges and his use of dynamic designs: when Caroline first appears in the film, she is running away from her hunter wearing a short black and white sleeveless cow-print belted tunic dress and black tights. White-framed sunglasses, a white bag, cut-out gauntlets and flat mid-calf boots complete her look.

As soon as she steps into the "cubist" environment of the Masoch Club, Caroline turns from victim into hunter. Her dark wig is removed to reveal a cascade of blonde hair, her dress is replaced by a seductive metallic mini-dress, silver sandals and a mask. A member of the audience removes

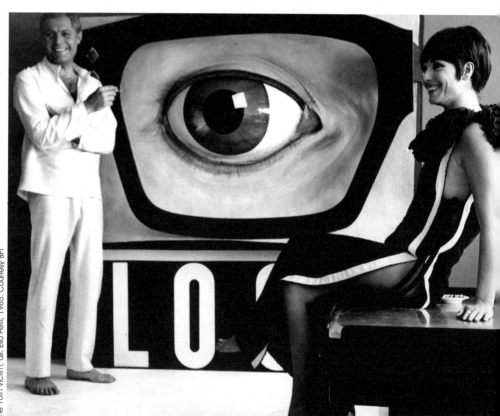

The 10th Victim, dir. Elio Petri, 1965. Courtesy BFI

Caroline's corset, unveiling a silver lamé bikini decorated, like her mask, with sharp metal flakes.[17] As she reaches the climax of her striptease, Caroline invites her hunter to take her mask off and, as soon as he recognises her, she shoots him through her bra. From a weapon of seduction, the bikini bra turns into a murder weapon, a "rapid-fire brassiere".[18]

At the same time in Rome, Marcello devises a clever – albeit more passive – way to kill his own victim, the horse lover Baron von Rauschenberg. Rather than going to Germany to kill him, Marcello lazily waits for the Baron to visit Rome to attend a race. Pretending that he is his valet, he eliminates the Baron using a pair of explosive boots. Both Caroline and Marcello turn accessories into murdering tools; both know how to "mask" their weapons, making them look like ordinary objects.

It's Caroline, though, who is the true expert in the masking game: when she and her team get off the plane arriving from America, her wardrobe still features black and white or all-white Courrègesian costumes. As she steps onto the tarmac, she is wearing a white crepe trouser suit, and her look is completed once again by cut-out gauntlets, headband sunglasses and a bag. In a scene where she is spying on her victim from a screen in her hotel room, we also see her wearing a white open grid tunic over a black leotard and black tights – a look that matches the op art painting hanging behind her. But as soon as she starts her new hunt in Rome, Caroline radically changes her style,[19] wearing costumes made by the Sorelle Fontana fashion house.[20] In the weeks before shooting started, Rome's paparazzi hid around the corner of the Fontana atelier, to take pictures of Andress coming out of costume fitting sessions carrying piles of suits and dresses.[21] Soon, rumours spread about the costumes: "As the story of the movie takes place in 2000 A.D., Ursula's clothes will be of metalised materials designed for 'easy space flight wear'", wrote the *Rome Daily American*,[22] while a journalist writing for *Momento Sera* described the material of the costumes as "very similar to aluminium".[23] The costumes chosen for the film were, in the end, very different from the ones described in these articles.

When Caroline first meets Marcello at the snack bar, she is posing as an American journalist, and is carefully attired in a peony pink silk crepe trouser suit with a matching clutch, flat sandals and plastic glasses with slits.[24] The idea for this costume probably came from an extravagant space-age jersey suit in mango pink designed by the Fontana sisters at the end of the 1950s.[25] Coltellacci's version of the space suit has a striking difference: while the front looks very simple and rather chaste, the back reveals the body in all its sexiness – the blouse is almost completely open at the back and the low-waist cigarette-slim trousers have a V-shaped plunging line that leaves the top of the buttocks exposed. The suit symbolises the dichotomy of Caroline's character: she's a tough hunter, but she's also a very sexy and at times fragile woman. With this feminine look, the cold Caroline starts to change: she allows herself to be moved by the sunset and even lets Marcello kiss her in Lidia's house.

The second dress Caroline wears is a nude-coloured number that softly hugs her figure, rather like a modern version of a chiton that radiates a deadly sensuality and extreme sexiness. Draping fluidly on Caroline's body, it transforms the hunter into a woman who wants to seduce and be seduced. The dress is cleverly used to make a satire of other film genres: Caroline is wearing it when she goes to the Roman Hunt Club, a rather exotic environment like the ones in the early Mondo Movies;[26] she is still wearing it at the Temple of Venus, looking like a Vestal priestess in a "peplum" film;[27] and when she tries to kill Marcello for the second time and walks among the Roman ruins, she looks like a revengeful dame from a Western.

The Sorelle Fontana dresses set Caroline apart from the film's secondary female characters. Lidia (Luce Bonifassy) seems to prefer black clothes with white geometric motifs, while Olga (Elsa Martinelli) sports a Vidal Sassoon hairstyle and bold modernist dresses à la Courrèges, styled with PVC accessories. The exposed skin on Olga's cut-out dresses is integral part of the design and becomes her signature look.[28] Caroline's nude-coloured dress also makes her stand out among the Tea Ming ad dancers: the latter wear two-tone skirts and short hooded capes with see-through visors reminiscent of cosmonaut helmets.

Coltellacci's costumes for the male characters are mainly uniform-like, and, though highly practical, they reflect more the regimented lifestyle as it is regulated by the Big Hunt. Marcello's costumes are based on Coltellacci's drawings, but made by Piattelli.[29] Italian menswear tailors of the early 1960s summarised the key characteristics of the perfect suit in three words: softness, lightness and suppleness. Marcello's glamorous victim style is based on these three qualities: his black suit is a masterpiece of minimalist tailoring and is the only weapon – a weapon of seduction – he is left with to fight against Caroline. His suit is impeccable and has a futuristic twist: the trousers are fitted and

Left: Ursula Andress and Zoe Fontana look at costume drawings at the Fontana atelier, Rome. Right: Andress with Giulio Coltellacci (and Zoe Fontana) at a costume fitting session at the Fontana atelier, Via San Sebastianello, Rome. Both photographs June 1965, courtesy Archivio Fondazione Micol Fontana, Rome.

have two front slit pockets: the collarless Nehru jacket (that suits his needs perfectly, thanks to a high armhole carefully designed not only to allow him to move freely, but also to shoot comfortably) is slender and not darted inward to the waist, so that the entire look is one of comfort, although slightly square in shape. The shoulders of this silhouette are gently sloping and Velcro is used instead of buttons. The tailor-made creations sported by Marcello are tempered by a sartorial softness, making him look like a bored futuristic dandy.[30]

There are a couple of "insider" jokes hidden in Mastroianni's everyday black look. Under his jacket he wears a *dolcevita* jumper (the turtleneck sweater made popular in Italy by Fellini's film); he also mentions that one of his favourite comic book characters is "The Phantom", but here the traditional superhero eye mask is replaced with a "lazier" option – black or yellow oval-shaped lens sunglasses, worn to cover Marcello's boredom rather than his eyes. The objects and accessories that surround Marcello give him a sort of cartoonish flair: he drives a Citroën DS with a bizarre Plexiglas roof, his only friend is Tommaso, a strange pet assembled from bits of metal and random parts of a doll, and he loves collecting comics.

Comics are another key mask in this film: blown-up pages of "The Phantom" adorn Marcello's studio, evoking Roy Lichtenstein's works, and at times the camera frames the dialogue between two characters as if they were flat images printed on the pages of a comic book. In the scenes shot inside Marcello's dressing room on the beach, Caroline and Marcello are framed by the steel structure of this yellow dome-like capsule, as if the film was a comic strip or imitated a painting by Mondrian. A comic-book rich yellow colour recurs throughout the film (his changing room on the beach, his dyed hair[31]), while red, the colour of blood, is totally absent. Death is basically "bloodless":[32] blood never stains or impregnates the clothes, as it would ruin their precise geometry and perfection. But, as Petri explained, these "antiseptic" deaths were also designed to make a satirical comment and symbolise how "everyday civilized life has almost reached the point of physical violence".[33] Satire is indeed the key mask in this film: originally, Petri had planned to shoot the whole film in the USA, to critique Americanism and the cruelty of interpersonal relationships in modern America. When the film shooting was relocated to Rome,[34] Petri turned it into a more general satire of 1960s fashionable objects, advertising techniques, the future middle classes and their hunger for new and superfluous goods. At the same time, the film became a satire of Italy and the Italians, portrayed as lazy, disorganised, bored by their wives and lovers, and victims of bureaucracy, religion and of an excessive respect for their parents.

After *The 10th Victim*, Petri concentrated more on political themes,[35] but this film's murderously stylish atmosphere continuede to characterise many movies released in the 1960s. William Klein's *Who Are You, Polly Maggoo?* (*Qui êtes-vous, Polly Maggoo?*, 1966), Mario Bava's *Diabolik* (1968) and his 1970 "I Futuribili" series of ads, Roger Vadim's *Barbarella* (1968), Fellini's "Toby Dammit" and Vadim's "Metzengerstein" in the episodic film *Histoires Extraordinaires* (1968) all echo in their costumes and atmospheres some aspects of Petri's futuristic fantasy. Besides, for years, the look of the film inspired many fashion houses, while Coltellacci's costumes became regular features on the catwalks of Milan and Rome between 1966-69.[36]

During the 1998 Florence Biennale, ten Italian fashion houses were called to restore a film that for its style, atmosphere and costumes represented inspiration. Gucci, led at the time by the Creative Director Tom Ford, chose Petri's film:

> The visual brilliance of *The 10th Victim* is clear from the first scene in which Ursula Andress dances at the Masoch Club wearing a mask, a skimpy bikini and minimalist sandals ... The film manages to evoke, stylistically and philosophically, the typical atmospheres of the Sixties. ... I always found interesting the rigid forms and the linear structures of the modernist architecture of those years and the decade's purity of forms and modernity still inspire me ... There's no doubt, Marcello Mastroianni and Ursula Andress might have been dressed in this film by Gucci.[37]

In film, as in fashion, directors and designers always tell a story. But often the ending of the story is a prelude to a new film or a new collection. Petri's *The 10th Victim* might have been the first and last journey into the world of sci-fi for the controversial Italian director, but – luckily for us – it was a new beginning in the endless love affair between fabulous cinema and inventive fashion.

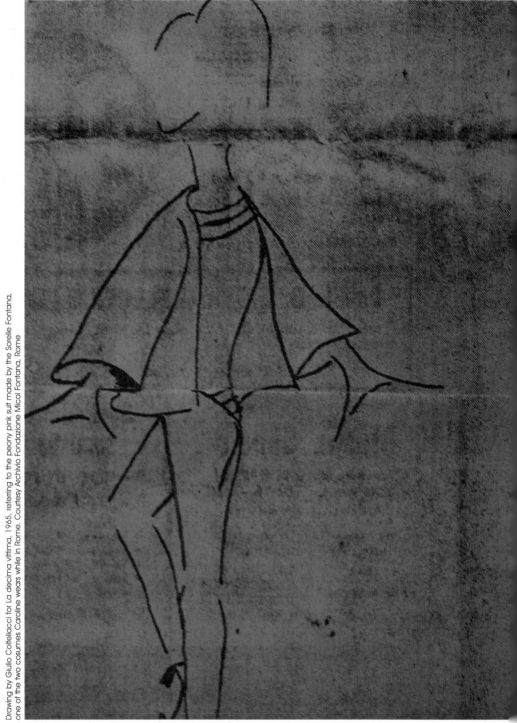

Drawing by Giulio Coltellacci for La decima vittima, 1965, referring to the peony pink suit made by the Sorelle Fontana, one of the two costumes Caroline wears while in Rome. Courtesy Archivio Fondazione Micol Fontana, Rome

Notes

1. With thanks to the Fondazione Micol Fontana, Rome for providing some of the material for this essay, and the Fondazione's Co-ordinator Rosita Ciprari for her help in facilitating my research.
2. Roman Coppola, "Lounge Cinema" in *Kill, Baby, Kill! Il cinema di Mario Bava,* eds. Gabriele Acerbo and Roberto Pisoni (Rome: Un mondo a parte, 2007), p.179.
3. The film started a sort of "paletot craze", with clients calling Piattelli's tailoring house to order the coat. Stefania Giacomini, *Alla scoperta del set* (Rome: Rai Eri, 2004), pp.14, 29.
4. A nightly ten-minute TV show comprising of non-stop commercials, peppered with cartoons and celebrity testimonials.
5. "Stranezze della moda per il prossimo inverno", Rai TV, 27 July 1966, Archivio Storico dell'Istituto Luce, Rome, Italy.
6. The cosmonauts' space suits inspired the clean-cut forms and shapes of the creations, all made using new and experimental materials, such as plastic and PVC; the trapezoidal shapes of the dresses and capes are reminiscent of rockets or arrows pointing towards the sky. The Sorelle Fontana collection featured blue and white sleeveless dresses and jackets with geometrical motifs formed by plastic plaques and rocket-shaped capes. Maria Vittoria Alfonsi, "Le donne spaziali trionfano lanciando la moda lunare", *Gazzetta di Vigevano*, 29 July 1969; "Pronto il guardaroba lunare", *Gazzetta del Sud*, 23 July 1969.
7. "The Seventh Victim" by Sheckley was first published in Italy in 1959 in the first sci-fi anthology edited by Sergio Solmi and Carlo Fruttero, *Le meraviglie del possibile*. In Sheckley's story, the hunter is a man.
8. Rossi states that Petri used two actors as the main masks for his films: Gian Maria Volontè represented the public man and political mask as he starred in most of Petri's political films; Marcello Mastroianni represented the mask of the private man. Alfredo Rossi, *Elio Petri* (Florence: La Nuova Italia, 1979), p.27.
9. The inflatable stools are reminiscent of Andy Warhol's helium-filled Mylar cushions and anticipate the see-through PVC "Blow" armchair (1967) designed for Zanotta by Carla Scolari, Donato D'Urbino, Paolo Lomazzi and Gionatan de Pas.
10. Naming Marcello's street after Fellini was a joke played on the director by writer and journalist Ennio Flaiano, who co-wrote many screenplays for Fellini's films. In a way, Flaiano predicted the future: today there is a street in Rome named after Fellini.
11. Elderly people must be turned over to the State for disposition, but most Italians hide them away in secret rooms.
12. Also known as the Cobra and made by L. M. Ericsson Company of Sweden, this phone went on sale in the mid-to-late 1950s. The phone was designed by a team headed by Gosta Thames.
13. The desire for superfluous and useless objects in *The 10th Victim* is reminiscent of the main theme of Georges Perec's first novel, *Things: A Story of the Sixties* (*Les Choses*, 1965).
14. A reference to Petri's passion for art, but also a joke on the debates about art among Italian intellectuals in the press. In one scene, a group of people behind Marcello are beating each other up, upon which a member of Caroline's crew remarks (in the original Italian version): "They are discussing art." See also Elio Petri, "E per lui facevamo a botte", *Corriere della Sera*, 24 November 1979, p.27.
15. "La Decima Vittima" (review), *Monthly Film Bulletin*, vol.35, no.408, January 1968, p.4.
16. Bruno Piattelli, *Azzurro sotto le stelle* (Rome: Newton & Compton Editori, 2002), p.270.
17. Andress later remembered that some of the awkward poses she assumes in this scene while dancing were the result of the metal flakes cutting into her flesh and causing her pain. Federico Bacci, Nicola Guarnieri and Stefano Leone, *Elio Petri. Appunti su un autore* (*Elio Petri. Notes on a Filmmaker*) (documentary), 2005. The silver bikini of *The 10th Victim* mocked the actress's white cotton bikini in Terence Young's *Dr. No* (1962). The knife that accessorised the white bikini is replaced in Petri's film by bullets.
18. Saul Kahan, "The 10th Victim", *Films and Filming* (April 1966), p.59.
19. In the '50s and '60s, many American actresses visiting or working in Italy had their wardrobes revamped by Italian fashion designers. Caroline's restyling by Sorelle Fontana is a tribute to those designers, but also an insider joke about the actresses' habits.
20. The sisters Zoe, Micol and Giovanna Fontana set up a dressmaking shop in Rome in 1943. Their fashion house later attracted many international clients (Jackie Kennedy, Audrey Hepburn, Empress Soraya of Iran, Princess Grace of Monaco, Elizabeth Taylor), and was called upon to design costumes for many films in the heyday of Rome's Cinecittà studios. Bonizza Aragno Giordani, *Lo stile dell'Alta Moda Italiana – Sorelle Fontana* (Rome: Fondazione Micol Fontana, 2005).
21. "Ursula si veste", *Giornale di Bergamo*, 6 June 1965; "L'assassina in cerca di diploma", *Il Giorno*, 8 June 1965; "Ursula Andress: una svizzera a Roma", *Voce Adriatica*, 8 June 1965; "Ursula Andress è a Roma – La bionda di turno", *Il Resto del Carlino*, 11 June 1965; "È il momento di Ursula", *Noi Donne*, 19 June 1965.
22. "Futuristic Ursula", *The Rome Daily American*, 11 June 1965.
23. "Abiti per il cinema delle Sorelle Fontana", *Momento Sera*, 15 June 1965.
24. Caroline's sunglasses are a slimmer version of the Courrèges white plastic glasses with slits following the curve of the eyelashes that were part of the French designer's Spring-Summer 1965 collection.
25. "Nasce il Made in Italy: 50 anni di moda italiana", CD-Rom distributed by the Fondazione Micol Fontana.
26. Fake documentaries with sensational scenes. This particular scene in *The 10th Victim* is a satire of the *Mondo di Notte* series.
27. "Pepla" or "sword and sandal films" are a genre of adventure or fantasy films set in Biblical or classical antiquity, often with plots based on mythology or history. For the contamination of genres in *The 10th Victim*, see also Alfredo Rossi, *supra* n.8, p.49.
28. In later years, the fashion designer Rudi Gernreich filled these gashes and cut-outs with see-through vinyl and plastic inserts. See also *Un secolo di moda – Creazioni e miti del XX secolo*, eds. Enrico Quinto and Paolo Tinarelli (Milan: Federico Motta Editore, 2003).
29. Bruno Piattelli made nearly all the costumes for Mastroianni during the actor's long career.
30. Marcello only abandons his black clothes to disguise as the Tramontisti (sunset-worshippers) high priest, in a white kimono-like robe, orange cummerbund and yellowish organza kaftan.
31. The colour of Marcello's hair also refers to the colour of the alien's hair and spaceship ("a saucer of enormous dimensions, yellow and bright like a sun") in Ennio Flaiano's short story "Un Marziano a Roma" (A Martian in Rome, 1954). Flaiano, *Diario notturno* (Milan: Adelphi, 1994), pp.265-87.
32. Saul Kahan, p.58.
33. *Ibid.*
34. Producer Carlo Ponti was not keen on shooting the film entirely in the USA for budgetary reasons.
35. After *The 10th Victim*, Petri shot a few "futuristic" TV ads for Shell (1966). Apparently, he was offered the job because advertising

agents in Milan had fallen in love with the film. Later, Petri regretted his involvement in advertising, claiming that professionally, morally and politically, it wasn't right for a proper director to work on commercial ads.
36. Biki created a "space-age collection" for Spring-Summer 1965. For Spring-Summer 1966, the fashion designer Veneziani presented two-tone dresses and jackets with geometrical motifs and mini-capes, while menswear designer Datti launched jackets with a geometric line that underlined the slimness of the figure. "Le idee 1966 del gruppo stilisti italiani", and Elsa Rossetti, "La moda italiana al vertice dell'eleganza", both in *Vestire*, Spring-Summer 1966, pp.15, 108.
37. *Moda/Cinema,* catalogue for the 1998 Florence Biennale (Milan: Electa, 1998). Frida Giannini, the new Gucci creative director, based her Spring-Summer 2008 menswear collection on the movie stars of Italian cinema and in particular on Marcello Mastroianni's '50s and '60s look.

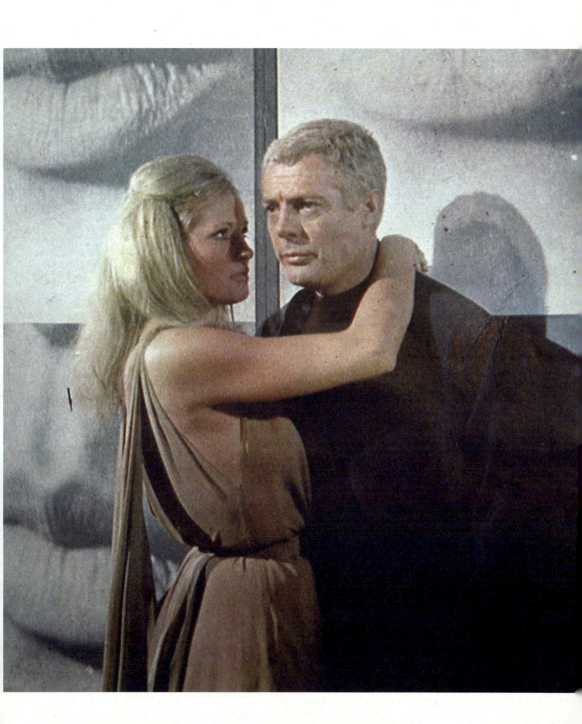

The Eyes are Trapped: Dario Argento's *The Bird with the Crystal Plumage* / Betti Marenko

There is an American in Rome, but he is not on holiday and this is certainly no longer *La dolce vita*. Enter Sam Dalmas, a writer who has just finished a book about rare birds and is now stuck for inspiration. In the city terror mounts, as a mysterious killer – a frightening figure in black leather gloves, black fedora hat and shiny patent black PVC coat – is slashing beautiful young women. A few days before he is due to fly back to the States with his girlfriend Giulia, a model, Sam is an accidental witness to the killer's attack on a gallery owner, Monica Ranieri. He tries to help her but ends up trapped between the gallery's two sliding glass doors. Stuck in this transparent cage he cannot reach the wounded woman who begs for help; he can only watch her writhing, utterly powerless.

Using this stunning stratagem, the Italian director Dario Argento, with his debut *The Bird with the Crystal Plumage* (which earned him the moniker "the Italian Hitchcock"), delivers two of the movie's central themes: captivity, imprisonment and encasement on the one hand, and the voyeuristic gaze on the other. In so doing, he sets the claustrophobic tone that so intensely shapes the ensuing events. Moreover, he forces *us* to watch, powerless and trapped like Sam who can only stare at the woman dying in front of his eyes. Sadistically, Argento espouses his obsession with the gaze and the power that it may (or may not) elicit, like a puppet master who turns us all into voyeurs. Consequently, the viewer is locked in this role, exactly like Sam, trapped in his glass enclosure. What we see is Monica, dressed in a white halterneck top and trousers, crawling on the white floor. A no longer immaculate whiteness pulsates on the screen, now tainted by the red of Monica's gushing blood and the auburn of her hair. In one unforgettable sequence she briefly rests against a creepy sculpture of a rapacious looking bird, holding onto the animal's claw. For a moment we look at Sam through a gap in the sculpture. Only later will we realise that we are looking through the eyes of a ferocious predator watching its prey.

The only clue found at the site of the attack is a black leather glove. Upon recounting the events to Inspector Morosini, who is conducting the police enquiry, Sam feels that there is a crucial detail escaping his memory. Over and over, flashbacks play in his mind. Increasingly obsessed with the event, he begins a personal investigation that leads him to a mysterious and macabre painting. Meanwhile, more women are horribly murdered and, while Sam is hunting for the author of the painting, which he has realised is the crucial factor in solving the case, the serial killer besieges Giulia in her apartment. "You won't leave this house alive," he hisses menacingly. She is trapped, like Sam at the gallery earlier on.

Indeed, one of the recurring motifs in *The Bird With the Crystal Plumage* is the inability to escape, the notion of entrapment. Throughout the movie, Argento disseminates powerful and often none-too-subtle signals, visual signposts whose purpose is to reinforce these themes whilst engendering a claustrophobic, confined atmosphere. For instance, Sam and Giulia are the only tenants on the top floor of a derelict building about to be pulled down, a prison-like edifice whose windows and doors have been bricked up. A chilling zoom of the camera makes us aware that the windows in their open plan loft-style apartment have heavy metal bars. Similarly, the artist who made the strange painting is a lunatic recluse who has walled up all the ground-floor doors and windows of his house. The theme of imprisonment is utilised on various levels. For instance, Sam cannot leave the country because the police have taken his passport; he is a prisoner of his lack of creativity, and later of his obsession with the murders; Giulia is a kept woman, who will be trapped in her apartment at the mercy of the brutal killer. Furthermore, when Morosini visits Sam after the fourth death, and the two are having coffee together, Morosini describes the murder scene as the "same black wall" (in the English version wrongly translated as "blank wall"). Tellingly, in the background we see a bricked doorway.

The glove, the cage, the glass trap are all signifiers of the idea of entrapment and physical enclosure. However, it is the recurring image of gloves that stands out. Not only because this is the first thriller centred on a serial killer in a black fedora, black coat and black leather gloves, an icon destined to become a blueprint, and later a *cliché*, for Argento himself and for many other directors in 1970s and 1980s cinema (see *Dressed to Kill*, Brian de Palma, 1980). It is the black glove itself that embodies dread. It represents the urban, sadistic, fashionable killer. It is a fetishised symbol of encasement, a second skin that dissimulates personal identity and disguises the killer in a masquerade: chilling and repulsive, perhaps, but always flawlessly stylish. For this reason, when, at the end of the movie, we see someone taking their gloves off, we sense that the end must be near. The removal of the glove signals a shift in the power struggle between Sam and the mysterious killer.

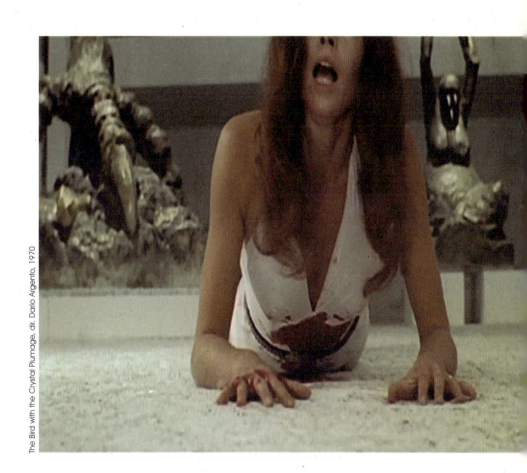

The Bird with the Crystal Plumage, dir. Dario Argento, 1970

Without this protective encasement – this second skin that, by disguising and altering the identity, signifies the serial killer – the veil is lifted and the game is up.

In *The Bird*, Argento employs the idea of dressing up as both a compelling disguise and as a vehicle for gender-bending. For example, in the nightmarish vision of the hotel hall packed with identically dressed men, Sam, following his aggressor, stumbles upon a boxers' convention. Their lurid uniform of yellow bomber jacket and blue cap, which would otherwise have made his aggressor instantly recognisable, becomes instead the hideous device for a seemingly endless multiplication, a cloning gone wrong, an ocean of replicas where no original is to be found. Clothes are never what they seem. They always conceal, hide, create a different reality; they are used to suggest an identity that is never what it appears to be; they skew appearances, divert attention, like a grammar of subtle digression.

Even the food is not what it seems. Sam joins the painter Berto Consalvi for a rustic dinner, and when he realises that he has just eaten cat meat (Consalvi keeps cats in cages) he flees the scene, horrified. This profound uncertainty is key to the unfolding of the plot and it is expressed, most notably, through role reversal and gender inversion. Not only do we see a woman donning masculine garb to kill her victims; it is precisely because she is *not* dressed in what we have already identified as the killer's attire that we fail to recognise her as such at the beginning of the movie. Led to assume that the sinister dress code of black gloves, fedora hat and raincoat signifies the killer, we cannot but fall for the visual trick that Argento is playing on us. In this sense, the killer contravenes the codes of femininity twice: first, because she is wearing masculine clothes; second, because those clothes embody the killer, whom we assume to be male.

And Giulia? She is a typical trophy girlfriend. Highly decorative (she is a model after all), she is portrayed as the type of woman who is prone to smooching and asking her boyfriend "Do you really love me?". We see Sam often being dismissive and patronising towards her. Even when he shows passion and grabs her in an embrace, it is frequently because other people are present, as if his goal is to show off his ownership of her body and, in so doing, reaffirming his masculinity. In spite of his Latin lover uniform of unbuttoned dark shirt, tight trousers and wavy, unkempt hair, Sam comes across as a man profoundly, if unconsciously, unsure of his masculinity. The more he insists on wearing and appropriating the signifiers of maleness, the more it becomes clear that they are a cover-up, semantic aids in his attempt at performing a masculinity increasingly under threat. Let us remember that Sam suffers from writer's block, and he ends up trapped not once but in fact twice in the art gallery, where he is physically constrained and forced to watch passively without being able to intervene. This insistence on Sam's powerlessness and inability to deliver seems to hint, none too subtly, at his emasculation and impotence. This theme finds its climax when Sam, chasing the killer, finds himself in the gallery for a second time, immobilised and powerless under a huge, spiky, Iron Maiden-esque sculpture. Crushed underneath this artwork, Sam is destined for a slow torture, or else, radical emasculation. Encumbered by failure, Sam resists the imminent loss of control by playing the *macho*, only accentuating the fact that gender and identity are nothing but a performance.

It is interesting to compare Sam's version of masculinity – brazen, overconfident and oozing sex appeal – with Inspector Morosini's manliness. With his classic hat and beige raincoat, short hair and thin moustache, he is a stereotypical police inspector, whose appearance speaks of a restrained, logical and "scientific" mind. He inhabits a world of white coats, of proven data fed into a huge (nowadays almost comical) computer, of proof – hallmarks of a forensic rationality that counteract sharply with Sam's instinctive spontaneity. It is no coincidence, then, that Sam's obsession with the murders spurs him back to writing, as if his creative juices needed the victims' blood in order to flow. His writing frenzy is ultimately the mirror of the maniac's killing frenzy.

As for the female roles, it comes as no surprise that Argento has been accused of misogyny for his tendency to choose attractive women to be subjected to the worst possible violence, an accusation he has always refuted by simply saying that in his movies it is not only women that are killed. However, he admits a predilection for *beautiful* victims: "I like women, especially beautiful ones. If they have a good face and figure, I would much prefer to watch them being murdered than an ugly girl or man." Certainly, to indulge in the cinematic killing of attractive women does not have to equate to misogyny. Nevertheless, it is true that the female gender in *The Bird* emerges as rather one-dimensional, frozen and predictable. Seemingly, the only role available to women is as decorative prop, either for sex (Giulia) or for violence (victims). Even the killer, who unsettles gender divisions

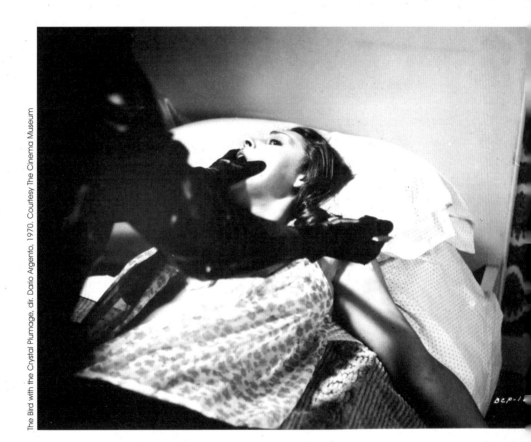
The Bird with the Crystal Plumage, dir. Dario Argento, 1970. Courtesy The Cinema Museum

by performing a male role in male garb, is ultimately confined to the psychotic realm. In fact, women are either coupled, and thus contained within heterosexual normativity, or else they diverge (the lesbian, the prostitute, the hysteric, the psychotic) and are thus open to a violence that is almost condoned.

The themes of disguise, role reversal and gender-bending are woven through the fabric of the movie via a spellbinding visual grammar which betrays Argento's obsession with vision being first and foremost illusion and deceit. Nothing is what it appears to be. The victim is the killer, the man is a woman, the suspect is innocent and the playboy is impotent.

The mis-identification of the victim with the perpetrator hints at Freudian and psychosexual overtones – the idea that a visual trigger can be responsible for madness repressed for too long. We discover that Monica has been subjected to the vicious aggression shown in the painting, and upon seeing the image she re-enacts her experience, this time identifying with the killer, not the victim. Opposites conflate: white turns into black, black swaps places with white. One of the most striking features of this movie is that it exhibits a masterful use of black and negative space, contrasting starkly with vast expanses of white and light. Argento achieves this not only with a sophisticated treatment of light and dark, thanks to Vittorio Storaro's photography. Again and again, he uses the costumes to build a narrative of hard-edged contrast, where black and white are the opposite poles of a continuum shot through with an intermittent rivulet of red.

For instance, as the movie opens we see a white typewriter, a black-gloved hand typing and a white sheet of paper. Then we see the new victim, a girl whose red coat becomes a crimson, bloody trail that trickles back to the knives laid down on a red cloth, then onto the black and white photograph of the victim-to-be, upon which the black-gloved hand scribbles the number three in red ink. Another example is found when we see Monica emerging from the shadows behind a red leather chair, impeccable in her white shirt and black tuxedo, coat and hat, which she theatrically removes to reveal a cascade of flaming red hair. Other "flags" are more subtle, but nonetheless potent. When Sam chases his mysterious assailant, he runs past a cinema showing *La donna scarlatta* (*La femme écarlate / The Scarlet Woman,* 1969). And the black and white contrast recurs again in the clothes that Sam and Giulia wear on a night-time walk. She wears a black patent leather hat, white coat and black trousers, while Sam is dressed in his customary black shirt and white trousers. Later, we see Giulia at home (with a prominently exposed white poster pinned to the wall saying "black power"), wearing a white towelling robe in contrast to Sam's black shirt. Again, they are perfect opposites, yet complementary. However, the proximity of opposites here is a mark not of harmony and coexistence, but rather of a world under threat. Speaking the symbolic language of chess, their garments fail, however, to transform the wearers into controlled players. Argento's insistence on black and white speaks of an impending checkmate on a living chessboard. Semiotically, white and black relates to the opposition between good and evil, which here are indeed turned upside down.

The emphasis on visuality is clearly stated at the beginning of the movie. The events at the gallery exploit a complex criss-cross of gazes and roles. The aggression unfolds in silence: as in a dream or nightmare sequence, we hear the sighs of the victim and can only look on. Here, the real protagonist is the eye. When, later on, the killer carves a hole in the apartment door with his knife, we see his eye staring at Giulia who, increasingly hysterical, tries to attack him, frantically and pointlessly stabbing at the hole in the door with a pair of scissors. Through the very same hole, we also see the eye of Sam's friend (and here, "Peeping Tom" is actually mentioned). The idea of being able to see the horror is taken further when another victim screams as she sees the petrifying shadow of the killer approaching her bed. Here, we are actually made to see this scream from *within*, as the camera pans out from her throat, a spectacularly effective device Argento uses again when, later on, we see Monica Ranieri's husband fall to his death.

Argento willingly confounds vision and gaze, appearance and reality. He plays tricks with memory and freely mixes the two- and the three-dimensional. Indeed, he has spoken of memory as the main theme of the film, and the aggression in the art gallery is played over and over again, as Sam tries to remember the important detail that he feels is missing.

Furthermore, the three-dimensional theatricality of the architectural modernist surroundings, shot with odd camera angles, turns buildings into menacing, dense, almost expressionist entities. For instance, when we see one of the victims climbing the stairs, the camera lingers on the sharp angles of the stairwell that create a hypnotic, somehow disturbing, design. Pointed lines and triangular shapes

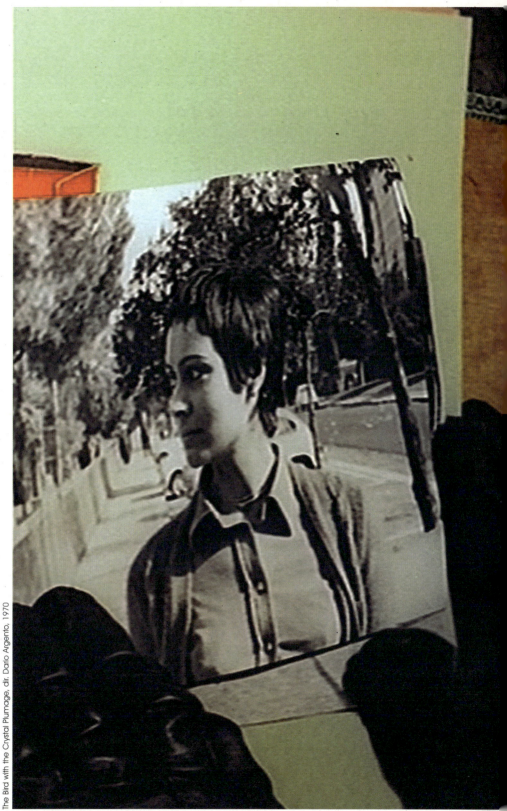
The Bird with the Crystal Plumage, dir. Dario Argento, 1970

converge into a negative geometry that mirrors and frames precisely the girl's outfit of white shirt and black waistcoat. Moreover, the two-dimensional world of photographs, newspaper clippings, paintings and visual art flatten reality into a reiteration of details that leads us beyond the threshold which transforms everyday items into symbols of terminal horror. Art references abound: Sam and Giulia's apartment is littered with works of art, and it is precisely within the confines of an art gallery, among weird and ghastly sculptures, that the movie begins and ends. Both the killer and Sam use photography to decipher reality, the former to stalk and meticulously prepare his fetishistic killings, the latter to uncover the links among the murders. When Sam and Giulia begin to investigate, we are shown photographs of the first three victims – crude details such as stockings crumpled around the ankles to suggest a possible sexual assault; hands grasping the earth; a throat cut, the victim resembling a mannequin. The effect is strangely dehumanising and rather Cindy Sherman-esque. There is a moment when Sam looks at the painting – he does so by looking straight into the camera. We are the painting; there is no escape; we are all being transformed into voyeurs; we are forced to watch the killings. Indeed, watching and killing are often synonymous. And thanks to a stunning use of the camera that offers plenty of subjective gazes of the killer and the victims, we sometimes see through the killer's eyes; at other times we are being spied on, stalked, followed, and attacked.

However, we can never forget who is looking. And this increasingly deranged logic of paranoia engulfs us, makes us captive, exactly like the rare bird at the zoo or a fish in an aquarium – incidentally, an image that gave Dario Argento the inspiration for the movie's core sequence.

All Images: The Bird with the Crystal Plumage, dir. Dario Argento, 1970

Criminal Gestures, Transformations, Signatures

Looking Sharp / Claire Pajaczkowska and Barry Curtis

The collar of a coat is a frame for the face that manages the transition from the clothing to the body, thus inviting certain kinds of interpretation: of status, appropriateness, quality and distinction. The gesture of turning up the collar reactivates the functionality of sartorial elements whose meanings have been tamed. The lapels tend only to be brought into play in extreme situations where hostile weather or hostile gazes need to be deflected. This mildly transgressive act connotes a kind of impoliteness – a purposeful rejection of the social and the sociable, and a sign of readiness for a new register of experience. In the documentary *Momma Don't Allow* (Karel Reisz and Tony Richardson, 1955) a dental nurse appears in the opening sequence wearing a white coat. Her boyfriend waits outside and she joins him, clearly impatient to leave work. When we next see her, she is wearing a coat with the collar turned up in preparation for her entry into a recreational world of jazz and dancing.

Turning up the collar is a way of dissociating from normality – a signing of an assertive yet inward turn. At the same time it is an armouring of the vulnerable nape, emphasising the width of the shoulders and the sheathing of the silhouette into a more streamlined form.

In movies, garments are not only present; they are also *presented*. The film theorist Christian Metz argued – in opposition to André Bazin – that cinema is a coded structure; that every cinematic shot presents its pro-filmic spectacles with the rhetorical flourish of a "voici!" – compelling the attention of the spectators to the "here it is!".[1] This "cinematic language" is in some ways similar to the "language" of fashion, which resides in the attention to differences in style. Style is in the "way" that something is made to appear. The etymology of the word fashion derives from the French word *façon* – a "way" of doing something. With *façon*, as with fashion, the meaning is to be found in the way something is used or done, rather than in the object or in the action itself.

Turning up the collar

In *The Godfather* (Francis Ford Coppola, 1972) Michael (Al Pacino), son of the wounded Don Vito Corleone (Marlon Brando), finds his father unprotected and alone in a hospital room. Aware of his father's vulnerability to the vengeance of the combined forces of rival gangsters and corrupt police, he selects a visiting baker, and places him as guard in the dimly lit entrance to the hospital. The baker is transformed from helpless mourner into menacing gangster by means of three gestures that also transform grooming into an act of armament: the rim of his hat is tilted downwards, obscuring his face; his right hand is thrust inside his overcoat pocket as if it were resting on a hidden gun; and in the final gesture that completes this transformational sartorial utterance, the protagonist inserts his thumbs into the baker's open-necked overcoat and briskly turns up his coat collar. In one act, he has conferred an air of unmistakable menace upon an ordinary man. The flatness and smoothness of the hyper-civilised attire of mourning has been fashioned into a sharp, erect boundary that frames, protects and hides the face and neck. The frame is now a swathe of darkness that transforms politeness into menace and latent violence.

Why is the nape of the neck such a powerful site of vulnerability? Jean-Luc Godard's camera obsessively stalks the nape of Jean Seberg's neck in *Breathless* (*À bout de souffle*, 1960) and Anna Karina's in *It's My Life* (*Vivre sa vie: Film en douze tableaux*, 1962), both New Wave tributes to American gangster movies. The erogenous zone of cinematic femininity is, in masculine characters, a zone of vulnerability. The collar-like cuffs, hems and turn-ups speak of the civilised surplus of cloth that frames the edge of a garment by doubling back on itself rather than ending abruptly with an unfinished, frayed or selvaged line. The transition from garment to skin is especially meaningful as a line of demarcation between nature and culture. Where jewellery has, traditionally, been the point of such demarcation for the female body, the critical difference between animal vs. human, and nature vs. culture is, for the urban man, signified by donning an excess of cloth in the form of a fold. It is *une façon*, a way or a style, of making an edge by marking a difference.

Another, accompanying, gesture of traditional urban masculinity is "shooting the cuffs" which allows immaculate, smooth and even starched sleeve cuffs to be displayed beyond the edges of coat sleeves. The anxious gesture of touching cufflinks, examining fingernails or adjusting the knot of the necktie whilst flexing or even twisting the neck from the collar, is also part of this gesture of self-conscious civility. But when the collar is turned up, usually by a swift, unobtrusive, almost furtive

The Godfather, dir. Francis Ford Coppola, 1972

gesture, a transformation takes place which reverses submission to the codes of civility into a defiant preparedness. The "best" defence is a good offence, suggests psychoanalyst J.C. Flügel in his classic study *The Psychology of Clothes*.[2] He also notes that a primary function of clothing is to increase bulk, to foster the illusion of size as a threat (this instinctive defence is well-known in nature and visually celebrated in films such as *Jurassic Park* (Steven Spielberg, 1993) which features a poison-spitting dinosaur, the Dilophosaurus, with a magnificently erect collar). A whole host of *noir* films, from Carol Reed's *The Third Man* (1949) to Fritz Lang's *The Big Heat* (1953), feature men in collars which articulate their sense of threat. Female fashion has used similar stratagems to amplify rather than reduce the silhouette. In Alfred Hitchcock's *Rebecca* (1940), for example, Joan Fontaine appears in a sharply tailored suit in a scene which marks her character's transition from helpless victim to active protagonist. Flügel correctly identified the unconscious conflict between display and shame that structures sartorial codes in human culture. It is no surprise that the battle between body as a concealed corpus and body as a revelation of the self should be located at the neckline.

There is a number of films preceding *film noir* which feature the motif of the raised collar, from Count Orlok's neckline in F.W. Murnau's *Nosferatu* (1922), to the collars of Edward G. Robinson in Mervyn LeRoy's *Little Caesar* (1931). But *film noir* is particularly interesting because of the separate and visually distinct realms of masculinity and femininity in an essentially modern and urban context. The clothing and its stylistic *façonnement* here is carefully designed to work at the liminal and subliminal levels of awareness. The men and women are ordinary citizens whose extraordinariness is often betrayed by slight sartorial details, attitudinal clues, or cinematic inflections. For example, the popular B-movies of the *Dick Tracy* series are a rich source of masculine fashion styling in 1940s America. The hero is often dressed in a belted, double-breasted overcoat, a few tones lighter than the clothing of the other characters, and his collar is often turned up. With one exception, he is the only character to wear his coat collar in this way, the code being transgressed in the film *Dick Tracy vs. Cueball* (Gordon Douglas, 1946). "Cueball" is a reference to the baldness of a villain who emerges from the docks and hangs out with some spectacularly insalubrious sailors. He wears the collar of his black leather jacket upturned, which marks him as the shadow side of Tracy's integrity.

In *film noir* the generic use of vernacular dress is of real value in finding a language to understand, describe and discuss the fashion of "ordinary" wear including, as they do, a range of unremarkable clothes that connote a desire to blend, to be camouflaged into mufti, to disappear into the civilian and urban crowd. The most self-consciously fashioned upturned coat collar is the back of the vicuna wool tie-belted coat that Norma Desmond (Gloria Swanson) buys for Joe Gillis (William Holden) in *Sunset Boulevard* (Billy Wilder, 1950).

Appearing at the start of the story in a towelling bathrobe (with upturned collar) as he types his screenplay sitting on his bed, Joe has only one sports jacket and baggy pants outfit until Madame takes him shopping. He is then dressed in a series of suits, swimming trunks and shiny accessories that are explicitly for the satisfaction of his wealthy mistress. In a scene set in "the best men's outfitters in Hollywood", Norma says: "We'll take it in navy flannel, single breasted, of course", and when Joe protests, he is silenced by her flirtatious, unmistakeably sinister threat: "And if you're not careful you'll get a cutaway." The reference to the styling of a men's jacket resonates with the threat of being "edited out" from the picture and being symbolically castrated. Joe keeps his overcoat on when indoors at an informal New Year's Eve party with his friends. Truly alienated from them and from himself, he is framed, standing with his back to a triptych of glass mirrors, opposite the prow of the boat bed in Madame's bedroom. The exquisite shot of the back of Joe's vicuna coat framed in the mirror, with the collar still turned up, signifies his moral entrapment by Norma's emotional blackmail. It is a sight unavailable to him, created by her desire, and for her controlling gaze. In spite of the invisibility of the nape of his neck, never was his vulnerability more painfully evident.

Looking sharp

The festival's title "If Looks Could Kill" aptly describes the narrative structure of *Sunset Boulevard*, and the masculine struggle against passivity that defeats Joe and the spectator's identification with him. Billy Wilder's predicament as an émigré refugee from the castrating anti-Semitism that curtailed his career in the German film industry before the Second World War provides him with a powerful resource of suspicion, doubt, paranoia and fear aggravated by the insecurity of his place within the deeply seductive and ambivalent world of Hollywood.

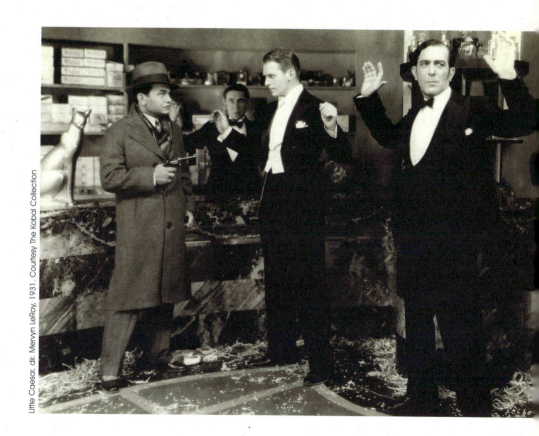

Little Caesar, dir. Mervyn LeRoy, 1931. Courtesy The Kobal Collection

Edith Head's costume in *Sunset Boulevard* encodes a neat antithesis between the opulent excess of Norma and the vulnerability of Joe who has limited resistance, and whose clothes constitute a toxic, and ultimately fatal, environment. It is the battle between seeing and being seen that exhausts and destroys Joe, and his power over words (which is the masculine domain of the scriptwriter) is unsuccessfully pitted against the female star's dominion over image. The interplay between activity and passivity – which is the elemental medium of subjective exchange – can, in the vulnerable man, become a battle between activity as life and the threat of passivity as death, or at least castration. Psychoanalysts have noted that the subject is constituted through this battle between image and words, or between imaginary and symbolic realms. At the core of this struggle is the experience of the body, as it exists in time and motion.

The way that fashion and film both generate the psychic envelope of self through a complex exchange of seeing and being illuminates the ways in which the dialectic of activity and passivity is fundamental to the mechanism of identification that secures the cultural environment within which all human subjectivity is constructed. Fashion and film are both privileged sites within which identification is made visible (and thereby understandable) as a *process* – a continuous movement and flow. While theorists of the image have been at pains to understand identification and subjectivity as a mechanism – as if it were a static structure – it is through analysing film and fashion that theorists can see that it has always been a fluid and dynamic relationship or "facilitating environment". The dynamic flow of the image signifies the flux of affective states as spectators are moved from delight to anxiety, from anticipation to fear, from pride to shame, and from guilt to desire – in a powerful articulation of fantasy, emotion and meaning.

Notes
1. Christian Metz paraphrased in: Peter Wollen, *Signs and Meaning in the Cinema* (Bloomington: Indiana University Press, 1973 [1969]), p.124.
2. J.C. Flügel, *The Psychology of Clothes* (London: Hogarth Press, 1950 [1930]).

Sunset Boulevard, dir. Billy Wilder, 1950

Sunset Boulevard, dir. Billy Wilder, 1950

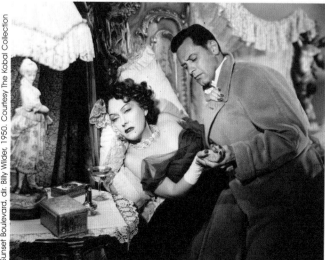
Sunset Boulevard, dir. Billy Wilder, 1950. Courtesy The Kobal Collection

Stained Clothing, Guilty Hearts[1] / Kitty Hauser

There's an epigraph to a chapter of Dick Hebdige's book *Subculture: The Meaning of Style* (1979) which has always struck me with its visionary intensity and decadent air. It's a quotation from William Burroughs' 1969 *Wild Boys*, a novel which describes an apocalyptic future where gangs of promiscuous, violent and amoral young men trample over the ruins of civilisation. In Marrakech, writes Burroughs, "the chic thing is to dress in expensive tailor-made rags and all the queens are camping about in wild-boy drag. There are Bowery suits that appear to be stained with urine and vomit which on closer inspection turn out to be intricate embroideries of fine gold thread ...". There are other sartorial tricks here too: "coolie clothes of yellow pongee silk", "felt hats seasoned by old junkies", and so on; but it's the embroidered stains that burn into the mind.[2] What an appalling yet superb recuperation of abjection; what high-stake dandyism. And what artisanal dedication from the tailors and the embroiderers – for it cannot be easy to reproduce dried urine or vomit in stitching.

The stain which on closer inspection turns out to be embroidered-on; it's a double-take which reproduces the usual double-take of the stain, but reverses its logic. The stain invariably appals before it gets a chance to explain, just like those on the wild-boy Bowery suits; but closer examination usually points to accidental or at least contingent causes. And stains are not supposed to be seen, still less vaunted. We imagine that Jackie Kennedy knew this when she refused to remove the pink suit she was wearing after her husband's blood was so publicly splattered over it in Dallas that fateful day in 1963. She continued to wear the blood-stained suit for the rest of the day, a fact documented in photographs of her arriving in Maryland and watching her husband's casket being loaded into an ambulance. When one such photograph was reproduced in the *Boston Herald American*, bloodstains on her skirt and legs were airbrushed out, as if to restore the First Lady's dignity, her much-discussed immaculate-ness (*immaculatus*, from *in* – not, and *maculare* – to spot).[3] But in not changing her suit Jackie, it seems, was not just traumatised into inaction. She knew she would be photographed, and she wanted the stains to be seen. Through the theatricality of dress in this most public of theatres she had turned her public humiliation (as Wayne Koestenbaum called it) into something else; she was visibly anointed by her husband's blood, she bore witness to his sacrifice, and she was herself made sacred by it.[4]

Jackie Kennedy knew in 1963 what, presumably, every other wary celebrity now knows: that stains and photography, stains and film, are in love. Paparazzi photographers and celebrity magazines delight in the sight of a starlet whose exterior is marked by sweat, wine or blood. Such stains automatically draw the eye to the celebrity body, supplying the photographic image with a ready-made *punctum*.[5] Photos of a stained body are assured a double-take (at least). Stains imply a scandal, even if it is only the scandal of *mortality*, what Philip Roth called "The Human Stain", revealing itself in the place – the celebrity body – where we have persuaded ourselves to pretend it does not exist.[6] Photographs like that of Britney Spears with a damp armpit, or of Mischa Barton, back from the gym, her tracksuit bottoms stained by an apparently leaky tampon, do not really turn us into detectives, as their disingenuous captions invite, and as chat-room discussions suggest.[7] Instead we are like Strephon in Jonathan Swift's satirical poem of 1732, "The Lady's Dressing Room", when he discovers that his beloved Celia does, after all, have bodily functions, their evidence encrusted in the arm-pits of her smocks, the toes of her stockings, and – famously – in her stinking chamber-pot.[8]

Such puerile paparazzi photographs are a function of a historically specific form of celebrity culture, built on an age-old equation (illustrated by the Swift poem) of successful femininity with neatness and the concealment of body fluids. But the relationship between stains and photographic media goes well beyond these market-driven exploitations of it. For the stain performs an invaluable *structural* role in a photographic image. The stain opens up a photograph to narrative in a very particular way, whether it occurs in a still or moving image. The stain is the visible sign of a story that (for the moment) remains hidden from view. It marks, in a sense, the point at which that hidden story enters the scene. It shows that *something has happened here*, even if we don't always know what that something is. It is, in effect, a wormhole of space and time in visible form; and it is the accidental fact of its visibility that makes it so effective in narrative terms. To be sure, paparazzi photographers take a keen interest in this aspect of staining, since it seems to offer peepholes into the most private of spaces which they consider it their job to penetrate. Amy Winehouse's bloodstained ballet pumps, for example, were touted as the evidence of intravenous drug use between the toes, in a hotel room whose dark goings-

Jackie Kennedy, 26th November 1963. Courtesy AP/PA Photos

on were written on the very bodies of Amy and her husband as they tripped out into the night. Stains speak, like scars, and wounds, even when the human beings that sport them will not.

For this structural reason, and for many others, stains play an important role in film and television drama, especially in narratives where there has been some kind of a cover-up. They may suggest hidden trap-doors of meaning; they can connect a scene with other, invisible ones, scenes that have taken place off-camera, out of the sight of audience or protagonist. To cite an archetypal scene of the criminal narrative, for example, the woman who believes her lover to be innocent of a crime finds his bloodstained shirt, and is forced to think again. A spreading stain on a hero's chest suggests to the audience that the man, who is pretending that everything is all right, has been fatally wounded. In scenes like these the stain suggests that not everything is as it seems. The stain is both a visible reality in a scene – a mark on a collar, or a petticoat, or a bed sheet – and evidence of something else, part of a chain of events which for the time being remains obscure. So concise is it in its complexity that Slavoj Žižek, discussing Hitchcock's films, used the image of the blot, or stain, to characterise a particular element in a cinematic scene which draws the eye, and disturbs an apparently natural order. "Everything is proceeding normally," writes Žižek, "according to routines that are ordinary, even humdrum and unthinking, until someone notices that an element in the whole, because of its inexplicable behaviour, is a stain. The entire sequence of events unfolds from that point."[9] The stain is the point of *anamorphosis*, suggests Žižek, referring his readers to Holbein's 1533 painting (a favourite of Jacques Lacan's), *The Ambassadors*.[10] The anamorphic "spot" in that painting seems to be a blur, until it is viewed from the side, when it reveals itself to be a human skull; the presence of the skull changes the meaning of the apparently straightforward portrait of the two men. The Hitchcockian stain, like this skull, "sticks out". To follow it is to disturb the perspective of the scene in which it appears, discovering that there is more to the reality of that scene than meets the eye.

The blot, or stain, in Hitchcock's films, writes Žižek, can in fact be just about anything; it need not be an actual stain. In *Foreign Correspondent* (1940) it is a windmill in a field of tulips that is uncannily rotating *against* the direction of the wind. In *North by Northwest* (1959) it is a speck in the sky that turns out to be a plane. But sometimes it is an actual stain. In *Stage Fright* (1950), writes Žižek, it is the stain on the front of Charlotte's dress which disturbs an otherwise unremarkable scene. In *Marnie* (1964), we experience a "blot" through the film's eponymous heroine. For her it is the colour red, referring back to a childhood trauma in which the image of a bloodstained shirt burned into her memory. At one point in the film Marnie spills red ink on her pristine white blouse as she sits at her office desk. We see the ink fall, and form a spot on her sleeve; the entire screen turns red as we witness her horror. Then, in a shot taken from above, we look down on the stain as Marnie does, before she rushes to the bathroom to wash it off. When a concerned colleague asks her if she is all right, she plays the incident down, insisting that she is just cleaning her blouse. But the cinema audience knows that there is far more to it than that. Marnie's reaction to the stain suggests a serious disturbance behind the poised figure she has tried so hard to cultivate. By the end of the film we know what that disturbance is, and why a white blouse spotted with red ink might trigger it. A flashback sequence shows how as a young girl, Marnie defended her mother by beating her aggressor, a sailor, around the head with a metal fire iron. It was the image of the dying sailor's white undershirt, stained with bright red blood, that stayed with Marnie long after she had erased the traumatic memory of her mother's attack and the sailor's murder. What remained was an apparently unaccountable fear of anything red.

Unsurprisingly, perhaps, Hitchcock is a master of the stain, fully alert not only to the range of its uses as a cinematic *device*, but also to its rich metaphoric range in both psychological and theological terms. The stain, after all, stands as the very image of the eruption of something that ought to have remained contained, something that needs to be cleaned away, and so Marnie scrubs at her sleeve, and Norman Bates cleans up the bathroom after the murder in *Psycho* (1960). And the association of the stain with sin – especially for women – goes deep in Judeo-Christian culture. Hitchcock knew that the stain is a metaphor as well as a reality. The bloodstains that appear in *Stage Fright*, *Psycho*, *The Birds* (1963) and *Marnie* – to name just a few – are not just ways of indicating wounds or accidents. They have a psychic reality for protagonists and audience alike, thanks to Hitchcock's direction and his careful staging. Care was taken in *Marnie*, for example, to get just the right contrast between the pristine whiteness of the sailor's undershirt and the blood that stained it. And so anxious was Hitchcock about the ink-blot scene, that he re-shot Marnie's sleeve from above so that the film's viewer sees the stain from the same perspective as she does, and feels her fear.[11]

Marnie, dir. Alfred Hitchcock, 1964

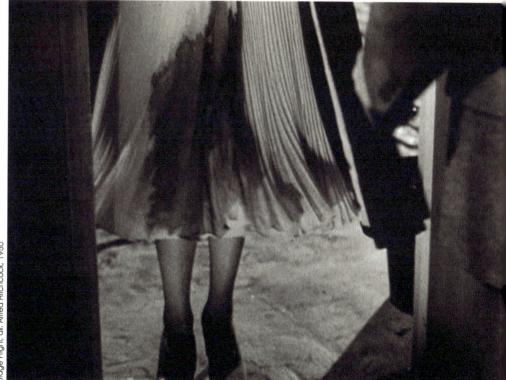
Stage Fright, dir. Alfred Hitchcock, 1950

There are other directors with a feel for stains – the Coen brothers, for example; or, in a different vein, Quentin Tarantino. In lazier hands, though, the stain does not always resonate in so many registers. Stained clothing – especially clothing stained with blood – is both ubiquitous and, on the whole, unmemorable in the millions of thrillers, murder mysteries, police and hospital dramas on the screen, where it does routine work identifying victims and assassins, suggesting guilt, misleading protagonists and so on. When forensic science comes into the frame, as it does in the *CSI* TV franchise (Jerry Bruckheimer Television, 2000-), stains (along with other marks, scuffs and traces) move to centre stage. Here, they might be stripped (more or less) of metaphoric resonance, but they certainly work hard for their money in other ways.[12] *CSI* dramatises the work of forensic scientists in solving criminal cases – typically murders. It is based on a fantasy of the absolute legibility of evidence, given the right expertise and state-of-the-art technology. So expert are the *CSI* workers that to them every stain tells a story. Thanks to techniques of bloodstain pattern analysis (BSPA), they can tell just from looking at a stained vest how the blood got there, from where, travelling at what speed, and so on. DNA analysis of the stain can identify the blood's owner (or owners). The crime scene investigation aims to reconstruct a criminal act precisely from the traces it has left behind, and it invariably (almost miraculously) succeeds. And so the stain *indicts*, it threatens to blow the murderer's cover; to the supernaturally skilled analyst it effectively spells out his (or her) name.

CSI relies, for much of its affective power, on the juxtaposition of the aftermath of horrific crimes, explicitly represented, and the clinical operations of forensic science and computer technology. It offers reassurance that "science" will work it all out, however unpromising the material (one episode shows half a corpse – hardly recognisable as such – stuck to the bottom of a transport container).[13] The show's detectives and coroners have always "seen it all before", and generally respond to the most degraded of human spectacles accordingly. But we, the viewers, are bound to respond differently; we enjoy both the frisson of horror and the satisfaction of seeing a seemingly intractable case solved. And here we come to another property of the stain in film. A stained garment might serve as a narrative device, it might signify repressed trauma (as in *Marnie*), or sin, or it might operate as evidence in a criminal investigation, as in *CSI*. But it surely remains the case that in the very first instance we tend to respond to stains on film or television as we might respond to them in real life. Stains evoke shock, alarm, disgust or dismay – primal things – before they become proof or symbol of something in some narrative. We respond to them more or less instinctively before we apprehend their cause.

Again, this fact can be manipulated by a director or cinematographer; think of *Pulp Fiction* (Tarantino, 1994). When it comes to stained women, the possibilities multiply. In *Stage Fright*, Johnny opens the door to Charlotte (Marlene Dietrich), who opens her coat (all of these openings are key to the scene's power) to reveal a large dark stain on the front of her dress. We don't yet know the cause of the stain, or the reason for her urgency. What we hear is a dramatic chord, with Dietrich's low voice saying "Johnny, you love me, say that you love me. You do love me, don't you?" What we see, framed by the door, and the coat, is the stain. The stain fills the visual field; it's impossible to look at anything else, and it's a horrifying sight. It emerges a few moments later that there has been a murder, and that it is the blood of Charlotte's husband that has stained her dress. Later still – much later – we discover that the entire scene (a flashback sequence) is a fabrication, and that the stained dress that Johnny keeps as evidence has been faked by him to conceal his own guilt. But none of this is immediately evident from the stain itself, in the scene in which it first appears. A similar scene occurs in *Hush… Hush, Sweet Charlotte* (1964), the gothic melodrama directed by Robert Aldrich a couple of years after *What Ever Happened to Baby Jane?* (1962). It is the night of a ball in Charlotte's father's house. Out in the summerhouse, Charlotte's lover has told her that their affair is over. Then there is a scene in which we witness his bloody murder (his head and hands are chopped off with a meat cleaver), but we do not see who is responsible. The scene shifts to the ballroom; a jazz band is playing, people are chatting and dancing. Charlotte slowly enters the room; at first she is in shadow. As she turns into the light the crowd fall silent and the band stops playing. There is a stain on the front of her party dress – in a similar position to Charlotte's in *Stage Fright* – and it seems to turn the ball-goers dumb with fright or consternation.

In both films the stained dress is cinematically very powerful. In both cases the woman's dress is white, and glamorous (Dietrich's gown is Dior – she apparently insisted on it), and so the bloodstain is highly visible; a kind of desecration, as it were (appropriate in the case of *Hush… Hush*, since Charlotte is wearing the traditional dress of the young debutante). In both films it is suggested that the

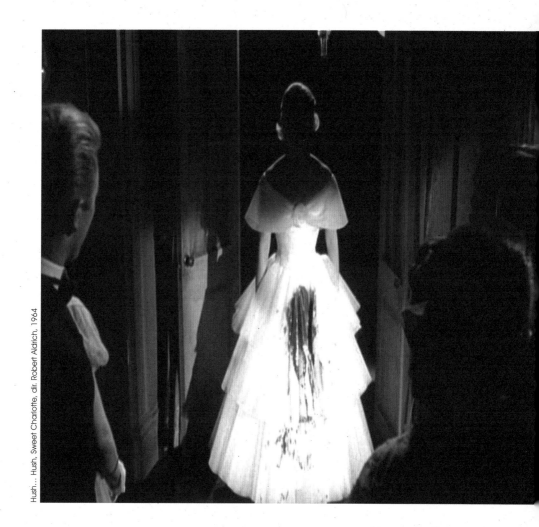

Hush... Hush, Sweet Charlotte, dir. Robert Aldrich, 1964

stained woman has committed a murder, although in both films this turns out not to be true. But in both cases the first time we see it, and before we know its cause, the stained garment is framed in such a way so as to provoke other reactions from the viewer, and invoke other associations. In both cases what we see is a woman, clearly disturbed, showing her bloodied skirts in public. And the consternation the bloodied dress causes us (like the party-goers in *Hush... Hush*) is surely due to its association not only with injury but with menstruation. Menstruation, after all, is a public secret which has to remain hidden (the successful woman, like the successful criminal, does not show any stains). Freud, of course associated menstruation with castration; and in fact the position of the bloodstain (whether by accident or design) is in both cases in just about the right spot for such a suggestion. Whatever the cause, the fact is that in both films, the image of the stained woman is both powerful and ambiguous; we do not know the source of the blood that marks her, and for a moment we – like the revellers in *Hush... Hush* – are turned to stone by its presence.

In Brian De Palma's 1976 film *Carrie*, the image of the bloodied woman is used to rather different effect. In the famous final scene, Carrie is drenched in pig's blood just after she has been crowned prom queen. In this case there is no mystery about the source of the stain. She has been the victim of a cruel practical joke, referring back to the time when she began menstruating rather publicly in the school shower. Just as in *Hush... Hush,* the party goes quiet faced with the desecration of the new prom queen, resplendent just a few moments before in her white dress. The blood is thick, and dark, and Carrie is unusually pale. Some of the revellers start to laugh at her. But Carrie has telekinetic powers, associated with her monthly period; and after being doused with blood she turns her powers on the prom-goers, with devastating results. Something of Carrie's power is echoed in the video game *Killer 7*, in which a character named Kaede Smith, identifiable by her blood-spattered white tunic, is an assassin capable of getting ahead by shooting forth showers of blood. Kaede, like Carrie, and like Jackie Kennedy even, succeed in turning the signs of abjection into power.

Finally, we might spare a thought for the stain-makers in cinema and television. Horror films give scope for an expressionist artistry in blood, nowhere more so than in the *giallo* films of Dario Argento and others, where special effects artists can drip and spray red fluids around with the freedom of a Jackson Pollock. But in film and television shows where the stain is in some way evidential, its fabrication must be painstaking, especially in a post-*CSI* context which has made amateur BSPA expert of us all. The stain-makers have to create marks that look authentic, that are believably contingent. As Georges Didi-Huberman writes (in relation to the Turin Shroud, the most famous stained garment of them all), the stain must be non-iconic and non-mimetic to insure its value as an *index*.[14] And not only must stains in a filmic criminal narrative look convincingly contingent, they must remain so in all of the scenes in which they appear. The precise nature of their contingency must remain constant. Stains are often cited as "bloopers", continuity faults in which a stain has a particular appearance and location in one scene, and inexplicably alters its shape, size, colour or location in another one. DVD viewers with time on their hands have found such stain-bloopers in films and TV shows including *Star Trek II: The Wrath of Khan* (Nicholas Meyer, 1982), *CSI* and *Lost* (ABC Studios, 2004-).[15] Faults have been found in *Carrie*, too, where stains that appear in one scene change shape or disappear in the next. To an extent, stains surely lose their impact once we see them as things made by studio hands, using chocolate sauce (as in *Psycho*), paint, or coloured corn syrup. But the real test is first impact. Tippi Hedren apparently vomited after seeing what make-up artist Howard Smit had done to her for her role in *The Birds*; proof, if true, of the visceral power of the well-placed scar or stain, even when we know it to be faked.[16]

Notes

1. Thanks to Alan Cholodenko, Ian Christie, Susie Cole, Eve Dawoud, Ursula Frederick, Robert Herbert, Martyn Jolly, Joanne Kernan, Louise Marshall, Rita Revez and Marketa Uhlirova.
2. William S. Burroughs, *The Wild Boys: A Book of the Dead* (London: Corgi, 1972), p.51. Quoted in Dick Hebdige, *Subculture: The Meaning of Style* (London: Methuen, 1979), p.23. Burroughs' novel was the inspiration for the 1984 Duran Duran song of the same name.
3. "Somehow that was one of the most poignant sights," wrote Lady Bird Johnson, wife of Lyndon Johnson, "that *immaculate* woman exquisitely dressed, and caked in blood" [my italics], *A White House Diary* (New York, Chicago and San Francisco: Holt, Rinehart and Winston, 1970), p.6.
4. Wayne Koestenbaum, "Jackie's Humiliation" in *Jackie Under My Skin: Interpreting an Icon* (New York: Plume, 1996).
5. The term comes from Roland Barthes, who uses it to describe a "sensitive point" in a photograph, an "accident which pricks me (but also bruises me, is poignant to me)", *Camera Lucida*, trans. R. Howard (London: Flamingo, 1984), p.27.
6. In Roth's novel, Faunia Farley describes the nature of the "human stain": "We leave a stain, we leave a trail, we leave our imprint. Impurity, cruelty, abuse, error, excrement, semen – there's no other way to be here," *The Human Stain* (London: Vintage, 2001), p.242.

7. A photograph entitled "Britney's Mysterious Armpit Stain" appeared in *The Sun* on 30 September 2007; the "mystery" was the fact that only one armpit was stained. Was it sweat, the readers were asked, or a stain from the can of drink she was carrying?
8. The poem is famous for its line: "Oh! Celia, Celia, Celia shits!"
9. Slavoj Žižek (ed.), *Everything You Always Wanted to Know about Lacan (But Were Afraid to Ask Hitchcock)* (London and New York: Verso, 1992), p.20.
10. Slavoj Žižek, *Looking Awry: An Introduction to Jacques Lacan through Popular Culture* (Cambridge MA: MIT Press, 1991), p.90.
11. See Tony Lee Moral, *Hitchcock and the Making of Marnie* (Lanham, Maryland and Oxford: Scarecrow Press, 2002), pp.47, 126.
12. *CSI* stands for Crime Scene Investigation. The original series was created by Anthony E. Zuiker and began in 2000.
13. This has resulted in what is known as the "CSI effect", in which public expectations of the capabilities of forensic science become seriously unrealistic.
14. Georges Didi-Huberman, "The Index of the Absent Wound (Monograph on a Stain)" in *October: The First Decade, 1976-1986,* eds. A. Michelson, R. Krauss, D. Crimp and J. Copjec (Cambridge MA and London: MIT Press, 1987), pp.43-44.
15. See http://www.moviemistakes.com and other websites.
16. Documentary *All About the Birds,* included on *The Birds* DVD (Universal, 2005).

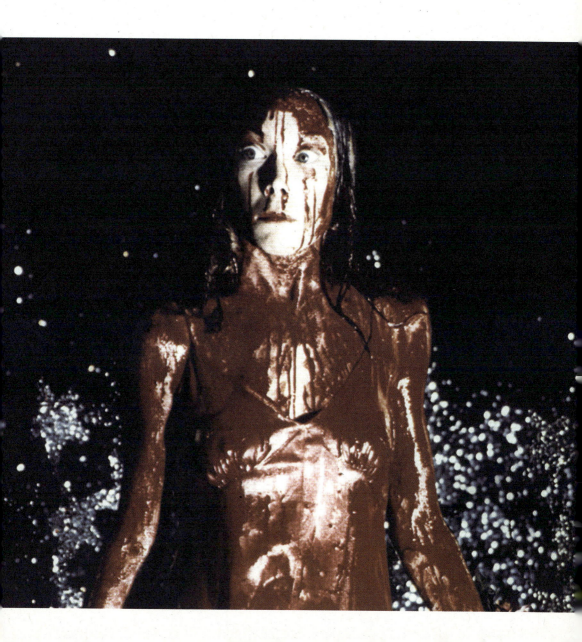

A Question of Silence: Revisited / Karen Alexander

During a recent masterclass in London, Tunisian director and editor Moufida Tlatli spoke about her magnificent debut feature *The Silences of the Palace* (*Samt el qusur*, 1994). The film focuses on a group of servant women who live through the last days of colonial rule in the palace of "the Beys"; they keep each other's sexual secrets while responding to male cruelty and aggression with heartbreaking silences. During the break I spoke to a mixed group at my table about Marleen Gorris's *A Question of Silence* (*De Stilte rond Christine M.*, 1982). The group's response was interesting: all the women knew the film, and one said it was one of her favourites (stating that she had celebrated her seventeenth birthday by taking all her friends to see it); the men, on the other hand, looked blank and didn't know what we were talking about – or only vaguely knew of it.

I start with this story as it points to the reaction that *A Question of Silence* received when it was released: the film was viewed as "a shocking example of uncontrolled feminism"[1] that specifically spoke very differently to women and men. The core of the story is the seemingly motiveless murder of a male boutique proprietor by three women when he challenges one of them for shoplifting. The journey we are taken on in the film is that of the middle-class female criminal psychiatrist Janine, charged by the court to investigate the defendants' motive for the crime. To her surprise she finds that her allegiance turns away from the obvious "insanity" explanation, sought by the male-dominated justice system, to a greater understanding and appreciation of women's place in society through observation, communication and dialogue with the three very different women: housewife and mother Christine, waitress Annie, and executive secretary Andrea.

For the male establishment, the certainty of the women's "abnormality" lay in the fact that they didn't know each other before or during their collective crime – a very brutal murder. The narrative unfolds like a thriller in reverse – the women never deny the crime: the silent question for us, as we observe in flashback the events leading up to the crime, is not whether they did it, but why.

A Question of Silence was produced in 1982 and emerged during a flurry of women's independent filmmaking – a period that included classic feminist films, such as Margarethe von Trotta's *The German Sisters* (*Die Bleierne Zeit*, 1981), Lizzie Borden's incendiary "feminist fable"[2] *Born in Flames* (1982) and Sally Potter's bold and adventurous *The Gold Diggers* (1983). Alongside this mini explosion of feminist cinema, *A Question of Silence* achieved cult status by doing what very few films have done before or since, which was to almost completely divide an audience along gender lines: "Some women stood up and cheered, while other (often male) viewers left outraged."[3] Male and female readings of the film remind me of the subtle differences in sizing for men's and women's clothing: one very rarely sees the label "XXL" on anything to do with womenswear – it's a psychological thing.

Aside from some men's newfound interest in fashion, women think about and use the places where clothes are bought differently – when women say "I'm going shopping" it's code for escape, while men tend to shop more functionally. The murder in the film takes place in an unremarkable boutique – something already in decline in the 1980s but a word that, simply by its exotic nature, is loaded with the promise of glamour and fashion, and clearly designates a space that is for women. Going to a boutique offered women a place to escape the torment of patriarchal society and the personal frustrations that could bring. For Christine this took the form of her husband and the stress of domestic life; for Annie the drudgery and ageist insults that her male customers delivered in the café where she worked; and for Andrea her supercilious and patronising male boss. The location of the film in this safe environment is very important and has often been overlooked; writing on the film tends to concentrate instead on gender politics, the nature of flashback narrative construction or the brutality of the murder of an innocent man.

Looking at the film almost twenty-five years on, I find these responses and comments cogent and vital, but at the risk of being thought frivolous myself, I would rather focus on the boutique, perhaps the last bastion of a specifically female space on the high street. The boutique in which the murder takes place is located in an unremarkable shopping centre. The women enter the space separately, and are not necessarily excited by the clothes but regard the visit as a retreat from the lives they experience in the male-dominated spaces of domestic life and work: the shop becomes a space of sanctuary. Unlike shopping in a supermarket, where it is hard to browse and not buy, clothes shopping can offer a space for contemplation, or even meditation – not unlike a church. Christine, Annie and

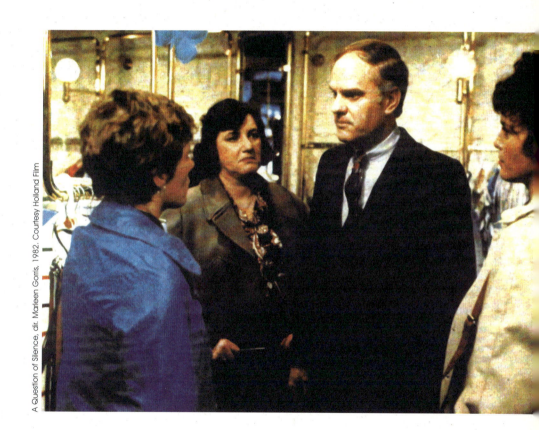

A Question of Silence, dir. Marleen Gorris, 1982. Courtesy Holland Film

Andrea idly browse the clothes racks, less out of interest than from habit. This is perhaps why they see themselves as fellow travellers when the male shop owner confronts Christine for stuffing a dress in her shopping bag. Something suddenly snaps for the women and they turn, Stepford Wives-style, to defend one of their own, reading the justified annoyance of the shop owner as unjustified male aggression, to which, in this hallowed space, a stop must be put. The shop then becomes a temple where it seems correct and legitimate to kill this man, almost like a ritual sacrifice, as other women shoppers watch in placid silence. We are offered no reasons for the boutique proprietor's death. He fails to recognise (as does the court) that Christine is probably suffering from kleptomania – a mental illness that causes uncontrollable urges to steal items, often goods that are easily affordable. A 2007 Stanford University study of the illness estimated that there are 1.2 million sufferers in the United States.[4] Kleptomania, famously depicted by Otto Preminger in *Whirlpool* (1949) and by Alfred Hitchcock in *Marnie* (1964), is a disease triggered by stress and suffered mostly by women. Christine appears vacant and ill when we see her at the start of the film, just prior to her arrest: for most of the film she exists in silent isolation, refusing to speak to the psychiatrist, choosing only to communicate via childlike pictures. We deduce that her catatonic state was already a factor of her damaged personality, and not something brought on by the horrific crime.

Countering Simone de Beauvoir's statement that fashion enslaves women, rather than offering the possibility of revealing themselves as independent individuals, author bell hooks views clothes and fashion as a form of female pleasure and resistance, one that counters internalised oppression and self-hate.[5] In his closing statement the prosecutor says of criminal women: "You can spot their type by looking at them." Janine the criminal psychiatrist is the only central female character whose demeanour and clothes state what she is – an unflappable middle-class professional – which makes her belief in her interviewees' sanity all the more convincing. Although not clotheshorses, Christine, Annie and Andrea are all in the boutique for their own reasons – as are, crucially, four other women who we never hear from but who witness the murder taking place and attend the subsequent trial – like a chorus bearing silent witness for all women.

Looking back on this period through the lens of 2008 and the Fashion in Film Festival, it is extraordinary how unimportant clothes and the boutique setting were considered to be when *A Question of Silence* was first released in the UK by Cinema of Women in 1983. We are now so used to the high-fashion offerings emerging from directors like Pedro Almodóvar teaming up with designers such as Jean-Paul Gaultier, or the recent period drama *Atonement* (Joe Wright, 2007), whose public debate was as much about how to get a hold of a version of the Jacqueline Durran-designed 1930s green dress worn by Keira Knightley, as about the film itself. In *A Question of Silence* the clothes take a back seat: what we are being offered is not woman as erotic object, or turned inside out displaying emotions and desires via her clothing, but woman as an ordinary, everyday person. After watching the film you would be hard pushed to select any memorable item of clothing – but I read this as deliberate strategy: when asked about being made up to look old for *Citizen Kane* (1941), director Orson Welles answered that it took as much time and effort to make him look young as it did to make him look old. For Gorris, as with all directors, nothing is left to chance. The unremarkable nature of the clothes in the film is telling us that you can't judge a book by its cover or a woman by her clothes: given the right circumstances, murder can be committed by any woman.

Looking at the film now, it is striking how timeless it is in relation to sexual politics and how utterly fearless and unique it was as a debut feature. *A Question of Silence* was not only a landmark film in terms of its production: it was a *cause célèbre* for women's films achieving wide distribution.[6] The 1980s was a time when Hollywood misogyny, epitomised in films such as *Dressed to Kill* (Brian De Palma, 1980) was being countered by Reclaim the Night marches – *A Question of Silence* really did offer something new and different, and almost a decade passed before Hollywood came anywhere near to capturing the same sense of "sisterhood", in the form of *Thelma and Louise* (Ridley Scott, 1991) However, the most memorable and subversive thing about the film is the uncontrollable laughter that rings out from the accused women in the court at the end of the film, prompted by the male prosecutor stating that he sees no difference between their case and one that might involve a group of men killing a female boutique owner. With one comment the film turns from deep seriousness to near-farce, "forging a bond among women – and between women viewers and the film".[7]

A Question of Silence taps into uncomfortable truths – those of women's bonding, female anger

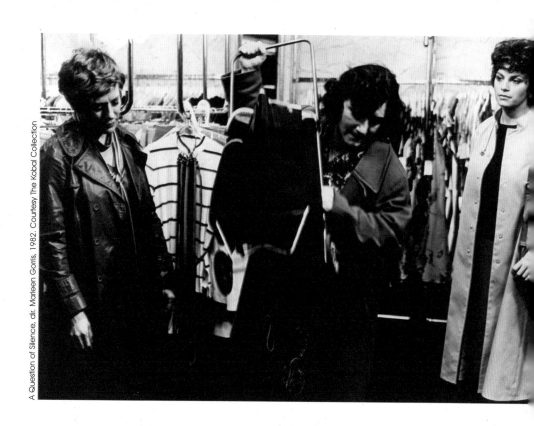

A Question of Silence, dir. Marleen Gorris, 1982. Courtesy The Kobal Collection

and male unease. When the film was released in Holland, women would confide in Gorris that they couldn't take their husbands or boyfriends – opting to go with a female friend instead, because they "didn't want a fight". These women knew that sometimes men just don't get it (think the prosecutor in the film who describes women shopping for clothes as "indulging in a harmless pastime", or the bosses at M&S who put male shop assistants in the lingerie department – thus taking the fun, fantasy and escapism out of underwear shopping).

Notes

1. Jane Root, "Distributing *A Question of Silence*: A Cautionary Tale" in *Films for Women*, ed. Charlotte Brunson (London: British Film Institute, 1986).
2. Annette Kuhn with Susannah Radstone (eds), "Lizzie Borden" in *The Women's Companion to International Film* (London: Virago, 1990).
3. Root, *supra* n.1.
4. Louis Bergeron, "No conclusive benefit found from treating kleptomania patients with common antidepressant medication", *Stanford Report* (March 21, 2007) http://news-service.stanford.edu (accessed 30/03/08).
5. bell hooks, *Yearning: Race, Gender and Cultural Politics* (London: Turnaround, 1991).
6. Root, *supra* n.1.
7. B. Ruby Rich, "Lady Killer: *A Question of Silence*" in *Chick Flicks: Theories and Memories of the Feminist Film Movement* (Durham: Duke University Press, 1998).

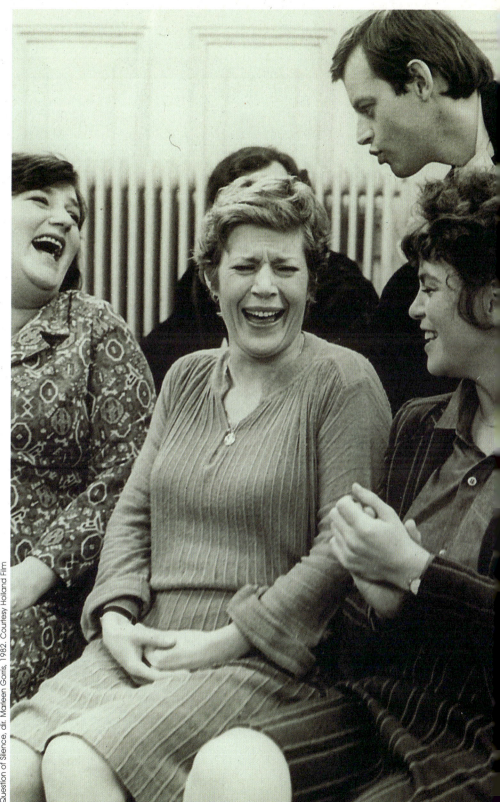

A Question of Silence, dir. Marleen Gorris, 1982. Courtesy Holland Film

The Virgin-Whore Complex:
Ms .45 and 1970s Feminism / Jenni Sorkin

Though touted as a feminist classic, director Abel Ferrara's 80-minute film *Ms .45: Angel of Vengeance* (1981) is clearly a male fantasy: so what if the rape looks a little pornographic, and the murder victims are lovingly slathered in amateurish ketchup-blood? The film's unbelievable premise has all the makings of an exploitation film gone fashionably awry: Thana, a mute seamstress, played by 18-year-old Zoë Tamerlis Lund, herself a fashion-model-turned-actress, works in the Garment District for a nameless but egotistical designer, toiling as a low-paid minion for New York's fashion elite. Her disability reinforces her difference and isolation; one day, instead of joining her co-workers for a drink, she is raped twice as she makes her way home from work. As a result, she suffers a psychotic breakdown, and becomes a vigilante seductress on a killing spree, murdering all men who display any kind of sexual feeling or action. Because Thana is presumably a virgin, she is unable to distinguish between desire and aggression, and is left with a permanent distaste, and strange revenge-lust, for both.

Because the plot is monotonous and the acting is over-the-top, the viewer's attention shifts immediately to the film's materiality: the handmade afghan on the couch with which Thana blankets herself for comfort; her slow, sensuous undressing before her bathroom mirror; even the garbage bags into which she places bits of her dismembered first victim have the look and feel of shiny black vinyl – foreshadowing the violent turn of events as Thana metamorphoses from schoolgirl virgin to killer-whore almost overnight.

While *Ms .45* is said to have been influenced by Roman Polanski's arthouse classic *Repulsion* (1965), in which a nearly mute Catherine Deneuve suffers from a pathological fear of rape, it seems likely that Ferrara is responding to more mainstream, and more specifically American, films. In a 2008 interview, he cites "Stanley Kubrick, Woody Allen and all of the great New York filmmakers" as early influences.[1] If we take him at his word, then *Ms .45* can be seen as a kind of B-movie backlash to two films from the 1970s, both of which depict versions of Thana's life and livelihood: Jane Fonda's high-class hooker/struggling actress Bree Daniels in *Klute* (Alan J. Pakula, 1971), and Diane Keaton's schoolteacher-by-day/slut-by-night Theresa Dunn in *Looking for Mr. Goodbar* (Richard Brooks, 1977). All three films characterise the double standards that modern young women face in contemporary urban society: single (marked by hours spent home alone in a cramped, dark walk-up apartment), ambitious (with enough gumption and spirit to be both drawn to, and repelled by, life in the big city), attractive (all three shot with many close-ups of the face, neck and décolletage), and presumably sexually available (predicated upon the previous three clauses). While all three films are set in New York City, Ferrara's is the most intimately shot, owing perhaps to the low-budget nature of his production, but offering up an unbelievable rawness, showing New York at a particular time and in a particular place: the savage uncertainty and high crime of the early 1980s, before the Upper West Side was bourgeois, and when Times Square was a squalid paradise of porn theatres and strip joints.

Made a year after Ronald Reagan's 1980 election and two years after the stunning loss of the passage of the Equal Rights Amendment, *Ms .45* captures both the sordidness and the uncertainty of the new era, after sympathy for the Women's Movement had all but faded. The Vietnam War had ended – badly. The Women's Movement had ended – badly. There was a new, ruthless president, with a keen interest in money, weapons and surreptitious foreign interference. The 1980s had begun… On the "macro" level, the character of Thana is an everywoman, rendered speechless by the casual brutality of her hostile environment. With make-up, fashionable trench coats and heels, she can create a façade, a mask of strength and indifference, or she can take matters into her own hands and transform not just her look, but her entire being, embracing her inner anger and using it to rid the world of lecherous, greedy, violent men, via the domestic tools available to her, whether it's the kitchen freezer for storing body parts (a nod to the famous 1953 short story "A Lamb to the Slaughter" by Roald Dahl) or a meat grinder; she feeds the pieces of one ground-up man to her elderly neighbour's (small) dog, a stunning reversal of the famed *Hustler* cover of June 1978 that outraged feminists at the time, in which a nude woman was fed upside down into a meat grinder, emblazoned with the caption attributed to publisher Larry Flynt: "We will no longer hang women up like pieces of meat."

Such a direct reference to meat crops up early on in the film, after Thana makes her way down the mean streets of 7th Avenue on her way to the subway, after declining drinks but before the first brutal attack. She is treated like a piece of meat, on display for the leering hoodlums lining the street. Thana is next seen in a grocery store, wandering dazedly past the huge array of packaged, bloody

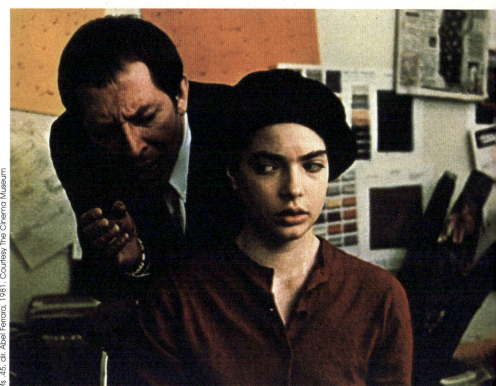

Ms .45, dir. Abel Ferrara, 1981. Courtesy The Cinema Museum

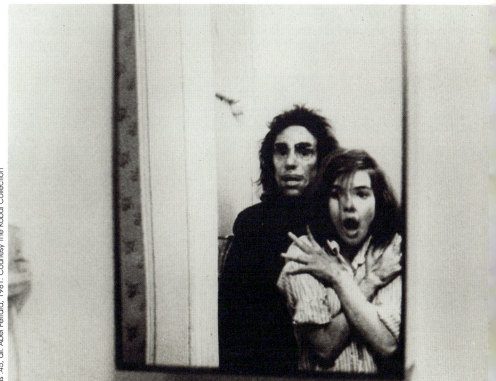

Ms .45, dir. Abel Ferrara, 1981. Courtesy The Kobal Collection

steaks and other meats. Here she is a woman in her element, a rare cut above the rest. After the rapes, she is sullied, put through the wringer, so to speak, and permanently transformed by the brutality inflicted upon her.

As Thana gains confidence in her killing, her look improves. In effect, she becomes more desirable as she becomes more violent, moving seamlessly from platforms to stilettos, from virginal schoolgirl cardigans to tight v-neck sweaters, from a pageboy haircut to a sleek no-nonsense ponytail. She stops being invisible, and starts being mistaken for a model, or a hooker. In these situations, Thana remains entirely passive, allowing herself to be lured into potentially dangerous sexual situations, which in turn create opportunities for more killing, circumstances in which she can unleash her (entirely warranted) female rage.

The climax of *Ms .45* is a Halloween party. The previous night, we see Thana practising her seductive gaze and shooting technique, posturing before the mirror in her nun's habit. Yes, Thana goes to costume ball as a nun, albeit a nun in sheer thigh-highs and heels. The party, with its guests dressed in outrageous drag-like costumes, resembles a midnight screening of the *Rocky Horror Picture Show* (Jim Sharman, 1975) rather than an event full of fashion industry types (or is it the same thing?): "My little workers, how are you doing?" coos the evil designer to Thana and her cohorts.

But when she departs, he describes Thana as one of his protégées. Thana has truly arrived: her nun costume is a smashing success, she dances like a normal (sexually available) girl, and is even seen leaving with a man, the shadow of her crucifix dangling against her naked thigh. But this normality is, alas, a façade, and the climax is a slow-mo *Carrie*-like ending, accompanied by a disturbing and screechy-creepy saxophone solo. Thana embarks upon a very public shooting spree, which ends when a woman stabs her in the back, quite literally, causing her to finally speak, uttering her own name before she collapses and, presumably, dies.

Thana is a male misidentification of what constitutes feminism. Her personality is closer to the ambivalence depicted by both Fonda and Keaton, women whose need for men is in conflict with their own ideas of independence and self-assertion. But Thana is not even this dimensional, since she lacks her own interior dialogue. As an audience, we are completely dependent upon her actions for her psychology, reduced to a series of impressionistic girl-at-the-mirror scenes. So she is not a real woman, like the women of mainstream 1970s cinema.

But neither is she a true vigilante like Valerie Solanas, the unapologetically butch playwright, man-hater, and author of the impassioned *SCUM Manifesto: Society for Cutting Up Men* (1968; lovingly played by Lili Taylor in *I Shot Andy Warhol*, Mary Harron, 1996), because she is voiceless. She is not a self-creation, like Solanas; rather, she is created by her circumstances. A rape victim-turned-fashion victim, remade into a sex symbol, capitalising on her voluptuous veneer in order to avenge the violence – both petty and actual – directed at all women, everywhere.

Notes
1. Vittorio Carli, "Abel Ferrara Interview" (2003), http://www.artinterviews.com/abelferrara.html (accessed 28/02/2008).

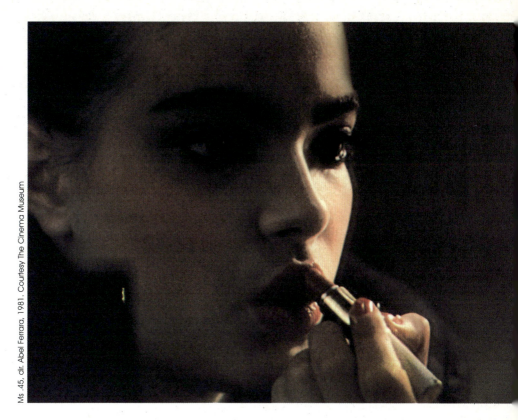

Ms .45, dir. Abel Ferrara, 1981. Courtesy The Cinema Museum

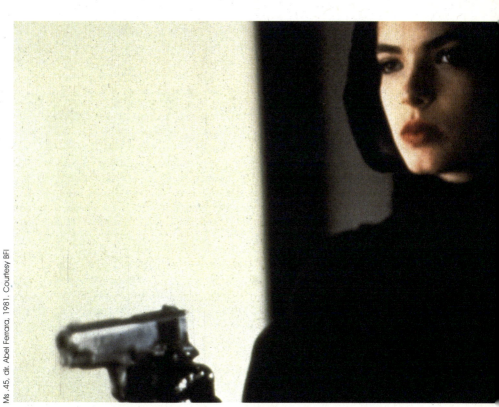

Ms .45, dir. Abel Ferrara, 1981. Courtesy BFI

Working Girl Turned *Office Killer*: The Onscreen Politics of Office Dressing Takes a Gothic Spin / Gilda Williams

By deciphering their highly readable codes of dress, we instantly recognise three types of working women in the popular film *Working Girl* (Mike Nichols, 1988), just as we readily recognise the four kinds of urban working women in the comic-horror *Office Killer* (Cindy Sherman, 1997), released some nine years later.

Working Girl told the late-1980s, post-feminist story of hard-working young Tess who discovers that her new female boss, Katharine – whom Tess had expected to be her same-sex supporter – proves even more ruthless than her previous male bosses, attempting to take credit for Tess's brainy new business idea. Taking advantage of Katharine's forced absence due to a skiing accident and encouraged by her straight-talking best pal Cyn, Tess gradually usurps Katharine's position and even her man. Meanwhile we, her appreciative audience, are meant eagerly to root for her well-deserved if somewhat deceitfully acquired success.

Office Killer instead tells the dark, late-1990s story of a doomed and misguided consumer magazine whose production is chronically blighted by malicious office politics, not helped by the staff's habitual ignoring of business culture's Big Rule No. 1: *Never, ever get romantically involved with a colleague*. Snarling über-boss Virginia sleeps with co-worker Gary; motherly temporary-consultant Norah is romancing computer guy Daniel; and the delectable, ambitious Kim is also involved with the indefatigable Daniel. Surely all this must be stopped, concludes pathetic and repressed copyeditor Dorine, who, it turns out, was sexually abused as a child and still lives at home with her cranky mother. Presumably as a result of all her personal misfortunes, coupled with the news of her office's need to "downsize" which will force everyone to work from home, Dorine falls prey to her barely suppressed rage and homicidal urges which will, by film's end, kill off almost the entire office. Downsizing indeed.

Two of *Working Girl*'s late 20th-century female archetypes find quite neatly their direct, updated counterpart in the later film: *Working Girl*'s boss-lady Katharine, sporting 1980s voluminous shoulder pads and bold, solid-colour power dresses, matches her late '90s version in *Office Killer* via the leggy, bejewelled, tough-talking office manager Virginia, chain-smoking in her dark grey "intimidation suit". And *Working Girl*'s ambitious and clever heroine, Tess (Melanie Griffith), looks uncannily like the similarly smart-but-frustrated career-girl Kim in *Office Killer*, played by Griffith's near-twin, Molly Ringwald. These latter two parallel characters, Tess and Kim, are obviously thinking as hard about what to wear to the office as they are thinking about the demands of the job; the results they achieve on both fronts will gain them – in tandem, they have learned – the success and respectability that has until now eluded them, enjoyed instead by their better-dressed female superiors.

In contrast with the parallel figures of Katharine/Virginia and Tess/Kim, the remaining three principal female characters suggest how the genre has been updated in these two films, and how Sherman's *Office Killer* sheds a Gothic light on the malaise and petty politics that surround the women and men in these corporate (and wannabe corporate) workplaces. These three figures include *Working Girl*'s Cyn (or is that "Sin"?), Tess's marriage-minded and working-class best friend, all big hair, bad advice and cheap miniskirts, and *Office Killer*'s Norah, the maternal figure positioned somewhere between the terrifying boss (Virginia) and the ambitious nobody (Kim). Sometimes dressed like a kind of office-minded mother-of-the-bride in pastel suits and shoes dyed to match, Norah slots into the company's hierarchy in a perfectly ambiguous 1990s fashion. She is the decade's ubiquitous "outside consultant", hovering somewhere between the upper and lower tiers of her host organisation, her style of dress shifting between reassuring den mother (beige jumpers and practical brown trousers) and better-than-you skirt suits, appropriately worn when handing out those hateful envelopes to staff, informing them that from now on they will be woefully reduced to part-time work from home.

Where the cultish *Office Killer* – in contrast to the mainstream *Working Girl* – takes off in a radically Gothic direction is in the introduction of a heretofore unconsidered type of working woman: the nerdy Dorine, the unrelenting misfit, with her shapeless skirts and orthopaedic shoes. Incomprehensibly to the surrounding office culture, Dorine seems patently uninterested in pursuing a career; she is satisfied simply with just keeping down a job, doing it well, and going home to mother. This is a woman whom John T. Molloy, in his hugely influential *Women's Dress for Success Book*, never even took into consideration as worthy of sartorial advice. That style bible, originally published in 1978 and revised in 1996 as *New Women's Dress for Success*, went virtually unchallenged for over a decade; like many real-life working women, all the female characters in both films – save for "crazy Dorine" – seem

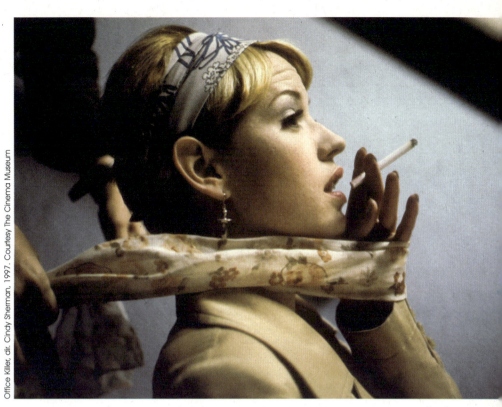

Office Killer, dir. Cindy Sherman, 1997. Courtesy The Cinema Museum

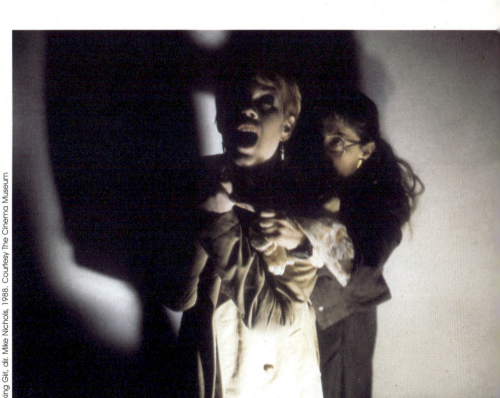

Working Girl, dir. Mike Nichols, 1988. Courtesy The Cinema Museum

to have heartily committed its dogma to memory (even when, on occasion, they refuse to go along with its rules). Dorine is not, as Molloy assumed, any "normal" working woman would be, struggling over whether her mode of dress is grooming her for a promotion; she abhors any such change. Nor is she cautiously assessing whether to wear a skirt above the knee to the office – she does not own such a "mini"; or how much jewellery can be deemed professional – she wears none; or whether she might be perceived as sexually provocative – her every garment, accessory, word and gesture betrays an overwhelming asexuality. She dresses with almost Quakerish modesty, her greenish-brown formless skirts and dirndls hanging well below the knee – though not quite long enough to conceal her cheap white polyester slip, forever dangling geriatrically in view, falling from her breastless, hipless, sexless body. Her clothes tell us immediately that she is interested in neither sex nor money – so it comes as no surprise, really, that such a "freak" turns out to be a rapacious serial killer. Disguised behind her unthreatening grey façade, Dorine methodically knocks off all her unsuspecting colleagues, collecting their corpses to form a macabre family scene, huddled round the TV, hideously decomposing on her increasingly blood-soaked and crowded basement sofa. And isn't that just what you might expect from someone so perversely indifferent to their appearance and career trajectory!

Dorine's ailing mother, bedridden and unaware of the chilling scene down in the basement, ought to provide a fifth female archetype among *Office Killer*'s medley of women characters; however, permanently attired in a flowery nightgown and thus never offering a publicly presentable persona, mother barely counts as a woman at all. One is reminded of Tess's tired remark in *Working Girl* to her boyfriend Mick when he gives her – yet again – the gift of sexy lingerie: "Y'know, Mick, just once I could go for like a sweater or some earrings … something that I could actually wear outside of this apartment?" In both instances, whether for the elderly unsexed mother or the young woman in lacy undergarments, both are dressed only for the privacy of the bed; clothes only really seem to count for a woman when they are seen by an admiring public at large – which includes the response of the women she wishes to impress, not just the men. When Jack, Katharine's boyfriend who is "accidentally" seduced by Tess, tells her – as if to compliment Tess's dress sense, "You're the first woman I've seen … that dresses like a woman, not like a woman thinks a man would dress if he was a woman," Tess replies, "Thank you – I guess." Her "I guess" suggests a suspicion that, if Tess were really dressed right, would he have the nerve to talk to her this way? It is not, in fact, either of the two potential compliments that her choice of clothing is really fishing for; he says neither "You look great!" (signalling sexual success) nor the even more elusive, "You look important!" (promising career advancement).

With stories told wholly from the female protagonists' perspectives, *Working Girl* and *Office Killer* are unmistakably women's films. Many young women in the late 1980s are said to have identified with Melanie Griffith's character as she discovers that office politics do not necessarily ease up when the ship is captained by a woman. By the late 1990s, however, a woman boss was (thankfully) no longer such a novelty, and the rules of corporate dressing had been so well digested by the culture at large that *Office Killer* could put a comically Gothic spin on the kinds of fashion dilemmas being thrashed out a decade earlier. And who better than artist Cindy Sherman could be recruited to orchestrate so many versions of womanhood, so convincingly? Yet despite their marked contrast in tone – *Working Girl* is Hollywood's romanticised reply to a recent gender change in the workplace, while *Office Killer* is an edgy horror/comedy aimed at a young art-house audience who appreciate this sort of black humour – both films, as it turns out, prove in the end to be feature-length makeovers. Griffith is transformed from the teased-up, poorly dressed back-office gal to the smartly coiffed (she deflates her massive, gravity-defying hairstyle to produce almost exactly the same sophisticated short red crop of *Office Killer*'s Kim), smartly dressed, smartly careerist success story. Dorine, in turn, unexpectedly swaps her school-marmish appearance in the very last scene for a moviestar-like *femme fatale* look, all eyeliner, platinum-blond hair and painted red lips as she drives off, in *Office Killer*'s surprise final image, to a new life with a better job, a changed name, and a flattering look – and Kim's murdered body slumped in the front seat beside her.

The life-changing makeover is a Cinderella-like staple in so many "women's" (or "girl's") films from the period, from *Pretty Woman* (1990) to *The Princess Diaries* (2001). In the horror-film spin on the makeover exemplified in *Single White Female* (1992), one "evil" woman makes herself over to become the unsuspecting female's unwanted *doppelgänger*, not just stealing the "good" woman's look but her identity, social position, possibly even her apartment and dishy boyfriend. *Office Killer* hints at such a

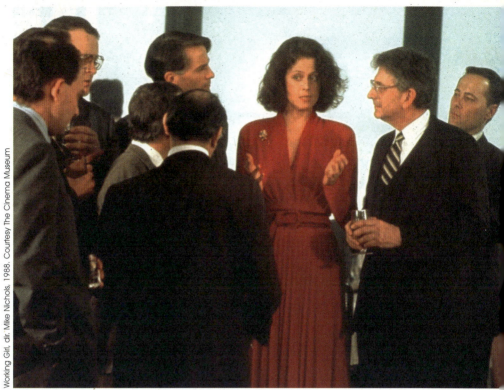
Working Girl, dir. Mike Nichols, 1988. Courtesy The Cinema Museum

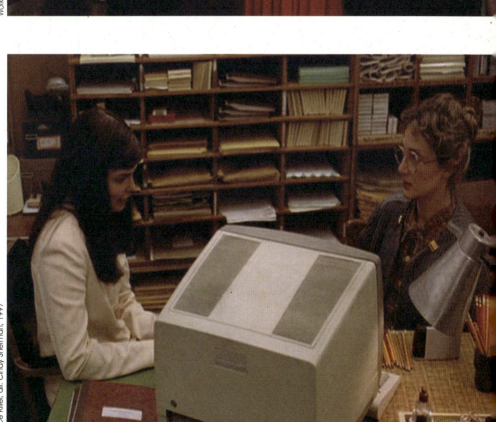
Office Killer, dir. Cindy Sherman, 1997

doppelgänger ending; the story sets up Dorine's sartorial transformation when Norah kindly gives her drearily dressed co-worker a bag of her discarded clothes. This secondhand power-dressing, combined with the earrings of the recently murdered Virginia which Dorine has the reckless gall to wear to the office, suggests that Dorine will be replicating one or all of her murdered female colleagues, finally assimilating the dress-for-success rules they, and so many business-minded women, have made their own. But no: Dorine opts most unconventionally for a pre-feminism kind of *femme fatale*, the sort of treacherous, unemployed female that populated old-fashioned *films noirs* before women entered the workplace. Dorine effectively replaces one of *Women's Dress for Success*'s "wrong" looks (the prudish, powerless blank) for another equally "wrong" and un-businesslike choice: the super-glam, super-sexy, hot blonde. By dropping the mousy look we all assumed was integral to her submissive, crazed personality – by denying the "unity of its image"[1] – and donning an equally all-encompassing vintage look, Dorine's character exemplifies the point we knew all along and which is especially visible in Cindy Sherman's hands: all of these women's looks are a masquerade, a disguise that can be manipulated at will.

Throughout the film Dorine "surprises" us by revealing that there is considerably more to her than we assume from her appearance. She takes command of the new computer technology before her more "up-to-date" colleagues; she is able, overnight, to re-write the crucial missing magazine article the whole office is sweating over; she is able, despite her slight frame, almost to overpower Kim in an attack on the stairwell; and, most tragically, she hides a dark and abusive past, somehow psychologically responsible for the dead bodies accumulating in her basement. All Dorine's secrets are safely concealed behind her unassuming look. Moreover, her uncoiffed, badly made-up face – all crookedly painted eyebrows and stringy hair – has the cinematic advantage of shifting her appearance from the librarian-like invisible woman at work to the unkempt and witchy, wild-haired and wide-eyed woman hideously distorted by her thick oversized spectacles and strangely pendulous skirts (think the frankly unsexual, homey Annie Wilkes turned vicious killer in *Misery*, Rob Reiner, 1990). When Dorine begins to flirt, finally, with a man – but only feels comfortable doing so with the decaying corpse of a former co-worker who regularly insulted her – the heretofore unreadable sexuality of this "madwoman in the basement" (a counter, perhaps, to the much-theorised, Victorian-era "madwoman in the attic"?[2]) begins to take on disturbing shades of necrophilia. The secrets behind Dorine's innocent façade multiply by terrifying increments.

Although there are direct parallels between four characters in these films (Katharine/Virginia; Tess/Kim) and the remaining women contrast in their on-screen personality (Cyn, Norah and Dorine), all the women in the films find a corresponding character if we base their positions on the unspoken dress-for-success code that each embodies. Thus the pre- and post-makeover Tesses, offer, in terms of appearance-based female roles, two different women.

The boss: the power-dressed career-obsessive
Katharine/Virginia
/ \

Transition staff: aware of the rules of appearance, but still committing faux pas
pre-makeover Tess/Norah

Rising careerist: polished, but still trying to be sexy
post-makeover Tess/Kim

\ /
The failure: chronically committing corporate-dressing errors
Cyn/Dorine

In both films, female viewers are implicitly asked to identify with the "normal" women occupying the central two positions; the uppermost and bottom women are effectively hysterics, signalled by their scare-hair and either excessive ("male-like") aggression (Virginia/Katharine) or excessive indifference to the rules and demands of the competitive workplace (Cyn/Dorine). Pre- and post-makeover Tess are obviously versions of a single female identity; but, analogously, in some ways *Office Killer*'s Norah and Kim also switch or share a single role. For example, they co-occupy the figure of "The Final Girl", which film theorist Carol Clover brilliantly identified in her 1992 book *Men, Women and Chainsaws*:

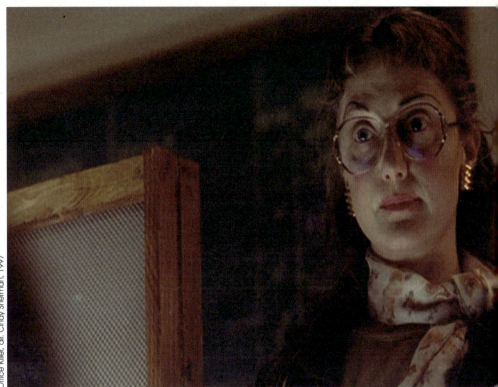

Office Killer, dir. Cindy Sherman, 1997

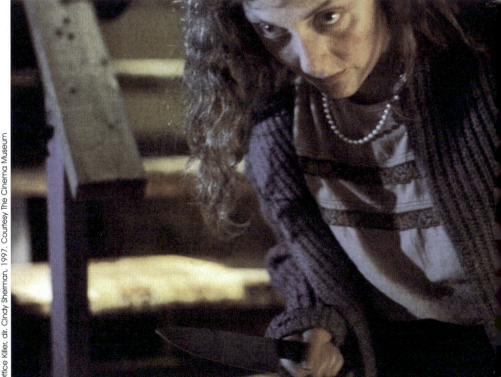

Office Killer, dir. Cindy Sherman, 1997. Courtesy The Cinema Museum

Gender in the Modern Horror Film as: "intelligent, watchful, level-headed; the first character to sense something is amiss and the only one to deduce from the accumulating evidence the pattern and extent of the threat; the only one, in other words, whose perspective approaches our own privileged understanding of the situation."[3] Throughout the film Kim alone fulfils the Final Girl's "intelligent, watchful, level-headed" comprehension of the situation, having detected single-handedly Dorine's viciousness. Yet, although Kim had been groomed for her final violent, prolonged encounter with the demented killer, it is instead Norah who is ultimately trapped in Dorine's demonic basement, hopelessly attempting to hide between laundry appliances and finally murdered in the obligatory, culminating chase scene. (Kim's demise is unseen, left to the viewer's imagination.)

Office Killer injects the *Working Girl* narrative with other horror and Gothic elements as well, for example the continual return to Dorine's home, the film's house of horrors. We are repeatedly presented with the spectacularly bland façade of this forgettable example of American tract housing, just as so much contemporary Gothic, whilst still centring on the Gothic novel's haunted house, replaces the distant Transylvanian castle or the mad scientist's hidden laboratory with the ordinary suburban home, a trope that is evident from *Halloween* (John Carpenter, 1978) to *The Silence of the Lambs* (Jonathan Demme, 1991), to *Scream* (Wes Craven, 1996). Moreover, at the centre of *Office Killer* is a classic Gothic prop: the missing manuscript. Like the decayed manuscript in such Gothic novels as Charles Maturin's *Melmoth the Wanderer* (1820), central to *Office Killer*'s plot is a missing magazine article, lost to cyberspace thanks to the office's cheap new computer technology, and which Dorine conjures virtually out of thin air one night, reinforcing in Kim the suspicion that Dorine is a deceitful, backstabbing monster. To Kim's disbelieving eyes this is not merely a display of exceptional writing skills on Dorine's part; her ability to rewrite the text is more like witchcraft, and furthers Kim's (and our) sense of Dorine's spookily superhuman, unpredictable abilities.

Borrowing further from the Gothic, Dorine is effectively a satanic twist on the reassuringly demure figure who crops up repeatedly in Gothic novels, from *Jane Eyre* (Charlotte Brontë, 1847) to the second Mrs. de Winter in *Rebecca* (Daphne du Maurier, 1938). Like Dorine, Jane Eyre spent a loveless childhood finding her own strategy for handling her unsupportive environment. As Michelle Masse wrote, "We see [Jane Eyre's] early training in deprivation, separation, and injustice that begin to make her into the spectator who will control herself rather than allowing anyone else to assume the role and who will keep her own distance,"[4] a description equally apt for *Office Killer*'s chronic loner, Dorine. Jane Eyre's suffering makes her stronger and eventually more attractive to sensible men like Rochester looking for an unspoiled, level-headed companion who will return his life to domestic peace. The second Mrs. de Winter, again like Dorine, "by being silently still … hopes to remain safely invisible to others".[5] And like Rochester, Max de Winter ultimately prefers his modestly dressed, resolutely unglamorous new wife – who foolishly and self-punishingly spends most of the novel dismally contrasting herself with the tall, fabulous (and, of course, treacherous) Rebecca whom, as we discover, Max is only too happy to have lost. Both *Jane Eyre* and *Rebecca* present a fantasy, "revenge-of-the-nerd-woman" plot; their heroine's common sense and unspectacular appearance prove infinitely more valuable to the rich and desirable men whose hearts these homely women have managed to capture and keep. Where such men – who prefer plain women to glamour goddesses – have vanished to today is anyone's guess; most modern women have probably never met any.

In contrast to these earlier homely Gothic heroines, late 20th century Dorine is never remotely desired by anybody. It has been said that women "want everything", but the suspicion today might be that men "want everything" in the woman herself: someone who can cook, tell jokes, look stylish, make money, demonstrate skill and inventiveness in bed, get along with their mates, offer sound financial advice and balance seductively in high heels. All the women in both *Working Girl* and *Office Killer* (with the notable exception of the *deranged* Dorine) are all trying so hard to be perfect – perfectly dressed, perfectly polished, perfectly desirable, perfectly professional, perfectly perfect in the eyes of both the men and women around them. Both films end when our plain-Jane female protagonist, Tess or Dorine, emerges from the career and style drought in which she was languishing to find happiness and success in a new job – indispensably furnished, of course, with a corresponding new and improved look. The body count in *Office Killer* is considerably higher than that in *Working Girl*, but the female protagonist's happy ending – "she looks *so much better* at the film's end than she did at the beginning!" – remains disquietingly unchanged.

Notes
1. Stephen Heath, "Joan Riviere and the Masquerade" (1986), quoted in Helen Stoddart, "*The Passion of the New Eve* and the Cinema: Hysteria, Spectacle, Masquerade" in *The Gothic,* ed. Fred Botting (Cambridge: D.S. Brewer, 2001), p.120.
2. Sandra M. Gilbert and Susan Gubar, *The Madwoman in the Attic: The Woman Writer and the Nineteenth-Century Literary Imagination* (New Haven: Yale University Press, 2000) [1979].
3. Carol Clover, *Men, Women and Chainsaws, Gender in the Modern Horror Film* (Princeton: Princeton University Press, 1992), p.44.
4. Michelle Masse, *In the Name of Love: Women, Masochism and the Gothic* (Ithaca and London: Cornell University Press, 1992), p.195.
5. *Ibid.*, pp.166-67.

Inside Out: Living Costumes in Brice Dellsperger's *Body Double (X)* / Drake Stutesman

Prejudice is one of the subtlest forms of crime. In *Body Double (X)* (2000) French video artist Brice Dellsperger reconstructs Andrezej Zulawski's cult film *L'important c'est d'aimer* (*The Important Thing is to Love,* 1975) to explore the cultural prejudices around narrative and, as such, how it defines "self". He wishes to "empty the fiction and draw out all the action of the [original] film ... so that it would no longer be anything more than an empty shell".[1] He "question[s] identity"[2] by stripping a story of its acceptable genre and placing it within another. His aim, in his revisionist art, is to make a "dreamlike memory of a movie",[3] as he puts it. But what is fascinating about *Body Double (X)*, among many other aspects, is that Dellsperger – in his desire to re-approach "narrative" as a form and wash it away – has created an intensely substantial work that neither derides nor exalts its original.[4] And this is where he departs from other contemporary artists such as Pierre Huyghe, Douglas Gordon and Ute Friedrike Jürss who have dismantled and reassembled classic cinema in their work. *Body Double (X)* transubstantiates or re-inhabits *L'important c'est d'aimer* to become something entirely new and yet retain its melodramatic feeling. Dellsperger creates this particularly with clothes and the body of performance artist Jean-Luc Verna, who acts out all of the film's roles. Mouthing the voices (for 102 minutes of the 113 minute feature), Verna appears in numerous, overlapping versions of himself and in the drag costumes of male/female/young/old. He plays each part convincingly.

L'important c'est d'aimer, starring Romy Schneider and Fabio Testi as lovers, is a perfect vehicle for this exploration of prejudice because, in the film, people are used and objectified. Not so much amoral as fallen, they struggle in a demi-world of exploitation, drugs and despair. Schneider's character is a stage actress forced into soft porn films, and Testi's a photojournalist with a past in Algeria and Vietnam, forced to photograph gay and straight sex. Though this is the periphery of criminal life, the film is not interested in crimes themselves. Rather, crime is a syndrome and the crimes within *L'important c'est d'aimer* are emotional – they are crimes against humanity. *Body Double (X)* confronts the detriments of this objectification by "objectifying" the film.

To do this, Dellsperger faithfully matched the original – scene-by-scene, set-by-set, shot-by-shot. He used real locations – darkened rooms, crumbling mansions, corridors, walled stairways, open grassy areas – because he wanted "the constraints imposed by the scenery/background" found in "places that offered the same spatiality as in the original".[5] Similarly, he kept the swirling or tracking shots, close-ups, and fluorescent-like lighting. His devices of interruption also match the film, which is punctuated by abrupt cuts (by editor Christiane Lack who won the Best Editing César) and by comedic sounds in George Delerue's otherwise lyrical score.

Set into this duplicate, digital cinema is Verna – his acting, his body movements, his facial diversity, his wigs, make-up and costumes. But it is the costumes,[6] faithful to the original look, fabric, style, cut and tailoring, that speak the loudest and with the most coherence because they carry profound narrative codes. The dirty outfit, tailored outfit, sexy outfit or drag outfit is predictably interpreted. Though, here, the clothes are a gay reference, they still make the *Body Double (X)* characters recognisable. But Dellsperger explores clothes (as drag) *through* clothes (as cultural classifications) by subverting their social placement. How and where is a man dressed as a woman playing a man positioned? With these kinds of questions disrupting the narrative, what happens to the cinematic fantasy world, what happens to the storyline, if referents, such as clothes, are played *as* referents? This manipulation of dress exploits the tension between clothes and costume. As Deborah Landis, costume designer and former head of the American Costume Designer's Guild, states: "Costumes are never clothes."[7] What she means is that we perceive costumes as clothes but they aren't – costumes are simply part of a production. They aren't for street wear or for couture.

Drag can easily comfort the audience into false security – it's "only drag". To see *Body Double (X)* as an exercise in drag misses the point though. In the video, the *clothes*, both as drag costumes and as "clothes", *are* the overt storyline. The only solid structure inside Verna's and Dellsperger's replications, they allow the viewer to move freely between the remake's instabilities because they steady the plot as much as undermine interpretations of it. Dellsperger wants to empty the narrative of narrative, then he seems to want to reinvent the narrative within clothes – so that they aren't even "drag". They are something else – a new story.

Drag, by its subversion, tends to expose rather than obscure, because it jolts the expectations. Dellsperger plays with the notion of "hiding", which is key to any crime. He hides in plain sight by

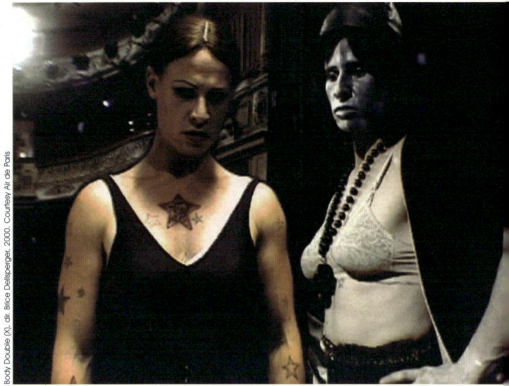

Body Double (X), dir. Brice Dellsperger, 2000. Courtesy Air de Paris

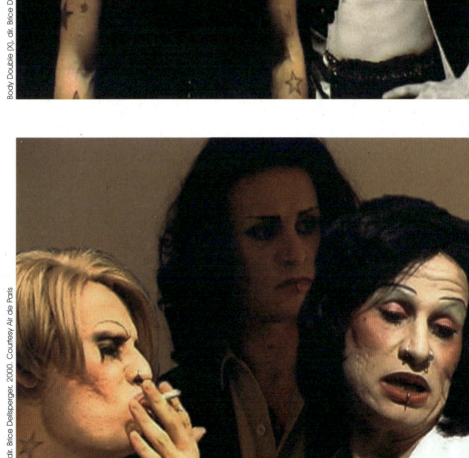

Body Double (X), dir. Brice Dellsperger, 2000. Courtesy Air de Paris

subverting the idea of disguise. What happens to audience expectations if *L'important c'est d'aimer*'s melodrama and its stock players are swallowed by Dellsperger's and Verna's soulful but Brechtian enactment of it? They rely on the costumes. Verna's "drag" *is* the melodramatic narrative. The clothes are read and the story understood. As such, Dellsperger's videos can be seen through fashion. Since the mid-1800s when Baudelaire famously declared "fashion" as modernity's most distinctive sign, a focus on clothing as a touchstone of social reality has continued to escalate. In a recent collection of interviews with designers, editor Francesca Alfano Miglietti aligns style with new *social* perceptions of the body and quotes fashion sociologist Patrizia Calefato: "[D]ressing exposes a body to an ever-present possible metamorphosis, and the fashion of our times has allowed itself to recount these metamorphoses ... In this way fashion has permitted the confusion of sexual roles, made visible on the surface that which was beneath (labels, lingerie, seams), inverted the covering function of fabrics by adopting transparencies, broken the equilibriums and rigid functionalisms of traditional costume and ritual dress ... [I]t has rendered the body a discourse, a sign, a thing."[8] This jumps from Baudelaire's sense of clothes and replaces clothes as the modern signature with nudity as the modern signature. The body is now what clothing once was but they have a strong symbiosis, often contextual. For example, the nude beach is still risqué because society is offended/titillated by the nude. Yet locker room nudity – prolonged, casual, ugly or beautiful – with strangers, is not risqué.

Dellsperger's work mines these anomalies. Clothing (and clothing on the body) is the most critical material of his productions and his approach actually does with the body what cutting-edge fashion often claims to do. How many fashion designers – from Thierry Mugler to Dolce & Gabbana, Alexander McQueen or Carol Christian Poell, or even labels such as Yves Saint-Laurent – have used fetish-wear, S/M, pornography, body mutilations and tattooing in their presentations, ads and catwalks? There is an intention to shock the public with these "outré" looks but, so often, these referents are just rehashed heterosexual pornographic images, hence safe, nothing frightening. It is the same bondage, same kind of nakedness, same objectification of women and very little objectification of men that has been around for thousands of years. There is no departure from these worn-out, depressing norms, rather the "new" version is so predictable, so socially comfortable (for men, for women), that it has no deviation in it at all.

Body Double (X) can so easily seem to fall into that category. It can be dismissed as camp or as bordering S/M. However, something else emerges in the video. It is distinct enough to make the viewer wonder what is being displayed and why. Verna has a stupendous ability to act through body language rather than through mimicry. Thus, his own account is that "I sculpt myself".[9] More so, he sees his body as able to cross the map of all history – "My basic statement is like this move in ballet, where you have your legs spread all the way out [grand jeté]. One foot is high culture. One foot is rock and roll. And the whole of human civilization is between my legs."[10] He uses his presence. His walk changes dramatically when playing Testi, his energy dissipates as Schneider's husband, his demeanour flattens as Schneider. Verna's humanity, his flesh and blood, though codified (as a gay man), brings the narrative into a bodily, and thus realistic, context. But his body, with a dancer's build and flexibility, that at times appears svelte and womanly and at other times heavy and male, is also a constant flag that this is not a typical film. Throughout the video, his maleness carries a female signature – he always wears a bra and at times, even as Testi, in a masculine stance, Verna's bust line is featured prominently. He is *always* a man wearing women's clothing (the bra is always present), even while wearing the clothes of young or old men, young or old women or a variety of people who are pretty, dissipated or haggard. He keeps us focused on the "who" of himself without that identity overcoming the characters he is trying to play. That is a remarkable balance and one that serves Dellsperger's desire to "empty fiction". Through Verna's stolid clothes and his solid self, set in a slippery digital space, the narrative – and all its myriad connotations and intentions – is ever there and ever full but with a fluid life. It can't be pinned down.

Notes

1. Quoted in: Thierry Davila, "Endurance of repetition, upsurge of invention: the remake and the workshop of history", REMAKE Exhibition Catalogue (English PDF), http://www.bricedellsperger.com, under "BD's reviews" section, 2003 (accessed 17/03/2008).
2. Brice Dellsperger, Introduction to *Body Double (X)*, http://www.bricedellsperger.com (accessed 17/03/2008).
3. Quoted in *Sexual Reproduction*, Michael Fallon, City News, 2003, http://www.bricedellsperger.com, under "BD's reviews, 2003" (accessed 17/03/2008).
4. In 1995, Dellsperger started what he called his *Body Double* series, short videos (to date there are 24) which remake, reset and rework sections from well know feature films, many American – from *Psycho* (Alfred Hitchcock, 1960) to *My Own Private Idaho* (Gus van Sant, 1991) and Lynch's *Mulholland Drive* (2001). Most are from Brian De Palma's oeuvre such as *Body Double* (1984), *Sisters* (1973), *Dressed to Kill* (1980) and *Blow Out* (1981). The films he chooses to re-invent are themselves multi-layered – full of cultural and cinematic references – and he sees his videos as palimpsests, layering one reality into another. Each, typically only three to 15 minutes long, re-enacts a scene using the exact soundtrack. In all these "remakes" or "body doubles" of an original film, a few actors will act many roles, wearing expressionistic make-up and drag (male as female, female as male or male dressed as female acting as male etc).
5. Brice Dellsperger, http://www.bricedellsperger.com.
6. The costumes were devised by Vietnamese-American conceptual artist Nicole Tran ba Vang, whose own artwork makes naked body parts (e.g. breasts or a nude back) appear as though they are stitched or even removable articles of clothing. (Her images appeared in ads for HBO's sardonic plastic surgery drama *Nip/Tuck*).
7. *Screencraft: Costume Design* (Burlington: Focal Press, 2003), p.8. Landis costumed the Michael Jackson music video *Thriller* (John Landis, US, 1985) and *Raiders of the Lost Ark* (Steven Spielberg, US, 1981), among many others.
8. Patrizia Calefato quoted in *Fashion Statements: Interviews with Fashion Designers* (Milan: Skira Editore, 2006), p.15.
9. Air de Paris Gallery's description of *Body Double (X)*, http://www.airdeparis.com (accessed 17/03/2008).
10. Quoted in *Sexual Reproduction*, Michael Fallon, City News, 2003, http://www.bricedellsperger.com, under "BD's reviews" section, 2003.

Criminal Desire, Possession and Transgression

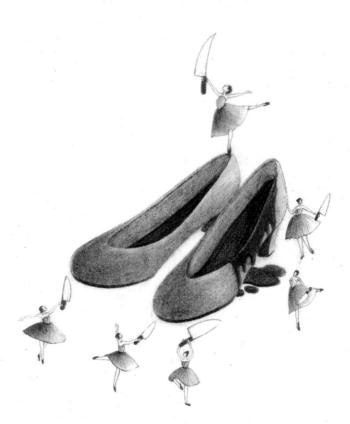

Fashioning Silent Film's Thieves and Detectives[1]
Christel Tsilibaris

Silent crime and detective film offers an abundance of examples where costume – and all the accoutrements that constitute it – are integral, if not central, to the narrative. *The Man With White Gloves* (1908), *The Gentleman Thief* (1909), *Nick Winter and the Case of the Famous Hotel* (1911) and *The Pearl* (1929) are four films which together demonstrate the versatility of the genre in employing clothing and accessories: as masks, as disguise and masquerade, as clues giving away their wearers (usually the villains), and as objects of desire which are stolen and retrieved. While the detective Nick Winter dresses in drag to fool an elusive thief, the "Gentleman Thief" and the "Man with White Gloves" use their dress and accessories as signifiers of gentlemanlihood – smooth criminals indeed – disguising themselves to win the trust of high and fashionable society. While these storylines typically address the fear of crime among the urban middle classes, playing out the social and economic tensions between those who *have* and those who *want*, fashion here also serves as a gateway to the world of entertainment and pleasure, capitalising on its value as a desirable commodity. This power of the commodity is in turn thematised in *The Pearl*: a single necklace stimulates a kind of desire that unites the different states of mind that are possession, obsession and romance.

Detective plots became fashionable in 19th century popular literature – the dime and pamphlet novels and comic strips – and through popular culture such as vaudeville sketches and theatre plays. Cinema, which in its early days drew heavily upon such material, quickly utilised the detective story for its own purposes. The genre provided a cast of recognisable character types, especially plain-clothed detectives (as opposed to uniformed police or gendarmes) and disguised criminals, in an endless series of adventures. Whereas in literature the unravelling of the crime by the detective focused on the search for and the deciphering of clues, in cinema the detective was also typically involved in more thrilling physical activities such as chasing and fighting. Cinema's developing visual language, accompanied by technical advances, was an important element in the shaping of the genre; cinematic techniques such as close-ups were frequently used, as they offered opportunities to reveal or highlight significant details which would be recognised as clues not only to the crime itself, but leading to the identity of the characters.

Detective films were as fascinated by the criminal's working practices as they were by the detective's pursuit of clues. In fact, the two sides of the law were seen to adopt strikingly similar methods: disguise, scientific process, and careful observation. Early filmmakers were equally captivated by the dextrous actions of the detectives and the criminals, but the focus would gradually shift in favour of the outlaws. In this process, cinema created a new type of male hero whose adventures would provide greater thrills and more sensational violence – now seen from the viewpoint of the "other side" of the law. Characters such as Zigomar (in films directed by Victorin Jasset for Éclair) and Fantômas (Louis Feuillade, for Gaumont) were master criminals who hypnotised the public in France and internationally.

Nick Winter and the Case of the Famous Hotel

A gentleman and an elderly lady enter the lobby of a Parisian hotel. While waiting to be guided to their rooms, the lady drops her purse. Her fellow guest chivalrously picks it up and returns it. Moments later, in the privacy of his room, the elegant gentleman reveals himself to be a thief.

Hidden in his Trojan horse-like trunk is his accomplice, whom he instructs to "visit" the old lady's room. Dressed in a black bodysuit and wearing black ballerina slippers – the crime outfit *de préférence* in early cinema – the accomplice sets out to steal the elderly lady's money. After tying his victim up, the villain is ready to grab the purse from her bag and leave. But the bag is booby-trapped! So, instead of escaping with the plunder, he is caught and handcuffed in the trap. As for the elderly lady, she turns out to be none other than Nick Winter, the shrewd detective.

Nick Winter and the Case of the Famous Hotel (*Nick Winter et l'affaire du célèbre hôtel*, 1911) is attributed to the French director Gérard Bourgeois, who started out as a stage actor before becoming an artistic director at the Lux studio in 1908. In 1911, he joined the Pathé Frères studios, and it is from here that he directed several films in the Nick Winter detective series. Starring Georges Winter, the series was intended as a parody of rival studio Éclair's Nick Carter series, which also featured a fictional French detective solving crimes during the early 1900s.

In his book *The Ciné Goes to Town: French Cinema 1896-1914*, Richard Abel observes: "Éclair's Nick

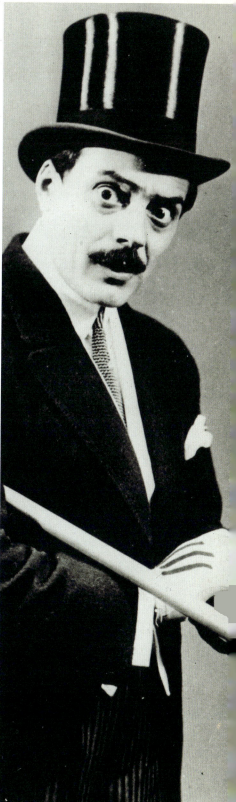

Left: André Brule as Arsène Lupin, La Vie Parisienne, 1908. Courtesy Mary Evans Picture Library. Right: Max Linder posing as a mondain. Courtesy Deutsche Kinemathek

Carter and Pathé's tongue-in-cheek Nick Winter – focused on the detective as an independent urban professional upholding the Third Republic's bourgeois social order";[2] similarly, the victims in both series were citizens with a bourgeois background, saved from ruin by these skilful detectives.

The Gentleman Thief

Another Pathé Frères production, *The Gentleman Thief* (*Le voleur mondain,* 1909), starred and was directed by Max Linder. Linder started his career at Pathé in 1905 and soon became one of early cinema's most prolific and popular comedians whose notoriety as a dapper Gallic *mondain* reached well beyond France, leading him to Hollywood in the 1910s. *The Gentleman Thief* is a take on a popular character derived from 19th and early 20th century vernacular literature, best exemplified by Maurice Leblanc's *Arsène Lupin*. This gentleman thief was suave and well-bred, stealing for adventure, or for the "greater good", doing so without causing any unnecessary harm that might stain his aristocratic origins. Although the happy-go-lucky thief in Linder's film (named Arsène Lupin but based on a script by Georges Fagot, not Leblanc) does indeed move in high society circles, his morals and his class are at best highly ambiguous. He may be full of charming vice and does manage to escape his destiny, as Arsène Lupin would, but his victims are conventional – innocent bourgeois, as well as public servants and ordinary people.

Linder's character in *The Gentleman Thief* is supremely worldly in his impeccable evening suit and bow tie. Feigning a romantic interest spurred by a dance at a ball, he skilfully guides his chosen lady to a drawing room. Embracing her, he whispers in her ear while sneakily removing a pearl necklace from the infatuated woman's neck. His seamless performance continues to fool in the streets of Paris. He sits in a café, sporting a beige trench and straw panama hat (a deviation from his trademark top hat), enjoying his drink, and when the police pass by, he roguishly asks them for a light and then swiftly disappears from the scene. When his game is finally up and a chase begins, he continues his deft masquerade by convincing a man – who happens to be wearing the same style hat – to don his coat. Complete chaos ensues, and in the grand finale, the cunning thief escapes in a hot air balloon to the safety of the skies.

The Man with White Gloves

The Man with White Gloves (*L'homme aux gants blancs,* 1908) was directed by Albert Capellani, a theatre-actor-turned-film-director, while he was working for the Société Cinématographique des Auteurs et Gens de Lettres (SCAGL), a Pathé Frères subsidiary. As Abel shows, the film was based on André de Lorde's play for the infamous theatre of horror, the Théâtre du Grand Guignol, and so was in keeping with SCAGL's aim of producing "artistic" but widely accessible films, in a bid to "dignify" cinema through an association with theatre and literature.[3]

Like *Nick Winter*, Capellani's *The Man with White Gloves* begins in a hotel setting. We see a prosperous-looking man changing out of his travelling clothes into an elegant tuxedo; alas, he finds that he's missing a pair of white gloves, which would put the finishing touch to his otherwise impeccable ensemble. A shop assistant promptly arrives at the hotel with a selection of white gloves and, after a quick repair job on one of them (which at this point seems completely random but later gains an unexpected significance), the assistant leaves the man pleased with his new purchase. However, far from being a gentleman, he is soon revealed to be a thief: he escorts a fashionably dressed woman to her house, only to emerge moments later with a jewelled necklace. But he makes a fatal mistake in front of her house. As he is pulling the stolen gem out of his pocket, he inadvertently drops his white gloves.

Hidden in the bushes is yet another (less elegant) thief, with similar intentions. But in – and on – his hands, the found gloves become a practical tool preventing him from leaving fingerprints. Once inside, this second thief is confronted by the woman; he strangles her and drops the gloves near her dead body, promptly fleeing the scene. After close examination of the white gloves by the authorities, their owner is soon identified through the unfortunate repair job. The incriminating necklace is found on the gentleman and he is wrongly charged with a double crime. In an act of cruel irony, the glove which represented the flourish that completed the thief's mimicry of the class he was about to steal from, also served another as a very practical tool, and finally came to haunt its owner, proving crucial to his undoing. Although it doesn't fit comfortably within the detective genre, *The Man with White Gloves* does exploit some of its typical themes, such as concealed identities, theft and the victimisation of the bourgeoisie, with disguise as an integral part of the plot.

Nick Winter and the Case of the Famous Hotel, dir. Gerarde Bourgeois, 1911. Courtesy Cineteca del Comune di Bologna

The Gentleman Thief, dir. Max Linder, 1909. Courtesy Deutsche Kinemathek

The Pearl

Driven by a desire to make films, the young Belgian Count Henri d'Ursel moved to Paris in the 1920s in search of inspiration and collaboration. Uninterested in the commercial aspect of film, d'Ursel aspired to create cinema with avant-garde sensibilities. He bought a camera from Abel Gance and befriended filmmakers such as René Clair and Henri Chomette, but it wasn't until he met the young poet Georges Hugnet that his film adventure began in earnest. The first film on which the pair collaborated, and which is now lost, was a visual poem on the theme of capital punishment: it began with a scaffold and a severed head, with the head rolling backwards, away from the basket and back to its body. In 1929, the same year d'Ursel made his second and last film, *The Pearl (La Perle)*,[4] he appeared in Man Ray's *The Mysteries of the Chateau de De (Les mystères du château de Dé)*. When he returned to Brussels, he became one of the most eminent figures in Belgian cinema. In 1938, he established the Prix de l'Image award for original screenplays, before becoming vice-president of the Cinémathèque Royale de Belgique.

In *La Perle*, a pearl necklace is placed at the centre of the action – it is a narrative thread which connects all the events that follow, and a powerful plot catalyst. The film begins with a young man buying a pearl necklace for his fiancée; the plot quickly thickens when a shop assistant is caught stealing the necklace and is as a result fired from her job. There follows a series of alternate attempts by the woman-thief and the young man to retrieve the necklace from each other, a game during which they manage to fall in love, double-cross each other, die and come back to life.

La Perle is one of the few Belgian Surrealist films ever made. Though Henri d'Ursel was never a member of the Surrealist movement, the influence of Surrealist aesthetics can be noted in the blending of reality and dream, fascination with a single object, which becomes a metaphor for sexual desire, and the inclusion of poetic sequences, some of which have a rather disconcerting effect. Nevertheless, the film is strongly grounded in the narrative convention, apparent in the guidance the viewer receives as to how better to distinguish between the imaginary and real.

Despite d'Ursel's commitment to avant-garde film and his rejection of commercial cinema, *La Perle* clearly echoes a film form which was undisputedly commercial – the crime film; more specifically, it pays homage to Louis Feuillade's famous serial *Les Vampires* (1915-16). *La Perle* stars a group of young female criminals who are secret residents in a hotel where they steal from rich guests. And just like Musidora's character Irma Vep in *Les Vampires*, these thieves are dressed in the famous hooded bodysuits. The appearance of these identically-clad women resolutely introduces *La Perle* to the the crime genre, with which it also shares a play with disguises and multiple identities, and the frenzied game of hide and seek between its two protagonists.

Notes

1. With thanks to Dorcas Brown, Felice McDowell, Maud Linder, Demetrios Matheou, Marketa Uhlirova and the staff at Cineteca di Bologna and Deutsche Kinemathek.
2. Richard Abel, *The Ciné Goes to Town: French Cinema 1896-1914* (Berkeley and London: University of California Press, 1994), p.354.
3. *Ibid.*, p.199. Abel expands upon this connection: "De Lorde's play was entitled *The Dead Rat, Room #6* or *A Pair of White Gloves*, which climaxed with a young Russian woman revenging the torture and death of her revolutionary sister by accepting a czarist general's invitation to a private dinner and then strangling him with her long white gloves"; see his footnote 46, p.508.
4. The script was written by Hugnet, who also starred in the film. Henri d'Ursel directed the film under his screen *nom de plume* Henri d'Arche.

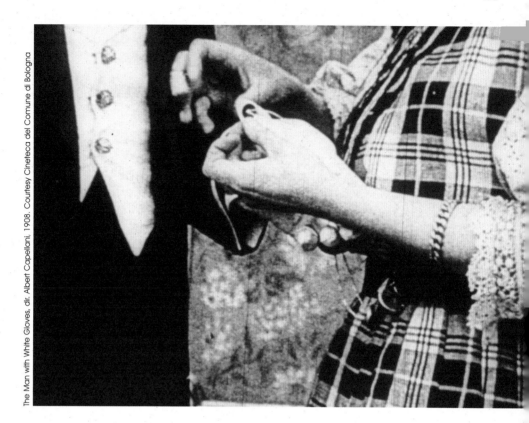

The Man with White Gloves, dir. Albert Capellani, 1908. Courtesy Cineteca del Comune di Bologna

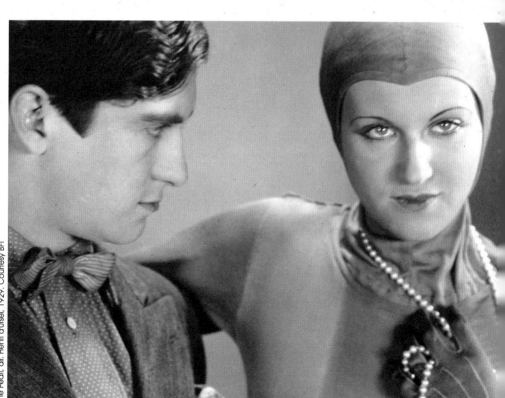

The Pearl, dir. Henri d'Ursel, 1929. Courtesy BFI

The Pearl, dir. Henri d'Ursel, 1929. Courtesy BFI

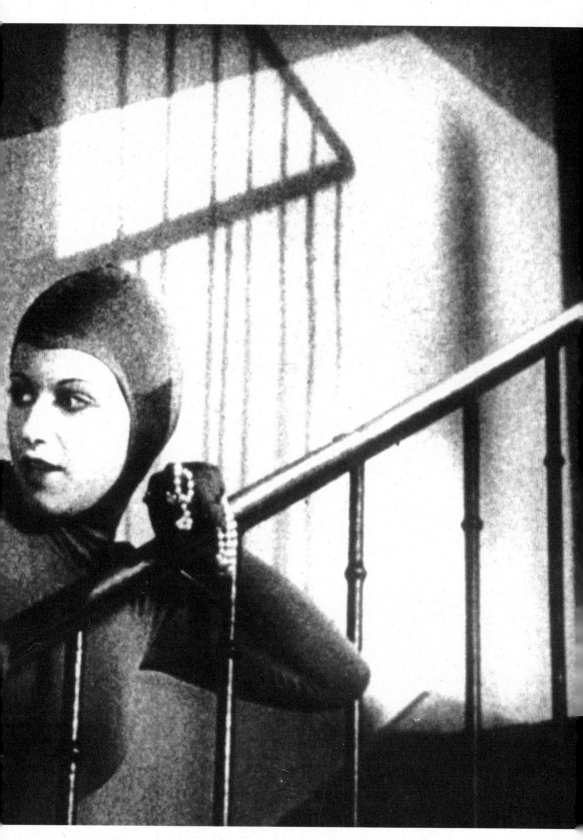

Scandal, Satire and Vampirism in *The Kidnapping of Fux the Banker*[1] / Marketa Uhlirova

On 4 January 1924, Czechoslovakia's leading satirical journal, *Humoristické Listy*, published a cartoon showing a man in a suit standing on the stage of a packed concert hall, gesturing benevolently towards a group of fashion mannequins. The caption read: "How to help the Czech Philharmonic Orchestra? Before and after each concert there will be a Paul Poiret fashion show." The joke referred to the internationally fêted couturier and his six Parisian mannequins[2] who featured in the film *The Kidnapping of Fux the Banker* (*Únos bankéře Fuxe*, 1923), which was about to be publicly released that day, and had been advertised as "not only an excellent comedy but also a fashion revue par excellence".[3] It poked fun not only at the filmmakers and producers who had somehow managed to bag Poiret for their film, but also at the relentless media campaign surrounding the release.

Poiret and his mannequins toured Prague in early December 1923, a month prior to the film's release, staging several pompous fashion shows in the city's Alhambra dance hall and Komedie theatre.[4] Their visit was an important and heavily publicised event. Major dailies and illustrated society journals raved about Poiret's shows in great breadth and detail, only reinforcing his celebrity status as the "King of Fashion", as he was commonly described. His mannequins, too, caused much sensation, with journalists marvelling at their youth, slender figures and ability to transform instantly from plain girls into grandes dames.[5]

During early December, Poiret and his entourage were the toast of the town, and with them, fashion began to spill out of the confines of women's pages. And similarly, *The Kidnapping of Fux the Banker* became something of a matter of public interest. The designer makes only a brief appearance in the film (which is a reconstruction of the surviving original film material made in the 1950s at the National Film Archive in Prague). He plays himself, credited as "Leon" Poiret, in a scene where he presents dresses, modelled by his mannequins, to the young debutante Daisy (Anny Ondra), who is about to order one for a special soirée. Tragically, the actual "fashion show" vignettes of the mannequins modelling the dresses are now lost[6] – something that is particularly unfortunate given that *The Kidnapping* was most probably a unique example of a narrative film featuring Poiret as himself, and showcasing his design work as *fashion*, not *costume*.

In a spirit that was both enterprising and highly pragmatic, the director Karl Anton and his producers seized the opportunity to capitalise on Poiret's huge reputation. The designer epitomised fashionability and *Frenchness*, but also a particular brand of high-class modernity of the *grand monde* – something that seemed to perfectly mirror the aspirations of Czech cinema in the 1920s. This was also a time when film internationally was establishing itself as a middle-class form of entertainment, and fashion became the perfect "accomplice" in the process.

The Kidnapping of Fux the Banker is now somewhat abandoned in the unwelcoming place that is the Czech cinema history. Yet, it was once considered a milestone, if not a breakthrough, hailed by some as the best Czech film to date.[7] And the stakes were high. With its relatively generous budget, criminal plot, emphasis on architecture and decoration, star cast, "fashion parade" and unprecedented media support, this American-style comedy[8] was anticipated as the saviour of the country's film industry, then at a point of deepening crisis. It was generally taken for granted that Anton's film would sell well abroad (which wasn't the case, despite the warm reception at home), and elevate Czech film to an international standard. In this light it's no surprise that *The Kidnapping* really does wear its internationalism on its sleeve. The opening scene sets the atmosphere through a simple but witty sequence of close-ups: a hand having a nail filed, a laughing manicurist, a typist, a barber at work. As the subsequent shot reveals, the person being pampered is not a woman but an elegantly dressed man – banker Fux – introduced in an intertitle as "a prematurely widowed banker and mondain [who] can't forget his work, his appearance, or flirting...".

The crime/detective film, although immensely popular via foreign imports, was quite alien to Czech film production (hence, again, it was perceived as suitably international).[9] So it is easy to understand why Anton opted to tackle the genre through parody. This was an opportunity for a tongue-in-cheek mimicry of the crime genre's conventions and unmistakable properties, from thefts and break-ins to investigations, trickery, disguise, mêlées and chases with the police – all of which Anton mixed into one farcical hotchpotch. His film also ridiculed the mannerisms of a whole host of archetypal crime characters – the detective "Sherlock Holmes II" (Eman Fiala); the masked villain (Eman Fiala again); a debauched millionaire mondain (Augustin Berger); a petty conman, Tom (Karel

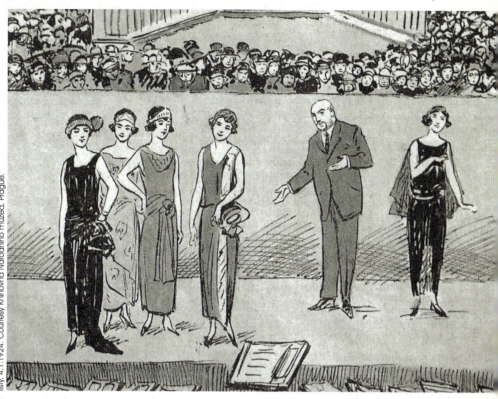

"How to help the Czech Philharmonic Orchestra?", Humoristické listy, 4.1.1924. Courtesy Knihovna Národního muzea, Prague.

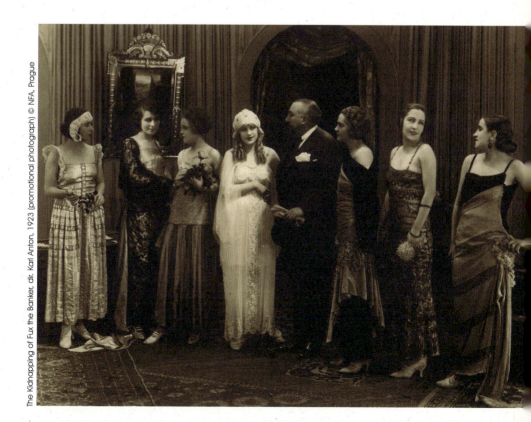

The Kidnapping of Fux the Banker, dir. Karl Anton, 1923 (promotional photograph) © NFA, Prague

Lamač); a greedy flapper, Maud (Bronislava Livia); and Daisy, her eager little helper.

Just about every character in *The Kidnapping* is an exaggeration – a mockery, but not out of spite, for its filmmakers were too much in awe of the originals they were imitating. In fact, it may be just as accurate to describe it as a *homage* to crime films, peeking from behind the mask of parody. In any case, the two aren't necessarily contradictory: as Fredrick Jameson pointed out in his classic study on postmodernism and pastiche, a good parodist "has to have some secret sympathy for the original, just as a great mimic has to have the capacity to put himself/herself in the place of the person imitated".[10]

Mucking about with the crime genre, *The Kidnapping* becomes a chain of character transformations and mistaken identities (detective as villain, conman as detective, madman as duke, detective as madman etc). It is positively riddled with disguise, pretence and posing, as well as "acting out of character", and this schizophrenic trading of identities eventually leads to a near-dissolution (manifested as insanity, quite literally) where anyone could pass for anyone else and where the innocent plead guilty to crimes they didn't commit. But this dissolution is only *internal*, as we are always in on the joke, and never left in doubt about who is who.

Two of *The Kidnapping*'s characters in particular – or, to be more precise, one character in two different guises – deserve more than a cursory glance because of their relationship to the originals they mimic: Sherlock Holmes II (also the film's official subtitle) and his darker incarnation, the kidnapper. Sherlock Holmes is clearly the most prominent and literal of references used here – an iconic figure and a tried-and-tested audience attraction. Yet, Eman Fiala's spoof of the English detective is a noticeable deviation from – if not an antithesis of – the canon of the elegant gentleman in a deer-stalker cap and Inverness shoulder cape, as seen in countless stage and screen adaptations internationally.[11] Fiala may be tall and lanky, and equipped with standard Holmesian attributes – a pipe (although not a drop-step) and a magnifying glass[12] – but that's where the similarities end. His bold-patterned woollen suits with ill-fitting waisted jackets, three-quarter length trousers and clashing polka-dot shirts, all accessorised with matching over-sized caps, make him an amusing cross between a gentleman and a clown.

Holmes II's detective work is as dubious as his attire. Hired by the banker Fux (and later by Fux's debtor Tom) to track down an unknown millionairess and beauty from a newspaper ad (Maud/Daisy), he is more a complicator than cracker. He also regularly resorts to illicit activities – not surprising, given that almost every character in the film is a cheat, or at least prone to some kind of corruption. In one characteristic scene, Holmes II is seen inspecting Daisy's legs with his magnifying glass, a shot which is followed by a POV close-up of the girl's body parts under scrutiny. This is at once a replication of one of early cinema's classic voyeuristic motifs,[13] an insider joke on the actress Anny Ondra's legendary legs, and a wink at the seemingly arbitrary nature of the real detective Holmes's procedures.

In his disguise as a mysterious villain, Holmes II is equally clumsy. Clad in a trademark skin-tight black bodysuit,[14] and with a mask pulled over his face, he prowls through bourgeois drawing rooms and leaps around with nimble, cat-like movements, just as every respectable bandit should. Although he appears to be more of a fool than a menacing criminal, he is nevertheless in one scene referred to as a *vampire* ("A vampire has kidnapped Daddy!"), a term which in this case designates a thief and a member of a criminal gang, not a gothic, bloodthirsty vampire.[15] This vampire-type, famously embodied by Musidora's character Irma Vep in Louis Feuillade's popular crime serial *Les Vampires* (1915-16), had only recently wowed Czech audiences; the masked criminal would also have been known from other serials and feature films, also shown in Czechoslovakia after the First World War,[16] including Feuillade's *Fantômas* (1913-14) and George Seiter's *The House of Hate* (1918). In *The Kidnapping*, the villain's bodysuit is emblazoned with a prominent white skull and crossbones, a motif which, while used as a device for parody, also has a narrative function. At one point it serves as a succinct visual clue that labels the real criminal: there is a scene in which Holmes II clutches a life-size skull just as banker Fux talks to him about the mysterious kidnapper, mistakenly suspecting his debtor, Tom.

Arguably, the truly modern vampire of *The Kidnapping* – being firmly rooted in the 1920s – is the amiable flapper and crook Maud who lustfully sucks possessions out of unsuspecting men. She is Daisy's "experienced friend" and her search for a rich suitor is the main plot catalyst around which all the comical situations revolve. Maud is first introduced through a close-up of a trail of smoke rising from behind an open issue of the magazine du-jour, *La Vie Parisienne*: evidently, she is a woman of

Ročník III. F I L M Strana

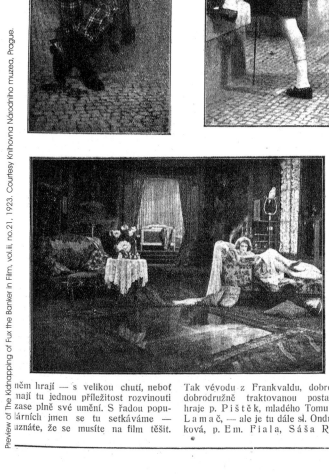

něm hrají — s velikou chutí, neboť mají tu jednou příležitost rozvinouti zase plně své umění. S řadou populárních jmen se tu setkáváme — uznáte, že se musíte na film těšit.

Tak vévodu z Frankvaldu, dobrou, dobrodružně traktovanou postavu hraje p. Pištěk, mladého Tomu p. L a m a č, — ale je tu dále sl. Ondráková, p. Em. Fiala, Sáša Ra-

šilov — čeho si přejete více. Děj filmu je fantasií, jež nebyla nija čerpána ze stávajících děl o známe nitém detektivu Sherlocku Holme sovi. Je to takový Sherlock Hol

leisure and an avid reader of fashion and women's magazines. The camera then shows her perched on a chaise longue, receiving a letter which announces: "Dearest, your demands and wishes have ruined me ... I hope you find a wealthier substitute." Maud's greed is then quickly marked as fashion-specific through two subsequent shots: one focuses on the floor of her room strewn with open fashion magazines, and the other shows Maud emerge from underneath a pile of boxes, clothes and dozens of pairs of shoes, despairing: "I am ruined, Daisy!" Her ruination is finally "put into perspective" in a shot of Maud and Daisy taken from a bird's eye view: the camera points towards the copious amounts of clothes among which the two friends are nearly lost. Clothes, it seems, are vital to life; men aren't. But both are as disposable as each other.

Maud's capricious materialism and self-indulgence encapsulates the social and cultural climate of the early 1920s, a period that completed the transition from Victorian to more modern values. One of the significant manifestations of this change was the emergence of the mass market for fashion, what the film and design historian Sarah Berry called a "fashion madness".[17] In the second half of the 19th century retailers and advertisers began to deliberately stimulate female shoppers' desire for things they didn't really need, but it wasn't until after the First World War that women en masse had better and more immediate access to desirable fashions and cosmetics. This gradual "democratisation" of luxury was propelled through the alluring displays in urban shop windows, and, increasingly, cinemas – the new shop windows.[18]

The notion that wives can lead husbands to economic bankruptcy was not really new in the 1920s but it did crystallise into something of a debate – one that oscillated between a popular joke and a moral panic. In a sense, it updated an earlier debate about kleptomania, another predominantly female – and middle-class – issue, a "disability" which became rife in the late 19th century. Both discourses emphasised fashion as a moral pitfall, leading to vanity and irrational behaviour. Both connected the temptation to possess with the condition of being possessed: women simply couldn't help themselves when faced with the spectacle of capitalism. And, last but not least, both were also marked by an underlying belief that an unhealthy desire for commodities was somehow linked to dubious sexual behaviour – be it in the arousal that women were supposed to feel when in proximity of seductive merchandise,[19] or the assumed readiness of women on both sides of the counter to sacrifice the virtuous life in pursuit of fineries.[20] But while kleptomania consistently cast women as victims of a "disease", arguing that their criminality was just a "symptom", the greedy flapper argument portrayed women as active and cunning vampires, placing their bad behaviour firmly in the realm of morality. These modern women were seen as fully, if not disturbingly, in control when it came to scheming and manipulating. If they were possessed, it was by their own criminal desire.

Throughout *The Kidnapping*, Anton flaunts fashion and style as a necessary means of social mobility – one that is also self-indulgent and carries sexual innuendos. And again, all of these displays of vanity would have had a strong cosmopolitan flavour. The figures of the *mondain* (Fux) and the *flappers* (Maud and Daisy) embodied these values perfectly. One can see why film – and Czech film in particular – would have found such behaviour seductive. At the time, Czech film was striving to redefine itself as more urban and modern, and was all too painfully aware of the omnipotence of image in this makeover. At the same time, visions of moral decline and bankruptcy (especially when associated with fashion) appealed to Czechs' puritanical side as they evoked a sweet dream of decadence and eccentricity, qualities that the Czechs so admired – and at the same time disparaged – in the French. So, unlike its American counterparts, which demonstrated a greater degree of ambiguity towards women's love of fashion, *The Kidnapping* offers no punishment or rehabilitation for the misbehaving girls.

From the viewpoint of Czech cinema history, the nature of Anton's film as a complex promotional exercise remains as remarkable as the film itself. The role Poiret played in this is worth briefly returning to because it illustrates a very modern use of branding and typifies the expectations and values of film audiences in its time. Although Poiret's sequence in *The Kidnapping* was really just an added bonus, a spectacle which was not integral to the storyline, his name soon sat at the very heart of the film's marketing strategy. The filmmakers' decision to involve him was clearly opportunistic, and was borne from their observation of the designer's astonishing power to steal the limelight and impress journalists. And indeed, Poiret single-handedly generated a lot of coverage. But it would also be safe to assume that narrative film was a great business opportunity for him to increase his notoriety. After all, Anton incorporated his personal appearance and, crucially, placed his product – something

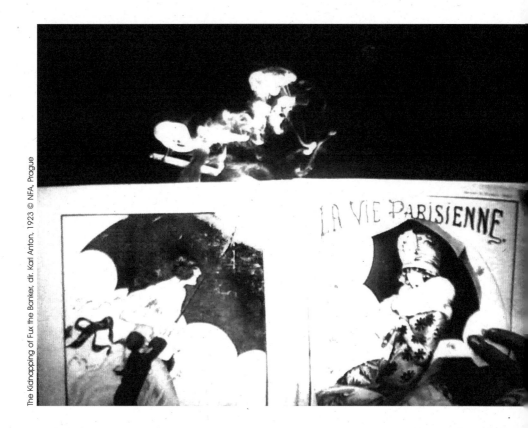

The Kidnapping of Fux the Banker, dir. Karl Anton, 1923 © NFA, Prague

The Kidnapping of Fux the Banker, dir. Karl Anton, 1923 © NFA, Prague

the couturier had actively exploited through theatre productions in the 1910s.[21] But Poiret, typically, denied this. As one journalist reported:

> Mr Poiret didn't want to understand that this was advertising for him, and pointed out – perhaps quite rightly – that he didn't need it … Elektafilm reportedly paid Poiret and his mannequins, for the three hours that the filming took, a good few thousand more than he got for his [fashion show] production in Lucerna Hall.[22]

Poiret's insistence that this was a one-way trade and his request for more than adequate financial compensation are testimony to his shrewd business mind and unwavering self-confidence (if not also slightly ironic, given that his business would begin to get into serious trouble only a year or so later). But his reaction also betrays a tacit power-relation between the big world (that he stood for) and its periphery (that Czechoslovakia was to him).

Poiret was certainly an easy press lure and the promoters of *The Kidnapping* left little to chance. The couturier's name was used in the vast majority of advertising, and even became the focus of a faux-crime report surrounding the film that ran in a number of Czech dailies in the days preceding the film's release. Beginning with the simple announcement: "Sherlock Holmes on the case of the kidnapped banker Fux", and progressing to: "The banker Fux enquiry draws closer to conclusion, thanks to Sherlock Holmes's wit" or "The veil of mystery lifting", and then to: "The kidnapping seems to have been resolved",[23] the "case" eventually culminated in a longer story, published on the day of the release, opening with:

> While the kidnap case seems to have been resolved, a new trace has been uncovered leading to criminals who have close ties with the whole affair. It has been reported that the French are demanding the release of Mr. Poiret who has been held in Prague by Elektafilm. It is beginning to transpire that Mr Poiret and his six great girls are somehow involved in this sensational kidnap case …[24]

This "sensational" climax to the promotional build-up (accompanied by the names of cinemas where audiences would find the conclusion to the story) is a fascinating example of the close ties between the strategies of film marketing, promotion and advertising, and those of film narration that had developed in connection with film serials in the 1910s[25] and continued to characterise the 1920s. It shows how the promotional discourse could mischievously imitate the film itself, in this case by toying with basic narrative strategies such as linear progress, narrative coherence (for the most part, the coverage deliberately avoided any mention of the film itself), disentanglement and postponement of resolution. Crucially, the coverage adopted a format that echoed the film's own parodic tone, and used it to gently undercut the clichés of journalistic scandalmongering.

Notes

1. With grateful thanks to Caroline Evans, Lorraine Gamman, Václav Kofroň, Laura McLean-Ferris, Martin Sekera and Sarah Waterfall for their comments and suggestions.
2. I use the term "mannequin", rather than "model", to be consistent with how fashion models were referred to at the time ("model" generally meant artist model).
3. *Film*, vol.III, no.21-2, 15.12. 1923, p.10. This, and all subsequent translations from Czech are mine.
4. Poiret's 1923 Central and Eastern-European tour featured two-hour fashion show productions showcasing over 100 outfits. They were conceived as spectacular entertainment for a substantial audience. See Eva Ruteová, "Poiret v Praze", *Tribuna*, 4.12.1923, pp.3-4; "Pařížský módní král v Praze", *Právo lidu*, 3.12.1923, p.3; and "Král pařížské módy Paul Poiret", *České slovo*, 4.12.1923, p.2.
5. Ibid.
6. The "fashion parade" is mentioned in several reviews and commentaries: see Kujal, "Únos bankéře Fuxe", *Český filmový zpravodaj*, vol.4, no.2, 1924, p.3; *Národní listy*, 5.1.1924 (evening edition), p.2. *Pražský ilustrovaný zpravodaj*, no.159, 1923, p.3; *Zpravodaj zemského svazu kinematografů v Čechách*, vol.IV, no.2, 1924, p.4. Other dresses in the film, namely those worn by Poiret's mannequins during the soirée and subsequent police chase, were supplied by a Prague-based couturiere, Arnoštka Roubíčková. See *Elegantní Praha*, no.4, 1924, p.60.
7. See *Elegantní Praha*, no.4, 1924, p.59; the influential Czech daily *Národní listy* called it the best original comedy: *Národní listy*, no.4, 4.1.1924, p.3; and the best Czech film lately: *Národní listy*, 5.1.1924 (evening edition), p.2.
8. A view repeated by much of the press, despite the fact that the film works with a range of identifiably European influences too.
9. There are only a few previous attempts at crime film or crime comedy, particularly connected with Václav Binovec's company Wetebfilm which too had a strong pro-international direction. See the descriptions of Binovec's (now lost) *Dobrodružství Joe Focka* (1918) and *Marwille detektivem* (1922).
10. Fredric Jameson, "Postmodernism an Consumer Society" in *The Anti-aesthetic*, ed. Hal Foster (New York: The New Press, 1998), p.130.

"To the cinema with you? Not in a million years! Someone could recognise me!" "And what if I bought you a coat with a fur collar to cover your ears? That would hide you nicely!" "Now you're talking!" Humoristické listy, 7.12.1923

— Do biografu s vámi? Ani za milion! Aby mne tam někdo poznal!
— A což kdybych vám koupil plášť s kožešinkou přes uši — v tom byste byla schovaná —
— Jó, to by bylo něco jiného...!

11. This much-imitated image of Sherlock Holmes was immortalised by the English illustrator Sidney Paget on the pages of *The Strand* in the 1890s. It was subsequently brought to life on stage and screen by the American actor William Gillette. By the 1920s, Holmes had become a notorious character on the big screen, through various European and American film adaptations (http://www.holmesonscreen.com (accessed 15/03/2008)). Holmes was the object of parody already in early cinema. See for example the Pathé comedies *Qui est l'assassin?* (1910) and *Un tour du monde d'un policier* (1906) discussed in Richard Abel, *The Ciné Goes to Town: French Cinema 1896-1914* (Berkeley and London: University of California Press, 1994).

12. His character is first introduced through his attributes, emphasising his preying eye, distorted comically through the magnifying glass: "An all-seeing eye... A source of inspiration... The elements that make up a person of genius... and the very person himself. Sherlock Holmes II."

13. Holmes's use of the magnifying glass to isolate a part of the body (woman's legs and ankles) through a close up is in keeping with the tradition of early cinema's erotic gaze. For earlier examples see Edwin S. Porter's *The Gay Shoe Clerk* (1903) or George Albert Smith's *As Seen Through the Telescope* (1900) where a magnifying device is also used to frame the visual field and facilitate the gaze. See also John Hagan, "Erotic Tendencies in Film, 1900-1906" in *Cinema: 1900-1906: An Analytic Study*, Roger Holman comp. (Brussels: International Federation of Film Archives, 1982), pp.234-35.

14. A theme unpicked elsewhere in this publication by Tom Gunning.

15. Ellen Mandel elaborates on the connection between vampirism and thievery in her review of Feuillade's *Les Vampires* in *Film Quarterly*, vol.24, no.2. (Winter 1970-71), p.56. Mandel argued that (modern) vampires of the early 20th century weren't attracted to blood as a source of power but instead lusted after the wealth of aristocrats.

16. The Czechs didn't get to see French and American crime serials until after 1918-19. Zdeněk Štábla, *Data a fakta z dějin československé kinematografie 1896-1945/II* (Prague: NFA, 1989).

17. Sarah Berry, *Screen Style: Fashion and Femininity in 1930s Hollywood* (Minneapolis: University of Minnesota Press, 2000), p.xii.

18. For an account of cinema as a shop window see Charles Eckert, "The Carole Lombard in Macy's Window", *Quarterly Review of Film Studies*, vol.3, no.1 (1978), reprint. in *Fabrications*, eds. Jane Gaines and Charlotte Herzog (New York: Routledge, 1990), pp.100-21. See also Jeanne Allen's "The Film Viewer as Consumer", *Quarterly Review of Film Studies*, vol.5, no.4 (1980), pp.481-99.

19. Sumptuous displays in department stores were particularly to blame for this. See Michael B. Miller, *The Bon Marché: Bourgeois Culture and the Department Store, 1869-1920* (London: Allen & Unwin, 1981), pp.200-206, and Elaine Abelson, "The Invention of Kleptomania", *Signs*, vol.15, no.1 (Autumn 1989): see esp. pp.134-43.

20. Bill Lancaster, *The Department Store: A Social History* (London and New York: Leicester University Press, 1995). Abelson outlines yet another link between kleptomania and sexuality, one that is, in hindsight, probably the most bizarre of them all: a prominent 19th century socio-medical discourse explained kleptomania as a neurotic condition caused by irregularities in female reproductive organs. Abelson, *ibid.*, pp.125-43.

21. Nancy Troy, *Couture Culture: A Study in Modern Art and Fashion* (Cambridge MA and London: MIT Press, 2003). Interestingly, Poiret courted narrative film very little in comparison to theatre.

22. *Pražský ilustrovaný zpravodaj*, no.159, 1923, p.3.

23. See *Tribuna, Národní listy, Právo lidu, České slovo* and their evening editions between 1.1.-4.1.1924.

24. *Právo lidu*, 4.1.1924, p.7.

25. See Vinzenz Hediger's account of promotional tie-ins between American film serials, the press and lierature. Hediger, "Self-promoting Story Events. Serial Narrative, Promotional Discourse and the Invention of the Movie Trailer" in *Il film e i suoi multipli*, Anna Antonini ed. (Udine: Forum, 2003), pp.295-316.

The Kidnapping of Fux the Banker, dir. Karl Anton, 1923 © NFA, Prague

Twenties Fashion, Ivor Novello and *The Rat* / Bryony Dixon

Nothing could be more fashionable in 1920s Britain than Ivor Novello's creation, the devil-may-care, eponymous anti-hero of *The Rat*. Originally a stage play written by Novello and Constance Collier (under their shared nom de plume David L'Estrange), it inspired a successful trio of feature films. In all three, Novello plays Pierre Boucheron, the "Rat", a jewel thief and chief of a Parisian underworld centred on the White Coffin Club – a world he rules with a flamboyant, if melancholic, charm that has the club girls fighting over him and the men in awe of him. The first of these, *The Rat* (Graham Cutts, 1925), is a genre picture in which fashion and costume play a significant role.

The key design element of the film is the setting of the White Coffin Club, a basement club in a poor part of Paris. The seediness of the locale is signalled in an establishing shot early in the film showing a rat bolting down a hole on a quayside of the Seine, with the Eiffel Tower in the background. The club is metaphorically the rat-hole of Pierre Boucheron and his cohorts. As such, it is appropriate that it must look cheap with its wooden benches and grubby tables. Its décor is deliberately macabre and redolent of the Théâtre du Grand-Guignol, another Parisian association. It is essentially a catacomb – the film appropriates some of the trappings of the iconic Louis Feuillade crime serials *Fantômas* (1913-14) and *Les Vampires* (1915-16). *The Rat* arguably also owes a debt to the recent German expressionist films. An environment of romanticised squalor is created and populated with exotic creatures – the underclass of criminals, debauchers and tarts.

With its morbid coffin-shaped interior windows (white coffins are made for dead children), Apache dances and fumes of absinthe, the club conjures up a world where it is acceptable for a hero to be a thief, a womaniser and a murderer. The setting places social classes in a liminal world where the jaded appetites of the idle rich might be tempted with the hint of danger, and sex for a price, and where the criminal underclass might get paid for making an exhibition of their poverty and brutality. In these surroundings clothes are as significant and codified as military uniforms, indicating status and intent.

In this first film outing for the character "the Rat", Pierre meets his match in the dazzling Zélie de Chaumet (Isabel Jeans). Sparks fly as each tries to gain the upper hand over the other. She is beautiful and powerful and used to obedience. But then, so is he. She represents success and access to the finer things in life that Pierre craves – albeit in a corrupt world – and he is torn between these superficial victories and something more noble. This underlying goodness in his character is represented by Odile (Mae Marsh), an innocent with whom he lives, though more as a brother than a lover. The only time we see an outdoor, naturalistic scene is through Odile's eyes, and it is the only time we see the Rat smile without a sneer. It is his inner conflict that is at the core of the narrative.

As the film opens, the bored *demimondaine* Zélie is preparing for an evening out. Her rich lover Stetz leaves for the notorious White Coffin Club to arrange an after-show party to satisfy Zélie's taste for the sensational. The key scene takes place when Zélie and her friends arrive at the club and watch the Rat win a staged knife fight. Zélie and Pierre engage in a flirtatious battle for dominance. He grabs the nearest girl and performs a violent Apache dance, ripping the girl's skirt with his knife. Zélie hands her man a bank note to give to the Rat by way of a tip; the Rat nonchalantly lights his cigarette with it. She remarks that they are alike – he rules in his world, she in hers. She looks for her cigarette case, which he hands back to her, having stolen it from her. He looks enquiringly at her long string of pearls; he says he'll get them later.

The use of clothes is highly codified in the film, as in most genre cinema. Other than a showy velvet cap[1] which in a flamboyant gesture in the opening scene he pins to the wall with his flick knife, Pierre Boucheron's clothes are those of the Parisian working man of the *belle époque* – collarless shirt and long scarf, corduroy jacket and trousers and the cheap soft-soled shoes so practical for the cat burglar. His confederates at the White Coffin Club are fairly showy in their attire, depending on their status in the ranks of the underworld. The gang leaders whom the Rat has to fight to keep at bay are flashier in their dress, with the razor-sharp sideburns, bowler hats, check suits and tight, striped jerseys.

The Rat's elegant but subtle costume sends a message of confidence – he doesn't need flashy clothes to impress and he wears his plainer clothes well. In the one-upmanship of the club he is smarter than his competitors and his dress sense shows that not only does he have taste and

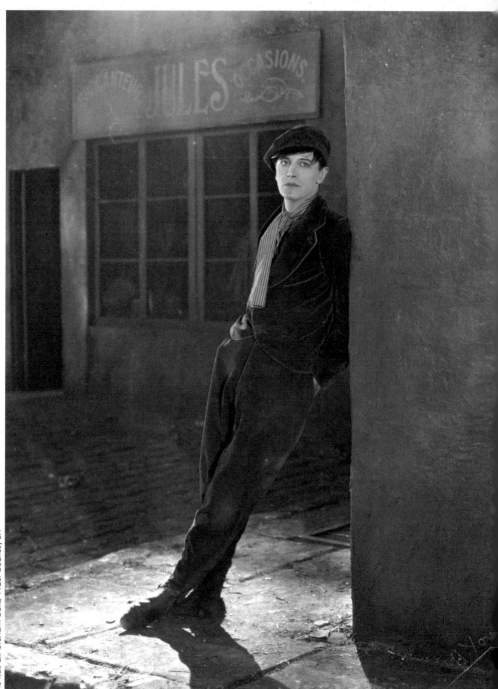

The Rat, dir. Graham Cutts, 1925. Courtesy BFI

intelligence in understating his look, but he knows full well that it is what the clothes *contain* that truly matters. He is an aristocrat among the criminals and when he is taken in by the rich Zélie, he assumes the demeanour of the upper classes as easily as donning a beautifully tailored suit.

From Novello's point of view, the costume is of course convenient. As well as having popular currency with British audiences who would be quite familiar with the image of the Apache from countless illustrations and paintings, the costume maximises the number of occasions on which Novello can get his shirt neck open to display his finest feature – the famous profile. Novello's physical beauty is really at the heart of the entire endeavour. The filmmaker Adrian Brunel, who had directed him in *Man Without Desire* two years earlier, observed that it was impossible to find any woman beautiful enough to share a two-shot with him.

Other denizens of the White Coffin Club are of course the girls, who are kitted out in the conventional tart costume of the time – tight skirts and shirts, black stockings and berets. These girls clearly spend all of what little money is left to them by their pimps on the clothes that are the badge of their trade. They are generally vulgar and made of cheap materials, perhaps enlivened with pinchbeck jewellery or a fancy scarf. It being the twenties, though, they rely for their effectiveness on sleek lines, and if they are revealing, it is in the legs and not the bust. This is the look more often associated with the whores of the quayside taverns and brothels frequented by sailors, and is a look that is recycled frequently by fashion designers.

Odile is the only character in the film who does not make a display of herself with her clothes; in her plain cotton frock, she might have stepped straight out of a D.W. Griffith melodrama. Her clothes imply old-fashioned 19th-century values, are slightly gamine and suggest vulnerability, poverty and modesty. This was an ideal role for Mae Marsh, who had played such parts for Griffith many times and had perfected the Parisian street girl a decade earlier.

Zélie, on the other hand, is thoroughly modern with her flapper dresses heavy with beads. Everything she wears is of the finest quality: as fine as her latest paramour's money can buy. Contrasting with the matt drabness of the club girls, Zélie's clothes shine and glisten. Bead and sequins flash and sparkle; silk, satin and velvet reflect the light of the lamps and candles of the nightclubs and her lavish apartment. She is a creature of the night and is at her best in these environs. Her keeper Stetz has a similarly manufactured look, always perfectly turned out in the latest expensive clothes.

For both of the lead characters, codified accoutrements accompany the codified clothes. For Zélie, the badge of her status is a magnificent string of pearls. This expresses her value, the price she can extract from a wealthy lover. The pearls are not only an expression of excess and the emblem of her power over men, she also uses them as bait to lure the Rat. After all, he is a jewel thief – something that will provide her with that dangerous brand of amusement she so desperately craves. If she succeeds in tempting him in, under the pretence at least of stealing the pearls, she proves her power over him, but the risk is great. If he were to steal the pearls she would lose everything – power, prestige, love and a fortune. However, she has detected in Pierre a desire for beauty and the finer things in life, which she can give him.

Pierre's accessory is his flick knife, which expresses his male power, in parallel to Zélie's pearls. With constant threats from his rivals, he must fight, quite literally and quite often, to retain this position. He also uses his knife to perform in staged fights. Like the pearls, the knife is provocative and emblematic but simultaneously real, functional and dangerous. Pierre uses it to kill Stetz when the latter attempts to rape Odile after trying to seduce her with jewellery (a habit of his, evidently). One assumes that he was not offering anything as grand as Zélie's pearls. But Odile has her own iconographic attribute – the altar with its statue of the Virgin.

The importance of musical and dance fashions cannot be over-emphasised in *The Rat,* and it is an important element in the evocation of 1920s Paris. In the early 20th century, new technology, combined with wider cultural shifts, had revolutionised the music industry, launching one dance craze after another. There are two surviving songs written by Novello himself, held by the British Library. "The Rat Step" presents a theme for Pierre and "The Lily of Montmartre" evokes the tragically sweet character of Odile, the innocent trapped in a world of violence. All of these stylistic elements combined to ensure that *The Rat* became a fantastically successful franchise incorporating four feature films,[2] novelisations and songs, as well as the stage versions.

A foxtrot, "The Rat Step", was composed to accompany the Apache dance[3] performed

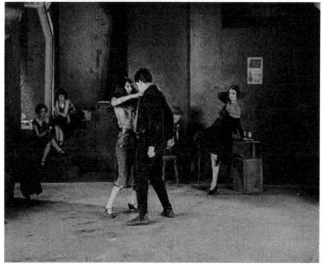

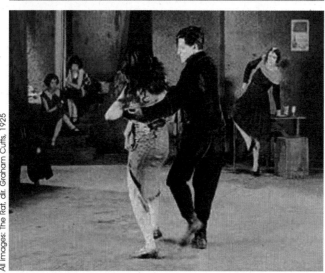

All images: The Rat, dir. Graham Cutts, 1925

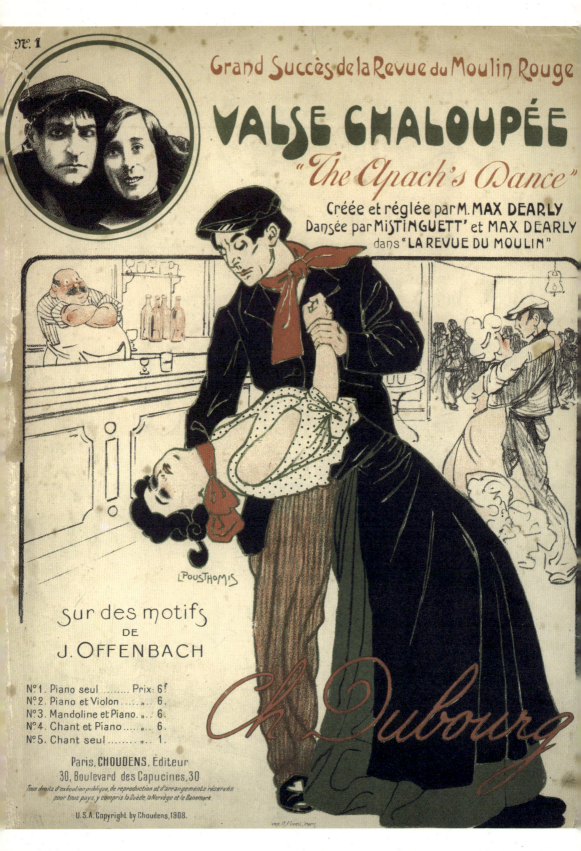

by Pierre at the White Coffin Club. The choice of such a dance is significant and was clearly meant to emulate the success of other performers, notably Rudolph Valentino, with whom Novello was frequently compared. Valentino's tango in *The Four Horsemen of the Apocalypse* (Rex Ingram, 1921) would still have been fresh in the minds of the audience, and even though Novello was no dancer of the Valentino mould, his intention was to portray himself as worthy of comparison with the enigmatic star. Tangos, foxtrots, Charlestons and shimmies were fully-blown dance crazes of the twenties with their own fashions attached. The foxtrot, popularised before the First World War by the ballroom dancers Irene and Vernon Castle, mutated into an American tango in which the male dancer was a model of masculinity but of the working (rather than gentlemanly) type, as indicated by his clothes and the evident contempt with which he treats his partner in the dance.

There are other aspects where the building of Novello's star persona relies on the stylistic tropes and the character built by Valentino. Much has been said of Novello's performances and their relationship to war neuroses; The Rat's descent into hysteria would certainly hint at a man with a "past", portraying the complex characteristics of the "aftermath" War generation. Novello's – and Pierre Boucheron's – cynicism and reckless attitude in some way personified the transition they were undergoing. In her autobiography, *Testament of Youth,* the writer Vera Brittain describes them as follows: "[O]ne and all combined to create that 'eat-drink-and-be-merry-for-tomorrow-we-die' atmosphere which seemed to have diffused from the trenches via Paris hotels and London night-clubs into the Oxford colleges. The War generation was forcibly coming back to life, but continued to be possessed by the desperate feeling that life was short."[4]

One scene in particular illustrates this painful "coming back to life": whilst in pursuit of Zélie, Pierre leaves Odile open to attack from Stetz. While Zélie and Pierre indulge in their passion for each other, Stetz attempts to seduce the innocent Odile. From something Zélie says, Pierre realises that Stetz had engineered their meeting, and he arrives just in time to prevent her being taken by force. He kills Stetz without compunction, as something necessary, but when Odile takes the rap for his murder, he is forced to choose between the life of sensuous pleasure offered by Zélie and a life of poverty with the inevitable descent back into crime. The tension between these two competing desires literally drives him mad and we see him in a state of hysteria. This may sit a little oddly with our notion of genre film, but such a display of sensitivity would have been regarded with more empathy by Novello's contemporaries. On another level, too, this demonstration of sensitivity would appeal to his gay following.

The Rat was clearly engineered to appeal to the British audience at this particular time, but it has also developed a longer-lasting fascination for wider audiences. With its use of costume, design, music, the romantically exotic characters of the Rat and his companions, and its Parisian setting, *The Rat* would have appealed to a British audience: wild things are allowed in the Paris of our dreams, so much more romantic and sensational than the drawing rooms of the West End theatres.

Notes
1. As an example of the marketing spin-off from the film, Michael Williams quotes from a fan magazine *The Picture Show*: "Thus in a competition run by the magazine it was a Mr. C.A. Morris, of Cheshire, who won the 'actual' Apache cap worn by Novello in *The Rat* by providing the best account of the star as a 'screen lover'". See Michael Williams, *Ivor Novello: Screen Idol* (London: BFI Publishing, 2003), p.18.
2. *The Rat* (1925), *The Triumph of the Rat* (1926), *Return of the Rat* (1928) and *The Rat* (1937).
3. "Apache" is a name for the members of the Parisian street gangs of the late 19th and early 20th centuries. The Apache dance (pronounced *a-pash* not *a-pa-tchee* like the American Indians) is a story dance recreating the encounter between a pimp and a prostitute in which the man behaves with sadistic brutality towards the woman. He might slap or knock her down, drag her by the hair or throw her around; the woman is forced into a subservient position. The dance shares some similarities with the tango.
4. Vera Brittain quoted in Williams, *supra* n.1, p.135.

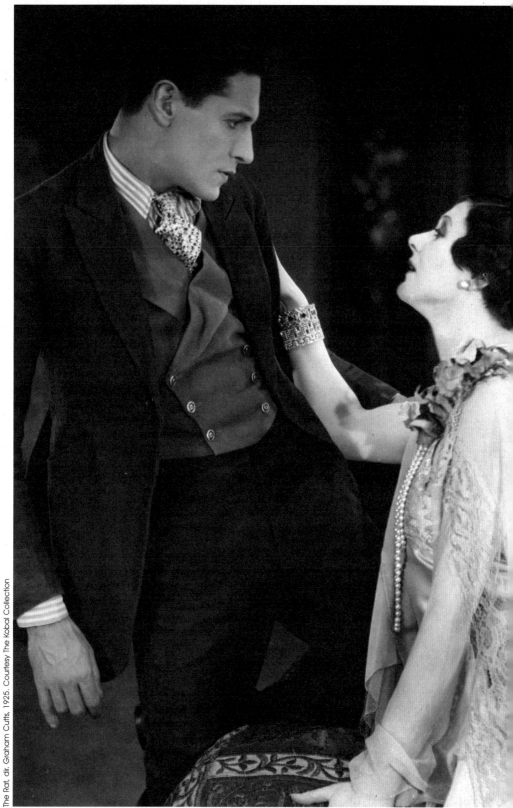

The Rat, dir. Graham Cutts, 1925. Courtesy The Kobal Collection

Asphalt, Theft and Seduction / Werner Sudendorf

Joe May's 1929 film *Asphalt* was the last silent picture to be made by the influential German producer Erich Pommer. It represents the sum of talents of May and Pommer, as well as Guenther Rittau, the cinematographer, and Erich Kettelhut, the art director. *Asphalt* incorporates the many bold characteristics developed by German silent film. It has elements of the documentary, the street movie and *huis-clos*,[1] and at the same time, bourgeois drama and even world war neurosis. The majority of films produced during the Weimar Republic broached the issue of how German confidence was shaken by defeat in the First World War. After 1918 the world of the fathers is repeatedly rocked by the mistakes of their sons and daughters, in this case in a very seductive way.

Like Walter Ruttman's *Berlin: die Sinfonie der Grosstadt* (1927), *Asphalt* begins with rhythmically cut scenes of Berlin street life, sliding into the bourgeois home of Constable Holk, then cutting back to the traffic of the big city, with the hand of a traffic warden in centre frame. The angle widens and we see a young Holk (Gustav Fröhlich) directing traffic. The chaos of the city and the tranquillity of the apartment, the proletarian clothes of the respectable family and the uniform of the policeman are the first pair of opposing concepts. The policeman is the one creating order in the chaotic city.

Despite the impression that the outdoor scenes may give, they were shot in a specially converted studio, constructed out of three entire UFA studios. The shop fronts in the movie were provided by real Berlin shops, benefitting from the advertising. Cars and buses drove across the studio, then around the back and through again, creating the impression of a constant flow of traffic. The first German camera crane was built for these street scenes – the idea having been imported from America by Pommer.

In the film's opening the camera gazes through a shop window, revealing a woman trying on stockings. A crowd gathers outside. A pair of thieves use the opportunity to steal a wallet. Here, the movie links the crowd's curiosity and the eroticism of a well-formed pair of woman's legs to crime. This link is made again when an elegantly dressed young lady (Betty Amann) is being shown diamonds in a jewellery shop. She dextrously makes a diamond disappear into the handle of her umbrella; again, beautiful legs and theft are juxtaposed in a single shot.

There are almost no female criminals in German films of the 1920s. Rogues, crooks and thugs are generally male. Alluring women clearly feature, though more as men's tools, or as prostitutes and lost souls. In Karl Grune's *The Street* (1923), Eugene Kloepfer meets a prostitute, whose head turns into a skull. German film is not preoccupied with criminal women, but more with the general decay of decency and morality. This is why the female criminal is often depicted as a man's accomplice, and often his victim as well. If inescapable evil is linked to the female character, then the story is full of witchcraft and magic. The most famous example of this is the robot Maria in Fritz Lang's *Metropolis* (1927), the evil counterpart to the good Maria. Likewise, in Henrik Galeen's *Alraune* (1928), Brigitte Helm is an artificial being. In contrast with American movies, there are no female spies; war is a man's endeavour. There are female impostors, though they are sometimes unwilling.

In *Die Schoenen Tage von Aranjuez* (Johannes Mayer, 1933), Brigitte Helm performs a cunning variation on the jewellery theft, which was later borrowed by Hollywood for Marlene Dietrich as the lead in *Desire* (Frank Borzage, 1936). In all three movies, the female thief is also an impostor. Her elegant, modern clothes give the impression that she is a woman of the world, a lady of taste and means. They subtly establish a relationship of trust with the jeweller. They share the same expensive hobbies. In all three movies theft becomes an erotic act.

In *Asphalt*, the crime is exposed and Constable Holk is keen to take the thief to the police station. She cries, begs and pleads in desperation, unable to pay the bail. The uniformed man does not waver, allowing her home only to get her papers. Once there, she just goes to bed. The policeman is gobsmacked. He wants to fetch an ambulance, at which point the thief jumps out of bed in her underwear and into his arms. In one of the final scenes we see Betty Amman's naked feet stroking Gustav Froehlich's polished black boots.

Contrasts, mirrors, Betty Amman's black hair framing her pale face with black-lined eyes; *Asphalt* is a film about visual effect, about being drawn into an underworld, a world of frothy decadence and opulence. Silk softens the harsh uniform, eroticism stifles morality. The costumes for *Asphalt* were created by Swiss designer René Hubert, who went on to work for Helm, Dietrich and

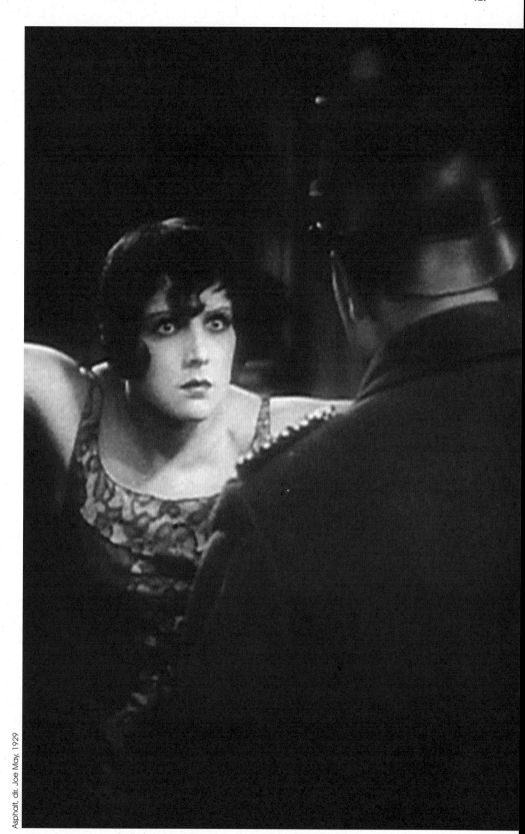

Asphalt, dir. Joe May, 1929

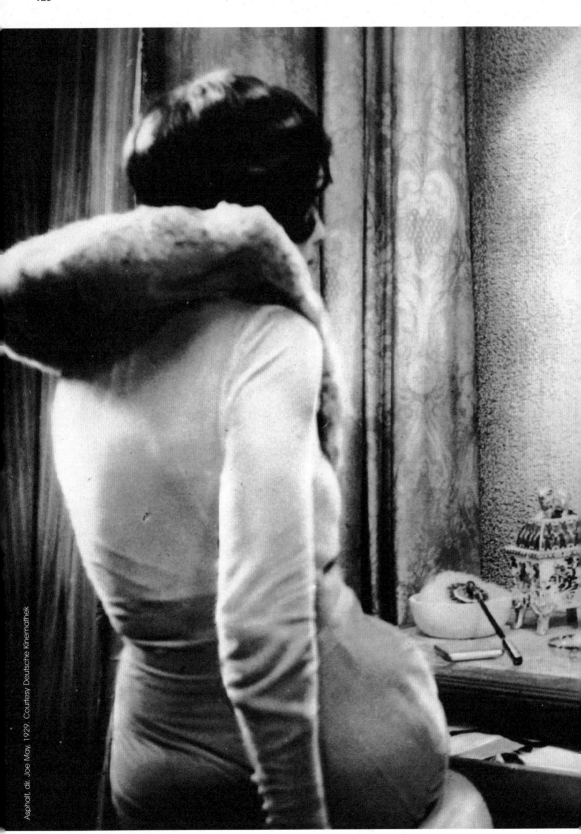

Asphalt, dir. Joe May, 1929. Courtesy Deutsche Kinemathek

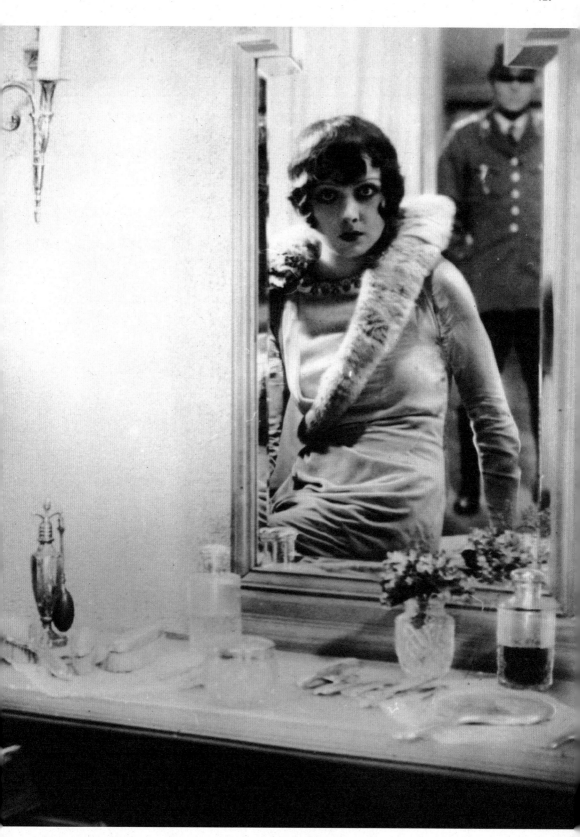

Greta Garbo. Even if bourgeois morality prevails, the central topic of the film is the temptation of sin.

Like many other films of the Weimar Republic, *Asphalt* documents a loss that German film did not easily recover from. Pommer, Hubert, May and Amann all emigrated to America in 1939. *Asphalt* remained their only collaboration.

(Translated by Elsa Lopes Pires)

Notes

1. A term referring to film's use of an enclosed space (such as a room).

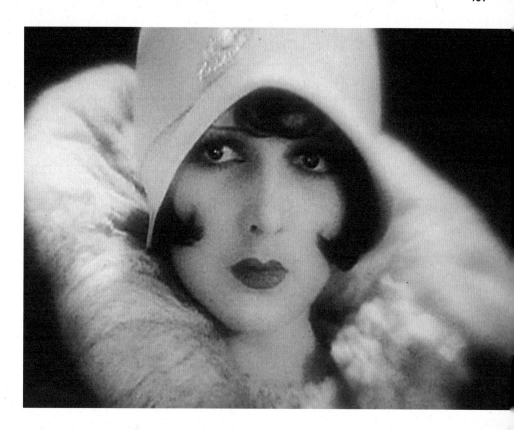
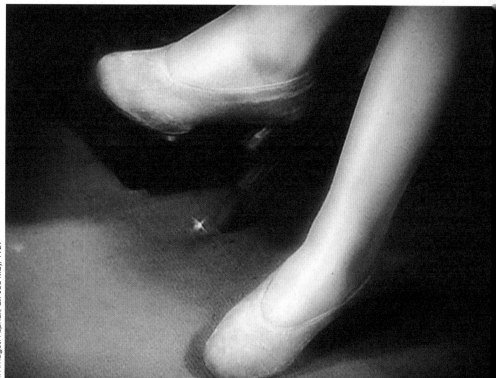

Both images: Asphalt, dir. Joe May, 1929

The Economy of *Desire* / Caroline Evans

In Frank Borzage's *Desire* (1936), Marlene Dietrich plays a glamorous jewel thief who sets up a scam to steal a pearl necklace from the Paris jeweller Duvalle et Cie. Arriving at the store in a white car, dressed in ostrich feathers and a pale, flowing dress, she masquerades as the wife of Dr. Maurice Pauquet, the famous "nerve specialist". There she charms the jeweller and arranges to buy a pearl necklace worth 2,200,000 francs. She asks Duvalle to deliver the necklace to her "husband" Pauquet's consulting rooms later that evening where Pauquet will give him a cheque. Dietrich then visits Pauquet, this time in a black car, dressed in a dark outfit and furs, where she poses as the worried wife of the jeweller. Pretending to consult the nerve specialist on her "husband" Duvalle's behalf, she arranges an appointment for 6pm. The two men duly meet in the presence of Dietrich, who introduces Duvalle, the unwitting jeweller-husband, to Pauquet, the unwitting shrink-husband. The former is expecting a cheque, the latter a medical consultation. Each thinks Dietrich is married to the other man. After the exchange of initial courtesies, their conversation proceeds at increasingly cross purposes, during which time Dietrich's character slips quietly away with the necklace. By the time the two men discover the deceit, Dietrich is on the open road, sleekly motoring south in yet another car, this time open-topped, a cigarette between her lips and, perched jauntily on her head, a peaked toque shading one eye, vaguely reminiscent of a chauffeur's cap.

Dress and accessories (cars as well as furs) are intrinsic to Dietrich's allure in *Desire,* and the scam could not have succeeded without them. Her deception works because it wins out in what Pierre Bourdieu has characterised as the symbolic struggle between "seeming" and "being".[1] In this struggle, social identity is secured as a bluff through luxury goods which are immanent with intention.[2] For the *petit bourgeois* described by Bourdieu, the symbolic importance of "seeming" produces an anxiety about image and appearance; but in *Desire,* Dietrich's character achieves distinction through her insouciance and panache. Her bluff, which takes her into the realm of criminal masquerade, is tantamount to a kind of dandyism, a social incognito played out through dress, appearance and style. A thoroughly modern woman, she proves herself to be resourceful, intelligent, incisive and quick-witted, as much as she is charismatic and seductive. As the film progresses, we learn that Dietrich, known to her associates as Madeleine, goes by the title "Countess de Beaupré", but that too may be a false identity. If it is a little disappointing subsequently to discover that the enterprising Countess was only lured into her life of crime by the obligation to repay a favour, she nevertheless carries the scam through with aplomb and conviction. Finally, in love, and a reformed character, she announces, "I have changed my mind – as a matter of fact, I have changed my life. I'm marrying Mr Bradley soon". Yet it remains unclear to the very end whether Madeleine de Beaupré was ever her real name.

The bluff, in all its forms, is ultimately one of appearances, of which a key component in the film is Dietrich's iconic face and cool sexuality, contrasted initially with the gauche enthusiasm of Gary Cooper's character Tom. At once jewel thief, buccaneer and seductress, it is impossible to disentangle the character Dietrich plays in *Desire* from her public image as a film icon in 1936, the year the film was made. Prior to that, Dietrich had made six films in the USA with the director Josef von Sternberg: *Morocco* (1930), *Dishonoured* (1931), *Shanghai Express* (1932), *Blonde Venus* (1932), *The Scarlet Empress* (1934) and *The Devil is a Woman* (1935). All had costumes designed by Travis Banton, head of costume at Paramount (1927-38) who also dressed Dietrich in *Desire*. Banton's designs combined with von Sternberg's lighting to produce fluid and mobile effects of furs, feathers, sequins, veils and chiffons in motion. In contrast to the quicksilver film surface of her clothes in these films, Dietrich's face make-up became increasingly hieratic. The film historian Sarah Berry describes how from the early 1930s the use of new panchromatic film stock allowed a lighter and more sculptural kind of make-up to replace the heavier make-up of early cinema. Each star's face was "individualised with a range of signature features: the shape of the mouth and eyebrows, the colour and form of the hair, and the amount and style of eye make-up worn".[3] This new look could be further stylised by studio lighting and photographic retouching, and Berry describes how von Sternberg, in particular, supervised Dietrich's studio portraits to maintain the image he had created of her in the cinema. For the films, von Sternberg's make-up and lighting department transformed Dietrich's face into a sculpted mask, lengthening her face by lighting her forehead, accentuating her cheekbones, and radically repositioning and plucking her eyebrows.[4] By the time *Desire* was made, all pretence of the natural was gone:

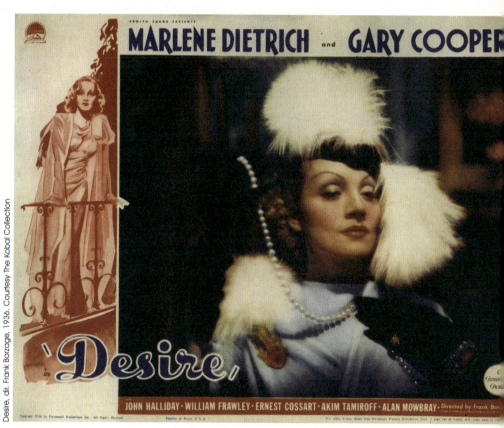

Desire, dir. Frank Borzage, 1936. Courtesy The Kobal Collection

her pencilled brows traced a permanent 180-degree arc over her heavy-lidded eyes. This was the face that constituted the "appearing", the "bluff" of femininity that was Dietrich's stock-in-trade. It was, above all, argues the film historian Drake Stutesman, the "base drama of sexual desire" that Dietrich and von Sternberg together factored into her iconic image in these films.[5] Dietrich's was a face that, in von Sternberg's words, "promised everything".[6]

Desire is a romantic comedy produced by Ernst Lubitsch, who also contributed to the script but did not direct the film.[7] In 1932, Lubitsch had directed *Trouble in Paradise,* another film about a couple of jewel thieves. Its morality was very different to that of *Desire,* in which the female protagonist renounces crime when she finds love. *Trouble in Paradise* features two crooks who remain true to their criminal principles to the end, and whose sexual desire for each other is heightened by their thieving skills as they outdo each other with their tricks. Despite the differences between these two films, both share an ebullient quality quite different to the darkness of von Sternberg's films featuring Dietrich. In the *New York Times* for 13 April 1936, Frank S. Nugent wrote:

> Ernst Lubitsch, the gay emancipator, has freed Marlene Dietrich from Josef von Sternberg's artistic bondage and has brought her vibrantly alive in *Desire* … [P]ermitted to walk, breathe, smile and shrug as a human being instead of a canvas for the Louvre, Miss Dietrich recaptures, in her new film, some of the freshness and gayety of spirit that was hers in *The Blue Angel* and other of her early successes. The change is delightful, and so is the picture.

All the same, her image retained its power and allure. Von Sternberg's films had consolidated and fixed her iconic image of dark and brooding sexuality in the first half of the 1930s; in *Desire,* the associations of European decadence and the *femme fatale* are grafted onto the freewheeling buccaneer character she plays.

Berry argues that, in 1930s Hollywood films, clothing and accessories acted as catalysts for new forms of social behaviour: "Hollywood films of this era are marked by a fascination with female power, from the ambitions of gold diggers, working women, and social climbers … [They] promoted specific kinds of gender, racial and class stereotypes, but they also drew attention to the ways that dress and performance increasingly functioned to define social identity."[8] Following Bourdieu, and drawing on a range of films featuring stars such as Dietrich and Garbo, Berry suggests that Hollywood films of the 1930s constituted a "mythology of 'bluff'", a celebration of the symbolic over "'real' status".[9] Arguing that Hollywood has always been concerned with social mobility and self-transformation, she cites Peter Wollen's argument that, since the early Hollywood film moguls came from the lower reaches of the garment industry, "it was only natural that they should want to associate the cinema with extravagant and spectacular clothes".[10]

That such clothes have transformative, even magical, powers is implicit in Bourdieu's idea of the symbolic capital of "seeming". Bourdieu recognised the capacity of fashion to transform, and hence deceive, in a paper that took magic as a prototype for the operations of modern fashion.[11] He subsequently returned to the subject to suggest that, in an advanced consumer culture, fashion takes on the role ascribed to magic in less developed societies.[12] A form of modern enchantment, fashion's legerdemain is a blueprint for the machinations of contemporary consumer capitalism.[13]

At the heart of *Desire* is another spectacular bluff, a magic trick. Driving to join her accomplices in San Sebastian, Madeleine has become entangled with Tom Bradley (Gary Cooper), an American automobile engineer from Detroit enjoying a once-in-a-lifetime European holiday. At the Spanish border, she slips the pearls into Tom's pocket in order not to be caught with them on her. Thereafter, she tries, but fails, to retrieve them in a series of manoeuvres, culminating in her stealing Tom's car and abandoning him in the middle of nowhere. Despite this treatment, Tom is reunited with her in San Sebastian where he finds her ensconced in the Continental Palace Hotel with her criminal associate, "Prince Margoli" (John Halliday), who poses as her uncle. The three dine together, Tom wearing the travelling jacket into which Madeleine had earlier slipped the pearls, the other two in evening dress. Madeline is seductive in black tulle and feathers with an imitation pearl necklace. At dinner she fails in her attempt to extract the real pearls from Tom's pocket under the table, succeeding only in convincing him that she is making a pass at him. After dinner Margoli entertains them with a series of conjuring tricks. As his final trick, he makes Madeleine's necklace disappear, and asks Tom to look in his right pocket. Tom, astonished, produces the real pearls and returns them to Madeleine.

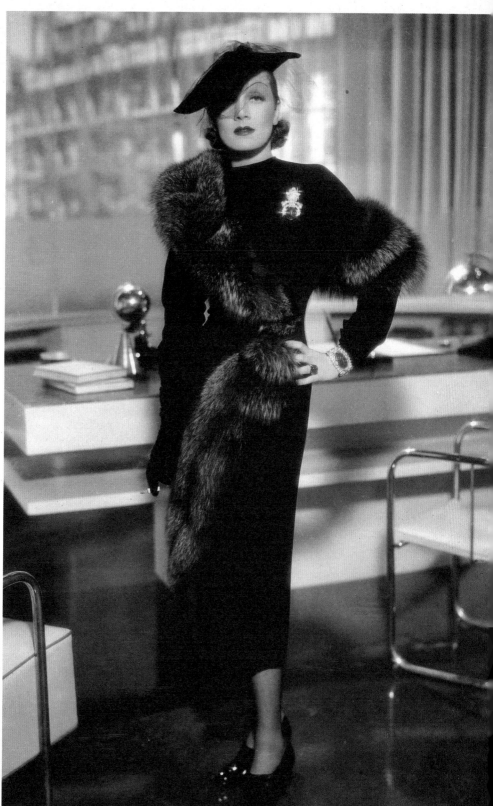

Desire, dir. Frank Borzage, 1936. Courtesy The Kobal Collection

Margoli's sleight of hand is simply another form of bluff enacted by a conman posing as an aristocrat. Tom is not unaware of Margoli and Madeleine's bluff, but goes along with it in order to be near Madeleine. And though Madeleine plays Tom, she is being played by him too, and by her situation. Over a twenty-four-hour period, from their first roadside meeting to the night at the hotel in San Sebastian, they discover their mutual attraction; in the drama of love, the action is no action at all, but the plot is pushed along through looks, words, gestures and inflections. It is here that Dietrich's iconic face comes into play as the only "truth" that Tom can know. At breakfast Tom exclaims, "All I know about you is you stole my car and I'm insane about you!". Borzage's vision is benign, some might say sentimental, in its invocation of the redemptive power of love. Later that morning, Madeleine, under pressure from her criminal associates, tries to break off the engagement and finally confesses to Tom that she is a jewel thief. Everything she told him was a lie, she says, except that she loves him.

That evening Margoli, Madeleine and Tom share a final meal together, and this time it is Tom who invokes magic as a metaphor. He addresses Margoli, describing "a parlour trick you once showed me. See this chicken? One, two, three …" and he eats it. "Gone. Where? In my stomach? It's in the inside pocket of your coat and it's not chicken any more, it's changed into a string of pearls." It is in fact a gun, and Tom disarms Margoli. He knows he was tricked but he doesn't care. He has already proposed a toast to "my hostess, who first stole my car and then stole my heart. The car was insured, but the heart wasn't". Love, it is implied, is treachery but it is also truth. You can't buy it, and a heart is only for stealing, not for sale. Suddenly Madeleine the thief occupies the moral high ground, and true love operates outside a capitalist economy.

The film's title, *Desire*, plays both on Madeleine's desire for the necklace and on Tom's desire for her and, by the end of the film, hers for him. So, finally, in the economy of desire, capitalist logic is confounded. Madeleine, accompanied by Tom, seeks Duvalle's forgiveness; in the final scene Duvalle and Pauquet appear as paternalistic witnesses at Tom and Madeleine's wedding. In *Desire*, the trickster is as "true" as the honest merchant, and true love escapes the confines of double-entry book-keeping, with its rationale of profit and loss.

Not so in the Soviet writer Mikhail Bulgakov's *The Master and Margarita,* an altogether darker story written only two years later in Stalin's USSR, which also contains a magic trick. Half-way through Bulgakov's novel, the devil stages a theatrical black magic show to mark his re-entry into Moscow society, aided by an alluring female assistant in a black dress. The black magic show opens with the magic shop assistant's incantation "Guerlain, Chanel, Mitsouko, Narcisse Noir, Chanel No5, evening dresses, cocktail dresses …",[14] commodities that can only have been known to Muscovites in the late 1930s through the magical medium of words. The devil proceeds to conjure up, first, real money and then, real Paris fashions, with which he barters with members of the audience, exchanging them for items of the audience's everyday clothes. At the end of the show the magical fashion shop disappears from the stage, the mountain of old clothes discarded by the members of the audience vanishing alongside the mirrors, curtains, model dresses, shoes and perfumes of the "boutique". The disappearing act does not stop there, sadly. In the following days and weeks, the magic clothes dematerialise and fully dressed women suddenly find themselves in their underwear in the street, while men pay taxi drivers with bank notes that subsequently mutate into soda water bottle labels.

The point is clear: fashion is a chimera. It is inherently treacherous, unstable and volatile. Appearances are a snare that cannot be trusted. The devil's vanishing trick, like Margoli's sleight of hand, is duplicitous; but in the romantic American film, duplicity is undone by the power of love. We know that at the end of the day Dietrich will go home with her man and metamorphose from a European jewel thief into a Detroit housewife, which in itself requires a leap of the imagination that only magic can effect. If *Desire*, insofar as it is a product of the Hollywood dream machine, is apolitical and individualist, at the end of the day, perhaps this economy of desire can only take place in a capitalist economy that privileges and repays "bluff", and in which "seeming" prevails over "being".

Notes

1. Pierre Bourdieu, *Distinction: A Social Critique of the Judgement of Taste* (London: Routledge, 2002) [1979], p.252.
2. *Ibid.*, pp.221, 252.
3. Sarah Berry, *Screen Style: Fashion and Femininity in 1930s Hollywood* (Minneapolis: University of Minnesota Press, 2000), p.104.
4. The evolving changes to Dietrich's face make-up over this period are revealed in a series of images from the period reproduced in Patrick O'Connor, *The Amazing Blonde Woman: Dietrich's Own Style* (London: Bloomsbury, 1991), pp.30-33.
5. Drake Stutesman, "Storytelling: Marlene Dietrich's Face and John Frederics' Hats" in *Fashioning Film Stars: Dress, Culture, Identity*, ed. Rachel Moseley (London: BFI Publications, 2005), p.28.
6. Quoted in Stutesman, *ibid.*, p.30.
7. Dietrich herself sets the record straight in her 1987 autobiography *Marlene Dietrich: My Life:* "Borzage … directed *Desire,* whose direction has been wrongly attributed to Ernst Lubitsch: Lubitsch wrote the script, but he didn't direct the film." Cited on http://www.marlenedietrich.org/noteDesire.htm (accessed 14/12/07).
8. Berry, *ibid.*, p.xvi.
9. *Ibid.*, p.xvii.
10. *Ibid.*, pp.xvii-xviii, and Peter Wollen, "Strike a Pose", *Sight and Sound,* vol.5, no.3 (March 1995), p.14.
11. Bourdieu, "Le Couturier et sa Griffe: Contribution à une théorie de la Magie", *Actes de la recherche en sciences socials 1* (with Y. Delsaut) (January 1975), pp.7-36.
12. Bourdieu, "Haute Couture and Haute Culture", *Sociology in Question* (London: Sage, 1993) [1980], pp.132-38. In this essay Bourdieu returns to this subject, and seeks to answer the question raised by the anthropologist Marcel Mauss in his essay on magic: "Where is the equivalent in our society?" Bourdieu replies that he hopes to show that it is to be looked for in *Elle* or *Le Monde* (p.133).
13. The idea that magic is a paradigm of late capitalist enterprise, and gives us clues as to its stratagems, has been explored more recently, and more explicitly, by Simon During, *Modern Enchantments: The Cultural Power of Secular Magic* (Cambridge MA: Harvard University Press, 2001). Elizabeth Wilson has taken During's arguments and applied them to fashion in "Magic Fashion", *Fashion Theory,* vol.8, issue 4 (Dec 2004), pp.375-85.
14. Mikhail Bulgakov, *The Master and Margherita,* trans. Richard Pevear and Larissa Volokonsky (London: Penguin Classics, 2007) [1966-67], p.128.

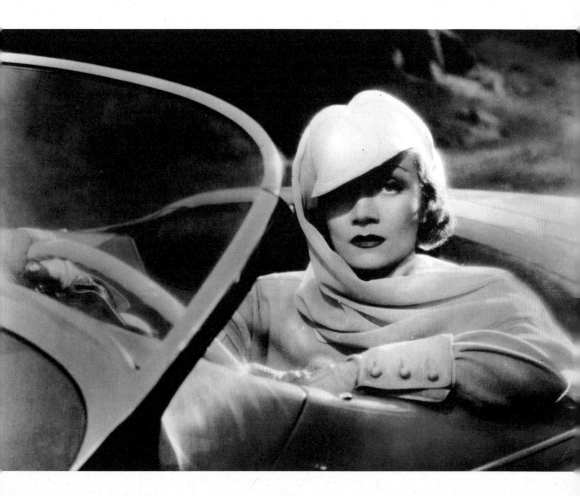

I Want That Mink! *Film Noir* and Fashion / Petra Dominková

One of the prominent features of *film noir* – if not a sheer necessity – is the figure of the *femme fatale*, an intelligent and powerful woman who inevitably leads men to destruction. Her aim, as Joan Copjec has shown, is often simple: money. Her greed is a "constant demand for more and more satisfaction".[1] However, for a *femme fatale* the money alone won't do. She wants her wealth to be seen and so she embellishes herself with glittering jewellery, luxurious dresses and designer hats. But one fashionable commodity in particular has become synonymous with *film noir*'s *femme fatale*: the mink coat.

The fur coat has traditionally been a powerful visual signifier of wealth and social class (an actual means of class identification: the wearing of furs was in the Middle Ages regulated by sumptuary laws) – it has been an elite garment highly charged with symbolic meaning, and an ever-present subject of moral debates.[2] In Leopold von Sacher-Masoch's famous 1870 novella *Venus in Furs*, the unnamed protagonist fantasises about talking to Venus: " I cannot deny," I said, "that nothing excites a man more than the sight of a beautiful, voluptuous, and cruel female despot who capriciously changes her favourites, reckless and rollicking", to which the Goddess replies: " And wears fur to boot!".[3]

Fur, a staple of 1930s fashionable wardrobes, was a rare commodity during the Second World War and consequently became an intensified sign of luxury that women came to truly treasure, clinging to it as the last bastion of glamour. Philadelphia's *Saturday Evening Post* reported in 1941 that "women's luxury-seeking psyches get a kick out of furs", singling out the mink as one of the most luxurious, expensive and labour-intensive furs on the American market of the 1940s:

> To make a mink coat … is hysterically painstaking and delicate. The raw material may be seventy mink skins worth eight dollars apiece. Ruin one and bang goes a day's pay. Yet to give the coat the long-lined elegance that Madame expects for her dough, each skin has to be shredded into strips about the width of a lead pencil to be diagonaled in a fashion that pulls the mink out to the three times its original length, all the way from the shoulder to the bottom of the coat-to-be, and yet leaves the dark center stripe on its back straight and rich. Then all the strips are sewn back together in the new alignment without pucker, bump or break – 4900 bits of delicate sewing![4]

Similarly, an article published some years later usefully spells out the mink's staggering economic value: "We come finally to the mink. A coat of this member of the weasel family is in the luxury class of furs Fur coats made of the rarer types of mink retail today as much as $3,000 and even more, although $1,000 - $2,000 is considered standard."[5]

In this cultural context it is not so surprising that *film noir*, a form that crystallised during the Second World War and flourished in the post-war years, would generously wrap its female protagonists in sumptuous furs – and fur coats in particular – for maximum impact.[6] *Film noir* really reinforced the symbolic significance of the mink, not only through visual representations of it but also through rich dialogues about it. When a wife receives a mink coat from her husband in Jules Dassin's thriller *Brute Force* (1947), she tells him: "It's the most beautiful thing in the world. It makes me feel like… I don't know… like I was somebody. All my life the one thing I really wanted was a fur coat." When her husband admits that he had to steal in order to buy it, she says: "I cannot give it up. I won't." She would rather risk her husband's imprisonment (which eventually happens) than agree to live on without a mink. Similarly, in Irving Pichel's *Quicksand* (1950), Vera, standing in front of the mink coat on display in a shop window, becomes visibly excited: "Isn't that the most beautiful thing you've ever seen in your life?" she asks her partner, adding: "I want that coat and I'm gonna get that coat whatever it takes."

Women in *film noir* simply want that mink. But rarely do they purchase it themselves. Mostly, the fur coat is a present from a husband (as in *Brute Force* or Max Ophüls's melodrama *Caught*, 1949), a lover (Fritz Lang's *The Big Heat*, 1953, or Robert Rossen's boxer movie *Body and Soul*, 1947), or a brother (Alexander Mackendrick's *Sweet Smell of Success*, 1957). Sometimes the origin of the coat is obscure, as in Cornel Wilde's *Storm Fear* (1955) or Michael Curtiz's *Mildred Pierce* (1945). The fact that it is mostly men giving fur coats to woman – who, in return, are supposed to become (or continue to be) their lovers – wouldn't be much of a surprise to Sigmund Freud. As he explains in his essay on fetishism, "the fetish

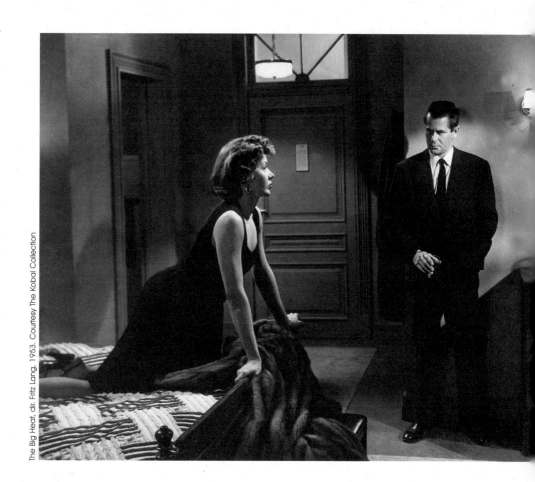

The Big Heat, dir. Fritz Lang, 1953. Courtesy The Kobal Collection

is a substitute for the woman's (the mother's) penis that the little boy once believed in and ... does not want to give up".[7] Indeed, Freud confirms that furs are among the most common fetishistic objects: "fur and velvet – as has long been suspected – are a fixation of the sight of the pubic hair, which should have been followed by the longed-for sight of the female member".[8] Thus, the fur coat becomes a substitute for woman's sex, and is willingly accepted as such within this transaction, while also fulfilling the function of making a woman look attractive. It evokes Laura Mulvey's description of fetishistic scopophilia in her seminal essay "Visual Pleasure and Narrative Cinema": "[It] builds up the physical beauty of the object, transforming it into something satisfying in itself."[9] By wearing a mink coat, a woman herself becomes a spectacle, and turns into a fetish, all the while looking at herself in the mirror for reassurance. Particularly telling of the fascination with the mink coat is a shot in *Brute Force* which shows the garment by itself, as if seen from the viewpoint of both a husband (the one who gave) and a wife (the one who received). The mink here seems to be a cherished object of desire for both of them. Or perhaps she desires the mink while he desires her – in it.

The acquisition of a mink coat does not just switch on a new glamorous identity; it initiates a new epoch in a woman's life, often symbolising her liberation from the confines of the domestic space and her entry into the public, urban realm. The lead female character in *Brute Force*, for example, is portrayed as a housewife until the moment she gets her mink. Similarly, Mildred, the heroine of *Mildred Pierce* (incidentally one of the rare breed of *film noir* women who may have bought her own coat), undergoes a transformation from apron to mink. Mildred openly voices her dissatisfaction with the "pre-mink" epoch ("I felt as though I'd lived in a kitchen all my life ..."), embracing the expensive garment as a means of release, a sort of gateway. *Film noir* does not always show this "pre-mink" epoch though. *Storm Fear* and *The Big Heat* are two examples which focus instead on the difference between a woman who wears mink and one who doesn't – the juxtaposition here serves to differentiate between the woman in mink as a rotten, selfish dame and an unpredictable force, and her mink-less antithesis, the maternal "good" woman who cares about her child and household.

Occasionally, the woman who desires a mink coat does not get it. For instance, King Vidor's depressing film *Beyond the Forest* (1949) features a woman determined to do anything to get the dream coat. The film's heroine, Rosa (Bette Davis), who is fond of heavy make-up[10] and extravagant clothing, dreams of moving to metropolitan Chicago in a bid to escape her boring small town. One day a fancy woman from Chicago comes to town and visits Rosa's house, where the latter is soon seen caressing the former's mink coat. She tries it on it and feels that this is exactly what she deserves. The mink coat here symbolises not only wealth, luxury and high society but also, importantly, the big city. However, Rosa does not end up getting the coat, nor does she move to the city. It is implied that Rosa's death at the end of the film is the result of her unsatisfied desire for a new life in Chicago, her fantasy of belonging to the higher society of which the mink coat was such a powerful promise.

Another striking example of how *film noir* utilises the mink coat as a means of class transition is Ophüls's *Caught* – one of the few crime-less *films noirs*. Leonora (Barbara Bel Geddes), a poor department store sales girl and mannequin, wears a fur coat at work to demonstrate to customers its quality and value. But she secretly harbours dreams of marrying a millionaire. And sure enough: even in *film noir* some dreams do come true and Leonora does marry her millionaire... Quite understandably, one of the first gifts she receives from her husband is a luxurious mink coat. It is a gift that ties a wife to her husband (who married her just for fun and whom she doesn't love either). When she later meets and falls in love with another man, he, significantly, buys her a simple cotton coat – a garment that stands for his pure intentions (and that is meant to replace the impure fur). But the mink – a haunting reminder of a failed dream – is carried right through to the "happy ending" when Leonora miscarries the millionaire's baby in a hospital ward, and the nurse takes the coat away, finally breaking the last bond left between them.

The mink coat plays a similarly important role in Mackendrick's *Sweet Smell of Success,* made almost a decade later (1957). This time it is a present to Susan (Susan Harrison), not from a rich husband but from her brother J.J. Hunsecker (Burt Lancaster), a powerful press agent. The mink coat here symbolises a close bond between sister and brother that has subtle – and disturbing – incestual undertones. All in all, the mink coat serves as an obstacle to Susan's romantic relationship with musician Steve Dallas (Martin Milner) because he is of a lower social status than the girl. At one point, Steve actually openly remarks: "This coat is your brother. I've always hated this coat." The mink coat

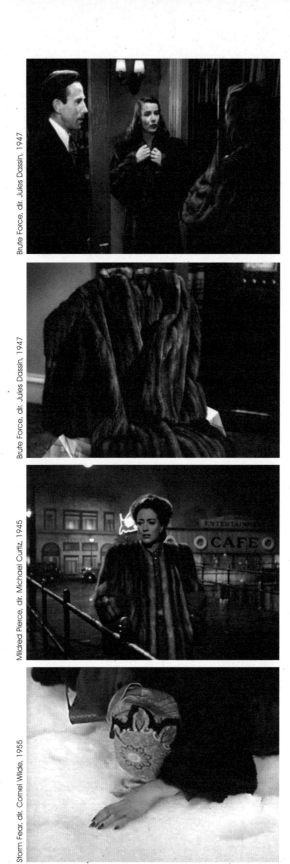

obviously stands for the real object of his hatred – her brother.

In *film noir,* the mink coat is never an innocent object of desire. Rather, it is a marker of badness, a bad omen, and often a hindrance or – quite literally – a burden. Cornel Wilde's lesser-known low-budget film *Storm Fear* tells the story of a mobster threesome – one woman and two men – who, having committed a robbery, find shelter in a mountain cottage during a harsh winter. When they are unable to stay any longer, the three decide to cross the mountains. Edna (Lee Grant), the only girl in the group, is dressed for the journey in a hefty mink coat, which under the circumstances has changed from a fashionable statement to a cumbersome thing that drags her down, making it almost impossible to walk. In a poignant scene, she throws away her pullover but refuses to part with the mink, claiming that it took ten years for her to be able to afford to buy it. She complains about her exhaustion, looking sumptuous as she is cast against the picturesque mountainous backdrop. Her refusal to get rid of the coat turns out to be fatal, however: her "female irrationality" angers her accomplice so much that he pushes her off a cliff and leaves her behind with a broken ankle. Here again, Edna's mink is at the heart of her demise, ultimately responsible for no less than her death. The last we see of her, she is lying face down in the snow, crying, still wearing her mink…

I would argue that the mink coat is one of *film noir*'s forceful clichés. True, it may not be exclusive to *film noir*,[11] but it is an undeniably crucial symbol in its iconography, loaded with intricately textured meanings. The mink speaks volumes about women's sexuality and social status, but is also connected with crime: it is often worn by molls (*The Big Heat*; *White Heat*, Raoul Walsh, 1949); the money that buys it is often stolen (*Brute Force*); it can be a reason, or pretext, for violence (*Storm Fear*); and, last but not least, the women who wear it are empowered enough to grab a gun with the aim of killing (*Mildred Pierce*; *Sudden Fear*, David Miller, 1952). How typical for *film noir* - a form that merges violence, sex and style into one.

Notes

1. Joan Copjec, *Read My Desire: Lacan against the Historicists* (Cambridge: MIT Press, 1995), p.199.
2. Andrew Bolton, *Wild: Fashion Untamed* (New York Metropolitan Museum of Art, New Haven and London: Yale University Press, 2005).
3. Leopold von Sacher-Masoch, *Venus in Furs*, trans. Joachim Neugroschel (London: Penguin Classics, 2000 [1870]), p.6.
4. J.C. Furnas, "Hide and Hair de Luxe", *The Saturday Evening Post*, no.30 (25 January 1941), pp.55-57.
5. Cedric Larson, "Terms of the Fur Industry", *American Speech,* no.24 (April 1949), pp.97-98.
6. This was also the case in television: one film fan remembers that when he was a child growing up in the 1950s "American sit-coms endlessly promoted the idea that what women wanted more than anything else was a mink coat", http://members.aol.com/MG4273/ophuls.htm (accessed 26/03/08).
7. Sigmund Freud, "Fetishism", *The Standard Edition of the Complete Psychological Works of Sigmund Freud (Vol.XXI)*, ed. James Strachey (London: Hogarth and the Institute of Psychoanalysis, 1953-73), pp.152-53.
8. Freud, *ibid.*, p.155.
9. Laura Mulvey, "Visual Pleasure and Narrative Cinema", in *Movies and Methods Volume II*, ed. Bill Nichols (Berkeley: University of California Press, 1985), p.311.
10. That applies, however, just to the first half of the film. In her essay "The Clinical Eye", Mary Ann Doane notices that in several films from the 1940s "the illness of the woman is signaled by the fact that she no longer cares about her appearance". Regarding Rose in *Beyond the Forest* Doane claims: "her fever at the end is signified by her misapplication of make-up as she gazes into the mirror. Her lipstick exceeds the line of her mouth and eyeliner is drawn on in a crooked line far from the boundary of the eye." Mary Ann Doane, "The Clinical Eye: Medical Discourses in the 'Woman's Film' of the 1940s", *Poetics Today* 6, no.1/2 (1985), pp.208-09.
11. The mink is a crucial prop in other film forms and genres, for instance Robert Asher's *Make Mine Mink* (1960) and William A. Seiter's *The Lady Wants Mink* (1953) – to name just two examples from the comedy genre.

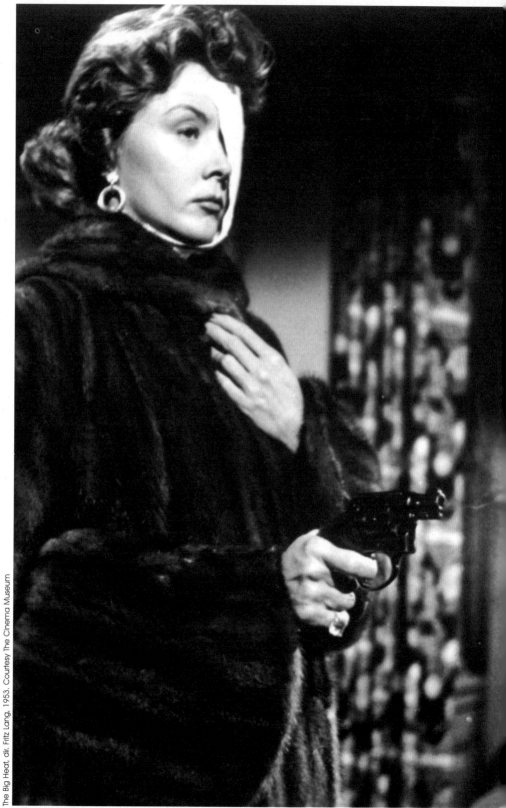

The Big Heat, dir. Fritz Lang, 1953. Courtesy The Cinema Museum

The Red Shoes / Hilary Davidson

It is night. On a platform edge in an empty subway station sits a pair of beautiful pink shoes, alone and ready to wear. No one is present; the shoes are abandoned, ownerless. Why not pick them up, put them on and take them home?

In the Korean film *The Red Shoes* (*Bunhongsin*, Yong-gyun Kim, 2005) gruesome answers to this question reveal the fatality of possessiveness in a ghost-tale concerning female identity and the psychological power of shoes. Motifs from the J[apanese] – and K[orean] – horror genre intertwine with ideas from two Western sources to which the title pays homage: Hans Christian Andersen's fairytale "The Red Shoes" (1845) and the Powell and Pressburger ballet film of 1948.[1] Three works wrapped within one title form the first of many triads recurrent through the film, repetitions of two women pivoting their opposition on a contested object of desire: man or shoes. *Bunhongsin* prioritises the violence implicit in the earlier texts to enhance the potency of the red shoes symbol as a vehicle for impassioned, destructive "self-fashioning".[2]

The pre-title scene is set by a schoolgirl who succumbs to temptation whilst waiting for a friend at the station. The elision into magic space happens quickly as she picks up the footwear in her hand; in the next shot they appear on her feet. From nowhere her prettier friend appears and demands the red shoes as her right. Why do they cause such instant jealous desire? The shoes themselves are archetypal 20th century designs fashionable anywhere from 1920 to the early 21st century (it's no accident that their shape resembles the ruby slippers from *The Wizard of Oz*). The newcomer wins a fight for the shoes and goes upstairs. She walks – or do the shoes walk her? – into the first of the film's corridors of light. Though alone, sounds of other footsteps echo menacingly through the empty station until, with a flash of a dark figure, the girl falls over. The camera, pulling back, reveals both legs severed below the calf as her screaming begins...

Andersen's vain heroine is being danced to death by her red shoes until she asks the executioner to chop off her feet. The scapegoat shoes with the dismembered bloody stumps still in them dance "away into the dark forest",[3] a physical removal of sin that saves the girl and her soul. *Bunhongsin* inverts this formula with brutal speed by saving the shoes from the girl. The amputation kills her; the shoes absorb the trails of blood, and return to a pristine state, ready to kill again. The 1948 *The Red Shoes* forms a conceptual link. Hein Heckroth, the Oscar-winning production designer, encapsulates both films' plots with a terse summary: "The girl wants the red shoes. She gets them. They destroy her. There will be other girls and they will destroy them too."[4] Throughout, the fetish power of the shoes is uppermost, not the agency of the women who possess, with deadly brevity, the shoes' allure. The wearer ends and the shoes start their story again (as the post-script scene reiterates). Moving amputation from climax to beginning reverses the story-sequence so that the narrative unravels the shoes' cursed origins.

After this blood-soaked start, the main story begins. A middle-class woman with a small daughter, Tae-Soo, leaves her husband after his infidelity. She moves to a small apartment and starts a new life with her dance-loving daughter. The woman finds the red shoes on a train and takes them home. When Tae-Soo sees her wearing them she becomes obsessed with the shoes and repeatedly takes them from her mother, who feels the same strange compulsion. A visiting friend finds their allure too strong and steals them, only to be found dead in a shop window that same evening, missing an eye, her feet, and the shoes. In a series of increasingly disturbing supernatural events, the shoes keep reappearing in Tae-Soo's possession. Blood gushes from basins and ceilings, footsteps are heard when no-one is around, ghostly figures from the past suddenly appear.

Soon a 1944 tale of two ballerinas emerges through flashback visions. The better dancer, Oki, possesses the red shoes and the love of the choreographer. Her rival Keiko is consumed with jealousy and kills Oki, taking her shoes, her man and her roles. Oki's supernatural revenge is exacted through scenery that strangles the new couple on their wedding day and it is Oki who is haunting the shoes in the present day. When the pattern is clear – she who takes the red shoes from another woman dies – the modern woman fears for her daughter's life. At the same time, the mother is conflicted by her increasing rage at Tae-Soo's refusal to give her back the shoes. The denouement plays out in the same empty station through stylised mechanics of apparitions, trains and blackness. The film finally identifies the modern woman's psyche with both Oki and Keiko to question the nature of haunting and ends with eerie ambiguity.

The Red Shoes, dir. Yong-gyun Kim, 2005 (poster). Courtesy Cineclick Asia

We first meet the protagonist in her suburban kitchen. She is anonymous, unnamed by her distant husband in a triad comprising mother-father-daughter. Her relationships determine her identification: inadequate wife, ignored mother, timid woman, not an individual person. Only an hour into the film do we learn to call her Sun-Jae.

Naming and identity are key issues of red shoe narratives. Andersen first calls his "little girl who was pretty and delicate" Karen when her mother dies and she receives her first pair of red shoes.[5] Powell and Pressburger's spirited ballerina Vicky loses her name and becomes defined through an immature femininity as "The Girl" in the central ballet of *The Red Shoes*. Their identities fluctuate around episodes of their shoe wearing. When Sun-Jae discovers her husband's infidelity, she is revealed as similarly embodied, by glamorous, expensive shoes, and the film's metaphor of shoes substituting self is activated. Sun-Jae returns home early to find male and female shoes beside the door. Her first sight of the clandestine activity upstairs is her own black stiletto dangling from the coitally-raised left foot of the other woman in this triad.

The scene that follows discovers Sun-Jae's astonishing dressing room of shoes staged in all the visual rhetoric of a luxury showroom. Glistening shelves fill a whole wall revealing visions of delicate heels and jewelled toes – a personal pleasure-feast of objectified beauty. Sun-Jae practices walking in the usurped black shoes that the Other Woman wore. A tri-fold mirror validates this act of performative identity as it reflects Sun-Jae back to herself, figured as an alternative person, while the mirror's wings fragment and multiply her vision.

Next, the minute grotty flat of Sun-Jae's independence becomes a site for transformation: haircuts, cleaning and domesticating, creating a feminised bower. Even in this reduction from her bourgeois life, a huge display of shoes demonstrates how Sun-Jae invests these objects with the most personal importance. They take central place in her apartment, a shrine lit with candles. Yet we never see her wearing any except the red shoes, suggesting that her inner facets are as effectively static and subject to repressive compartmentalising. Glass shelves box in all her other selves, just as Snow White was kept lifeless in a glass coffin.

Her less-attractive friend Mi-Hee voices some uncomfortable insights about Sun-Jae, digs about "self-pride that will do you wrong", and the things she wants like "money ... and glamorous shoes". Coming uninvited to the flat, Mi-Hee comments that Sun-Jae is "keeping up her hobby" of collecting shoes, belittling their psychological importance to her friend. The crime for which the shoes later punish Mi-Hee is perhaps her refusal to uphold the way her friend sees herself.

Looks really can kill in this film as it revolves around the light, seeing and reflection embedded in almost every scene. The inorganic cityscape is all glass and sinuous metal; hollow marble halls and fluorescent corridors. Sun-Jae and Mi-Hee are both ophthalmologists. Building her new clinic introduces Sun-Jae to the interior artist (and object of desire) In-Chul, a man predicated on the visual, who designs a giant eye logo for her. Women use the film's many mirrors to view *doppelgänger* selves, or search their reflections for identity in the vanity of surfaces. Seeing the red shoes inspires an instant lust for their possession, especially when they are possessed by another. Unexpected glimpses of sexual betrayal spur murderous actions. Flickering lights herald the ghostly presence's control of seeing and blindness. A bulb explodes into Sun-Jae's eye, damaging her vision, which is already shaken by waking nightmares.[6] Can we trust what she is shown to be seeing, or her sense of time? When the lights go out or the mist rolls in, obscurity is also significant for what the characters do not see themselves doing. Losing an eye, the ability to see, is common to the victims of the red shoes. The theme conjures up theatrical magic spaces where controlled lighting manipulates audience perceptions.

I argue elsewhere that Andersen's story is rooted in his own psychopathology, his narrative symbol of red shoes tied to the inner experience of the wearer.[7] Both Powell and Pressburger's Vicky and Yong-gyun Kim's Sun-Jae have their interiority conveyed through camera shots, editing, and blurring of reality and the visions we see them see. *Bunhongsin* conflates external actions of spirits and internal drives of the unconscious to provide a dualistic explanation for the narrative events. The psychology is definitely Freudian. Extending the analyst's categorisation of a shoe as a symbol of female genitalia[8] leads to a surprisingly feminist reading of a woman's passion for them: the possibility of creating a perfect self-contained sexual relationship, with herself taking both gender roles. Her phallic foot fills her waiting shoe and the pleasure is all hers, compounded by scopophilic delights of looking at her feet wearing the shoes.[9] The first girl seen trying on the red shoes closes her eyes and exhales as she concentrates on her internal reactions to wearing them. Unlike an orgasm, the sensations

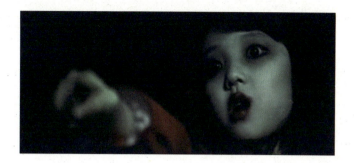

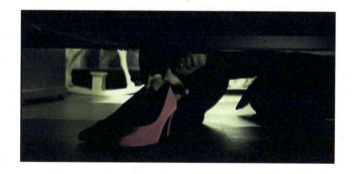

All images: The Red Shoes, dir. Yong-gyun Kim, 2005

are instant, assured, and easily repeated.

The power ascribed to shoes by belief and psychology practices relates to their nature as a vessel, and female desire for shoes responds to their self-containment. Like the equally fetishised corset, there is a liminal interface between an object moulding and moulded by the body. Feet mould shoes' materiality to retain an impression of the absent wearer, holding a person's spirit in their empty interiors. Builders exploited this quality by concealing shoes in place of living sacrifices to bless the building.[10] Unlike soft clothing, the rigid structure of shoes keeps their form without the foot. They wait, containing and continuing emotions created by the relationship between the wearer's projections and the shoes, telling tales of who the wearer is and who she would like to be, quotidian or outrageous, independent of wear-processes that mediate the body.[11] The shoemaker Manolo Blahník knows this well. He names each design after the imaginary woman evoked, a power of magical narrative that helps to make his shoes' fantasy identities some of the world's most desirable. Madonna famously said that Blahník's shoes are "better than sex and they last longer",[12] reinforcing the concept of private individual pleasure.

The red shoes woman is larger than life. She is alluring, mysterious, self-confident; her emotions are modified by dress. When Sun-Jae demands the stolen red shoes back, Mi-Hee, in make-up, carrying bags full of designer gear, asks her, "You know how great I feel right now?" Sun-Jae does: she rode the shoes' energy the night before to seduce the designer with vamping confidence, and it's a feeling she's obsessed with keeping to herself. But this woman is as incorporeal as magazine pages, the catalogue of static selves moving perpetually, like film, in a moment that never existed. In real life the fashion event or the construction of glamour is impossible to sustain. The idea of the red shoe woman remains forever connoted but unattainable, and will consume the person transformed by this trope.

Bunhongsin asks how far someone will go to reclaim sexual experience or desirable identity "stolen" by another woman through the red shoes vehicle. Death is retribution for this original and most serious crime in a cinematic space defined purely by feminine negotiations of disempowerment. The enemy here is always the "other" woman, however embodied. The men exist only to catalyse female actions and relationships and are less important than the red shoes whose functions they mirror. They are ciphers, excluded from significance as from the private inner intensity of shoe-wearing.

The shifting mother-daughter relationship between Sun-Jae and Tae-Soo contains the same watchful tensions as the other pairs of women who usurp roles. An early close-up shot focuses on Tae-Soo's cherry-red Mary Janes with Dorothyesque bow. This childish association with the colour later causes the husband to ask his wife: "Aren't you too old to like red [pink]? It doesn't suit you." The struggle over red shoes intensifies to become a competition for the survival of the mother's ageing identity. Is the daughter a replica or a rival? Her (vision) *doppelgänger* is heavily made up, foreshadowing the adult femininity waiting to be inscribed on her blank face. This version exerts a fascination that leads Sun-Jae into a hallucinatory world. It fascinates Tae-Soo, too, as she plays with her mother's make-up and covets the red shoes to practise this future self. She is Sun-Jae-in-waiting, growing to replace her so fast that the mother has already tried to sever Tae-Soo's superior place in the father's affections, and no matter how desperately she screams in the final scene for the ghost to "take me instead", Sun-Jae's maternal anxieties struggle against a jealousy that Tae-Soo and her father are each other's favourites. The girl's blood-red nightgown invokes iconography from Nicolas Roeg's film *Don't Look Now* (1973) to emphasise the threat of the small daughter-figure as "other".

Yet it's possible that Tae-Soo senses how to harness the red shoes' power properly, and is protecting her mother by her obsessive clutching of them. The key is her love of dancing. Oki used the shoes to make beauty, controlling the shoes' energy, uniting pleasures of body and soul, in a liberated expressive identity as a dancer. Keiko tries to steal her ability and loses everything. To use red shoes in their proper sphere of dancing – as Tae-Soo could do – is to gain self-possession. Worn with malevolent intent they possess the self and divert bodily creativity to destructive purpose.

Critics of the 1948 film were disturbed by the "dark fairytale". The irony is brought home when Sun-Jae tells her daughter she will read her "a fairytale so you won't have any scary dreams". This fairytale *is* a scary dream and the 21st century K-horror turns to confront the darkness. In his research, Heckroth asked several children: "What do you most want to see when you see the ballet?" to which six replied: "When they cut off the feet"[13] – a bloodthirsty wish that took sixty years to fulfil by radically centralising graphic depictions of the action.

Many reviewers have noted that these "red" shoes are actually deep candy pink, a seeming

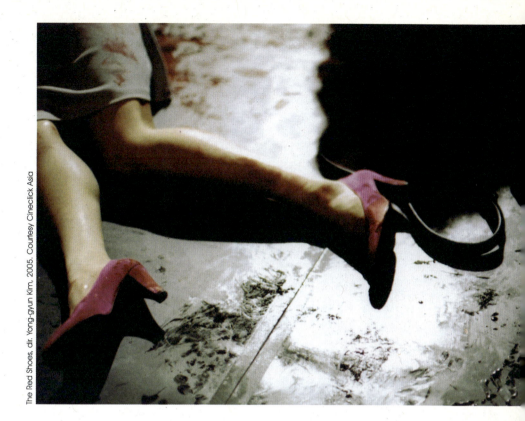

The Red Shoes, dir. Yong-gyun Kim, 2005. Courtesy Cineclick Asia

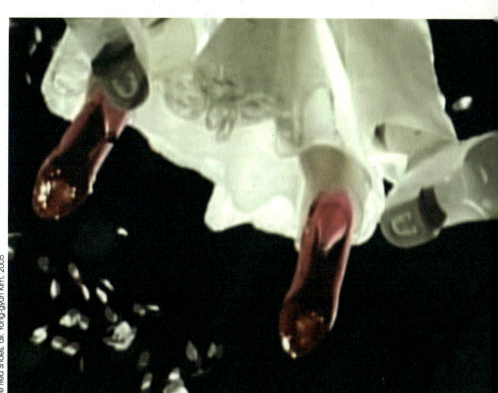

The Red Shoes, dir. Yong-gyun Kim, 2005

discrepancy rooted in the various cultural contexts. *The Red Shoes* translated to *Bunhongsin* in its Korean release, so this title alludes directly to the 1948 film. The Korean syllable for *pink* has a spectrum of ruddier uses than in English, qualifying phrases for *poppy*, *red light district*, and *orange pekoe*. Similar ambiguity once affected the English *purple,* which could historically determine a colour range from violet to pure red.[14] This "purple" operated as both a status-sign and a descriptor. The Red Shoes sign is disjointed from literal interpretation, finding comfortable expression in pink shoes that operate within the sign's death/desire meanings.[15] And they cause enough spilled blood to lend them any red they lack.

Reviews have also given mixed responses to the number of J/K-horror "clichés" *Bunhongsin* employs: a girl ghost in white hanging her head; a lone woman in a strange apartment; a cursed object; damp hauntings. However, each referent in *Bunhongsin* to the ocean of collective modern signifiers builds an intertextuality beyond cliché. Though it relies on horror shorthand typified by *Ring* (*Ringu*, Hideo Nakata 1998, itself drawn from a Japanese folktale), *The Grudge* (*Ju-on*, Takashi Shimizu, 2000) and *Dark Water* (*Honogurai mizu no soko kara*, Hideo Nakata, 2002) it also evokes discourses of crime, clothing and identity in films such as *Fight Club* (David Fincher, 1999), *Single White Female* (Barbet Schroeder, 1992) and the aforementioned *Don't Look Now*. One mode's cliché is another mode's motif. If film is the folklore of the 20th century as Powell put it,[16] then repeated symbols are a folk and fairytale necessity, as the copious Aarne-Thompson-Uther folktale plot motif index testifies.[17] The film's success lies in elegant nods to the established western connotations of the red shoes symbol. The political resonance of the pro-Japanese ballet near the end alerts the non-Korean viewer that the film no doubt nuances different emphases for those with the cultural code.

The Andersenian red shoe trope of *Bunhongsin* concerns the fatal struggle between a life that is and the life that might be; between self and other-self, a meeting of polarities that self-destructs. The desirable *doppelgänger* haunts the present woman, tempting her with visions of delirious transformation. Red shoes represent the new identity to become a fetish of this power. Taking the red shoes is stealing the material conduit of a woman's self when she is so vulnerable that her identity collapses without such props. It's stealing a dream, with all the deadly rage that such an intimate, precious theft incites. And if a pair of shoes is psyche/self, what does it mean when that pair is split, as happens with the red shoes' own *doppelgänger*, the black stilettos? (Like Kipling's suspenders, these must be particularly remembered.)

The privileged space of the horror film allows exploration of the passionate extremes implicit in a pair of red shoes beyond mainstream boundaries ameliorating Hans Christian Andersen as well as Powell and Pressburger.[18] The three works form a harmonious intertextual meta-triad deepened by *Bunhongsin*'s 21st century semiotics and willingness to face the dark interiors of female possession. Its polysemic red shoes dance through ambiguous ghost-lit realms of fashioning, desire and jealousy where the criminal and her victim haunt each "other", mirror-close.

Notes
1. To avoid confusion I will refer to the Korean film by its original language title throughout.
2. Lorraine Gamman, "Self Fashioning, Gender Display and Sexy Girl Shoes: What's at Stake – Female Fetishism or Narcissism?", *Footnotes: On Shoes,* eds. S. Benstock and S. Ferriss (New Brunswick: Rutgers University Press, 2001), pp.93-115.
3. Hans Christian Andersen, "The Red Shoes", *A Treasury of Hans Christian Andersen,* trans. Eric Christian Haugaard (New York: Barnes and Noble, 1993), pp.231-36.
4. Monk Gibbon, *The Red Shoes Ballet* (London: Saturn Press, 1948), p.54.
5. Andersen, *supra* n.3, p.231.
6. In Andersen's "The Snow Queen" (from the same volume of stories as "The Red Shoes"), a shard of glass from the Snow Queen's mirror lodges in Kay's eye to make the boy see only the worst of life. His playmate Gerda must sacrifice her red shoes as part of her journey to heal him.
7. Hilary Davidson, "Sex and Sin: the Magic of Red Shoes", *Shoes: A History from Sneakers to Sandals,* eds. P. McNeil and G. Riello (London: Berg, 2006), pp.272-89.
8. Sigmund Freud, *Three Essays on the Theory of Sexuality,* ed. J. Strachey (London: Basic Books, 1998) [1962], p.21, n.1.
9. Other Freudian readings include red shoes as castration – see, amongst others, Erin Mackie, "Red Shoes and Bloody Stumps" in Gamman, *supra* n.2, pp. 233-50; and as manifestations of the death drive in Laura Mulvey, *Death 24x a Second: Stillness and the Moving Image* (London: Reaktion, 2005), pp.72-76.
10. June Swann, "Shoes Concealed in Buildings", *Costume* (1996, vol.30), pp.56-69.
11. For a discussion of women's self-categorisation through emotional investment in clothing, see M. Banim and A. Guy, "Dis/continued Selves: Why Do Women Keep Clothes They No Longer Wear?" in *Through the Wardrobe. Women's Relationships with Their Clothes,* eds. A. Guy, E. Green and M. Banim (Oxford: Berg, 2001), pp.203-19.
12. *Manolo Blahník Drawings* (London: Thames and Hudson, 2003), p.82.
13. Gibbon, *supra* n.4, p.53.
14. Gösta Sandberg, *The Red Dyes: Cochineal, Madder and Murex Purple,* trans. Edith M. Matteson (Stockholm: Tidens förlag, 1994; repr. Asheville, NC: Lark Books, 1997), p.26.
15. The director's commentary mentions that the shade of pink appeared warmer in the film version and has lost tone in the transfer to DVD.
16. Michael Powell, *A Life in Movies: An Autobiography* (London: Faber and Faber, 2000) [1986], p.664.
17. Hans-Jörg Uther, *The Types of International Folktales: A Classification and Bibliography Based on the System of Antti Aarne and Stith Thompson.* Vols.1-3. FF Communications No. 284-86 (Helsinki: Academia Scientiarum Fennica, 2004).
18. Even so, the UK release has been edited to reduce the horror and sexual content.

Peeling the Groomed Surface

father her loved
 truth wicked. Sometimes

 Dick! Oh staring tonight? Easy boy.

 Dick! father
 you because

 She
 come you much.

Models Murdered / Charlie T. Porter

In *The Lodger* (1927), Alfred Hitchcock's first commercial success, the woman in danger is a model fulfilling the role that cinema usually bestows on the beautiful: she is a woman who deserves to be punished. Except in Hitchcock's case, her employment is used to point to unexpected positives: the character, Daisy Bunting, may be a ditz, but she's a relatively liberated one, recognisably 20th century in her attitude to what she should be able to do. In contrast, her mother is a Victorian worrier, her position as landlady marking the upper end of her expectations in life. Hunched over, skirt long, tops drab, hair up in a bun, it is fashion that highlights the distinction. *The Lodger* is a silent movie, and clothing helps to tell its story.

The Lodger is about a London murderer called "The Avenger" whose female prey are young blonde women. The film centres on the Bunting boarding house, where a lodger takes a room just as news of The Avenger's seventh victim breaks. Daisy still lives with her parents, and is the subject of concern, both because of her employment and the colour of her hair, but also because the murder scenes are getting increasingly closer to their home. Moving matters to crisis point, the man who's just taken up lodgings, played by Ivor Novello, fits the description of The Avenger, not helped by the menacing intensity of his interest in Daisy (and also the drape and menace of his clothes – if this man wants to avoid being accused of multiple murders, he needs to dress more jovially). To all involved – u as the audience, and those in the film too – it seems inevitable that Daisy will become The Avenger's next victim.

The film was made four years after Coco Chanel introduced her famous jacket, and by this point the then provocative message of her clothing – that women have the right to independence and equality – had spread wide. We first see Daisy stepping onto the catwalk, which looks more like a circu ring than the recognisable up-down strip of the modern fashion show (cinema is a fascinating filter through which we can see the development of shows – here the models dawdle, as they did in the 1970s, as shown by an Ossie Clarke show attended by David Hockney in Jack Hazan's 1974 documentary *A Bigger Splash* (clearly, the rapid catwalk pace that you see in Robert Altman's *Prêt-à-Porter* 1994, is a more recent development). For the fashion show, Daisy is wearing an extravagant white fur coat over a gown; the models all around are just as opulent, one with a cigarette in her hand to suggest that these are woman who understand the meaning of the word "louche". It's actually not the catwalk clothes that are interesting in this film, since as voiceless women in pretty frocks they're fulfilling cinema's traditional role as victims. More important is what these women are seen to wear in their normal lives. Hitchcock takes us backstage, ostensibly to reinforce the sense of the public obsession with the Avenger case (and maybe equally significantly, an obsession with the elusive figure of the model, actually known in those days as mannequins), since we see all the models talk of the murders with gallows humour. During these scenes, we are fed information on a subconscious level about the clothes they are wearing – their cloche hats, body-skimming slender dresses and mannish jackets, signs of the radicalism happening at that time in women's wardrobes on a mass scale. Just by dint of their fortunate birth-date, these are groundbreaking women, their career in the fashion industry exaggerating the freedoms they are allowed.

The mother, born a couple of decades too early, will never break out of her dowdiness. But Hitchcock is careful not to make Mrs Bunting a moraliser – she seems in awe of what her daughter is able to do within society. The young Hitchcock has a different motivation for embracing female emancipation, setting a pattern for his entire career; he wants his women to be free so that he can have his various murderers hunt them down. It's the first appearance of a dichotomy that's at the centre of much of Hitchcock's work – he embraces feminism, while still seeing women as natural targets: liberated, but victims because of it.

Taken by its very definition, the model is something that's exemplary, as it were an ideal. It's a natural arc in storylines for something that's ideal to suffer some sort of fall – we don't like ideals to exist untested. And so it is that models in the fashion industry are made to suffer in cinema. Taken in isolation, this argument could be used to explain away this fact, but of course there are other elements at play, most importantly the male-dominated society's exploitation of women. There are our personal feelings of rejection: models have publicly been told that they are beautiful. No matter how secure we are with our own appearance, in most there will be some tinge of jealousy, if only for the affirmation that their chosen career gives them.

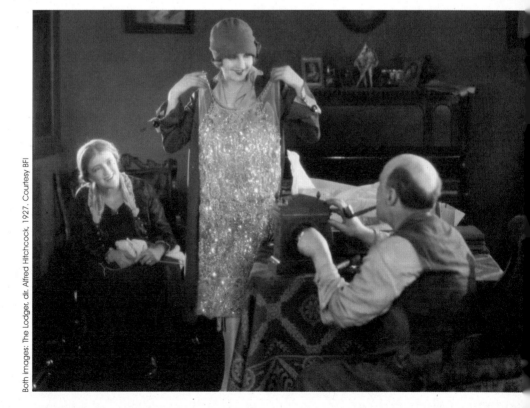

Both images: The Lodger, dir. Alfred Hitchcock, 1927. Courtesy BFI

There's also the flippancy of fashion itself, which puts itself in a position to cause ill feeling. The fashion industry repeatedly uses displays of extravagance to flaunt its elevated position and taunts those below it. It's in the high price-tags of clothes, in fashion's close relationship with celebrity and the exclusivity of the catwalk show circuit. These are all tools used by brands to say as much about who it doesn't want to be associated with – the vast majority of the global population – as the ultra-rich few that it does. In reality, this is all just a ruse to cause envy in the have-nots, who then buy the entry-price products like fragrance and bags, the mass sectors of what's called the luxury market.

It's a business model based on jealousy that fuels an entire industry, but it does have an unfortunate by-product. It means that fashion itself becomes the subject of derision, scorn and knee-jerk hatred. Because of the tactics employed by the fashion industry to create desire, much of that reaction is justifiable. Models are on the frontline of this – although they are being used to create the envy, the public don't see the conglomerate the models are representing. It's as if the models are seen as the ones who have set out to create envy themselves. It adds to the ease with which they are allowed to become the victims of villainy in cinema.

Should we pity these poor models as victims? Sometimes. The acclaimed biopic *Gia* (Michael Cristofer, 1998) shows the real-life breakdown of morals and spirit suffered by '80s model Gia Marie Carangi, and echoed in the sad tale of many a model – they often become victims of themselves. Everyone remembers these tales and assumes that they count for all in the industry. Perhaps this stereotype of models as uninhibited sexual animals and drug fiends is another reason why they are punished on film.

But don't feel too sorry for them, since most of those within the fashion industry, including the models, subscribe to the skewed morals which propel it forward. That "don't wake up for less than $10,000 a day" comment from Linda Evangelista stuck because it's an extreme example of the truth. Once in the bubble, it's easy to get swept into the clichéd but accurate vileness that characterises much of the industry. In this world, most would actually enjoy watching a film of models being murdered – they'd find it funny.

In *The Lodger*, there are two key levels on which fashion works, two levels that often cause fashion to stumble over itself rather than move forward. There is this position it puts itself in which invites the general public to feel hatred towards it, encouraging an extreme extension of this in the exaggerated world of the cinema – that those involved are the rightful victims of murder. But then there is the actual clothing itself that works to define social and geographical situations. More often than not, the former take attention away from the latter. In fact, the former positively hate the latter, finding it worthy and unbearable. Yet it is the latter that has the resonance and the power. It's just that it isn't as glamorous, isn't as decadent, isn't suited to the plotlines needed to give movies their momentum. In cinema at least, no one wants to murder a fashion academic.

This is a prime example of cinema's entirely imbalanced attitude to fashion – it is used as a plot device to allow for either violence (*The Lodger*; *Blood and Black Lace*, Mario Bava, 1964; *Eyes of Laura Mars*, Irvin Kershner, 1978) or ridicule (*Zoolander*, Ben Stiller, 2001; *The Devil Wears Prada*, David Frankel, 2006). The value of fashion, and those that work within it, is seen as negligible. Yet as we've seen with *The Lodger*, fashion plays a much more fundamental role in cinema, allowing a director to pinpoint precisely the mood of his characters and the society around them without having to script a word.

Eyes of Laura Mars, dir. Irvin Kershner, 1978. Courtesy The Kobal Collection

Sometimes the Truth is Wicked: Fashion, Violence and Obsession in *Leave Her to Heaven*
Rebecca Arnold and Adrian Garvey

Leave Her to Heaven, directed by John M. Stahl in 1945 and adapted from a best-selling novel by Ben Ames Williams, was a huge commercial success in its day. A generic hybrid, its fusion of melodrama and *film noir* tropes is realised in vivid Technicolor, lending a stylised hyper-real quality to the action. In characteristic 1940s style, a layer of pathology intensifies the frustrated emotions and domestic tensions of a classic family melodrama narrative. The autonomous heroine becomes a fearful and destructive figure, an agent of violence and death.

The film's protagonist, Ellen (Gene Tierney), is presented as an obsessive character, acting out an unresolved father complex on the hapless Richard (Cornel Wilde), who is overwhelmed by her driven, perfectionist nature. "There's nothing wrong with Ellen, she just loves too much," Richard is counselled by her mother, but this excessive love – always contrasted with the conventionally nurturing affection promised by Ellen's sister Ruth – is shown as threatening and consuming, and leads to the death of both Richard's brother and the couple's unborn child.

Theme and *mise-en-scène* identify the film as melodrama, primarily a non-realist, heightened genre in which the repressed feelings of the characters are manifested in stylistic and visual excess. Stahl is now best known for a number of 1930s films, including *Imitation of Life* (1934), which were to be remade in the 1950s by Douglas Sirk. Indeed, the production values, "adult" themes and use of colour in *Leave Her to Heaven* strongly anticipate the more intense style of 1950s melodrama.

The film's narrative simultaneously follows a classic *noir* trajectory, with Richard's fateful encounter with Ellen precipitating a descent into a disordered world of deviance and crime, and Ellen herself embodying many characteristics of a *film noir* archetype. This is elucidated by what Janey Place described as "the combination of sensuality with activity and ambition", identified with the *femme fatale* and contrasted with "the general passivity and impotence which characterizes the *film noir* male".[1] Crucially, Kay Nelson's costuming of Ellen gives her authority, while simultaneously masking her alienation and providing clues to her fractured psychology.

Ellen's discomfiting power is made apparent in the couple's first meeting; as Mary Ann Doane notes, her "relation to an excessive, *wild* desire is signalled from the very beginning of the film by her appropriation of the gaze, by the fact that she stares intently at Richard".[2] Despite its comic tone, this scene clearly establishes the nature of the couple's relationship, with Ellen drawn by Richard's resemblance to her dead father, then undermining both his romantic and literary efforts.

For this first encounter Ellen wears a deceptively simple greige dress. Both its soft colour and subtle cut, emphasising her elegant figure, denote her superior status as a woman of fashion. The dress acts as a backdrop to her gold jewellery – contemporary fashion shoots also favoured this sophisticated combination, which emphasised the glow of precious metals against matte, fine wool neutrals. It also serves to emphasise Ellen's face, her perfect make-up and glossy hair. When she dons an oversize fur-collared coat to leave the train, her alliance to fashion, luxury and grooming is complete.

The elegant, soft folds of later outfits serve to reinforce this image further, and to contrast her reliance on fashion with the other female characters in the film. While her mother and Ruth both wear costumes that are in line with the fashion of the time, neither is particularly stylish, and they are certainly not wearing the high fashion outfits that Ellen favours. Hollywood often used fashion unproblematically as part of the overall glamorous representational styles that dominated many films of the period. However, in *Leave Her to Heaven*, Ellen's style signals her otherness. Her obsessive attention to her appearance is cast as a symptom of her obsessive love, her glamour as an intimidating threat to those around her. It is a means for her to seek control of her self-image, and to gain influence over the people she encounters.

Even when she adopts more "homely" styles during her time at "Back of the Moon", her plaid cotton skirts and sleek trouser ensembles retain an air of studied perfection. Ellen seems too aware of how to use these garments performatively. She is presenting a mask of domesticity, just as she presented a mask of upper-class fashionability earlier in the film. In each case, Ellen's costumes provide clues to her psychological state, and thus to the dangers she presents to herself and to those around her. She disguises her alienation from her mother and Ruth, and from anyone she perceives

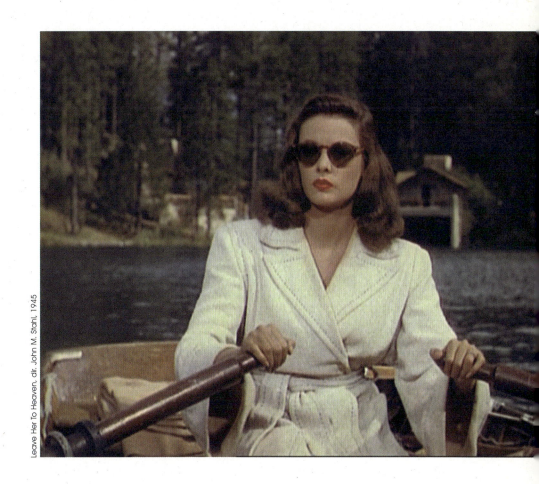

Leave Her To Heaven, dir. John M. Stahl, 1945

as challenging her relationship with Richard, in particular his disabled brother Danny.

This representation of fashion as symptomatic of a damaged psychological state, that ran counter to women's "natural" role as wife and mother, was echoed in other aspects of American culture in the post-war period. There was a marked concern with contemporary gender roles, in particular how men and women would cope with the impact of the war, and how they would return to normality. Several books, including Ferdinand Lundberg and Marynia F. Farnham's *Modern Woman: The Lost Sex* (1947) and Richard Curle's *Women: An Analytical Study* (1949), highlighted these issues, and portrayed fashion as not just unnatural, but also a highly problematic expression of femininity, as is apparent in Lundberg and Farnham's characterisation of the woman of fashion as "a neurotic ... the frequently seen overdressed, over-perfumed, over-bedizened person, the ever-current version of the 'glamour girl'".[3] Fashion magazines such as *Vogue* and *Glamor* ran articles discussing the problems of gender and dealing with returning husbands once the initial glow of the allied victory wore off, and women had to get used to returning to a more subordinate role.[4] These anxieties were also expressed in many Hollywood films of the period.

In *Leave Her to Heaven*, this ambivalence towards fashion and femininity is clearly expressed in Ellen's oriental flower-print dress, worn towards the start of the film in New Mexico. It is very similar to a 1944 advertisement for an Adrian ready-to-wear outfit, which was made of the same soft drape fabric and blush colours, cut to shape to the body and emphasise the shoulders. This dress separates Ellen from the other women, its colour exaggerates her femininity, and its print states her exotic otherness. She uses this powerful glamour to ensnare Richard, who seems both thrilled and intimidated by her seduction of him. She skilfully uses not only her patrician fashion style, but also her consciousness that she is "other" to manipulate him into a whirlwind marriage.

It is not just Ellen's costuming that is deployed in the film to signal her fashion status and to entrap Richard. Gene Tierney's athletic body is displayed to full effect in the trim suits and flowing dresses, as well as in her riding gear and swimwear. Sportswear became a signature fashion style in the America of the 1930s, and by the mid-1940s it was established as part of a national ideal of modern, dynamic femininity and streamlined physicality. It was represented in fashion magazines as quintessentially American, and therefore in contrast to the leisured elite styles of Old World couture. Both Ellen and Tierney encapsulated this ideal. Indeed, Tierney was one of the very few film stars to be found on the pages of high-fashion magazines such as *Vogue* and *Harper's Bazaar* at the time. Her upper-class air and athletic figure meant that she fitted in well with the society women and models that dominated their pages.

This imagery resonated with contemporary fashion photography, particularly the work of Toni Frissell and Louise Dahl-Wolfe. These photographers combined snapshot-style nonchalance with monumentalising portrayals of models in simple sportswear that emphasised lean athleticism, as described by *Vogue*: "It is not just an accident of Nature and heredity that American women, as a group, have the most admirable figures in the world ... [with] our long-legged frameworks, our athletic lives, and our conscientious efforts towards sleekness."[5] This ideal was then connected to the "ideal" American landscape, from pale sandy beaches and clear blue seas to arid deserts, which were already a symbol of national identity. In Frissell's photographs of models paddling in the ocean, and Dahl-Wolfe's shots of models at Frank Lloyd-Wright's famous Taliesin West building set against Arizona skies, women became emblems of the American ideal of simplicity and naturalness.

Leave Her to Heaven's vivid Technicolor echoed Dahl-Wolfe's use of colour to construct hyper-real visions of an Edenic landscape. Ellen's increasingly destructive obsessions, and violent horror of Danny, and later her own unborn baby become all the more shocking when portrayed in this environment. The bright sunshine glistening on the water, the lush trees, Ellen's trim bathing suit and pure white wrap, her fashionably sport-toned body; these all add to the shock when she allows Danny to drown. Her crime is committed in a setting diametrically opposed to the twilight city streets of most *film noir*. Her violence is passive, yet fatal. Her tortured psychology and aberrant behaviour in this pivotal scene dramatically subvert expectations constructed in fashion photography and Hollywood cinema, and already established within the national, and arguably international, psyche. The clues to Ellen's mental state, hinted at in her perfectionist and obsessive approach to fashion, which were heightened through her manipulation of American style ideals, come to catastrophic fruition as she turns into the perverse, anti-maternal woman feared by contemporary commentators.

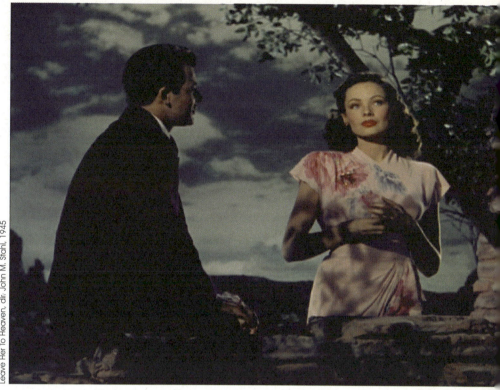

Leave Her To Heaven, dir: John M. Stahl, 1945

Detail of Adrian Original and Enka Rayon advert, Photograph Georges Hoyningen-Huene (Vogue, 1944)

Her transgressive nature pushes her to further murderous acts in the second half of the film. Her pregnancy, which she anticipated would bring her closer to Richard, merely makes her more paranoid, convinced that she is losing him to Ruth. As her stomach swells, she begins to reject her new, maternal body, disgusted by the growing baby's impact on her once elegant figure. She attempts to disguise it in a series of muffling robes. These once again mimic contemporary fashions for "relaxing wear" and nightwear. Yet to Ellen they underline her perceived entrapment and she becomes increasingly agitated by her lack of control over her body. When she decides to throw herself down the stairs to abort the baby, she remakes herself, discarding her thick wool dressing gown for a diaphanous sky blue lace nightdress and negligee and matching satin slippers. In Ellen's psychological state, this signals her realignment with fashion and all that it embraces. She is reclaiming her sensuality, glamour and sexual allure, while dressing to perform another violent act. Her first outfit, worn when she returns from the hospital, underlines her perverse triumph, with her body displayed in a blood red swimsuit as she runs up the beach, exhilarated following a swim in the ocean.

While Richard is the defendant in the extended courtroom sequence at the end of the film, its eventual purpose is to expose and condemn Ellen. Her criminality is twofold: she is guilty of murder and she has also transgressed expectations of appropriate feminine behaviour. The film reinforces this punitive viewpoint by framing the entire story in flashback, related by a lawyer, as a moral lesson. However, the apparently happy ending, which unites a chastened Richard with Ruth, is sombre and perfunctory, and, ultimately, the film fails to contain Ellen's disruptive force. *Leave Her to Heaven* entwines the themes of fashion, obsession and violence, which reflected contemporary anxieties concerning gender and morality. Fashion's role in the construction of self-image, and therefore in exposing hidden psychologies, is exploited in Ellen's costuming to define her character, and provide clues to its hidden flaws. Yet it is also an essential part of our reaction to her. Despite her transgressive and shocking crimes, Ellen's all-American *femme fatale* transcends the moral message that the film nominally espouses.

Notes

1. Janey Place, "Women in *Film Noir*" in E. Ann Kaplan (ed.), *Women in Film Noir* (London: British Film Institute, 1978), pp.52-53.
2. Mary Ann Doane, *The Desire to Desire: The Woman's Film of the 1940s* (Bloomington and Indianapolis: Indiana University Press), p.121.
3. Ferdinand Lundberg and Marynia F. Farnham, *Modern Woman: The Lost Sex* (New York: Harper and Brothers, 1947), pp.222-23.
4. See for example "Anxious Women", *Harper's Bazaar* (October 1946), and Dorothy L. Sayers, "The Woman Question", *Vogue* (15 January 1947). Simone de Beauvoir published an article based on work for her forthcoming book *The Second Sex*: "'Femininity, the Trap' ... A French View", *Vogue* (15 March 1947). All references are to American editions of fashion magazines.
5. "Good Form in America", *Vogue* (1 February 1939), p.114.

Leave Her To Heaven, dir. John M. Stahl, 1945

Leave Her To Heaven, dir. John M. Stahl, 1945. Courtesy BFI

Plein soleil: Style and Perversity on the Neapolitan Riviera / Stella Bruzzi and Pamela Church Gibson

Plein soleil (*Purple Noon*), René Clément's 1960 adaptation of Patricia Highsmith's 1955 thriller *The Talented Mr. Ripley*, is not an automatic choice for a fashion and film festival. However, several factors make it interesting in relation to fashion, film and criminality, such as the extraordinary physical beauty and star persona of its central actor, the rising, angel-faced icon of French cinema, Alain Delon; the specific linking in both book and film of criminality with costume and issues of masquerade; and the interweaving of costume into the *mise-en-scène*.

In the original Highsmith Ripley novels, the protagonist is the criminal who gets away with it, not the police and detectives in pursuit. A later novel (*Ripley's Game*) was made into a movie in 2002, directed by Liliana Cavani and starring John Malkovich as Ripley. Whereas we are used to Malkovich playing the hero as villain, Delon – in his first starring role – might be expected to play a straightforward hero. Furthermore, the underworld is central to French cinema; its depiction during the 1940s and 1950s had featured older, more battered and morally ambiguous actors such Jean Gabin in *Grisbi* (*Touchez pas au grisbi*, Jacques Becker, 1954) and Jean Servais in *Rififi* (*Du rififi chez les hommes*, Jules Dassin, 1955). Clément's choice of Alain Delon for Ripley was a very deliberate rupture with tradition: he was neither seamy nor louche but young, glamorous and conventionally handsome. Allegedly, while working as a deckchair attendant on the beach at Cannes – where rumour has it he was first spotted – Delon was not only acting as gigolo by night but was also connected in some way with the criminal underworld. Later, though acquitted of any blame, he was involved in a notorious trial, his bodyguard having been found dead, presumably murdered.

Delon was one of the first male heroes to be stripped and fetishised on screen. Steven Cohan refers to the 1950s as "the age of the chest";[1] there were the phallic torsos central to the Hollywood epic, glimpses of Paul Newman's sinewy physique in *Cat on a Hot Tin Roof* (Richard Brooks, 1958), Marlon Brando's famously sweaty singlet in *A Streetcar Named Desire* (Elia Kazan, 1951) and William Holden standing astride Kim Novak in *Picnic* (Joshua Logan, 1955), his ripped shirt falling of him. And then, of course, the defining scene of *From Here to Eternity* (Fred Zinnerman, 1953), in which Burt Lancaster rolls in the Hawaiian surf with Deborah Kerr, is most notable for the way in which the lighting, the cinematography and the *mise-en-scène* all foreground Lancaster's splendid musculature while Kerr's body is discreetly covered in a black one-piece and mostly obscured from view. As with Delon in *Plein soleil*, Lancaster was the object of our gaze. The iconic moment of the film is when Delon, as Ripley, temporarily takes control of the boat, gripping the helm, dressed only in white jeans, his perfectly proportioned classical torso contrasted against the luscious blue sky, which emphasises the colour of his eyes.

The film's creation of Delon as an icon is exemplified by a scene which has no apparent narrative function but is simply there to build up the importance of this image – Tom's extraordinary, obscure and unmotivated stroll around a Neapolitan fish market. This sequence is shot with a documentary-esque hand-held camera that appears to be following and reacting to Delon as if the scene was improvised. Delon, in turn, is behaving out of character: no longer the meticulous and precise fraudster, more the movie star caught on his day off, chatting to the fishmongers, sampling their wares and looking at him as if expecting to see another, less obtrusive camera on him. If this sequence has any relevance at all, it is in cementing our desire for and our desire to identify with the film's star, through the prolonged and numerous raw-edged, slightly breathless close-ups of Delon as he walks by, with his jacket held nonchalantly over one shoulder. The impetus of the scene seems to be to capture the actor's easy, youthful, narcissistic beauty, his gracious though detached smile. Why, then, set such an iconic, abstracted scene in a fish market, intercutting Delon's tanned features with close-ups of weird varieties of fish? The perversity of this juxtaposition serves as just one indication that meaning and richness in *Plein soleil* are embedded not in plot and narrative, so much as in *mise-en-scène* and tonal stylisation, centred on the figure of Delon.

Earlier in the film, however, Tom Ripley (Delon) had been a figure of abjection, his body blistered by sunburn; the metamorphosis of the figure of masochism into the dominant object of desire completes the sadomasochistic subtext of *Plein soleil*. Unlike his configuration in Anthony Minghella's much later *The Talented Mr Ripley* (1999), Tom in this version is much more preoccupied – as he is in the original book – with narcissistically identifying himself with and as Philippe (Maurice Ronet), of wanting to emulate him, then to enact him, then to acquire his life. This becoming Philippe

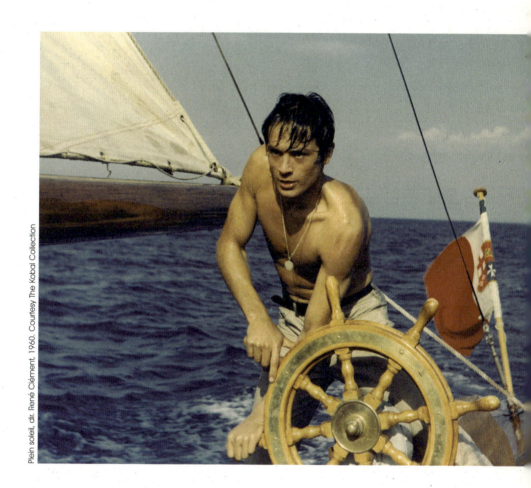
Plein soleil, dir. René Clément, 1960. Courtesy The Kobal Collection

is enacted on the level of costuming and dress, as in the early scene in which Ripley – thinking he is alone and unobserved, as Philippe and Marge (Marie Laforêt) are canoodling on the sofa, raids Philippe's wealthy man's wardrobe. He puts on Philippe's clothes and the white Gucci shoes fit him perfectly; he chooses a striped blazer and matching tie, fixes his hair in a complementary preppy style. He then goes up to his mirror image and kisses it – not merely a demonstration of his attraction to Philippe, as Chris Straayer posits,[2] but a more complex demonstration of narcissistic desire commensurate with *Plein soleil*'s pervasive fetishisation of Delon: disguised as Philippe he is talking to himself, seemingly to Marge, telling her he won't leave her to return to America. In Highsmith's original, the scene concludes with Ripley, dressed as Dickie (Philippe in the film), saying to his reflection: "You know why I had to do that [kill Marge]. You were interfering between Tom and me – No, not that! But there is a bond between us." Like Minghella in his adaptation, Straayer argues that Ripley is "left out of the erotic triangle", but this is only part of it, as what Clément omits from his adaptation is Tom talking to his reflection about leaving Marge for him. Tom's departure from the lovers on the sofa is also the moment at which he falls in love with *himself,* upon realising how easy it is to impersonate and become Philippe.

Whereas in both the original novel and in Minghella's later adaptation, it is Tom who is in love with Dickie/Philippe, in *Plein soleil* the sexual attraction is virtually reversed. Delon's complex appeal – his boyishness, his opacity, his hardness, his macho detachment – is perfect as the focal point of the film's layered eroticism. At the start of the film, Ripley and Philippe enter, the latter in an open tan-coloured suede shirt, the former wearing a pale blue cotton shirt untucked at the back and mis-buttoned as if put back on in a hurry. If one didn't know better, one would assume that they were lovers – and Marge's palpable jealousy backs this up. Marge is presented throughout as conventionally pretty and dressed in the Riviera style of the time of striped one-pieces, off the shoulder t-shirts and shirtwaister dresses. In contrast to Tom, however, who appears naked even when dressed, she appears clothed even when engaged in sexual congress. Marge is superfluous and never the object of the camera's attention; when she and Philippe argue and she leaves him and Tom alone on Philippe's yacht (named, conventionally, "Marge") she becomes "yesterday's girl".

The situation when Marge vacates was already charged in many ways. Throughout, Philippe has been casually cruel towards Tom, and on the yacht their bantering becomes sadistic as he goes from criticising Tom's table manners to punishing him by putting him overboard onto the yacht's dinghy so that he and Marge can have sex uninterrupted – a practical joke that backfires as Tom is left in the hot sun for far too long and becomes sunburnt and feverish. Earlier, on this trip, Philippe seems to have derived definite pleasure from his awareness that Tom is watching their lovemaking through the cabin window; the sadism therefore could be interpreted as the result of Philippe's guilt-ridden repression of his attraction to Tom. The game, however, doesn't just go one way: Tom secretes an earring in Philippe's shirt pocket in order to inflame (once again) Marge's jealousy, so that she might leave the two men on their own. When Marge demands to know who the earring belongs to, Philippe flies into a rage and throws her manuscript on Fra Angelico into the sea, an excessively vindictive act that prompts Marge's departure from the boat.

Left alone, there is a temporary rapprochement between Philippe and Tom, but as it turns out, within a few minutes, Philippe is murdered, the last stage in this sadomasochistic endgame. At this point the two men are at their most indistinguishable, both dressed in dark blue shirts, a use of costume that connotes their potential as a couple. However, it is also at this point – as they play cards on deck – that they discuss in intricate detail what Tom might do to assume Philippe's identity successfully once he has murdered him. Then, Tom grabs the knife he has hidden by his side and stabs Philippe. The *mise-en-scène* of *Plein soleil* contributes to the perversity of this scene – this all happens very fast, against the breathtaking blue of the sea and the sky. Tom immediately appropriates Philippe's identity: at almost the same time as he swaddles the corpse in tarpaulin, ties it up and throws it overboard, he goes into the cabin to get out of the wardrobe Philippe's garish, purple Hawaiian shirt. It is not the act of the murder that is the sexual conclusion of the preceding sadomasochism but the frantic need to become Philippe.

After the murder, Tom adopts Philippe's identity but in such a way as to become far more stylish and soigné than Philippe ever was. Tom uses Philippe's money to perfect an impersonation of what he believed Philippe could be; whereas Philippe himself had been a bit "Eurotrash", Tom as Philippe wears beautifully cut suits, blazers and loafers – approximating in his dress and personal styling

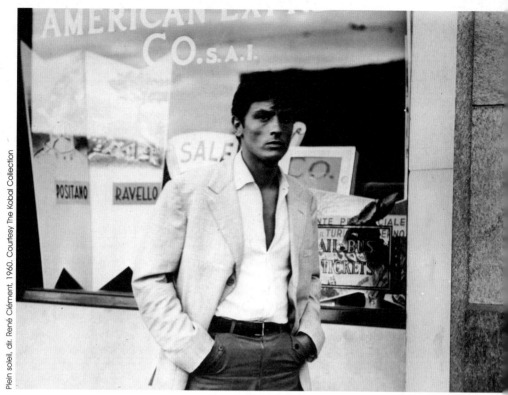

Plein soleil, dir. René Clément, 1960. Courtesy The Kobal Collection

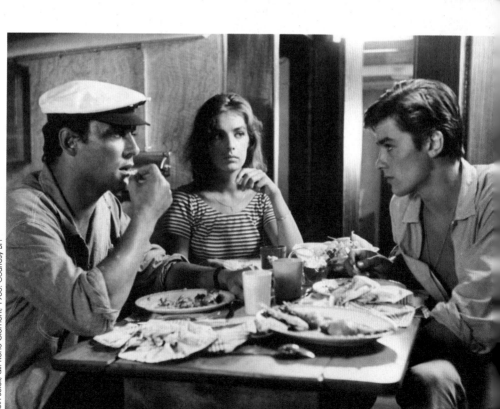

Plein soleil, dir. René Clément, 1960. Courtesy BFI

the French and American image of the perfect English gentleman. Tom's journey from the guilty Cocteauesque moment when he tries on Philippe's clothes at the beginning to the calm performance of idealised elegance and privilege is characterised throughout by an intense narcissism. Clément's camera style collaborates in the acknowledgement of his beauty – the many close-ups of Delon's face are lit in such a way as to emphasise his cheekbones, his perfect jawline, the colour of his eyes and his long, dark lashes.

As if frightened by Tom's entirely self-sufficient, autoerotic assimilation and extension of Philippe, *Plein soleil* invents a situation entirely absent from the book, which is a sexual encounter between Tom and Marge – totally unmotivated and virtually untenable. The only thing that seems to link them is costume: they are both in pristine white linen, as she offers to show him around the old city of Naples. It could be argued that Tom, once again, is falling in love with himself, the film's circularity having become by this point both perverse and claustrophobic. Ironically it is at this juncture that Tom relaxes noticeably – going swimming with Marge (in dark striped trunks and a towelling robe) and stretching out languorously in a deckchair – as if sure that his adoption of the perfect gentleman persona is now complete.

Plein soleil changes the book's ending quite crucially by having Tom being found out, with the discovery of Philippe's body, just as he thinks he's got away with it. The film's multiple game-playing, the sadism and the repression of homosexuality seem to culminate and converge in this ending: a final act of punishment, perhaps. This is an interestingly accurate rendition of Highsmith's Tom Ripley – until the final images of the policeman coming to question him. For Ripley in the novel is polymorphously perverse, uncontainable and unknowable, but he gets away with it – however, Clément seems to need to impose conventional closure and morality, where Highsmith relished her creation's slippery and lucky immorality. It is this rich ambiguity that Delon encapsulates and which launched his multifaceted career as the cold, mesmeric chancer of 1960s European cinema.

There is a tradition in cinema of the dapper, nattily dressed criminal, a tradition into which Delon as Ripley effortlessly falls. Just as the gangsters of 1930s Hollywood were recognisable as men of crime through their fetishisation of beautiful suits and their love of showy sartorial flourishes, so Ripley is marked out as the criminal of *Plein soleil* by his narcissistic fixation with clothes, particularly Philippe's. The cinema criminal's clothes are usually indicative of a different, sometimes perverse, sexuality; in *Plein soleil* Ripley's clothes are linked to his ambiguous sexuality, his narcissism and his psychopathic tendencies.

Notes

1. Steven Cohan, *Masked Men: Masculinity and the Movies in the Fifties* (Bloomington, IN.: Indiana University Press, 1997), p.189.
2. Chris Straayer, *Deviant Eyes, Deviant Bodies* (New York: Columbia University Press, 1996).

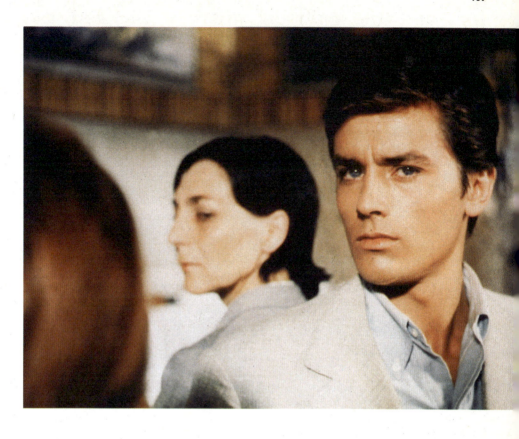
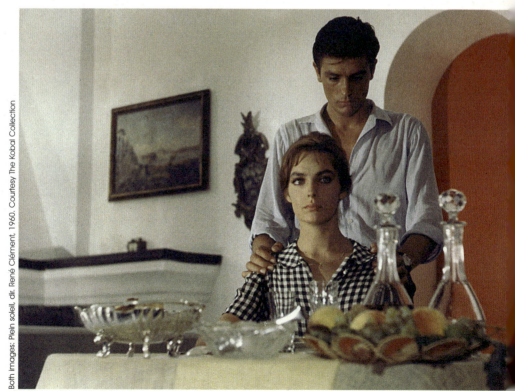

Both images: Plein soleil, dir. René Clément, 1960. Courtesy The Kobal Collection

Death on the Runway: Mario Bava's *Blood and Black Lace* and Arne Mattsson's *Mannequin in Red*[1] / Tim Lucas

The shooting title of Mario Bava's Technicolor thriller *Blood and Black Lace* (*Sei donne per l'assassino*/Six Women for the Killer, 1964) was *L'atelier della morte* – "The Fashion House of Death". This rejected title reflects the sense of irony that Bava's friends and family remember as being at the core of his personal character. An experienced cinematographer, responsible in the 1950s for cultivating the most glamorous of Italy's "Hollywood on the Tiber" icons (Gina Lollobrigida and Steve Reeves among them), Bava believed that all cinema was at heart an illusion; he believed, and proved, that the skilled application of fashion and glamour photography principles could make any subject or scene arousing – even a crime scene strewn with murder victims.

In putting his theory into practice, Bava made motion picture history. While *Sei donne per l'assassino* wasn't the first successful – or even the first innovative – colour thriller, it did revolutionise the way thrillers were made, particularly in Italy, and it is recognised today as the smoking gun (or glittering straight-razor) behind an entirely new kind of thriller: the *giallo*.

It must be understood that the meaning of the word *giallo* varies between English and Italian filmgoers. Italians use the word *giallo* (and its plural form *gialli*) to describe all mystery and thriller fiction, regardless of style and period; the word, which means "yellow", refers to the colour-coded mystery novels and story anthologies published in Rome by Edizioni Mondadori, an idea that the company borrowed from the popular "yellow jacket" mystery fiction published in Britain by Hodder & Stoughton. To an Italian, the Miss Marple films starring Margaret Rutherford qualify as *gialli*, as does any film based on the writings of Agatha Christie, Edgar Wallace or Sir Arthur Conan Doyle, and the film genre of the same name can be traced back to the silent days.

In English-speaking countries, however, the term *giallo* has been specifically adopted for a phenomenon that began with Bava in the early 1960s – with his black and white feature *The Girl Who Knew Too Much* (*La ragazza che sapeva troppo*, 1962) and the segment called "The Telephone" ("Il telefono") in his 1963 colour anthology *Black Sabbath* (*I tre volti della paura* / The Three Faces of Fear). These films specifically inspired other filmmakers to follow his example, including Dario Argento, Antonio Margheriti, Sergio Martino and (in a rare American case) Brian De Palma. West of Italy, a *giallo* is an exquisitely decorative and vicious thriller viewed, at least in part, through the eyes of a killer; it is a murder mystery that eroticises – or at least fetishises – violence, revelling in the details of titillating murder rather than the details of deduction and police procedure.

Alfred Hitchcock was perhaps the first to properly mine this territory with the famous shower scene in *Psycho* (1960) – arguably, screen's first true *ménage à trois* of sex, violence and cinematic technique – but it was Bava's genius that took that example, whose deliberately stark and sordid black-and-white photography imbued the sequence with tabloid-flavoured shock and revulsion, and applied to such material the tenets of fashion and glamour photography: velvety lighting, heightened colours, curvaceous corpses arranged in poses of provocation.

Bava may have been pointed in this direction by an obscure Swedish thriller entitled *Mannequin in Red* (*Mannekäng i rött*, 1958). It was the second in a series of five films starring Karl-Arne Holmsten and Annalisa Ericson as the husband-and-wife detective team, John and Kajsa Hillman. Based on a series of pulp novels by Folke Mellvig, the series began with *The Lady in Black* (*Damen i svart*, also 1958) – photographed in black and white by the destined-for-greatness Sven Nykvist – in which the Hillmans investigated a series of murders allegedly committed by a ghost. All of Mellvig's novels had the gimmick of including a colour in the title, and as director Arne Mattsson prepared to make his second *Hillmanthriller* (as they are known in Sweden), he took a lead from the title and decided to photograph *Mannequin in Red* in colour. Replacing Nykvist as cinematographer was Hilding Bladh, whose biggest prior success had been Ingmar Bergman's *Sawdust and Tinsel* (*Gycklarnas afton*, 1953). Bladh approached colour cinematography very much as Mario Bava had when he photographed *Adventures of Giacomo Casanova* (*Le avventure di Giacomo Casanova*) in 1955: he lit the sets and actors as he would have done were he filming in black and white. This, combined with diffused lighting filters and intricate cross-lighting, helped to give *Mannequin in Red* a distinctively velvety texture which added greatly to its overall ambiance of luxuriant criminality and sin.

Since Mattsson's film was never widely distributed to other countries and remains unavailable in English (it is being presented at this festival with English subtitles for the first time), a thorough account is necessary. Like *Blood and Black Lace*, *Mannequin in Red* is set in a fashion salon where a series of murders takes place. The salon in Mattsson's film, "La Femme", is owned and operated by the

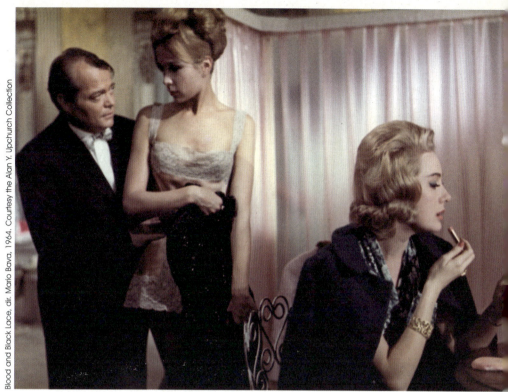

Blood and Black Lace, dir. Mario Bava, 1964. Courtesy the Alan Y. Upchurch Collection

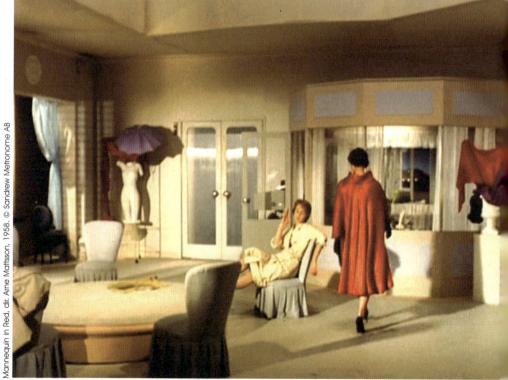

Mannequin in Red, dir. Arne Mattsson, 1958. © Sandrew Metronome AB

wheelchair-bound Madame Thyra Lennberg (played by Lillebil Ibsen, and always seen with a white cat on her lap) who comes to John Hillman's attention after he uncovers a blackmail scheme involving Lennberg's troubled foster son Bobby (Bengt Brunskog). When Katja (Elsa Prawitz), one of La Femme's star models, is found dead with a dagger in her back in the salon's display window, Hillman's wife Kajsa agrees to go undercover, working as a freelance model to keep an eye on things from the inside. The behind-the-scenes reality of the salon, Kajsa finds, is quite the opposite of the alluring image it projects, with a great deal of less literal back-stabbing going on as the business prepares for its annual fashion show. Mme Lennberg's second-in-command, Birgitte "Gitte" Lindell (Anita Björk), plans to model her own original wedding gown design at the show, but she is replaced when the doting Rickard von Hook (Lennart Lindberg) persuades Mme Lennberg to headline his wife Gabriella (Gio Petré), a local nightclub singer, instead.

In time, Mme Lennberg is seemingly killed when someone disables her elevator and sets her house ablaze, and a mock gallows near the salon that displays a hanging mannequin[2] is found to be hanging Gabriella by the neck. Gitte assumes her position as La Femme's new administrator, but strange occurrences indicate that Mme Lennberg may still be alive. One night, the old woman's chauffeur fetches her empty wheelchair and takes it downstairs to her limousine, but only her white cat emerges from the back seat. She is also unsettled by the unexplained appearances of a woman in black (Eivor Landström), who seems to have inherited Mme Lennberg's cat. Meanwhile, John Hillman's investigation, accompanied by the comic shenanigans of his partner Freddy (Nils Hallberg), leads him to suspect Bobby of the crimes, but they continue even after Bobby is found dead on the stage where the fashion show is to take place, shot by his own hand. One night, while Gitte is working late, she hears the unmistakable squeak of Mme Lennberg's wheelchair and sees her slowly approaching through the darkness. She was not killed in the fire that Gitte set, only badly burned. When Gitte asks how she managed to escape, Mme Lennberg stands up in her wheelchair and walks toward her, gripping her would-be murderess by the throat. Gitte's lifeless body topples over the edge of the mezzanine and falls at the Hillmans and Freddy's feet, just as they arrive. To their amazement, Mme Lennberg descends the stairs, walks past them and phones for the police.

The murders in *Mannequin in Red* are not at all graphic, and this fact – combined with the humorous content relating to Freddy and his silly girlfriend Sonya (Lena Granhagen) – places Mattsson's film far more in the realm of the West German *krimi*, as signified by the Edgar Wallace thrillers produced by Rialto Film, than the Italian *giallo*. Yet the look of the film captures – rather, anticipates – the look of Bava's *gialli* on a level that even deliberate imitations never have. Nevertheless, Bladh and art director Bibi Lindström make choices that Bava and Giorgio Giovannini would never have made. For example, although the Mattsson film was shot in Eastmancolor (and presumably developed at Technicolor, as per Bava's preference, judging from the look of it), the basic colour template is disappointingly monochromatic. The walls, carpets and furniture at La Femme are cream-coloured, and much of the wardrobe worn by the cast is similarly muted in hue – greys, moss greens and mustards – in order to accentuate its calculated uses of red.[3] The heavy use of whites and creams robs too many shots in *Mannequin in Red* of the riper beauty it might have had with a bolder palette, but with its beautiful women, soft lighting and prowling, low-angle camera movements through the darkened salon, Mattsson's film remains the most striking approximation of the classic Bava style to be found in the earlier work of another cameraman.

But Bava took these elements further, as he also did with those he admired in the West German *krimis* and Hitchcock's *Psycho*. As screenwriter Joseph Stefano once noted in a television interview: "The slasher movie came along because, if *Psycho* had two of these scenes, think what it will do at the box office if it has three! And then, the next time, you say four …"

The Italian title *Sei donne per l'assassino* provides the viewer with a literal score card for the mayhem ahead, placing it within the tradition of "body count" mysteries like Christie's *Ten Little Indians* in fact, it is generally credited with reintroducing the "body count" movie, a subgenre that Bava would continue to push with his 1968 screenwriting project *Sette vergini per il diavolo* ("Seven Virgins for the Devil", filmed by Antonio Margheriti as *Nude ... si muore*) and the iconoclastic *A Bay of Blood* (*Antefatto - Ecologia del delitto* / Ecology of Murder, 1971) which featured thirteen characters and thirteen murders in a scenario that notoriously inspired the *Friday the 13th* series that began in 1980. Although *Sei donne*'s title was changed to *Blood and Black Lace* for the American market, the US sales campaign harped on numbers too, promising "The 8 Greatest Shocks Ever Filmed!".

Principally scripted by Marcello Fondato, *Blood and Black Lace* is the story of a series of

Mannequin in Red, dir. Arne Mattsson, 1958 (poster). Courtesy The Swedish Film Institute Stills Archive. © Sandrew Metronome AB

murders visited upon the models employed by a fashion salon – "Cristian Haute Couture". The chain of events begins with the death of Isabella (Francesca Ungaro) and continues after the chance discovery and disappearance of the dead model's red diary, a treasure trove of all the incriminating secrets lurking behind the salon's glamorous façade: drug addiction, abortions, extramarital affairs. It stars Eva Bartok (herself a scandalous personality of the time, having infamously given birth out of wedlock to a child later identified as the product of her affair with Frank Sinatra), Cameron Mitchell, and a cast of young actresses some of whom had experience in fashion modelling. Although it's one of Bava's most tightly plotted films, the finer points of its narrative are (for most viewers) overcast by its sadistic violence and perverse visual beauty. For all that, it reflects – even in its title – Stanley Kubrick's maxim that "All a good film really needs is six non-submersible units" (that is, six great scenes). Fondato's script is extremely capable in the way it baits the audience's suspicion, juggling the film's various intricate relationships while proposing (and later exonerating) its red herrings, but all of this hard work is ultimately secondary to the diabolical genius that Bava and camera operator Ubaldo Terzano brought to its visual interpretation.

The ruination of beauty is a theme that runs throughout Bava's work, from the post-war documentary shorts that catalogued the damage done to Rome's ancient art and architecture, to the very first scene of *Black Sunday* (*La maschera del demonio*, 1960), showing the hammering of the spiked mask onto the face of Princess Asa. It also persists through his later work, in the form of the outrageous murders that result from a contractor's plan to level the natural forest surrounding a scenic bay and replace it with a contemporary resort in *A Bay of Blood*; this ecological struggle, if you will, is reiterated in *Baron Blood* (1972), in which an ancient castle is being modified into a commercialised tourist trap. But only in *Blood and Black Lace* does the theme of violated beauty so nakedly occupy centre stage. One of its protagonists, Inspector Silvester (Thomas Reiner), speculates about the killer: "Perhaps the sight of beauty makes him lose control of himself and kill."

In *Blood and Black Lace*, Bava films the murders of six beautiful women in a way that is savage and shocking, yet also sensuous and almost supernaturally beautiful. The acts of violence are eroticised in the moments preceding death, while the aftermath of violence is depicted ironically – with the women's brutalised remains elegantly posed, as though participating in "still life" fashion editorials for *Death* magazine. In some instances, the irony extends to panning away from a fresh corpse to a laughing cupid or some other decorative angel, or the plucked strings of a harp, which has the doubly perverse effect of introducing an element of spirituality to the proceedings. The "Madonna lighting" Bava had used on Gina Lollobrigida and Maria Fiore in the 1950s here falls on the faces of dead and mutilated women, revealing angels in the wreckage. Colour also plays a crucial part in these scenes – heightened, irrational splashes of amber, green and lavender light that suggest not the encroachment of supernatural forces (this story, after all, is rooted in reality), but the presence of danger, the hot blush of a maniac's subjective arousal and excitement. Making a fetish of the instruments of crime, eroticising the quickening and suddenly halted breath of half-naked, full-breasted victims, romancing an atmosphere of terror out of scenic beauty, filming death as an orgasm and corpses as angels… These would become the hallmarks of the best *gialli* that followed in the wake of *Blood and Black Lace*.

But what inspired Bava to lend grace notes of beauty to the horror of violent death? The answer might be traced, in part, to Lewis Milestone's *All Quiet on the Western Front* (1930), which Bava singled out on more than one occasion as his favourite film. Impressive as it is, Milestone's anti-war classic would not seem at first glance to have had much influence on Bava's horror films, though it is possible to see the influence of its battle sequences on similar scenes that Bava filmed for various movies; for example, in Jacques Tourneur's *The Giant of Marathon* (*La battaglia di Maratona* / *The Battle of Marathon*, 1959), Bava – like Milestone's cameraman Arthur Edeson – placed his camera on a dolly at the bottom of specially dug trenches, to better depict war at ground level. For many viewers, however, *All Quiet on the Western Front* lingers in the memory on the strength of the powerful, poetic gracenote that Edeson's substitute cameraman Karl Freund devised for the film's finale. In this scene, the young German soldier protagonist Paul Baumer (Lew Ayres) sees a butterfly land and flex its wings on the battlefield, not far from his foxhole. Irresistibly attracted to the alighting of this beautiful thing in a place where beauty has become so impossible as to be alien, he reaches out from his hiding place to touch it – attracting a sniper's bullet. It may have been the first time that death was depicted onscreen in such poetic terms, and it may have been this scene that impressed Bava most deeply, for its ironic juxtaposition of beauty and horror, and also for the element of spirituality it brought to an otherwise meaningless, random act of violence.

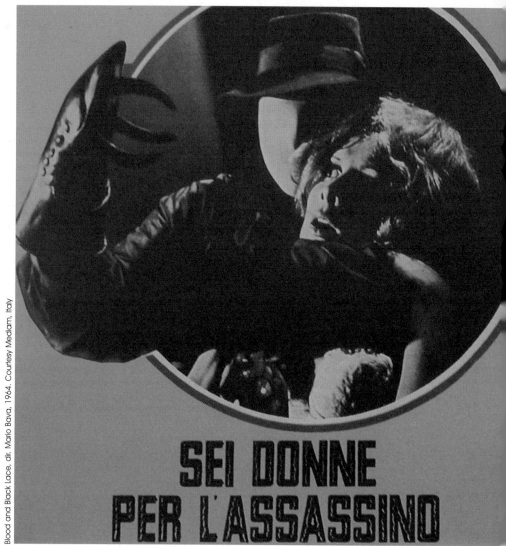

Blood and Black Lace, dir. Mario Bava, 1964. Courtesy Mediam, Italy

Bava's attention to colour is evident in the first murder sequence, as Isabella takes a night-time walk through the park at Via Sciarra wearing a shiny red raincoat. The presence of red not only attracts the eye and signals danger, it tricks the viewer into "seeing" blood where none has yet been spilled. As Isabella walks through the park, her coat projecting the warmest and most vital of colours, her message is negated as the assassin – a faceless cypher of black and white – steps into frame, his mask limned in a deathly cold blue. Isabella suffers a brutal death, but we actually see very little of the attack: the killer grabs her, slams her head several times against a tree, and then garrotes her; as he drags her dead body deeper into the woods, the camera lingers on the fresh scars entrenched in her face and cleavage, and as Death drags its prey out of view, the camera tilts up to reveal a chucking ornamental stone cherub. Point and counterpoint.

Inside the couture house, Mark returns from repairing a fallen sign advertising the salon, and the camera follows him to a private place, where we observe him – behind a wall of bevelled glass – taking some pills in silhouette. Not only does the shot implicate him in the drug-trafficking going on at the salon, but his second return from outside (after the murder of Isabella) posits him as a suspect, as does – in this shot – the foregrounded image of a mannequin clad in red velvet, a chromatic reminder of Isabella. The colour red is woven throughout the picture in decorative ways: it is the background colour of the fallen sign, and also the colour of the salon's telephones, drapes and mannequins. When Isabella's diary is found, it is bound in red leather, making it a personification, of sorts, of the lady in red. Appropriately, the diary is first discovered during a fashion show by Nicole ("Heyyyy," she purrs, "Isabella kept a diary!"), the only girl at the salon willing to model the black dress that was scheduled to be worn by Isabella. The other girls describe Nicole as "cynical", an opinion borne out by the way she opens the diary at a random point and recites a romantic passage aloud, in flagrant disrespect of the dead.

The discovery of the diary prompts a Langian montage of every face in the place that harbours a secret. Everyone in the room clearly covets the diary – to destroy it, to know what's in it, possibly to use what's in it. Soon after its introduction, Isabella's diary assumes an almost superhuman aura – an object of unholy fascination for every vulture in the place, until Nicole insists on her right to present the diary to the police herself and slips it into her purse – which happens to be black, the colour of Isabella's "bad luck" dress. Every sweaty close-up is then reprised, followed by a cut back to the purse itself, giving it an equal weight of personality in the montage, and amplifying its dark threat.

Black subsequently becomes as telling a colour for Nicole as red was for Isabella. After putting the diary in her bag, she receives a phone call, allegedly from Frank, arranging to meet her at his antiques shop. The attentive viewer's suspicion may be raised by the telephone, which is red with a black receiver – it is identical to, and probably the same prop as, the telephone used by Michèle Mercier in the aforementioned *Black Sabbath*. Bad luck seems to envelop Nicole, humming in the very air around her; it begins to take definite form while she is modelling on the catwalk, as her handbag is stolen under the cover of a passing wardrobe rack – a shot reprised decades later in Wes Craven's *New Nightmare* (1994).

Hitchcock was fond of telling interviewers that, while other directors gave audiences slices of life, he gave them slices of cake. It's an apt analogy because the results of Hitchcock's meticulous pre-planning are often confectionary; and if his thrillers are slices of cake, Bava's are even heavier on the icing. He lavishes attention on the surface of things. Nowhere in his *oeuvre* is this more apparent than during Nicole's visit to Frank's antique shop. It is Bava's quintessential Technicolor sequence, and perhaps the definitive example of how to shoot a horror sequence in colour. Nicole has tempted bad luck by wearing the dead woman's dress, and here she innocently crosses the threshold of a shop filled entirely with second-hand possessions. The shop's interior is fraught with unexpected colours – green, violet, gold, and magenta – and the strobing of the "Dancing" sign glimpsed outside at a nearby nightclub turns the harlequin lighting into a veritable heartbeat, in which all the variety of life alternates with the absolute void of death and nothingness.

The sign also offers a tacit explanation for the music heard throughout the sequence; it is Carlo Rustichelli's tango-flavoured theme music, which remains distant-sounding on the soundtrack until the assassin first makes his presence known – at which point, it reasserts its identity as soundtrack music with a sudden, startling increase in volume that brings it right into the room. Rustichelli's score is further manipulated by having it abruptly cut off as Nicole fights for her life in the dark; its sudden absence has the uncanny effect of making Nicole seem doubly exposed and vulnerable. As the scene progresses, her black dress is ripped to reveal her bra, introducing an erotic *frisson* that is certainly

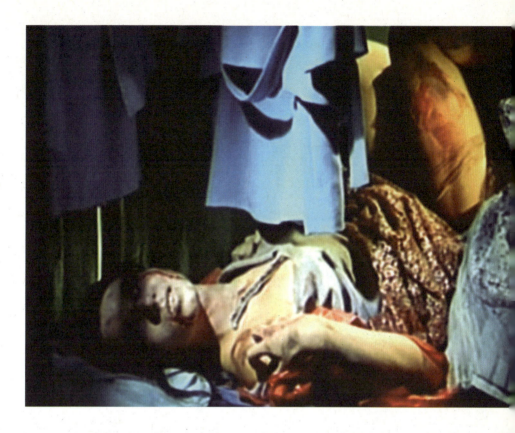

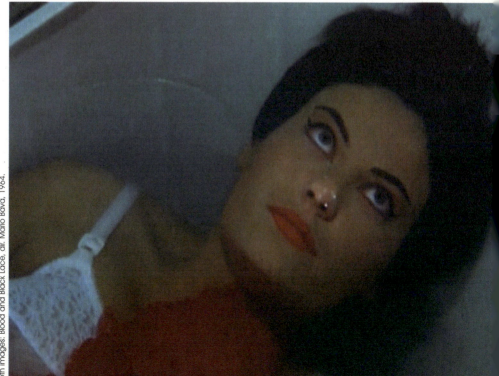

Both images: Blood and Black Lace, dir. Mario Bava, 1964.

indebted to *Psycho* (whose first scene made history by showing its leading lady, Janet Leigh, wearing a bra), but which was still extremely rare in horror films in 1964. Ultimately, Nicole makes the acquaintance of an unforgettable medieval fashion accessory: a spiked iron glove that is slammed onto her face with merciless force – a variation of the Mask of Satan in *Black Sunday*. The scene was originally shot in such a way as to make Nicole fight against this threat to her life and beauty, but during the editing process Bava and editor Mario Serandrei decided that the scene was more frightening if the glove's conquest of the woman was swift, blunt and merciless.

The shocking nature of the murders in *Blood and Black Lace* tends to distract one from the details of the plot and how well constructed it is. Early in the fashion show sequence, a brief dialogue scene between Nicole and Peggy establishes that the Countess's moods have become more erratic since the death of her husband (the salon's former owner) in a car accident. Here, in a blithe throwaway reference that will later help to elucidate the reasons behind the murder campaign, Bava can be found indulging his predilection for back-story, extending his narrative beyond its actual length not with illusion but with allusion. Audience suspicions and expectations are also constantly baited and surpassed, as in the scene where Peggy is followed to her doorstep by Mark. We're on guard because Mark has been acting suspiciously; we know he's hopped-up on something, we saw (what we presumed to be) his silhouette eavesdropping on Nicole's phone call shortly before she was killed, and he was also shown to be outside and in the vicinity when Isabella was murdered. But in this scene, he's revealed to be an ordinary man who has fallen in love with a disinterested, but not uncompassionate, woman.

Peggy's own suspicious behaviour is revealed to have a fairly honest motive. It is she who has stolen Isabella's diary, but not to use its information against others, as we might expect. We're left guessing about her true intentions right up to the last second: when she determines that the diary contains a reference to a skeleton in her closet – a secret abortion – she tears out only the pertinent pages… and then, on second thought, without reading further, she throws the entire book on the fire – which can be read as either a cautious gesture or a very generous one.

The film reaches its apex of sadism with the sequence showing Peggy's torture and death. Forty years later, it remains a hard scene to top for its unrelenting cruelty; it could easily pass for a playlet filmed at the Théâtre du Grand-Guignol in Paris. With its subterranean catacombs, abducted girl, and the unmasking of her abductor, this scene suggests a certain debt to *The Phantom of the Opera*, but the unmasking here is staged to increase suspense rather than assuage it. Mary Arden, a *Vogue* cover girl, plays the scene vulnerably yet courageously; it's her shock that makes the unmasking seem real, and it's wonderful to see Peggy's whimpering give rise to a sense of pluck when the pain she has suffered leads her to cross that line where she realises she has nothing left to lose. Those who watch the scene closely will notice an abrupt sound edit at the end of the scene. Additional footage was filmed of her face being pulled off the stove, ruined and smoking; Arden believes that the shot was probably considered too strong and too tasteless to be included – but it must have been a late decision, because the cut was made after the film was scored, as is evidenced from the sharp curtailing of the music cue.

The death of Greta (smothered by a pillow as her legs writhe orgasmically) would seem to be the weak link in this daisy chain of death, design-wise, but the suspenseful preamble to this moment finds Bava working at the top of his game. When Greta returns home and discovers Peggy's ravaged body in the boot of her car, Lea Krugher's nerve-wracked performance leaves us uncertain of whether she's hiding the corpse to protect herself from being framed with the murder, or whether she put it in the trunk herself to dispose of later. After hiding the body behind a decorative partition below the stairs to the second floor of the Marquis's dwelling, Greta goes upstairs, where Bava's camera attends to her disrobing by framing the shot in leaves, suggesting a view through a window that isn't really there. Peeled down to a black slip (unlucky colour), she flinches at the nearby sound of a harp. At this, we cut downstairs, where the strings of the instrument are still vibrating in the foreground of the shot, and a stone cherub peers into frame, completing the ironic suggestion of a hovering angel of death. As the strings cease to vibrate, the camera begins a slow, inexorable track across the floor, snaking toward the partition, revealing the concealed body of Peggy, which is then pulled offscreen by its ankles, her ghostly blue face seeming to float away of its own accord.[4]

Whereas Greta's death is all build-up, the murder of Tao-Li takes us by surprise: there's no suspenseful build-up whatsoever; indeed the murder is already in progress when we join the scene. This sequence remains shocking today for many reasons. First of all, the very suddenness of the scene – which grabs us, as it grabs its victim, and thrusts us into the midst of her struggle for life (the pounding kettledrums of Carlo Rustichelli's orchestra mimicking her thundering heartbeat), catching us off guard; its lack of overture may be read as Bava's admission that Hitchcock had already played the bathroom murder card to perfection in *Psycho*. Secondly, as the killer turns the corpse over, Tao-Li's

breast is cupped and squeezed – a first in the horror genre, taking advantage of a breakthrough precedent in Joseph L. Mankiewicz's *Cleopatra* (1963), the first all-ages movie to show a man caressing a woman's breast. The aftermath of the murder, as the soulless, voluptuous shell slides underwater like a shop mannequin, is deeply unsettling. Has a victim ever seemed so heartbreakingly vulnerable as Tao-Li, lying there, cradled by her bathwater? As she sinks, the scene becomes as redolent of birth as it is of death – and here, once again, Bava succeeds in showing us the angel in the wreckage and the obscenity of murder. The climax of this scene – a shot of Tao-Li's submerged, staring face as a cloud of blood billows into frame from her slashed wrist – was censored in many different countries, including most prints circulated in the United States until its first DVD release in 2000. The scene doesn't trump the shower murder in *Psycho*, but it isn't redundant, parodic, or disgraceful; the fact that it, like Hitchcock's shower murder, has also been widely imitated – in such films as J. Lee Thompson's *Happy Birthday to Me* (1981), Dario Argento's segment of *Two Evil Eyes* (*Due occhi diabolici*, 1990), and Martin Scorsese's *Kundun* (1997) – testifies to its own unique power and originality.

Blood and Black Lace is built upon the model of *Psycho* in another significant way. While *Psycho* introduced the killer with the split personality, *Blood and Black Lace* introduced the killer with the split identity. After revealing the culpability of Max Morlan (Cameron Mitchell) halfway through the picture, Bava reserves for the final reel the surprise that he was working in concert with Cristina (Bartok), who is herself responsible for the murders of Greta and Tao-Li. By sharing the identity of the assassin, the two lovers (who were being blackmailed by Isabella, who knew of their involvement in the death of Cristina's husband) are able to provide each other with alibis. It's an elegant solution to the mystery – more than thirty years before Wes Craven pulled the same trick in *Scream* (1996) – and it also perpetuates Bava's fascination with twins and doubles. In the midst of juggling all of the red herrings in this picture, Bava and screenwriter Fondato fortunately remembered to include a bit of dialogue between Max and Cristina, revealing that they are secretly married, thus giving Max a legal path to her fortune in the event of her death (which he unsuccessfully tries to arrange, and does execute, but not to his own profit).

Over the years, *Blood and Black Lace* has been accused of objectifying its female victims and eroticising the violence used against them. On the contrary: in my view, it is the fashion world that objectifies and does damage to women; as an industry, it has probably done more to reduce women to a soulless surface image than any other. Pornographic cinema is often accused of similarly reducing its female characters to empty vessels, but such films are more likely than the average fashion layout to depict women as warm-blooded, un-abstracted human beings capable of emotion, appetite and fulfillment. At its worst, the fashion world abstracts women to the point of making them look inhuman, if not actually dead. Real flesh-and-blood women have literally killed themselves trying to live up to the images created by the architects of high fashion, and this has become true of the satellite worlds of entertainment and advertising as well.

If anything, *Blood and Black Lace* shows us how offensive are the aesthetics that we apply to women in life, when applied to them in death. By arranging the models' corpses in a photogenic manner, Bava was certainly making an ironic statement; he didn't get any special kick out of expressing violence against women through his art. He sympathised with women too much for that – any careful examination of Bava's work will reveal that all of his best, multi-dimensional characters are women. It's clear that he identifies with them, and it is obvious from the way he photographs them that he loves them. We always side emotionally with the *sei donne*, not with the *assassino*. We often assume the victim's point of view prior to their moment of death. Obviously, there is an erotic element in the murders – dresses get torn, or the women are attacked while in a state of undress – but as titillating as this may be for some viewers, it serves two legitimate purposes: it introduces an added dimension of vulnerability to the moment, and it juggles another red herring, namely Inspector Sylvester's theory that the killer is a sex maniac. What Bava is really doing by "eroticising" these scenes is imparting information visually, allowing us to draw our own conclusions, and then surprising us by showing, as he so often does, how deceptive appearances can be.

Notes

1. This essay is a revised and abbreviated adaptation of a chapter from my recent book *Mario Bava: All the Colours of the Dark* (Cincinnati, OH: Video Watchdog, 2007), pp.542-567.
2. An age-old gesture in Sweden to celebrate the completion of a new building or roof.
3. Bladh would use much the same approach in the next *Hillmanthriller* for Mattsson, *Horseman in Blue* (*Ryttare i blatt*, 1959), which emphasised the colour blue.
4. This shot provided the climax for the film's French trailer, which I was once privileged to see in 35mm with a select group of friends. We had all seen this movie at least a dozen times before on video, but this shot assumed a power on the big screen that was completely unexpected. It was like being touched by the hand of God.

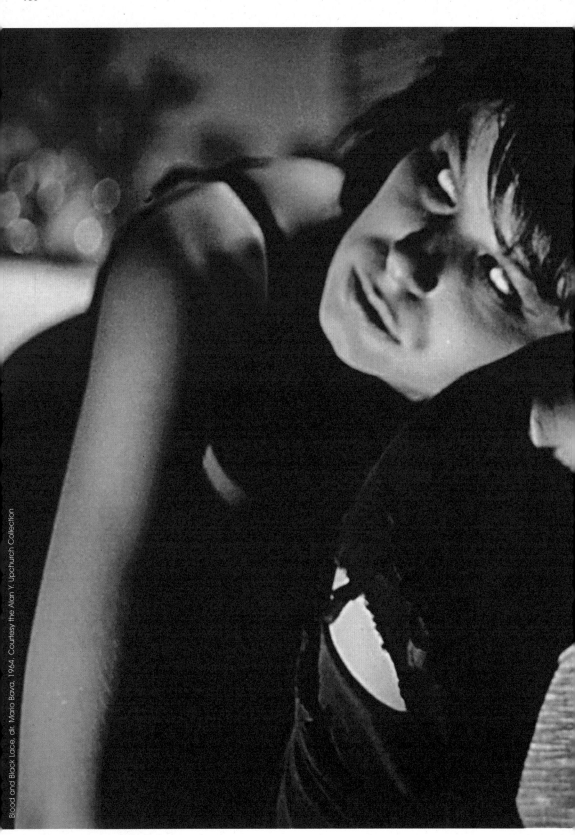

Blood and Black Lace, dir. Mario Bava, 1964. Courtesy the Alan Y. Upchurch Collection

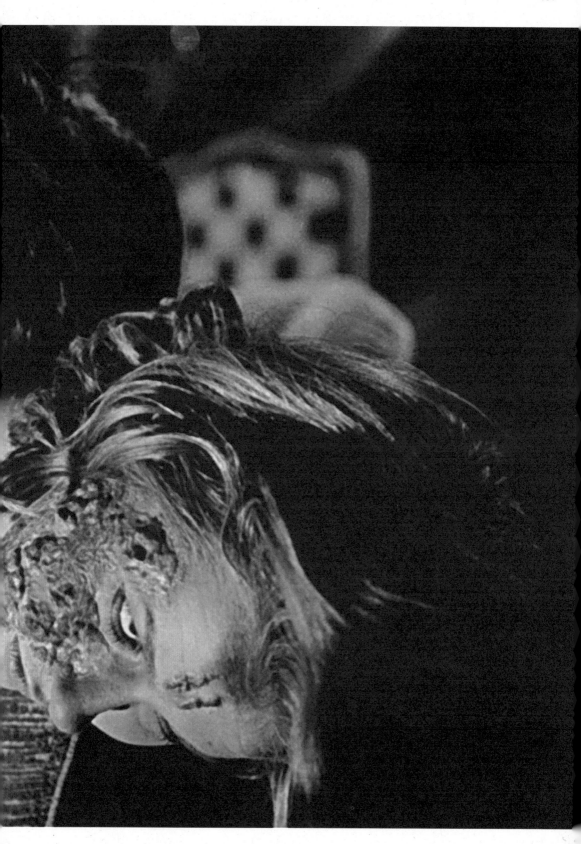

Mannequin in Red: Death and Desire in a Couture House / Louise Wallenberg

In 1958, the Swedish director Arne Mattsson – most famous perhaps for his erotically explicit and romantic drama *One Summer of Happiness* (*Hon dansade en sommar*, 1951) with Ulla Jacobsson – released his second crime film based on a Folke Mellvig novel, with the titillating title *Mannekäng i rött*, which translates directly into English as *Mannequin in Red*. This film, like his first Mellvig crime film *The Lady in Black* (*Damen i svart*), also based on a Mellvig novel and released that same year, centred around a happily married couple, Mr and Mrs Hillman (Annalisa Ericsson and Karl-Arne Holmsten), a successful detective team. Just like the first film, it included a colour in the title.[1] All in all, Mattsson would adopt five of Mellvig's novels for the screen, all of which acquired a certain reputation in Swedish film history and among cinema aficionados but which, perhaps understandably, failed to attract an international audience.[2] The Mellvig adaptations made in the late 1950s, however, were not Mattsson's first crime dramas. He made the thriller *A Guest is Coming* (*Det kom en gäst*) in 1947 based on a Stieg Trenter novel, and in 1949 he made *Dangerous Spring* (*Farlig vår*), a film which deals with prostitution and murder.

Nonetheless, it was the series of Hillman-movies, as they were called, that would situate Mattsson as a crime director. To a Swedish audience these films are famous not for their quality (although some attention has been given to Mattsson's use of Eastmancolor, his way of framing images and his use of unexpected angles), but rather for their supposed quirkiness and their apparent deviation from other Swedish films made at that time. Looking back at them forty years after they were made, it becomes clear that they have in fact played an important role: together they came to lay the foundation for a genre that was very different from those then dominating Swedish cinema. Few directors actually had access to the industry during the 1950s, and Swedish film was very much an arena dominated by two young (competing) men. On the one hand, there were films made by a young Ingmar Bergman, who made both comedies and dramas; and on the other, there was the corpus of films made by Hasse Ekman, who mostly made romantic comedies, although he also mastered the drama, as revealed in *Girl with Hyacinths* (*Flicka och hyacinter*, 1950).[3] Mattsson was the only director offering crime dramas (often with a comic twist), and this was – to the Swedish audience and the Swedish film scene – a genre that clearly differed from other output. However, although audiences at that time were quite taken by the Hillman-movies, film critics showed little appreciation. Mattsson's films nevertheless paved the way for a genre that would later prove vital to Swedish film production.

In the past four decades, Sweden has produced more crime dramas than films belonging to any other genre, and most of these films are based on crime novels by Swedish novelists. The first crime novelists to achieve true success on the screen after Mattsson were the author-couple Maj Sjöwall and Per Wahlöö, who gave life to the lonely, tired and disillusioned detective Martin Beck in a group of ten novels, collectively titled *The Story of a Crime* (1965-75). Beck's misadventures are still being made into films, currently with a fourth actor playing the lead role.[4] But other, more contemporary novelists have also had their crime and detective novels adapted for the screen (sometimes one might wonder if it wasn't the screen that these authors had in mind when writing). Henning Mankell's novels about detective Kurt Wallander are widely successful, with an international as well as a national audience, as are Liza Marklund's novels starring the crime-solving reporter Annika Bengtzon, among many others.

But *Mannequin in Red* not only paved the way for a new genre in Swedish film, it also has connections to the work of directors such as Mario Bava and can – to some extent – therefore be seen as a forerunner to the Italian *giallo* that developed in late 1950s and early 1960s cinema. This connection is brought up by Tim Lucas in his recent book on the Italian director Bava, where he points out how his use of fashion and glamour photography (velvety lighting and heightened colours) in his *Blood and Black Lace* (1964) "may have been pointed in this direction" by Mattsson's *Mannequin in Red*.[5] And yes, the two films have much in common: they share not only the focus on serial murder mysteries, spectacular death (although Mattsson rarely shows the actual violence) and stark colours, but also the emphasis on using both surprise and suspense as a guiding principle. However, *Mannequin in Red* is a film that puts spectator surprise in the front seat: we, the spectators, know only as much as, or even less than, the characters. Hence, we are subjected to a string of never-ending surprises, leading us to ask: "Why"? Since we are forced to wait until the end before we get to know who did it – and why, both Mattsson and Bava also lead us to ask: "Who"?

The musical scores are central to both Mattsson and Bava. In *Mannequin in Red*, as in many

Mannequin in Red, dir. Arne Mattsson, 1958 (poster). Courtesy The Swedish Film Institute Stills Archive. © Sandrew Metronome AB

other films belonging to the serial killer genre, a specific tune indicates when the next murder is about to take place; this tune is very simple, quite monotonous, and, of course, very foreboding: it is dominated by a (supposedly) male voice whistling – which, in this genre, is of course nothing new. Another connection between Mattsson and the *giallo*-genre is of course the use of catching and titillating titles. But while *Mannequin in Red* as a title is suggestive, explicit and rather informative, it is hardly as poetic as some of the titles of the Italian *gialli*: Bava's *Five Dolls for an August Moon* (*5 bambole per la luna d'agosto,* 1970), and Dario Argento's *The Bird with the Crystal Plumage* (*L'Uccello dalle pliume di cristallo,* 1970) and *Four Flies on Grey Velvet* (*4 mosche di velluto grigio,* 1971) – all conspicuous and highly spectacular whilst also quite canny.

The title *Mannequin in Red* brings to mind just what it suggests: a mannequin in pungent red, perhaps walking down a catwalk, presenting herself (and her gown) self-consciously to a triple audience – the fashion show audience, the film director with his crew, and us, the cinema audience. Having watched the film many times, this image still springs to mind, which is awkward, given that there is no such sequence in the film. The "mannequin in red" is killed off at the very beginning of the film. Before we even get to see a glimpse of her, she is referred to by a male police officer as a blackmailer and, implicitly, high-class prostitute. As we are introduced to her via the early discussion held between the police officer and the main protagonist, the private detective Hillman, we are led to believe that she will play an important role in what is to come. But when she is first visually introduced in the film, it is as a corpse with a long knife planted in her back. She is discovered as her dead body, dressed in white pliable chiffon, suddenly falls in the display window at "La Femme", the couture house where she was working. At first taken for a dummy, she seems for a moment to come alive with a slow movement forward, yet her hitting the floor, face first, proves that she is no dummy. Here, the film cleverly plays with our expectations: the mannequin in red is killed wearing white, a simple visual device distancing her from the implied criminal and sexual connotations. In death, everyone is innocent; the violent and erotic colour red is taken away from her and she makes her sortie in snow white, just like an angel. Nothing, then, is what is seems.

We do, however, get to see a woman in red who probably is the actual mannequin in red (or, at least, the actress playing her corpse, Elsa Prawitz). Following the first scene, where she is discussed by the police officer and Mr Hillman, the title and opening credits roll. The first shot of the credits is static, showing the silhouette of a city at sunset. To the left in the shot stands a woman – the mannequin, presumably. She is leaning against a chimney, consciously putting herself on display, and she is dressed in a flaming-red sleeveless dress with deep décolletage. The camera then moves in, via a tracking shot, on a flat black square occupying the centre of the screen, tracking towards it until this black square fills the entire screen, excluding both the woman and the city silhouette from the frame. On this black screen the credits are now presented, headed by the title of the film, in stark red capitals. As the credits come to an end, the camera tracks out again, back to the same position it started from, and we now have a freeze-frame of the woman, still leaning against the chimney. Giving her such a significant position, and having her in title for the entire film, leads us to believe that she will take centre stage in the drama that is to unfold.

There is a widespread belief that the fashion industry, especially *haute couture*, is an arena rife with somewhat mad, paranoid and self-obsessed people. The industry is often viewed as an ideal environment for superficiality, jealousy and competitiveness, and possibly also evil. This belief has nurtured several novels and films: *haute couture* houses are used as a setting, and fashion designers, fashion photographers and fashion models are portrayed as power-crazy, mean and mentally unstable characters. Still, this world is also presented as titillating and extravagant, which helps to make the characters awkwardly attractive. Just think of films like *Made in Paris* (Boris Sagal, 1966), *Mahogany* (Berry Gordy, 1975), *The Devil Wears Prada* (David Frankel, 2006), or the aforementioned *Blood and Black Lace*.[6] And Mattsson's *Mannequin in Red* goes all the way in using the fashion house as the site of evil: La Femme, run by the cold, domineering and seemingly heartless Miss Thyra Lennberg (Lillebil Ibsen), constitutes a space where competition, envy, malevolence, unexpected sexual desire and, finally, murder are played out – at least within the upper echelons of the hierarchy. Competing for Miss Lennberg's favours (and for an imminent inheritance) are her foster son "Bobbie" Nordahl (Bengt Brunskog), presented as the family's black sheep, and her more sophisticated, yet clearly opportunistic, niece and nephew Gabriella and Richard von Hock (Gio Petré and Lennart Lindberg). While not one of these three relatives seems to be interested in continuing the legacy of the couture house, someone else is –

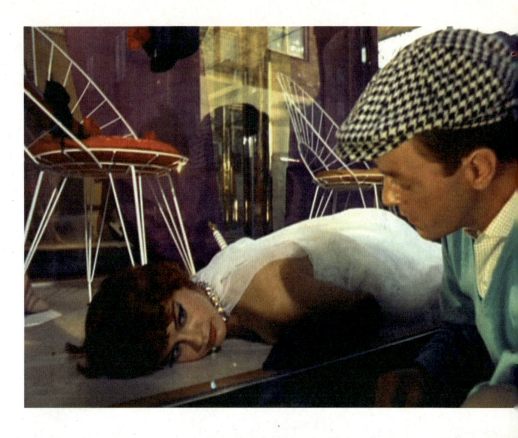

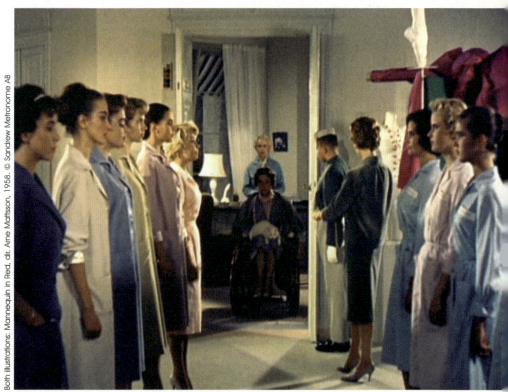

Both illustrations: Mannequin in Red, dir. Arne Mattsson, 1958. © Sandrew Metronome AB

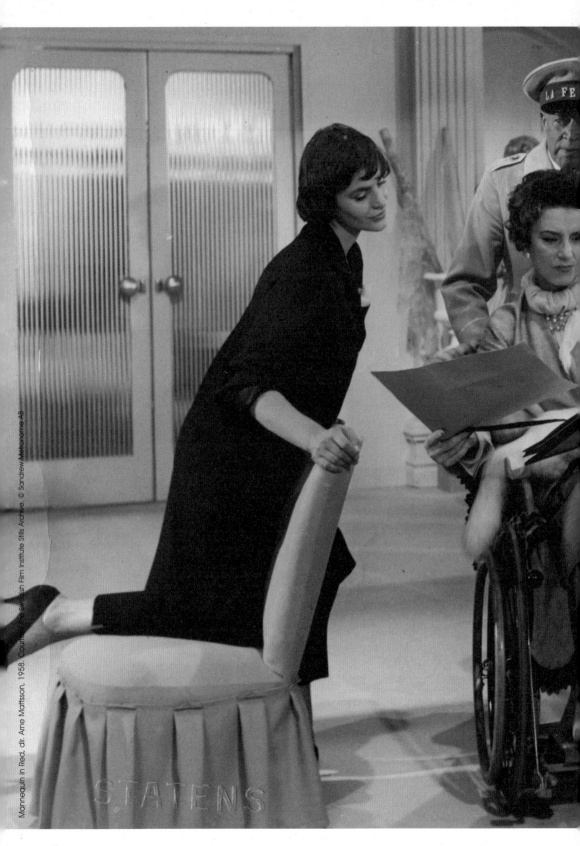

Mannequin in Red, dir. Arne Mattsson, 1958. Courtesy the Swedish Film Institute Stills Archive. © Sandrew Metronome AB

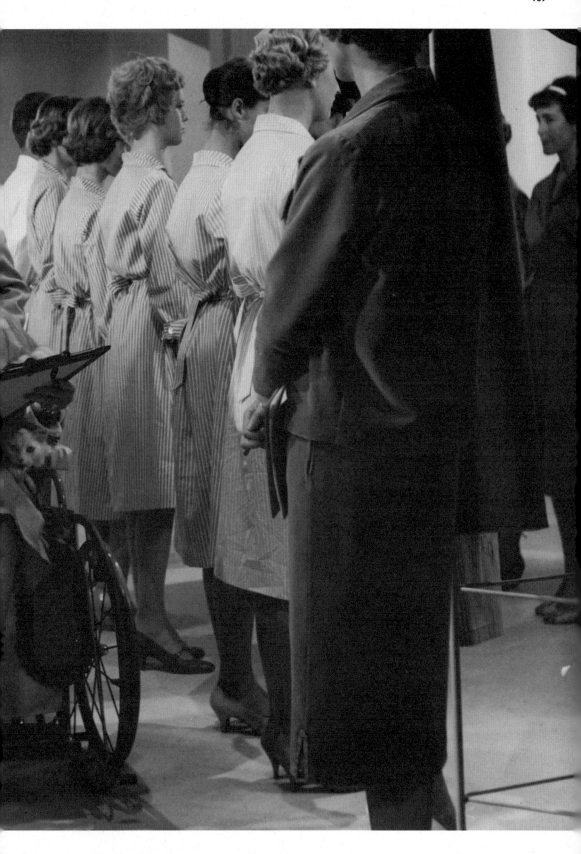

and this someone is the amiable Miss Birgitta Lindell (Anita Björk), La Femme's head designer, a hard-working employee whose work is often snubbed by Miss Lennberg with sharp remarks and disapproving looks. As the story progresses, we learn that Birgitta was at one point romantically involved with Bobbie (a car mechanic who lives in a cabin), who is still very attached to her. However, she is now involved with the elegant Richard (working in one of the prestigious museums as first curator), whom she is about to marry. So far, everything seems pretty straightforward and conventional in terms of both cinematic narrative and representation.

There is an interplay between showing and hiding that is skilfully developed throughout the film and which takes place on several different levels. The first murder is used to indicate that this juggling act between what is shown and what is hidden is also integral to the killer's method of taking out *her* victims (yes, the killer is a woman, which of course connects Mattsson's film even closer to Bava's): showing off the killings in spectacular ways, while not getting caught. The mannequin in red is killed and put explicitly on display in a shopping window; Gabriella is strangled and hanged with a rope from a roof outside La Femme, also for everyone to see; and Bobby is found lying on a theatre stage by a group of tourists, shot dead. Mattsson takes his game further in the final fashion show, which takes place on the same theatre stage where Bobby has just been killed. The models and head designer Birgitta show off their dresses to a large audience, fully aware of the fact that the murderer is probably in the audience or among the mannequins themselves. While bravely modelling the elegant and colourful creations of the talented Birgitta, the mannequins are clearly very scared, since they expect a new murder to take place. This is a significant scene in the film because it serves – perhaps more than any other moment in the film – to connect fashion to death, and to the risk of death.

However, Mattsson cleverly transgresses this connection in his play of showing and hiding. The harsh Miss Lennberg is supposedly killed in her own home, which has been set on fire by the killer, but it will later turn out that she actually survived, and she will, with the help of a mysterious nameless woman, and then in person, come back to haunt the real killer. But Mattsson's game continues further. Beside the more conventional murder mystery narrative runs another, more implicit narrative and discourse that is waiting to be discovered. I have earlier pointed at the straightness of the film's narrative and representation. What comes as a surprise, and may constitute some sort of third meaning, is the unspoken, but visually quite explicit, desire expressed towards women on Birgitta's part. Although she has been involved with Bobbie and is now about to marry Richard, her longing eyes are at several points in the film directed towards other women, and hence, her supposed straightness must be questioned. This makes her character more interesting and complex as well as paradoxical; this paradox, or ambivalence, could easily lend itself to a reading of her as the murderer – and yet, it doesn't. Hiding her lesbianism, trying to conform to a heteronormative structure, she is seen as a victim herself, and hence she can't be the killer. Rather the opposite: we are for a long time made to believe that she is, in fact, to be the next victim. Birgitta, however, is not the only one we may read as a lesbian: throughout the film there are many hints at lesbianism (again, via the hiding and showing game), and I would go even further to argue that this theme plays a crucial role in the narrative: that on an implicit level, the film is *about* lesbianism.

In addition to Birgitta's obvious longing for women, we have Gabriella's somewhat peculiar relation to "Peter" Morell, a short-haired girl with very distinct features who works at La Femme and is often dressed in sparkling colours that makes her highly visible in relation to the other girls. And yes, she is called "Peter", hence positioning her as masculine, even though her dresses are highly feminine. The way Peter and Gabriella speak to, look at and touch one another certainly indicates that their relationship is sexual. At one point it becomes clear that Peter also has, or has had, a relationship with Birgitta as they look lovingly at one another, expressing what might be interpreted as erotic desire. The old and lonely Miss Lennberg can also be read as possibly lesbian: she has never married, she has no children of her own, but she has a best "friend" (Eivor Landström), a mysterious woman who appears after her "death" to supervise the fashion house from a distance, and whose name is never mentioned. Whereas the other female characters – except for the happily married Mrs Hillman and the model Sonja (Lena Granhagen), who obviously longs to marry – express lesbian desire either through longing looks or through their more physical relating to one another, it is this nameless woman, the best friend, who actually authenticates lesbianism. She makes evident a form of love that historically has been silenced and kept secret.

This implicit representation of lesbian desire and love is of course rather unusual to both

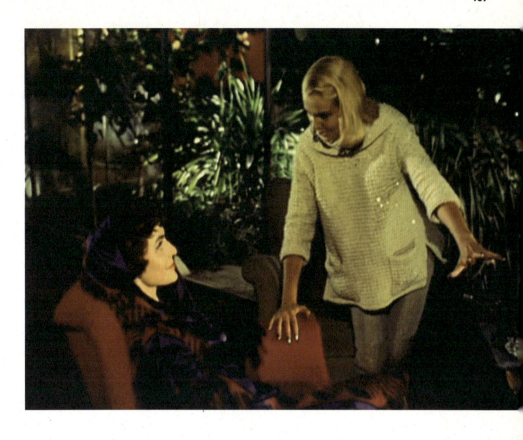

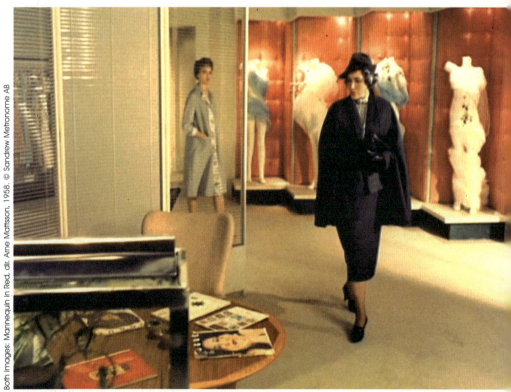

Both images: Mannequin in Red, dir. Arne Mattsson, 1958. © Sandrew Metronome AB

fashion and crime narratives, and so Mattson, knowingly or not, makes an important contribution in portraying and critiquing the invisibility and the silencing that has surrounded lesbian love. No matter how quirky *Mannequin in Red* might seem, it still has an immense value in that it actually acknowledges lesbianism. In fact, I would go as far as to argue that this film is *about* lesbian love and desire – and about the enforced silence that has made it very difficult, if not impossible, for lesbian women of earlier generations to live fully.

In addition, the film contains another queer desire that perhaps is more difficult to define: the substantial number of costumes used in the film are all fabrications of one man's desire for the ultra-feminine, the excessive, the sensual. Designed by the famous costumier Mago (born Max Goldstein), the garments express a strong love for women's fashion in the 1950s, upholding the Feminine as its ideal. Mago's creations are, I would argue, *queer* creations, as they are the result of a desire that transgresses any rigid structure for hetero- or homosexual desires that so well sustain the heteronormative dominance.

Mago started out as a fashion illustrator for the evening press in the 1940s, but would soon become engaged by the theatre, vaudeville and the Swedish film industry as a costume draftsman and later designer. In the early 1950s he was approached by Ingmar Bergman and over the years the two developed a close working relationship. Their first collaboration was *Sawdust and Tinsel* (*Gycklarnas afton*, 1953), and after that Mago would make costumes for twelve of Bergman's films. He also made a name for himself internationally, designing costumes for the theatre and film in Oslo, Copenhagen, London, Vienna and Los Angeles, and working closely with various famous prima donnas of the silver screen – Zarah Leander, Ulla Sallert, Marlene Dietrich, Annalisa Ericsson, Maggie Smith and Ingrid Bergman – all of whom constituted female ideals for Mago to dress up in his fantastical, almost magical designs. Obviously an important figure, he helped them to create, shape and – in some cases – prolong the star persona they represented on stage. In a way, then, Mago was indeed the ladies' man.

And with a film like *Mannequin in Red*, a dream must have come true: creating dress after dress for some of the Swedish screen's most famous women of the time, and creating an illusion of real haute couture. Mago's fascination with beautiful and extravagantly dressed women was to some degree extreme, and reading his memoirs (written in 1988), this fascination can be understood as a deep and – as it would prove – productive fetishism that manifested itself at a very early age.[7] With *Mannequin in Red*, he got to draw a stream of fancy outfits ranging from dresses with deep décolletages, exciting cuts velvety suits, tight shiny trousers and voluptuous chiffons to romantic light blue and pink oh-so-feminine dresses – fetishising his women as imaginary and phantasmatic constructions of the Feminine. But his queer fetishism goes further: in his memoirs, Mago is open in emphasising that already as a young boy he was strongly attracted to grooming, and certain adornments in particular, and how the non-acceptance of this by the adults in his life only increased his fascination. He writes: "There were no limits to my enthusiasm when I discovered that there were women who wore green nail polish."[8] He openly discusses how this early erotic fascination with long green nails – and with women who showed exaggerated femininity or were sexually provocative – would only grow over the years. So, when he dresses Gabriella von Hook for her introduction scene, in which she sings a rather daring song at a nightclub, she appears in a metallic sweater (which leaves the back bare), tight trousers – and very long nails painted with metallic blue polish, thus distinguishing her as extravagant and different.

Death, fashion and desire – what a perfect combination. While other directors working within the genre may have taken the "lesbian erotic" further (as if any portrayal of a house full of supposedly beautiful women necessarily had to include nudity and sex), Mattsson cleverly avoids falling into any simplistic and male-centred heteronormative pattern.[9] Instead, he offers a critique of how lesbians have had to hide and suppress their desire so as to pass as "real" women. Women's fashion and the dressing up at La Femme are thus used as a masquerade that helps the women to conceal their real identities. Fashion can be used both as an alibi and as a shield. And when the murderer – after having killed off four people – is caught and strangled by one of her own victims (Miss Lennberg), we are left with the sort of grand finale that does not offer any relief, nor a satisfactory conclusion. Rather, we are left feeling a certain discomfort and sadness as Mattsson invites us to feel empathy for, rather than aversion to, the serial murderer.

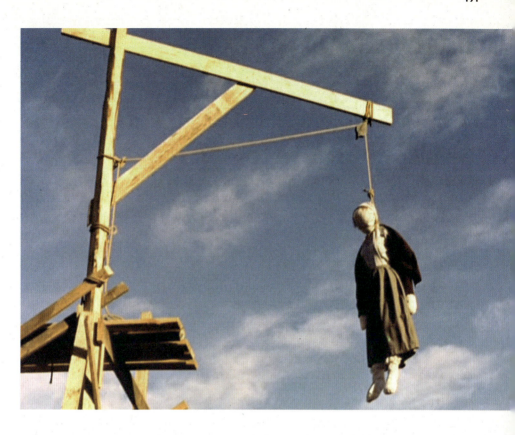
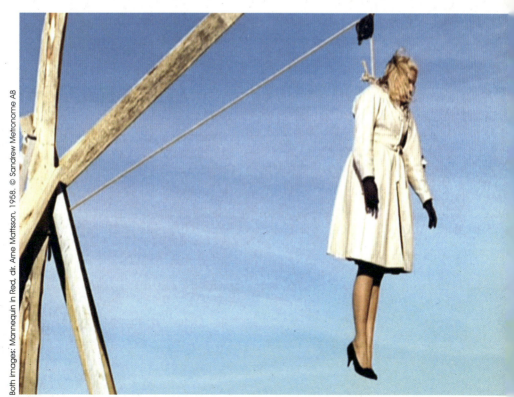

Both images: Mannequin in Red, dir. Arne Mattsson, 1958. © Sandrew Metronome AB

Notes

1. The adaptations of Mellvig's novels were not Mattsson's first ones to have a colour as leading star in the title: in 1949 Mattsson filmed *Woman in White* (*Kvinna i vitt*), based on the novel by Wilkie Collins.
2. The other three films were *Rider in Blue* (*Ryttare i blått*, 1959), *Lady in White* (*Vita frun*, 1962), and *The Yellow Car* (*Den gula bilen*, 1963).
3. This film is interesting for two reasons: first, the fact that Hasse Ekman – famous for his rather conventional and silly comedies – mastered the film in such a skilful manner, and second, the fact that it is the first Swedish film to deal openly with lesbian love.
4. Four Swedish actors (Keve Hjelm, Carl Gustaf Lindstedt, Gösta Ekman and Peter Haber) have played the role of Martin Beck in the Swedish productions, but there is a fifth actor (Jan Decleir) who appears as Beck in two German adaptations of Sjöwall-Wahlöö's books.
5. See Tim Lucas, *Mario Bava: All the Colours of the Dark* (Video Watchdog, 2007); the quotation is taken from the re-worked version of Lucas's article published in this catalogue.
6. *Mahogany* (Berry Gordy, 1975) is connecting the fashion world not only with envy, competition and evil, but also with sexual deviance and frustration. Here Diana Ross plays a famous fashion model and designer who is almost killed by Anthony Perkins' sexually troubled (that is, impotent) fashion photographer.
7. See Mago, *Klä av, klä på: tecknat och antecknat* (Stockholm: Författarförlaget, 1988).
8. Mago, *Klä av, klä på: tecknat och antecknat* (Stockholm: Författarförlaget, 1988), p.40.
9. For a comparison, see Mario Bava's *Five Dolls for an August Moon*, in which lesbian sex plays a crucial part, or even Jesus Franco's *Lesbian Vampires* (*Vampiros Lesbos*, 1971).

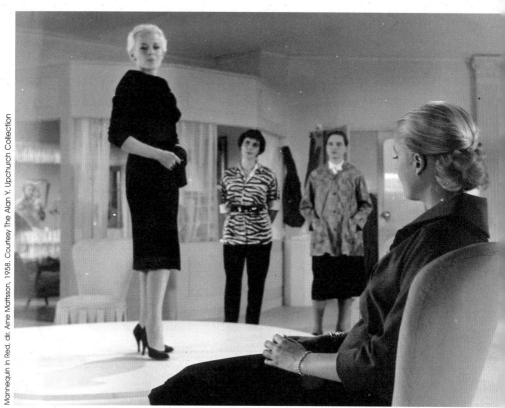
Mannequin in Red, dir. Arne Mattsson, 1958. Courtesy The Alan Y. Upchurch Collection

Desire and Death before the Apocalypse / Román Gubern

Fata Morgana (1965), Vicente Aranda's second film, inaugurated the avant-garde cycle of the School of Barcelona (1965-1970). During those years, several Catalonian filmmakers turned away from the social realism that was predominant in Madrid's film production. They perceived that the censorship of the Franco regime prevented them from freely exposing the problems that emerged out of the General's dictatorship, and so instead oriented their work towards formal experimentation, exploring new and more imaginative imagery. As the director Joaquim Jordà explained at the Pesaro Film Festival at the time: "since we cannot do Victor Hugo, we do Mallarmé." In his previous film Aranda had tried to expose social criticism based on an idea inspired by F. Scott Fitzgerald's *The Great Gatsby* (1925), but *Fata Morgana* represented a complete change of direction, with its focus on the fascination engendered by the 29-year-old top model Teresa Gimpera – in her day an ever-present visual fetish in Spain. Her stage name was Gim, the same name as in the movie. Journalist-novelist Gonzalo Suárez originally suggested to Aranda that he produce a documentary in black and white about the much-admired model, whom he considered to be a "member" of Alfred Hitchcock's family of blonde beauties (Tippi Hedren, Kim Novak, Grace Kelly) – all women whose impassioned characters were hidden beneath a cold and detached appearance. But this joint venture (with Suárez as the scriptwriter) finally evolved into an esoteric film. Its never-solved mystery corresponded to the cycle "before the Apocalypse" and its aesthetic was typical of the Swinging Sixties, featuring icons such as the Beatles, Andy Warhol, Mary Quant, pop art, Barbarella, science-fiction comics and Richard Lester films. *Fata Morgana* also marked Gimpera's debut in the feature film arena.

The title of the movie, *Fata Morgana,* sounds rather cryptic and provocative as well as evoking the title of poems written by Henry W. Longfellow (1842) and André Breton (1940). Morgana was also the name of both King Arthur's legendary half sister and a rare mirage that can be observed in the Strait of Messina. Besides this enigmatic title, we hear a quote attributed to Kafka at the beginning of the film, which lends an ambiguous quality to the story line: "Life is a deviation in spite of the fact that we are not sure that deviation exists." The film opens with a sequence of frames of a comic strip created by Pelayo Izquierdo, in which a detective refers to a woman who is about to be killed and whom he has to save. This technique provides an aesthetic key to this futuristic thriller, with a look connected to comic books and the advertising world of the time, close to Joseph Losey's contemporary film *Modesty Blaise* (1966), based on a British comic strip by Peter O'Donnell and Jim Holdaway, and starring a blond Monica Vitti, snatched away from the existentialist dramas of Michelangelo Antonioni.

The action in *Fata Morgana* begins in a city that is being evacuated following what we presume to be a thermonuclear catastrophe in London. No details of the catastrophe are offered, which creates a vague and bleak atmosphere of global threat similar to that of Ingmar Bergman's film *The Silence* (*Tystnaden*, 1963), or Hugo Santiago's *Invasion* (*Invasión*, 1969), based on a script by Jorge Luis Borges. In fact, the critic and filmmaker Ado Kyrou would later detect in *Fata Morgana* "an atmosphere worthy of Borges".[1] In one scene we see the Professor (Antonio Ferrandis) sitting on a merry-go-round, describing an apocalyptic vision of the prophet Ezequiel to Gim. The final scene reveals a helicopter flying away from the camera, evacuation orders blaring from its loudspeaker while Gim and five of her young fans remain on land. After this, the end, a sign appears announcing "then, the same thing happened as in London" – the feared catastrophe that we can imagine but cannot see. Today I would argue that the Apocalypse according to Aranda proposed a deconstruction of the catastrophic film genre, before the cultural trend of deconstruction appeared in the Western film industry.

Fata Morgana, placed in this unusual collective framework, is also a film about desire and the criminal impulse, with both motives being firmly interlinked throughout the plot. The project originated as a visual celebration of a glamourous Spanish model, and it is probably not inaccurate to claim that both the director and the scriptwriter were secretly in love with her – a circumstance that could have contributed to the tempestuous split of the two collaborators during the film's production. It is interesting to note that Gim, before appearing in person, is first shown in black-and-white photographs and, larger than life, on a billboard advertising Cinzano vermouth. Her gigantic picture here is cut out by some young fans, presumably for their collection. Gim, as a person, has been wiped out and substituted by her ever-present iconic image, a reflection of the power of the media in the "society of the spectacle". Disobeying official orders, Gim does not abandon the virtually empty city, and the few men that are left chase her through it. Even an evacuation service truck, equipped with a loudspeaker, harasses and insistently follows her through the streets.

Teresa Gimpera in front of an advert featuring herself, 1965. Courtesy Vicente Aranda

Fata Morgana, dir. Vicente Aranda, 1965. Courtesy Filmoteca española

The model's continuous presence in the advertising media turned her into an object of collective desire. Aranda gives us a behind-the-scenes insight and illustrates Gim's exposure in the media in a scene in which she is wearing fashionable Courrèges sunglasses and announces the name of a perfume in front of a camera while, absurdly, reciting a monologue from *Hamlet*.[2] The great physical and media magnetism that Gim exerts makes her a predestined victim of a jealous serial killer called Miriam (Marianne Benet). As the Professor explains in his peculiar lecture on women and violence, a fatal attraction between the assassin and the victim inevitably occurs, making their encounter similar to a romantic encounter. Similarly, Álvaro (Alberto Dalbés), who is in love with Gim, says to her: "They don't hate you, they desire you." *Fata Morgana* suggests that desire can be a form of hate, and hate a form of desire (movie buffs will remember a dialogue between the main character in *Gilda* (played by Rita Hayworth; Charles Vidor, 1946) and her jealous husband: she tells him that she hates Glenn Ford, to which he enigmatically replies: "hate can be a very exciting emotion").

The figure of the Professor in *Fata Morgana* appears as a protean oracle, sometimes disguised as a blind man and, at one point, as the "Invisible Man" in James Whale's classic film. He is a criminologist whose prophetic clairvoyance recalls that of Dr Mabuse in the 1922 Fritz Lang film. Aranda's Professor proposes the Sadean syllogism, suggesting that "all murders are the story of an encounter and all encounters are love stories". As examples of this reciprocal fatal attraction he names Iphigenia, Marilyn (Monroe), Ophelia and Desdemona. The fatalism of this encounter also evokes situations characteristic of Kafka and Borges. According to the Professor's theory, Gim adopts the role of a blonde Little Red Riding Hood in a subconscious search for her Wolf. The Professor, disguised as a blind man (like Tiresias and many other ancient oracles), warns Gim that she will not be able to escape from her destiny. Nevertheless, Gim does succeed. She is too beautiful for the author of the fable to kill her off.

Miriam, the killer, lives in an environment filled with elegant designer objects (created by the sculptor Xavier Corberó, the actress's husband at the time). Miriam's first appearance in the film is heralded by the slow progresss of a flexible spring as it descends a stairway; Miriam appears behind the spring. Among the objects in her house, one in particular stands out: an elegant silver phallic fish spitting a dagger out of its mouth. This is the object used by Miriam to commit her crimes. It is supposed to be a representation of beauty which is able to kill, as in many ancient fables. Miriam does not succeed in killing Gim but she does end up killing the Professor, who predicted her death.

Who is responsible for Gim's salvation, then? Certainly not J.J. (Marcos Martí), the young detective who tries to protect her, albeit incompetently. J.J. is a dynamic and scatterbrained youth who spends the whole movie running around, evoking Cary Grant in Alfred Hitchcock's *North By Northwest* (1959). The person who actually saves Gim is the author of the film, although he does leave her alone and exposed to the catastrophe that threatens the near-deserted city at the end of the film.

The labyrinthine structure of *Fata Morgana* is a typical trait of the narrative of Alain Robbe-Grillet, and its ambiguous ending is a technique described in those years by Umberto Eco as *opera aperta* (open work). Extensive use was made of elements derived from popular culture (comics, thrillers, science fiction, advertising, models) in creating this experimental, avant-garde film project, which had a disconcerting effect on viewers upon its release. Catalonia boasted an important avant-garde tradition in the field of visual arts (Gaudí, Picasso, Miró, Dalí, Tàpies…) and this vanguard had survived precariously throughout the lengthy Franco dictatorship. Aranda tried adapting his unconventional language and his aesthetics to the sphere of popular culture and to his futuristic thriller, while also deliberately using various elements derived from the theatre of the absurd and from surrealist poetics. When *Fata Morgana* was shown during Critics' Week at the Cannes Film Festival in 1966, and later in the Karlovy Vary Festival, French critics were able to appreciate the scope of the experiment. Bernard Cohn, in *Positif*, detected influences of Buñuel, Resnais, Fritz Lang and Louis Feuillade and wrote: "Modern techniques (television), graphic arts and comics are used with great skill. The use of objects (especially the fish-dagger which, we are told, is to lead us along a false trail that is of no usefulness) and the science-fictional sets make this film deeply fascinating."[3] The reviews written by Pierre Billard and Marcel Martin maintain that *Fata Morgana* displayed the "disturbing splendour of a Mediterranean Kafka".[4] When *Fata Morgana* was launched in the American market, the distributor didn't know what to do with the title and tried to emphasise the meaning of the film, renaming it *Left-Handed Fate* (after having eliminated the first and easy option, "The Fatal Woman"), because its invocation of destiny must have seemed less cryptic to him than the original title. The *Variety* critic Gene Moskowitz, slightly

Fata Morgana, dir. Vicente Aranda, 1965. Courtesy Vicente Aranda

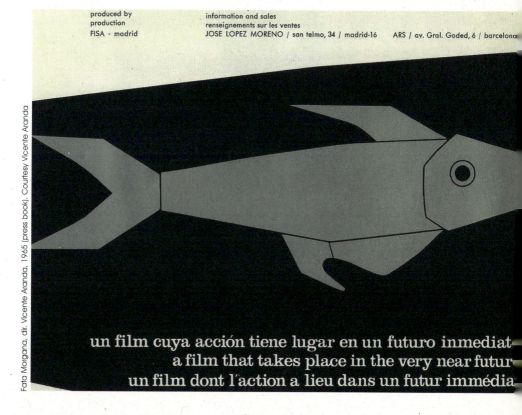

Fata Morgana, dir. Vicente Aranda, 1965 (press book). Courtesy Vicente Aranda

Fata Morgana, dir. Vicente Aranda, 1965. Courtesy Vicente Aranda

taken aback by the film after seeing it in Cannes, nevertheless recognised its "exuberance and freewheeling attack not ordinarily seen from Spain", admitting that it was "an unusual pic with special handling and labelling".[5] Yet *Fata Morgana* continued to be an enigmatic and singular work inspired by a man's fascination with the beauty of one model; the film is hardly classifiable, and more likely designed for the tastebuds of exigent cinema buffs.

Notes
1. Ado Kyrou, *Amour, érotisme. et cinéma* (Paris: Eric Losfeld, 1967), p.138.
2. Gonzalo Suárez was a friend of Courrèges at the time and sought the designer's permission to use his slitted sunglasses, then very much *à la mode*, in the film.
3. Bernard Cohn, "Une semaine de critique en 1966, à Cannes", *Positif* 79 (October 1966), p.95.
4. Pierre Billard and Marcel Martin, "Cinquième Semaine Internationale de la Critique", *Cinéma 66* 106 (May 1966), p.86.
5. *Variety* (11 May 1966).

Teresa Gimpera promotes Fata Morgana, 1965. Courtesy Teresa Gimpera.

Delinquency, Dress and Power

"So What!" Two Tales of Juvenile Delinquency
Roger K. Burton

The press and media of the 1950s and early 1960s seemed to be obsessed with the growing number of "out of control" juvenile delinquent gangs. The result of a newfound liberalism, youth had found its feet for the first time since the Second World War. Fuelled by a heavy dose of the latest craze of Rock 'n' Roll music, these frustrated, cash rich, fashion conscious kids made great press. But their outrageous behaviour caused public condemnation, and infuriated the moral Right to such an extent that the banning of Rock 'n' Roll music by some radio stations, and the ritual burning of rock records by religious fanatics, were just some of the extremes deemed necessary to quell the teenage revolt. At the same time, filmmakers across America and Britain responded to the debate by producing a number of low-budget teenage exploitation movies, most of which were moral tales of identity-seeking delinquents who attain maturity through rebellion. Instead of halting the growth, the films actually served to unite youngsters into a mood of defiance.

The first and perhaps best known of these movies is *The Wild One* (László Benedek, 1953), starring Marlon Brando as Johnny, a smug outlaw biker whose leather-jacketed gang, the Black Rebel Motorcycle Club, terrorise the inhabitants of a small US town called, ironically, "Wrightsville", for no apparent reason other than to have fun. In one of the film's classic scenes, Johnny is leaning against the jukebox, drinking beer, when a girl says to him: "Hey, Johnny, what are you rebelling against?" After a brief pause Johnny casually comes back with: "What've you got?"

Johnny's brooding and yet flippant attitude typified the feelings of so many misunderstood youngsters, and the film attained legendary status because it actually confirmed the way kids felt. It is no coincidence that sales of black leather jackets and motorcycles rocketed across the United States – such was the impact of *The Wild One* on teenage culture at the time. Due to the film's controversial nature it was, however, banned in numerous countries in the years following its release, and even in America it was feared that it might cause riots. In Britain, the film's anti-social threat was taken so seriously that the authorities banned public screenings until 1968, some fourteen years after its release.

Two years after Brando's iconic role took to the silver screen, James Dean shocked even larger audiences with his tortured character in *Rebel Without a Cause* (Nicholas Ray, 1955). The film further endorsed those "crazy mixed-up" kids' emotions, and caused riots in many towns across America. Dean's own legendary status was soon guaranteed after the 24-year-old actor was killed in a car crash, just before the film's release. Dean and Brando, joined by Elvis Presley a year later, were to completely change the way young men were seen in popular culture: sexier, confused, more feminine, and even more ambiguous. Their importance as role models would help to pave the way for the 1960s youth revolution.

Both William Morgan's *The Violent Years* (1956) and Sidney J. Furie's *The Boys* (1962) are little-known films – but they are important nonetheless, as they clearly illustrate the social stigma of post-war youth who were victimised because of the way they looked, and ostracised for their rebellious behaviour. However, it was also a time when the public with a conscience began to re-evaluate both the teenagers' voices and their dress codes, and here we see that it wasn't just the kids or the parents who were on trial, but society's morals and values as a whole.

Made from a screenplay by the one and only Edward D. Wood, Jr (*Plan 9 from Outer Space*, 1959), *The Violent Years* is a rare girl-gang B-movie set in status-conscious mid-50s Los Angeles. Like *The Boys*, it opens in a courtroom. Only here it is the parents, a wealthy newspaper publisher and his wife, who are in the dock; they are on trial because of their spoilt teenage daughter Paula. Neglected by her parents, who were too busy with their careers, Paula missed out on those heart-to-heart talks that every young girl needs. So, in an act of rebellion, she and her gang of untamed high-school girlfriends, Phyllis, Geraldine and Georgia, become thrill seekers and turn to crime. These girls might look sweet and innocent in their sporty Californian-style tight sweaters, pointy bras, waspy waists, poodle skirts and sneakers. But don't let their pretty faces fool you: they are cold-hearted criminals, out to do anything that's bad.

Disguised as men, in Levi's jeans, leather jackets, work caps and bandanas, and referring to each other as Phil, Paul, Gerry and George, the girls proceed to rob gas stations at gunpoint, and whilst their parents are away they take the liberty of throwing a pyjama party with a bunch of older men. During the party, an uninvited colleague of Paula's father arrives, and proceeds to give the girls a hard time.

Both illustrations: The Violent Years, dir. William Morgan, 1965

In one scene he stares past Paula's breasts and makes a sarcastic comment about a couple making out on the sofa: "That's a nice pair". She retorts with a stinging "They have their points."

The gang then take a drive to the local lover's lane, find a fashionable young couple who are snogging in their convertible, and hold them up at gunpoint. This action results in the girlfriend being stripped by one of the gang of her stylish beaded sweater, which Paula wants as a trophy. Paula then orders another member of the gang to bind and gag the girlfriend, but with no rope around she orders her to tear the girlfriend's skirt into strips and use that. The girlfriend is duly tied up and bundled into the back of the car, while the terrified boyfriend looks on. The gang proceed to drag the boy off into the forest, and the scene closes as Paula undoes her top and prepares to rape him. Later the gang are hired by their glamorous fence to wreck their own school classroom, as a way of aiding the ever present Communist threat; these girls will do anything for kicks. However it all goes wrong when Paula – "I shot a cop... So *what!*" – ends up dying whilst giving birth to an illegitimate child in prison.

The judge, in his final summing up, preaches to the parents that they should raise their children with a healthy respect for "property and human life" and, of course, the Church. At this point the film cuts to a shot of a church, just in case the bad parents in the audience don't know what one looks like.

Even though girl gangs in the mid-1950s were quite rare, and young males were mostly responsible for violent crimes such as fights, muggings and car theft, *The Violent Years* makes the point that girls too are often involved in breaking the law, and that they can influence male offenders' behaviour.

Made six years later, Furie's *The Boys* is a gripping period piece which centres around the media controversy that engulfed capital punishment at that time, and was one of the first British social melodramas to acknowledge the rise of teenage gangs and the juvenile delinquency rife within them. The eponymous characters are four working class teenagers, inaccurately described here as "Teddy Boys", who are implicated in the murder of a night watchman. Benefiting from Furie's dexterous use of flashbacks during the testimony scenes, the defence lawyer (Robert Morley) tries to convince the jury to render a charitable verdict. His basic argument is that the government expects a death sentence in cases involving robbery, but is more lenient towards crimes of passion. Prosecuting attorney (Richard Todd) is unmoved – his job is to prove that the boys aren't the innocent victims of society they're made out to be.

The Boys readily illustrates the widespread discrimination directed at post-war youth by a conservative British society. This point is driven further home by the adult witnesses, intimidated by the boys' outlandish appearance and dress codes, and antagonised by their threatening behaviour.

Furie embarks on a close study of the boys, who all sport the latest Italian slim-line style, made fashionable in the UK by Cecil Gee during the late '50s. This popular look became the precursor to the modernist or "Mod" movement of the early '60s, and was actually far removed from the Teddy Boys' long garish jackets and creepers of the mid-50s. However, such was their unruly reputation that the label "Ted" was still used widely by the public when referring to this "type" of young male.

As if in celebration of the Italian style, Furie's camera focuses on the boys as they dress up for a night on the town. Close-ups highlight such important details as their blow wave hair-dos, bum freezer jackets, contrast waistcoats, immaculate Denson fine point winkle-pickers, four-point pocket handkerchiefs, slim ties, and pin-through collar shirts; he also emphasises the then current trend for "bold stripes" – traditionally associated with social outcasts since the 18th century – on their shirts, ties, suits and even a raincoat worn by a trendy young vicar who is put in the dock by the defence council to illustrate that not every youngster can be labelled a delinquent just because they dress in a particular way.

As the evening's events unfold we see and hear conflicting stories, firstly from the witnesses' points of view, and then – after being reluctantly primed by their defence lawyer – from the boys themselves, who maintain that they were "just" out for a night of harmless kicks. A series of boisterous pranks are revealed as we follow them around town. First we see them get thrown off a bus by an irate conductor; they then proceed to upset a rather pompous older man and his debutante girlfriend after playing around with his sports car; next they manage to cause a ruckus with an outraged man in a cinema queue. We see them head for a wash'n'brush-up in a public toilet and end up taunting the attendant. This scene is the most stylish and beautifully choreographed; the boys ape it up and strut

The Boys, dir. Sidney J. Furie, 1962

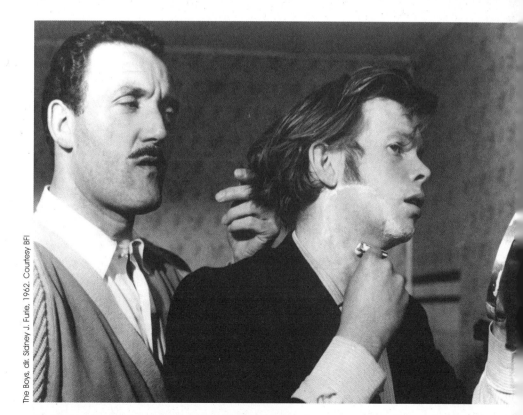

The Boys, dir. Sidney J. Furie, 1962. Courtesy BFI

about like peacocks, combing their hair, straightening their ties and posing for the camera, with each shot being played out like a fashion shoot. Then, after an unsuccessful attempt at chatting up a couple of trendy bouffant-haired girls in a pub, they drop into a local dance hall. Soon bored and frustrated with this dull place, and by now practically out of money, Stan, the gang's leader, comes up with a solution, and they wind up in yet another pub directly across the street from the site of their intended break-in.

The entire night's exploits are peppered with male bravado, play fights and one-upmanship, as each member jostles for position in the pecking order of the gang. Male narcissism is constantly referred to and observed by the camera as the boys preen themselves at every given opportunity. They are equipped with accessories such as cigarette holders, usually associated with theatrical types at the time, steel combs and a switchblade knife casually used by Stan to manicure his nails, which also inevitably becomes the murder weapon. In the dock Stan is asked to defend the way he acts, and he replies quite nonchalantly, "It's the fashion, innit?"

Both illustrations: The Boys, dir. Sidney J. Furie, 1962. Courtesy BFI

Smell of Female / Cathi Unsworth

Ladies and gentlemen – welcome to violence!
She came burning across the white desert plains, a vision in black. Raven hair, matching leather gloves, jeans, biker boots and the lowest of low-cut tops revealing cleavage like the prow of a battleship, above a tiny, cinched-in waist. Heavy black eyeliner across her lids, her eyebrows and mouth set in rigid lines, like a Kabuki mask. In the dust behind her, a trail of broken bodies scattered across the mythic landscape.

There never was a girl like Varla before. In the sun-kissed California of 1965, she appeared in stark monochrome, the centrepiece of a film conceived and directed by a man known as the "King of the Nudie Cuties", ex-World War II cameraman and breast fetishist, Russ Meyer. Yet, in casting the burlesque star Tura Satana as his lead, and allowing her to endow Varla with all her personal traits of toughness, resilience and pitch-black humor, it could be argued that with his *Faster, Pussycat! Kill! Kill!* (1965) Russ Meyer became the greatest feminist director of his time.

This is the story of three go-go dancers who get sick of taunting drooling males and set out across the desert in souped-up Porsche 356s, racing, fighting and spitting out one-liners like they're high on nitroglycerine. They encounter a wholesome couple and kill the boy, take the girl hostage and drive further into the endless wilderness. Through the portal of an outback gas station and its loose-lipped attendant, they discover a delinquent family sitting on a pile of cash, a sick Old Man and two sons who could have staggered out of Steinbeck's Dust Bowl thirty years earlier. Conniving to relieve them of their fortune, the girls' lust for cash and kicks ends in a bloodbath.

There are many reasons why *Faster, Pussycat!* is so much more than an exploitation film. Meyer's army training taught him many skills – fast-cut editing, stark angled shots and the ability to make a low-budget production look astonishingly good. Cinematographer Walter Schenk frames the landscape in superb high-contrast black-and-white, rendering every frame iconic. The ball-busting banter and sheer surrealism of the characters – one of the Old Man's sons, a muscle-bound mute, is merely known as "The Vegetable" – are a delight. But integral to the movie's allure are the girls themselves.

Bouffanted blonde Billie (Lori Williams), resplendent in white hip-huggers and a padded gingham crop top, is the all-American babe gone bad. She burns rubber, swigs whiskey and seduces men with wanton abandon. Smoldering Rosie (Haji), a lithe Latina in jeans and a tight white vest, peers through her side-parted black curtain of hair, an aloof, exotic mystery. The functionality of her feminine take on Marlon Brando's classic *On the Waterfront* (Elia Kazan, 1954) hints at the true nature of Rosie's sexuality, although Meyer did not tell either Satana or Haji that they were supposed to be lovers until the moment the plot reveals it, for fear that they might have imbued their characters with some unwanted tenderness.

Centre stage is Tura Satana. There could never have been a girl like Varla unless there was a girl called Tura first. Born Tura Luna Pascual Yamaguchi, the daughter of a silent screen actor of Japanese/Filipino descent and a Cheyenne/Scots-Irish circus performer mother, Satana's startling beauty had brought her trouble from the start. At the age of nine she was gang-raped by five men as she walked home from school. Her assailants were never prosecuted so Satana made a vow to exact her own revenge. With the help of her Karate expert father she turned herself into a skilled martial artist. Then she tracked down each and every one of her rapists. "They never knew who I was," she later recalled, "until I told them."[1]

The genesis of Varla continued throughout Satana's adolescence. At 13 she joined a girl gang who carried razor blades around their necks, secreted switchblades down their boots and wore leather gloves for fighting. Thus Varla arrives on the big screen authentically dressed for combat. When Lori Williams first clapped eyes on her, she thought "she looked like a mass-murderer".[2]

Almost all the killing in *Faster, Pussycat!* is down to Varla but it's the first blood that remains the most shocking. Initially it seems that the girls are just playing with boy racer Tommy (Ray Barlow as an Elvine hunk betrayed by his taste in board shorts) and his girlfriend Linda (Susan Bernard in bikini and hair bows). When Varla taunts Tommy into racing her, his first reaction is incredulity. But when she proves her superior motoring muscle, that soon turns into rage: "Look, I don't know what the hell your point is!" he screams at her. "The point of no return," Varla coolly replies, "and you just reached it." She proceeds to kill him with her bare hands in front of the screaming Linda.

Tommy's argument, however, was a pertinent one. The truly scary thing about Varla is how she appears from out of thin air to turn a swell couple's happy day out into a nightmare – and all for sport.

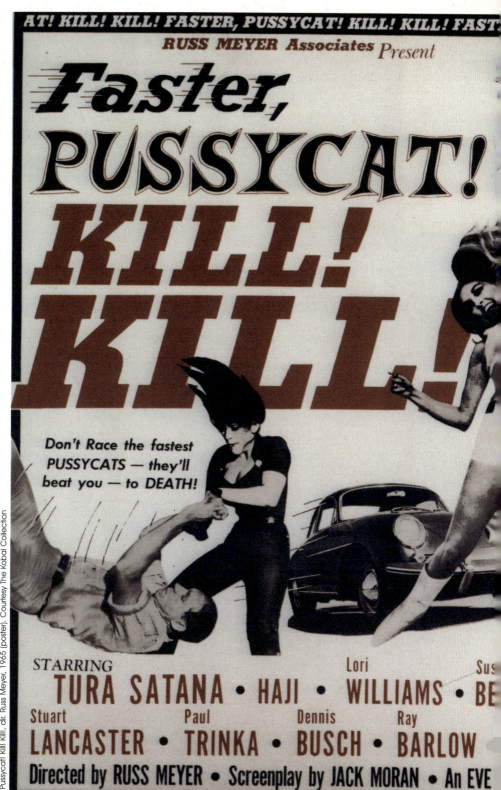

Faster, Pussycat! Kill! Kill!, dir. Russ Meyer, 1965 (poster). Courtesy The Kobal Collection

Varla is *The Hitcher* (Robert Harmon, 1986), the *High Plains Drifter* (Clint Eastwood, 1973), and *Blue Velvet*'s Frank Booth (David Lynch, 1986) rolled into one. But these are characters that in 1965 were all yet to be born. Of course, when they eventually were, all of them would be men.

No, there never was a girl like Varla before. And though *Faster, Pussycat!* bombed so badly on its release that the actresses were advised to remove the film from their CVs, what Meyer and Satana achieved would light a long, long fuse. The benchmark was set for a particular type of violent femme whose look in the coming decades would continually echo Satana's woman-in-black, her severe haircut and make-up and that threatening expanse of cleavage. It was a style that came straight from the mean streets and would be constantly referred to by other directors and performers who identified with Satana's hard ride out of the ghetto, when, as she put it, "You either had to belong to a gang or die".[3]

We are the hell-cats nobody likes / Man-Eaters on motorbikes!

The next time a bunch of girls as authentic as these were to appear on the screen was in Herschell Gordon Lewis's 1968 ode to the female biker, *She-Devils On Wheels*. Lewis had been filling up drive-in theatres since the beginning of the decade with his garish gore films that pioneered the use of heavy colour saturation, and had previous form in Nudie Cuties too. Who better to capitalise on the then-current vogue for biker flicks by directing the first ever all-female version?

Lewis knew he would have to cast this film from outside the Actor's Guild. In order that his leads could handle the hogs they'd have to spend most of the movie straddling, he hired real-life biker chicks to play his fictional Man-Eaters gang. The female Cut-Throats division of the Miami-based Iron Cross provided the film's most compelling characters – gang leader Queen (Betty Connell) resplendent in leopard skin, silver go-go boots and a towering beehive; and her sidekick Whitey (Pat Poston), a 300lb Valkyrie on a bike, complete with long white plaits and German army cap, who is fond of making up limericks as a prelude to fighting, fucking and racing – the Man-Eaters' main occupations.

These girls provided authenticity to the Man-Eaters' drag with some more street-fighting fashion – Queen wears a bike chain as a belt around her waist that doubles up as a weapon; other girls have switchblades concealed in their boots and razorblade necklaces. Lewis's love of wince-inducing colour extends into their wardrobes, a retina-frying mix of hallucinogenic pinks, greens, oranges and yellows, clashing stripes and silver hot pants, worn under club jackets with a wolf's head Man-Eaters logo stitched on the back. When riding in formation towards the screen, the Man-Eaters are a motorised bad trip, heading your way.

Like Meyer, Lewis delighted in presenting a world of shocking role-reversal, where it is the women who act purely on motives of lust, anger and the need for domination. In a script written by Allison Louise Downe, a former probation officer and longtime Lewis collaborator, the men are either compliant sex slaves or rival gangs easily brought to their knees. The most joyful celebration of female superiority is expressed in the movie's theme song, "Get Off The Road", a snotty garage classic penned by Lewis that would, along with *Faster, Pussycat!*, drip into the counter-culture of a future generation, thanks to a band of B-movie addicts called The Cramps.

A couple of misfits from Akron, Ohio, band nucleus Lux Interior and Poison Ivy Rorschach were the first of the punk generation to value the subversive style of these two films. Their 1983 live album *Smell of Female* takes its title from *Faster, Pussycat!* dialogue and they covered "Get Off The Road" on their 1986 album *A Date With Elvis*. With a band fronted by a towering cross between Elvis Presley and Herman Munster wearing eyeliner and stilettos, and a flame-haired bass player in a sparkling red bikini promoting them, it's little wonder that new fans began to seek these movies out.

A contemporary of The Cramps, "No Wave" artist Lydia Lunch was also divining *Faster, Pussycat!* when she collaborated with the New York filmmaker Richard Kern on the 1986 short film *Fingered*. Lunch plays a phone sex operator who gets bored with talking, hooks up with a client (Marty Nation) for some knife-wielding sex and then takes off with him for a drive into the desert. Here they find a young female hitch-hiker (Lung Leg) whom they abduct and rape in a junkyard. Shot in close-up black-and-white, the film is as brutal and claustrophobic as its makers intended.

Both Lunch and Kern are admirers of Meyer, and Lunch's look was a punk remodel of Varla's – a vision in black with weapons secreted about her person. But this is not a film designed to entertain, it is an investigation into abuse and annihilation that remains difficult for some to stomach. *Fingered* was selected for the 1988 Berlin Film Festival but was repeatedly boycotted by feminists who attempted to destroy the film print. In 2007 Kern reflected: "My film gave the radical feminist movement something

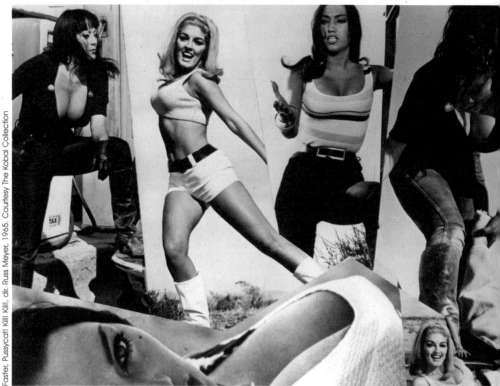

Faster, Pussycat! Kill! Kill!, dir. Russ Meyer, 1965. Courtesy The Kobal Collection

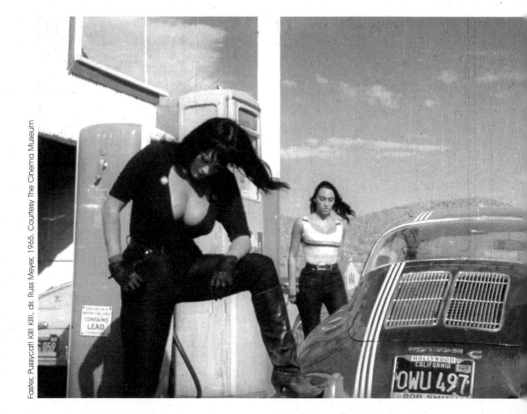

Faster, Pussycat! Kill! Kill!, dir. Russ Meyer, 1965. Courtesy The Cinema Museum

to rally against. Twenty years later, the same groups praise the film."[4] The same thing would happen to *Faster, Pussycat!*, when in 1995 film critic B. Ruby Rich began championing Meyer's film as a work of radical feminist, Queer Cinema importance. The fuse was burning, faster, faster…

Arnold Schwarzenegger – in a bra

The next incarnation came in a time and place not dissimilar to the world of exploitation cinema in the Sixties' America. Thirty years on, it was in Hong Kong that a new wave of independent directors created the hugely influential "Heroic Bloodshed" genre. Combining stunning martial arts sequences with characters taken from comic books or ghost stories and styled with a fetishistic reverence for *film noir*, these sumptuous thrillers were just the place for our ass-kicking dames to reassert themselves. Director Johnny To delivered the goods in his *The Heroic Trio* (*Dung fong saam hap*, 1993).

While John Woo's gangster movies had modernised the Chinese heroic code of *yi* for a new audience, To did his best to satirise all that rampant masculinity with a film in which the cops are powerless to defend Hong Kong against supernatural forces without the help of two superheroines, Shadow Fox and Thief Catcher. Two become three when they lure their former foe, Invisible Woman, away from the Evil Master she is serving, a vile old goat who rules his kingdom from a sewer, commanding her to steal babies born on a prophetic date to become his horned heirs.

Johnny To cast three markedly different leads. Anita Mui, who plays Shadow Fox, was a pop diva, Hong Kong's answer to Madonna, whose presence has a tragic resonance – she died in 2003 aged only 40.[5] We first encounter her as Tung, the wife of Inspector Lau (Damian Lau) who is charged with trying to protect the disappearing infants and has no idea who he is really married to. Mui's initial look is classic '40s mystery – a side-parted swathe of immaculately rolled hair, a blood red coat with padded shoulders and nipped-in waist. The Invisible Woman is Michelle Yeoh, who studied ballet in England as a child, a talent that endows her action sequences with an easy grace and perhaps explains why here she resembles Kate Bush in her leotard and flowing red robes.

The two women first clash when Invisible Woman snatches the Chief of Police's son from under Inspector Lau's nose. Shadow Fox comes to her husband's aid, appearing above the rooftops of a city that resembles a neon Edward Hopper painting, complete with replica vintage cars. Swathed in a grey cape that flutters about her as if she is indeed commanding the shadows to become her wings, Fox looks down through her silver mask and unleashes her throwing stars against her assailant in a breathtaking battle for the baby. Invisible Woman escapes with her charge, wounded – her blood drips onto the crowd below.

Having failed to protect his boss's son, Inspector Lau is in for further humiliation when an armed gang seize a chemical factory and begin shooting hostages. This time it is Thief Catcher who comes to the rescue. Maggie Cheung, a brilliant polyglot actress who was to go on to international stardom, gets the greatest entrance and the best clothes. While the other girls are ethereal beings, cloaked in diaphanous layers of chiffon, Thief Catcher is the street fighter of the Trio. She appears on the huge black bike of The Man-Eaters' dreams, chomping on a cigar, kitted out in a combination of *The Terminator* (James Cameron, 1984) and fetish gear – shades, a leather jacket over a basque, hot pants with suspenders and biker boots. Pushing the cops to one side, she straddles one of the toxin canisters strewn around the scene, lights a fuse with her cigar and launches herself like a rocket into the middle of the hostage-takers.

Camp and hilarious, *The Heroic Trio* echoes the words of film critic Roger Ebert, talking about *Faster, Pussycat!* in 1995: "What attracts audiences is not sex and not really violence either, but a pop art fantasy image of powerful women … exaggerated in a way that seems bizarre … until you realise Arnold Schwarzenegger, Sylvester Stallone, Jean-Claude Van Damme and Steven Segal play more or less the same characters."[6] In 2005, that pop art would lift itself off the pages of a comic book to explode into a whole new vision of cinema.

The ladies are the law here – beautiful and merciless

Frank Miller's *Sin City* (1991-2) has long been the Holy Grail of the comix cognoscenti. These graphic *neo-noir* novels, set in a parallel Manhattan with a more fitting name, are a hardboiled depiction of the collusion of politicians and clergymen with corrupt cops and gangsters. At the top of this tree are Senator Roark, protecting his kiddie-rapist son, and his brother, the Cardinal, whose own choirboy protégé eats the souls of women. Outside the city limits in Old Town, prostitutes maintain an uneasy

She-Devils on Wheels, dir. Gordon Lewis, 1968. Courtesy Library of Congress

The Heroic Trio, dir. Johnnie To, 1993. Courtesy The Cinema Museum

truce with the police and racketeers. Everything that Miller writes underscores an all-encompassing misogyny at the dark heart of America.

Miller was loathe to transfer his books to the screen and had to be persuaded by longtime fan Robert Rodriguez, a modern exploitation movie master, who had made his name with the $7,000 shoot-'em-up *El Mariachi* in 1992. In his 2005 adaptation, Rodriguez embraced the new technology of digital backlot, a process of shooting actors against green screens on hi-definition digital cameras, which enabled the movie to recreate Miller's original drawings.

From the opening sequence – a woman standing alone on a balcony overlooking the vertiginous night cityscape, everything in monochrome except her red dress and lips – *Sin City* is a dazzling visual feast. In a combination of three stories, *That Yellow Bastard*, *The Hard Goodbye* and *The Big Fat Kill*, a world-weary cop (Bruce Willis as Hartigan) and two ex-cons (Mickey Rourke as Marv, Clive Owen as Dwight) attempt to protect and avenge the women of Sin City from the myriad misogynists pitted against them. Fortunately for them, these dames know how to fight.

The plots converge in Cady's Bar, where the lowlife drink as dancer Nancy (Jessica Alba) whirls a Wild West routine across the counter. Nancy is the girl that Hartigan saved from Roark Jr eight years previously, when he blasted away "both his weapons" – his gun and his dick. She is also friends with hulking outcast Marv, who is on the trail of the Cardinal's choirboy, murderer of the woman he loved. From the sidelines, Dwight looks out for his waitress lover Shellie (Brittany Murphy). He will lead us to Varla's 21st century incarnations, the women of Old Town.

Shellie is being harassed by her former boyfriend Jackie Boy (Benicio del Toro), a dirty mac-wearing woman beater. Dwight pursues him into Old Town after a fraught encounter at Shellie's apartment. Dwight knows the score here: the women pay off the cops to keep out would-be pimps and on these streets they are "their own enforcers". Leader of the pack is Gail (Rosario Dawson), a leather-and-fishnets clad dominatrix with a Mohawk and earrings that resemble razorblades.

All the women of Old Town wear a mix of rubber, leather and chains indelibly linked to punk's appropriation of fetish-wear and the burlesque styles favoured by Ivy Rorschach and Lydia Lunch, which by 2005 had become highly fashionable. These outfits, complete with whips and various items of ninja hardware, are the final extension of Varla and Queen's girl-gang dress trickery. The dual purpose is explicit – they can lure men in and they can spit them out in pieces.

The effect of Hong Kong cinema on this futuristic *noir* is reflected not just in a landscape that recalls *The Heroic Trio* with its combination of Art Deco architecture and '50s fin-tailed cars, but also in the character of Miho (fashion muse, model and actress Devon Aoki), the doll-faced assassin who is the girls' most deadly weapon. Rodriguez' self-penned score further enhances the feeling of forty years of film being pulled together, combining a jazz that echoes *Faster, Pussycat!* with a garage punk edge.

Though, true to tradition, *Sin City* was misunderstood in some quarters and criticised for its violence, Miller's is the most deeply sympathetic feminist take on society of all these films. Which is why it has an undercurrent of sadness that can't be dispelled by its humour; the irony that the Old Town girls represent the section of society most likely to come to a violent end is far from lost on this writer. These women are not killing for kicks but for the necessity of preventing men from taking away what little they have. In comparison to them, Varla seems to be the creation of a more enlightened time.

So, where next for her offspring? Rodriguez' associate and friend, Quentin Tarantino – that serial movie shoplifter – recently announced an intention to remake *Faster, Pussycat!*.[7] Tarantino received a co-director's credit for *Sin City* for his work on one scene,[8] but this seems to be more of a favour from Rodriguez than a recommendation. His previous "homage" to Meyer and Hong Kong cinema, *Kill Bill Vol. I* (2003), displayed an elementary misunderstanding of wardrobe by dressing Uma Thurman in the most unflattering jumpsuit in movie history. The power of *Faster, Pussycat!* stemmed from the fact that Tura Satana was not wearing a studio-designed costume, but exactly what a real girl gangbanger would have put on to go out for a rumble. No self-respecting female from any era could have contemplated kicking ass while looking like a banana. As it would be impossible to improve on the original in any meaningful way – and with a director who increasingly seems to fetishise violence for its own sake, rather than the powerful women Meyer adored – the only possible reaction is to scan the horizon for a black Porsche with an angry Tura Satana at the wheel. My own hope is for another new movie that takes Varla's spirit boldly on. And perhaps, this time, it could be directed by a woman…

Notes

Jimmy McDonough, *Big Bosoms and Square Jaws* (New York: Jonathan Cape, 2004), p.159.
Lori Williams interviewed for *Go, Pussycat, Go!*, a documentary that accompanied the 2005 40th anniversary re-release DVD of *Faster, Pussycat! Kill! Kill!* (Arrow Films).
Marc Isted, "Tura!" *Psychotronic Video 12*, Michael J Weldon (New York, 1992), http://picpal.com/tarart.html (accessed 17/03/08).
Graham Rae, "Transgression Confessions: An Interview with Richard Kern", *Film Threat* online (Los Angeles, December 2007), www.filmthreat.com (accessed 17/03/08).
Mui died from cervical cancer, a disease that had killed her older sister in 2000.
Roger Ebert, "Faster Pussycat, Kill! Kill!", *Chicago Sun Times*, 24 March 1995, http://rogerebert.suntimes.com (accessed 17/03/08).
Reported by Liz Smith in "Tarantino wants to remake *Faster Pussycat!*", *Variety*, Los Angeles, 16 January 2008, http://www.variety.com (accessed 17/03/08).
Literally one scene – the Clive Owen/Benecio Del Toro talking severed head hallucination.

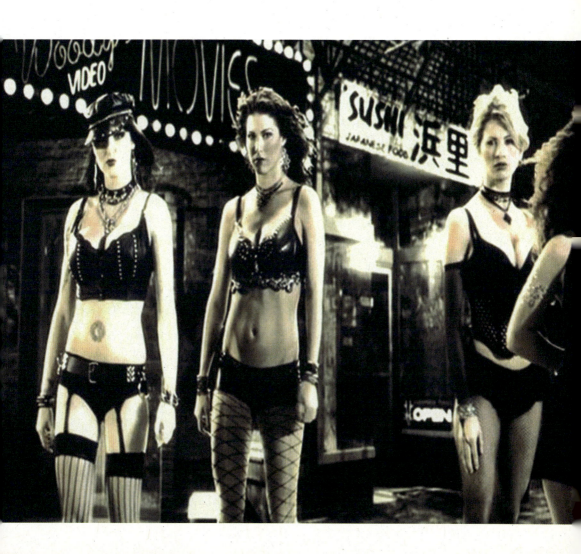

On Gangster Suits and Silhouettes[1] / Lorraine Gamman

This article is written as a sequel (in two parts). The first part focuses on the modern gangster silhouette and offers reflections on the meaning of the narcissistic aspect of menacing men and their suits. The second part looks at the HBO TV series *The Sopranos* (1999-2007), and asks why it features so many representations of fat Mafia men who don't always look their best, even when fully tailored. It also examines the postmodern and melancholic implication of *The Sopranos*' crime, and consumer as well as clothing narratives.

Part 1: The Gangster Silhouette and Mainstream Movies

> Gangster films are about looks – they are about making the spectator desire what the gangster possesses.
>
> Stella Bruzzi

James Cagney, Edward G. Robinson and Humphrey Bogart are movie stars who clearly knew how to wear a suit. In Saturday afternoon repeats of films like *Little Caesar* (Mervyn Le Roy, 1931), *"G" Men* (William Keighly, 1935), *The Amazing Dr. Clitterhouse* (Anatole Litvak, 1938), or Rod Steiger in *Al Capone* (Richard Wilson, 1959) and Ray Danton in *The Rise and Fall of Legs Diamond* (Budd Boetticher, 1960), movie gangsters reveal a narcissistic preoccupation with clothing, and in the way they link violence and vanity, they often operate to glamorise menace. The suits in gangster movies also help the actors cast a spell over the audience.[3] Many of these films provide accounts of American back-street kids who mad it to the top of the underworld only to be transformed into suit-wearing "Spivs" who receive their just deserts in the end. All of the American actors who have played Al Capone, notably Jason Robards in *The St Valentine's Day Massacre* (Roger Corman, 1967), share this quality, as do British 1960s fictional villains such as Michael Caine in *Get Carter* (Mike Hodges, 1971) or Richard Burton as Vic Dakin in *Villain* (Michael Tuchner, 1971). So why has the *suit*, "the whole range of tailored jackets, trousers, waistcoats, overcoats, shirt and neck-ties that make up the standard masculine civil costume all over the world",[4] lasted as a clothing style for such a long time? And why is the modern suit – often irritatingly "perfect" in its presentation – adopted by gangster movie icons?

All the classic gangster films feature forceful masculine figures: lean and mean in tight-fitting tailoring (two-tone or occasionally Savile Row suits). They entertain us by violating the law (and/or prevailing social morality) whilst remaining good-looking and sartorially special, if not always good-hearted. Stella Bruzzi's useful analysis reviews the different ways in which European and American gangster films engage with masculine archetypes and male narcissism. She argues that "vanity in a man came to signify evil and degeneracy (the most obsessively narcissistic gangster is often the most violent)".[5] On the subject of their suits, from Cagney's double-breasted jacket to Caine's single-buttoned, high-lapelled 1960s look, they operate to repress almost everything of the man, back behind the defensible lines of the image and also of the tailoring. Even in the more obviously dated Al Capone hats, spats and double-breasted jackets, featured in the TV series *The Untouchables* (1959-63), where the Spivs are hounded by the svelte waistcoated Eliot Ness, gangster movies seem to use the suit as a boundary that marks the "defensible space" of the body in the way that Oscar Newman used the term to describe both real and symbolic boundaries of architecture.[6] Melodramatic alpha-male anti-heroes – and the violent ones too – are clearly transformed when the tailoring works. Even gangster movies that end with moral tales *against* lives of crime often cannot get the message across, because plot lines do not contain or override the powerful symbolic meanings of the glamorous suits on screen that the guys lived for – and often died in. As Robert Elms has pointed out, "preposterously expensive tailor-made suits appear to have some sort of alchemical ability".[7] The reason so many gangsters wear them in the movies may also be aimed at using the magic of tailoring to block the penetration of the onscreen hostile gaze – a point I shall return to.

The Godfather Parts I-III (Francis Ford Coppola, 1972; 1974; 1990), *Once Upon a Time in America* (Sergio Leone, 1984), and crime films like *Goodfellas* (Martin Scorsese, 1990), *Reservoir Dogs* and *Pulp Fiction* (Quentin Tarantino, 1992; 1994) all feature action-packed spectacles of hard men wearing sharp, often bespoke business suits. Gangsters as "sexy beasts" appear in full filmic profile, conservatively dressed in designs that fashion historians argue have "stayed virtually the same for 200 years".[8]

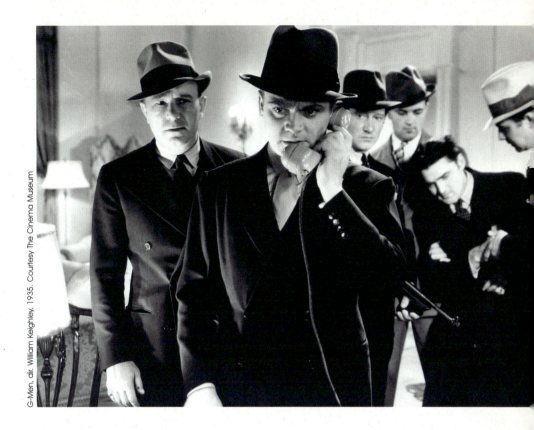

G-Men, dir. William Keighley, 1935. Courtesy The Cinema Museum

The Sopranos, HBO, 1999. Courtesy The Kobal Collection

The gangster is a "dandy" par excellence, like the 19th century Dandy who dressed as if going to a funeral and, according to John Harvey, made "simple and dark and especially black clothes fashionable".[9] Today's movie gangsters exhibit similar taste. On screen they are protagonists who carry the action forward, but are also dressed to kill; glamorous figures, in the original definition of the word. These images also offer what Laura Mulvey has described as "to-be-looked-at-ness",[10] perhaps because the gangster, to paraphrase Harvey's account of the Dandy, "renounces plumage, but his image [on the screen] offers a form of masculine display".[11]

Tarantino, with his lead characters in *Reservoir Dogs* and *Pulp Fiction* dressed in black ties and Agnès B suits, uses such styling almost as "genre reinforcement". In fact, Tarantino has argued that suits give gangsters a uniform, one that aids their anonymity: "when the cops come back later and ask, 'What did they look like?' [you'd say] 'I don't know – they look like a bunch of black suits'."

Gangsters are definitely dandyish, but their suits often operate to contain the gangster's inevitable fragmented identity, that may eventually spill over onto the screen (Tarantino's forte) as the crime action accelerates. Gangster suits also fetishise the male body. They offer the spectator a view of what Rebecca Arnold has called "fashion noir",[12] but also a constrained form of male display. Their presence may, to some extent, argue against the case made by J.C. Flügel in his *The Psychology of Clothes* (1930) about the "great masculine renunciation" of fashion in the 19th century.[13] Gangster suits may be contained and sombre, but they nevertheless turn the male silhouette into a sexy fighting machine, accessorised with big guns and black shades, creating an image "to be looked at". Just think about the violent eroticisation of John Travolta and Samuel L. Jackson in *Pulp Fiction*, with blood and splatter on their suits – their image offers perverse fetishisation of menace as sexual spectacle. The suits holds the body like a fetish container that cannot be penetrated by a hostile gaze, and so the red blood (not their of course) on the front of the suit becomes symbolic of real guts hanging out, and another form of visual styling that contains the gangster's interiority.

Gangsters on film are mostly all image, all "outside". Dick Hebdige, writing about the Krays in David Bailey's *Box of Pinups* (1964), an amazing photographic image of identical twin gangsters, in identical suits, exhibiting identical menace, goes on to offer an ethnographic account of how these men lived within a subcultural "system of closure", and how their image, and their use of the media, was important to their success.[14] Hebdige's phrase "system of closure" also sums up what a well-tailored gangster suit can do and "contain". We may be bedazzled by the details of pockets, vents, buttons and cuffs that give swagger and charisma to the gangster persona (all fastened, often, with just one button) but actually, the gangster's suit operates to "close" off the inner man who rarely speaks his feelings. Gangsters therefore offer iconic images and even at moments of tense emotional drama are always mysterious, given that so little emotional dialogue is forthcoming. Enigmatic understanding via *Godfather*-style one-liners is usually the common form of speech; Don Vito Corleone needs only to say "Michael, I never wanted this for *you*…", to convey his emotion about the corruption of his hope for his youngest son.

This sort of emotional repression, alongside the semiotic effect of a tailored suit on screen, delivers many different connotations to different viewers. Some knowing viewers are more focused on the clothing than the rest of us and can recognise whether the seams are sewn by Bethnal Green, Soho or Savile Row tailors. The gangster "Spiv", who is groomed to excess and holds the scrutiny of the erotic cinematic gaze (for both men and women), is rarely dressed in Savile Row; Italian suits (from Soho) are more popular with these characters – the Establishment and James Bond wear Savile Row. Additional, excessive focus on male grooming and presentation, as delivered by the "Spiv" – as Christopher Breward has argued in his book *Fashioning London*[15] – serves to emphasise, often by a subtle fashionable touch to the tailoring of an otherwise immaculate suit, the *lack* of social status of the men in question. I would argue that the Spiv factor, articulated through specific types of suits and excess, is often a way for middle-class filmmakers to covertly show the audiences that some tailored characters do not pass for gentlemen (and so end up looking like pimps). In *Get Carter*, when Michael Caine is on the train, dressed immaculately, dining in a first-class carriage and looking fantastically classy in a suit, we can observe that he is out of place – not by his excessive tailoring (delivered by the costume designer Evangeline Harrison) but by the way he wipes the silver cutlery with a napkin and allows one loose hair to fall over his face to show us that underneath, he is not really what he may seem.

Celluloid gangsters, manicured and coiffed to perfection, use fear as a form of glamour that even the fictional characters in the movies want to emulate: "I've always wanted to be a gangster," says

Get Carter, dir. Mike Hodges, 1971. Courtesy The Kobal Collection

Ray Liotta as Henry Hill in *Goodfellas* (Martin Scorsese, 1990). Liotta goes on to explain why gangster cars, clothes and violent lifestyle inspired his imagination, and why he felt that it offered a better job opportunity than being "the president".

Yet the suits that gangsters wear, as I have argued earlier, offer an account of masculinity that originated in the 19th century and have come to inform modern definitions of what it means to be a real "man" who leaves it to the girls to offer "display", while he "works". Yet the "work" the filmic gangsters deliver is hardly comparable with the traditional accounts of manual work, or newer accounts of "office" work, and so the suits in gangster movies are excessive even when sober in colour and tailored with restraint. Here, "excess" produces the male suited masquerade[16] as response to "lack" (of "use value" connected to the work gangsters actually do). I am arguing, then, that representation of the gangster in terms of style perhaps dates back to the time when men gave up gaudy clothing and decided to be sombre, "useful" rather than "beautiful", and because there is a contradiction in terms of the "use" value of the work gangsters actually deliver, the gangster's groomed image is over-determined. This is a surprise, because by the late 19th century, "beauty" as a trope was left to the female species, whose soft feminine clothing contrasts vastly with those in the masculine "work" sphere; in gangster movies it means that women's clothing contrasts vastly with those tight-fitting suits worn on the hard bodies of the male leads. A modernist form, then, gangster suits in the movies are nevertheless contradictory because on the one hand the suit contains feelings and reinforces masculinity as a hard exterior image that constrains some aspects of display. On the other hand, the suit helps to turn the male form into a performative spectacle and holds the gaze, providing narcissistic and voyeuristic identificatory opportunities for men and women, as well as strong homo-erotic overtones connected with the over-emphasis on appearance.

Film directors have kept such gangster movies edgy, however, by ensuring that these male narcissistic fantasies articulated by excessive grooming are tempered by (a) the central character's gradual self realisation (or disintegration) amidst existential dilemmas and moments often articulated in terms of clothing presentation; (b) wry and often humorous reflection linked to incidents where the gangster's behaviour is either outrageous, subversive or linked to life-or-death issues. No wonder gangsters wear suits that are reminiscent of funeral-wear.

The wry looks and black humour of such life-and-death moments, or gangster wit, offer alongside the clothing narratives the most pleasurable moments of gangster movies (Scorsese's films do it best). Obviously, gangster movies differ widely and contain too many diverse themes to address here, and did change very much in the post-war consumer years when fashion influenced the gangster genre and introduced consumer desire as part of the motivation of the business of crime. In addition to films already mentioned, *The Long Good Friday* (John Mackenzie, 1980) started to break new ground with the emergence of more reflection and the fading of the narcissistic focus. Low-budget British gangster movies such as *Face* (Antonia Bird, 1997) and *Sexy Beast* (Jonathan Glazer, 2000) continue this reflective focus and contain many narrative elements that disrupt the narcissistic display and violence associated with the genre, introducing more melancholic moments or "gallows" humour. In part 2 of this sequel, I suggest that Freud's account of "melancholia" and "endless mourning"[17] (as well as his account of narcissism) may be useful to understanding the clothing style and humour, as well as the shifts and motifs in *The Sopranos* TV series that subvert many of the established codes and conventions of the gangster movie genre.

Part 2: Suits and *The Sopranos*

> Lately I get the feeling I came at the end ... the best is over ...
> Tony Soprano

The Sopranos can be best described as a long-running Mafia TV soap opera. Based on Mafia books such as *Wiseguy*,[18] the Sopranos are gangsters with family and weight problems that have filled many prime-time viewing hours of the early 21st century and received much critical acclaim. After 86 episodes, multi-authored scripts and imaginative sets, music, clothes and soundtracks (and countless gangster-style murders), many have found the series and the actors in it utterly compelling. The editor of the *New Yorker*, faced with the news that *The Sopranos* would finally end in June 2007, went as far as to pronounce it "the richest achievement in the history of television".[19] And I agree with him. One of

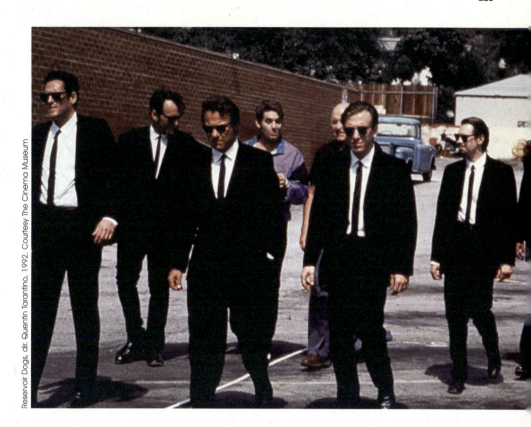

Reservoir Dogs, dir. Quentin Tarantino, 1992. Courtesy The Cinema Museum

Goodfellas, dir. Martin Scorsese, 1990. Courtesy The Cinema Museum

its biggest achievements has been to transform the shape of the gangster silhouette from well-clad, lean and mean fighting machine into all *underbelly*. Unlike in gangster movies, there is little erotic objectification of the male body in *The Sopranos*, or simple accommodation of narcissism. The men in it are rarely handsome in the classical sense and are rarely found dressed to kill in pin-striped business suits; the narratives are also very complex and often feature many unresolved moral dilemmas.

Unlike the traditional gangster movie that depicts handsome American-Italians – hard men with ticking facial muscles, prancing about with big guns and sharp suits whilst involved in turf wars, *The Sopranos* "guys" from the outset appear very different. The drama is centred not so much on image and how they look, but on how they *cope*. *The Sopranos* are not just heavyweight TV gangsters. They are in fact played by overweight white men who, despite their tattoos and the series' trendy theme tune by the British acid house band Alabama 3 ("you woke up this morning – got yourself a gun"), are almost anti-fashion. They share their bulk and their attitudes towards women with Hip hop's gangsta-cool contingent rather than *The Godfather*'s gangsters; in fact, like their counterparts in rap music, they clearly support materialism, sexism, violence, homophobia, drugs and murder. But the main difference is that they often wear bland golfing not bling designer sportswear. This is not an accident. Since the second series, *The Sopranos* were styled by Julia Polsca who says that Tony's signature look is "loud short-sleeved shirts, many of which come from a company called Burma Biba", adding that she has been "chastised" for showing Tony in shorts "by the owner of a store where I shop for some 'mob attire'". Polsca also says that she was told: "A boss would never wear shorts ... it's undignified."[20] She defines the look of other significant Soprano characters as: "Pussy – polyester coordinated 'sets'; Paulie – running suits, often by Alan Stuart; Furio – tight knit shirts; Silvio – loud silk shirts and slacks." Like so many overweight rappers, *The Sopranos* men offer little erotic or sartorial pleasure to the female viewer, even if there is much emphasis in the series on the fact that they are not too fat to fuck – *Bada Bing* girls on top, of course.

As a male icon, James Gandolfini as Tony Soprano looks to me a bit like my dad at the same age. Gandolfini simply does not compare with Robert de Niro, Al Pacino, or other gorgeous Hollywood actors who have played Italian gangsters on the big screen. With the exception of Michael Imperioli who played Christopher Moltisanti (the only character in the TV series to wear dark glasses and look good in a suit), *The Sopranos* shows the contemporary underbelly of America as it really is – overweight and often emotionally overwhelmed. These hard men, such as Vincent Pastore who plays Salvatore "Big Pussy" Bonpensiero, are not as cool as cucumbers but are often deeply agitated. Paulie "Walnuts" Gualtieri, who has wispy uncontrollable hair and anxieties about health and gang status, is typical. *The Sopranos* is full of men like these, whose lives hover between comic reality and the stuff of nightmares. We know that any exchange we watch could tip without warning from pleasantries and humour to murder (here, there is a debt to films like *Goodfellas*, as David Chase, the creator of *The Sopranos* series, has acknowledged).

Tony Soprano is not an old-movie-style "outsider", casting a sinister shadow over the American family, but its antithesis. He is regularly shown inhabiting a domestic world in casual clothing, where his wife Carmela and his children's presence is important, and compares with any regular representation of the American family. Geoffrey O'Brien argues that Tony Soprano is a "domesticated gangster inhabiting a world in which women had equal dramatic weight. It is with his wife, his daughter, his sister, his mother and his analyst that Tony engages in his deepest emotional struggles".[21]

Tony's main character difference, therefore, is that he is in the middle of a mid-life crisis and develops his inner life on screen via encounters with women and regular visits to his shrink, where he often sits and looks at his feet (Allen Edmond, evidently, supplies most of Tony's shoes, including his golf shoes). His shrink is Dr Jennifer Melfi (Lorraine Bracco), who wears business suits by Vestimenta and relentlessly strives to make Tony Soprano aware that not all women are there for sexual pleasure, and that life is complicated and dependent on the choices we make. Her independence and different world view is represented by her clothing, which looks more "professional" than that worn by other women in the series, as well as by what she says to him. Outside the therapy room, and outside his domestic life, Tony's erotic but dismissive gaze at women (the lap dancers and strippers in Silvio's nightclub *Bada Bing* where Tony has his office) is comparable to the way women in Gangsta music videos are portrayed. But in *The Sopranos* there are no soft lenses on either women's bodies or faces, nor men's: here the camera shows us the full pound of flesh.

It's true that some gangsta rappers, such as Notorious B.I.G. and Fat Joe, were/are overweight

too: approximately the same size as Tony's colleague "Big Pussy" Bonpensiero (who looks over 20 stone) or Bobby Bacala (played by Steven R. Schirripa who is bulked up for the series). In Series 6, Bacala, sweating after playing baseball, casually tells Tony (who asks what he weighs) that he is "265lbs!" Few women I know find any of the Sopranos men attractive, and some of the depiction of overweight men (Pussy in the gay nightclub) verges on the *grotesque* as an aesthetic trope. Silvio Dante (Steve van Zandt) looks smaller in comparison to other male Sopranos characters, and so his character is made to stand out with his big hair quiff and terrible, brightly coloured Versace ties that he wears to the *Bing*.

The difference with *The Sopranos*, compared to most Hollywood gangsters on film, is that TV allows for more character development as the weeks go by, as well as the ability to reference gangster "movies". I have given up counting how many times *The Godfather* is mentioned, and not just by Christopher who is writing a film script, but by many other Sopranos characters, including Tony's son A.J. (Anthony Junior, played by Robert Iler), who is shown to measure his life experiences against Mafia "fictions", often unable to balance his reality with Hollywood Mafia films. Also, Tony Soprano and crew are given the sort of postmodern inner lives and conflicts rarely seen in early gangster films or in gangsta *bling* MTV music video promotions. In fact, *The Sopranos* is bursting at the seams with issues bigger than the size of the bum or waistline of the gangster's latest squeeze, or the clothing labels chosen for the actors to wear in the series.

What I love the most about *The Sopranos* is not just that the men are clearly not perfect movie gangsters, but that there is not one truly *fashionable* character in any of the 86 episodes: even women like Carmela (Edie Falco) who are seen to care about image and dress for the occasion – a lilac beaded dress from Cache for dinner with Tony, or in mob funeral *bling* – have no real fashion sense at all and leave the audience wondering. Many of the female characters either wear so-called suburban but frumpy respectability (Carmela in St John knits), or if they are sexy girlfriends like Adriana (Drea de Matteo), they dress in lycra running kit, or worse. Adriana is seen playing an American in Rome, for example, in tight-fitting zebra animal prints; when nightclubbing, black stretch vinyl or bad taste '80s Escada or Dolce & Gabbana trousers make an appearance. Even at funerals *The Sopranos* women are dressed to the nines, and exhibit the sort of bad *bling* taste (too many buckles and motifs on the clothing) expected of the *nouveau riche*. The taste, like the layers of fat on the men, hints at working-class roots. Indeed, this focus on "bad taste" is so successful that Polsca received an Emmy nomination for an episode in which she dressed the actors for a mob funeral.

Despite the apparent bad taste, Tony and other Sopranos characters are compelling on screen because it is what goes on in their heads, rather than what they *look* like, that seduces us. Tony Soprano is so stressed with life's problems that we feel sympathy for him. His mother is scripted as a monster, and the black dog of depression follows him everywhere, so we watch him taking Prozac, and getting rightfully "down" when his mum and his Uncle Junior really do conspire to kill him.

Tony's depression is reasonable in the account Freud gives of both normal and pathological melancholia, which Freud says may arise in reaction to the loss of a loved person, or to the loss of some abstraction which has taken the place of one, such as one's country, liberty, or other ideals. It is, however, how Tony deals with the loss of so many boundaries – his straightforward abandoning of so many emotional ties, his self-centered transformation of his losses (particularly of the colleagues he is forced to dispose of) to make sense of it all – that provides the quality that gives *The Sopranos* more depth than the account of narcissism can deliver. Tammy Clewell sheds further light on this. In her definitive article "Mourning Beyond Melancholia",[22] she locates theorists after Freud who have developed the account of melancholia, including the feminist psychoanalyst Julia Kristeva, whom she paraphrases as arguing that:

> mourning defines a repudiation of attachments as a condition of normal subjectivity and signification. Conversely, the failure to mourn the mother results in an inadequate integration into society that may lead to clinical depression, a condition Kristeva sees as arising when the subject has "been unable to find a valid compensation for the loss".[23]

Tony never seems really to get over the process of mourning (even if it appears that he comes to understand the loss of his mother before she actually dies). His lifestyle, which often puts him at risk of being killed, requires him to repress mourning. In fact, death plays such an integral part in his

business that he clearly needs to incorporate loss into his daily masquerade[24] and to repress his strongest feelings. So despite the wins and the up moments, there is a sense of "failed" mourning. His mother Lydia is represented as a cynic too, and is heard to say to her grandson in her dying moments, "It's all a big nothing." No wonder Tony is represented as being unable to find valid compensation for his life of crime, and that some fashion images from the series – such as those shown in the *Vanity Fair* editorial (April 2007) – easily move from grunge to abjection.[25] Despite his family, the other women and all the wealth and riches he has access to, what has been lost is Tony's belief that the Mafia and the material comforts he derives from the job are really worth it.

At happier moments, all of this is well hidden, when Tony engages with his family or hits the town with the boys. In between, he talks philosophy with the Canadian geese that pass by his swimming pool, or gets psychological advice from his therapist to cope with random panic attacks caused by his daily life of crime, without really understanding the essence of his dilemma. When the shit really hits the fan, he focuses on what is for dinner, like a proper Italian.

In fact, much of the series is devoted to what I call "emotional eating". Tony is often seen near the fridge, "at home" in a shapeless white dressing gown or PJs, wolfing down bowls of ice cream and a lot of emotion, all hinted at by the way the camera pans down to scan the rolls of fat covering his stomach. Geoffrey O'Brien suggests that this focus on abject bodies is also evidenced by the fact that a great number of *The Sopranos* scenes are set in "hospital rooms, retirement homes, and funeral parlours … showing a beauty pageant of the body in decline …".[26] I would go even further and argue that hospital and other dramas that focus on gore – from *CSI* to *The Sopranos* – offer a morbid gaze[27] at abjection, which delivers voyeuristic pleasure to viewers.

Tony Soprano does work as an authentic representation of a bona fide Mafia boss, precisely because we see him making a living by grabbing the spoils from hijacked lorries, skimming construction contracts, running illicit gambling schemes, and committing the violence and murders that are necessary to enforce his business deals. As a consequence of a business and legal threat, he is "forced" to murder his nephew's girlfriend Adriana as well as his best friend Sal, and later his friend and nephew Christopher. Despite this carnage, we remember that he has told his psychiatrist he believes that deep down he is still a "good guy" and "family man". Despite the many murders Tony orders or commits himself, somehow we believe this too, although towards the end of the last series his complicity becomes less easy to forgive, as do some of his awful leisure-wear choices.

Tony Soprano and colleagues save "dressing up" in suits for special occasions – funerals, weddings and Mafia business. Even then their overweight frames can rarely display the sartorial elegance expected of anti-heroes in traditional American gangster films. Yet, Tony Soprano occasionally does pull off the look, so much so that he has featured on the front cover of *Vanity Fair*, in a dark suit and draped by a near-naked Adriana. While it is not true to say that his style does not matter, the fact that he does not look like a stereotypical gangster movie hero doesn't mean he isn't sexy. His lack of model looks and extreme bulk merely help to enhance issues about normality/abnormality that are integral to the attraction of the series.

What *The Sopranos* shares with most of the Hollywood gangster movies is the central concept that gangsters are human beings like the rest of us, with domestic problems and personal issues. They are not simply good or evil. The main difference is in the way this humanity is represented. More than any other Mafia fiction, *The Sopranos* connects crime to everyday consumer culture and consumer desire, and offers a distorted mirror image of the truly warped ways of life we see around us and which we have been slowly conditioned to accept as inevitable. It is within these complex narratives that we see a glimpse of a critique of the American way of life, via the representation of the ordinariness and banality of life in the criminal underworld. Tony tells nosy neighbours that he works in "waste management", and this metaphor says it all about an underlying critical stance of the series. The wasteful and bulk packaging that is typical of consumer goods, as well as the bodies of gangsters in *The Sopranos*, articulate environmental concerns about Tony Soprano's life of crime and what taking the American dream of "plenty" too far actually leads to, with clever subtlety.

The opening scenes of *The Sopranos*, grey and iconic, suggest that the action could be in any place, at any time; it is almost "supermodern" in its emptiness.[28] The action itself is actually located near The New Jersey Turnpike, where the northern part has few old-fashioned mean streets and instead reveals "Nowheresville" at its worst; this backdrop and the clothes influence the feeling of the series. For example, when (Robert Loggia) Feech La Manna is released from prison, he continues to

wear some of his old clothes (lots of Banlon shirts); yet he still blends the out-of-real-time backdrop well, and fits in with the none too fashion-forward Sopranos guys. And it's not just the fashion. Some of the crimes perpetrated seem dated too, about 20 years out of sync.

What is absolutely up to the minute about *The Sopranos* series, however, is not just this postmodern slippage of time, but the way distinctions between good and bad are not always maintained in black and white, but blur into a grey supermodern landscape; likewise, the clothing often drains from hard black to grey and soft nondescript shades of beige, or washed-out grunge colours.

Gangster films have always been persuasive because they do the opposite – they dress up crime, and offer powerful iconic images. They also often make connections between the way business and crime operate, raising questions about whether or not criminals are so different from the rest of us. *The Sopranos* does this with less sartorial elegance but perhaps with more wit and brilliance, and tries to answer these questions (or dilemmas?) in a post-industrial global crime context where Russians, Albanians and many other ethnic groups involved in the business of crime in America are shown as marginalised and are perceived to wear different clothing and exhibit different value systems from the established Italian-American Mafia men with whom they "co-operate". Almost anything goes: after the Iraq War and scandals like Enron, nothing is surprising and perhaps this acceptance of cynicism is what we should question in terms of what effect *The Sopranos* has on the world in terms of the meanings in circulation. *The Economist* suggests that the series "overturns moral certitudes" and observes that "the tensions created by the growing global reach of shows like *The Sopranos* may prove far more difficult to manage in the long run than the tensions created by the passing neo-conservative moment".[29]

The Sopranos is not just another form of American colonialism of TV, or fashionable gangster fiction where the actors will be remembered as much for what they wore as for their roles or the violence they delivered. Instead, *The Sopranos* offers not just a new look at the male silhouette in suit styles and shapes, but also a new and complex look at consumerism and the "American way".

Aside from its different view of the gangster silhouette, *The Sopranos* does not do anything radical like challenge gender stereotypes. Crime dramas often seem to try to ignore the influence of the Women's Movement (unless they make the character *exceptional*), and *The Sopranos* presents no female characters at all whose desire, or even fashion sense, can transform their circumstances. Despite the promise of fiery women in the earlier series, few women (those that are not lap-dancers or prostitutes) are seen to make a successful and independent wage from crime in the way true-crime biographies – from Moll Cutpurse to Shirley Pitts – indicate that women have done so.[30] Instead, the Sopranos women get to be duped wives and sexualised girlfriends, difficult mothers or dutiful daughters. But the anarchic power of Tony Soprano to live and sort out his life his own way, as well as to offer a humorous and wry reflections on crime and life (which is the biggest pleasure of the series), may not look stylish or beautiful, but it is of course more compelling than middle-class angst or smart-arse attempts by fashionistas to express so-called "superior" taste.[31]

The moral complexity of *The Sopranos* is certainly superior to any other gangster movie or series, perhaps because it anticipates an intelligent viewer. *The Sopranos* shows us that crime might pay, but criminals are rarely happy people who have found themselves, or use money to "better" themselves or even dress well. Consequently, *The Sopranos* has few radical statements to make, except for its account of the amorality typical of contemporary consumer culture. It features criminals who, just like the law-abiding majority of Americans and the rest of us, often make idiotic consumer or romantic choices. Ultimately, Tony Soprano is *sexy* because he is attractive and powerful. It is here that the word "glamour" is useful, in the alchemical sense of spell-making, rather than in the sense of wanting to aspire to be just like the icon. Tony Soprano casts a spell because we have watched him for almost eight years inside this never-ending Mafia soap opera, and he has reached parts of our hearts and minds that other Mafia stories have not reached. We have seen his multiple faces, multiple roles and multiple worlds. *The Sopranos* as a representation has redefined crime as a way of life as well as the gangster genre. It's not just the historically specific form of the suit as worn by gangsters in the movies – and the gangster silhouette – that has been redefined by *The Sopranos*, but also the idea of the *ordinariness* of crime and crime families. We see that the mob, in an era of diminished expectations, are not as unusual or as special as Hollywood once led us to believe, and that there may be no final, transcendent happy ending for them or us.

Notes

1. With thanks to Alistair O'Neill, Caroline Evans, Suzanne Moore and Adam Thorpe for their helpful comments on this article.
2. Stella Bruzzi, *Undressing Cinema: Clothing and Identity in the Movies* (London: Routledge, 1997), p.87.
3. The original meaning of the word "glamour" was the act of casting a spell over someone, particularly to change how things appeared to him or her. The primary modern meaning of the word relates to fascination, charisma, beauty or sexual attraction.
4. Anne Hollander, *Sex and Suits: The Evolution of Modern Dress* (London: Claridge Press, 1994), p.3.
5. Bruzzi, supra n.2, p.69.
6. Oscar Newman, *Defensible Space* (New York: Macmillan, 1972).
7. Robert Elms, *The Way We Wore: A Life in Threads* (London: Picador, 2005), p.266.
8. Hollander, supra n.4.
9. John Harvey, *Men In Black* (Chicago: University of Chicago Press, 1996), p.31.
10. Laura Mulvey (ed.), *Visual and Other Pleasures* (Basingstoke: Macmillan, 1989), p.19. NB, Mulvey referred to female, not male figure as object of the gaze.
11. Harvey, supra n.9.
12. Rebecca Arnold, *Fashion, Desire and Anxiety: Image and Morality in the Twentieth Century* (New York: IB Tauris, 2001), p.74.
13. J.C. Flugel, *The Psychology of Clothes* (London: Hogarth Press, 1930).
14. Dick Hebdige, *The Kray Twins – The Study of a System of Closure* (Birmingham: Centre for Contemporary Cultural Studies, 1974).
15. Christopher Breward, *Fashioning London: Clothing and the Modern Metropolis* (Oxford: Berg, 2004).
16. The argument that men masquerade, as well as women, can be found in Mark Simpson, *Male Impersonators: Men Performing Masculinity* (New York: Routledge, 1994).
17. Ernst L. Freud (ed.), *Letters of Sigmund Freud*, trans. Tania Stern and James Stern (New York: Basic Books, 1960); Sigmund Freud, *On Narcissism: An Introduction* (standard edition 14, 1914), pp.73-102; Sigmund Freud, *Thoughts for the Times on War and Death* (standard edition 14, 1915), pp.275-300; Sigmund Freud, *On Transience* (standard edition 14, 1916), pp.305-07; Sigmund Freud, *Mourning and Melancholia* (standard edition 14, 1917), pp. 243-58; Sigmund Freud, *The Ego and the Id* (standard edition 19, 1923), pp.1-59.
18. Nicholas Pileggi, *Wiseguy: Life in a Mafia Family* (New York: Pocket Books, 1987).
19. David Remnick, "Comment: Family Guy", *The New Yorker* online, 4 June 2007, http://www.newyorker.com (accessed 30/01/08).
20. See *The Sopranos* – Behind the Scenes. Dressing the Sopranos: A Costume Designer's Notes, HBO (2008) http://www.hbo.com/sopranos/behind/costume (accessed 30/01/08).
21. Geoffrey O'Brien, "A Northern New Jersey of the Mind", *New York Review of Books*, vol.54 no.13, 2007, http://www.nybooks.com (accessed 30/01/08).
22. Tammy Clewell, *Mourning Beyond Melancholia: Freud's Pyschoanalysis of Loss*, Japa, 52/1, http://www.apsa.org (accessed 03/03/08).
23. Ibid., p.51.
24. See also Caroline Evans, "Masks, Mirrors and Mannequins: Elsa Schiaparelli and the Decentered Subject" in *Fashion Theory: The Journal of Dress, Body and Culture* (vol.3, issue 1, March 1999).
25. For more on the relationship between fashion, trauma and abjection, see Caroline Evans' book *Fashion at the Edge: Spectacle, Modernity and Deathliness* (New Haven and London: Yale University Press, 2003).
26. Geoffrey O'Brien, "A Northern New Jersey of the Mind", *New York Review of Books*, vol.54 no.13, 2007, http://www.nybooks.com (accessed 30/01/08).
27. Lorraine Gamman, "Steve Russell and the Challenge of the Morbid Gaze" in Steve Russell, *You Look Well (chemical warfare)* exhibition catalogue (Colchester: Russell Studio, 2007).
28. Marc Augé, *Non Places: Introduction to an Anthropology of Supermodernity*, trans. John Howe (London and New York: Verso, 1995).
29. The Economist "Bada Bing! Say Goodbye to Tony Soprano", *The Economist*, 7 June 2007, http://www.economist.com (accessed 30/01/08).
30. Moll Cutpurse (see Mary Frith) on http://en.wikepedia.org. Lorraine Gamman, *Gone Shopping, the Story of Shirley Pitts, Queen of Thieves* (Harmondsworth: Penguin, 1997).
31. Some American Italians, however, wanted the series banned because they felt that it gave a negative representation of Italians' way of life. See *The Sopranos* website: http://www.hbo.com/sopranos.

Co-Conspirators

LOWER PRICE
SIGN

grey wig

SOUND
AUCTIONEER

layers
OF
CLOTHES

poor hooker

SIGN $100
 $50
 $25

Do a cartwheel
DANCE WITH POLE
TWIRLING a plastic bag

GARBAGE
GARBAGE C
TELEPHO
CHAIR
DOG

grey wig
DROOPING
BREASTS
UMBRELLA
RIPPED
black tooth
SMUDGED
LIPSTICK

TRICKS
A POLE
GUM

Fingerprint on Lens
Laura McLean-Ferris

Artists may be detectives or criminals, heroes or villains. They may steal like pirates from films, advertising, music, literature or other artists. They may live at society's fringes or, equally, police a moral landscape. Crucially, however, they trace, they research, and they focus on details, offering them up forscrutiny, discussion and even trial.

Co-conspirators[1] is a programme of newly-commissioned films and videos by contemporary artists, photographers, fashion designers and performers, which weaves together concerns from several different backgrounds of creative practice. All contributing artists were asked to respond to the Fashion in Film Festival's 2008 theme: "If Looks Could Kill", allowing them to ask a multitude of questions about the nature of the moving image, and about the relationship between fashion, crime and violence and their wider implications. What is the significance of conventions found in cinema, and what do they reflect on, or about, the societies that they emerge from? Do audiences crave cinematic violence and crime more when it is accompanied by a distinct sense of style, or a deviant look? To answer these questions, details and traces must be chased and pinned down.

While the development of photography was, during the late 19th century, associated with the documentation of the criminally insane and the development of the "mugshot", criminologists were concurrently adopting the scientific study of fingerprints.[2] In a sense, the *Co-conspirators* artists employ these two techniques to investigate their subjects: the camera and the fingerprint-like trace that can give the game away. Thus, each short film's subject is treated like a fingerprint, hair or fibre brough under the forensic microscope. What might at first seem insignificant or inconsequential can, in fact, encase an entire world or narrative within it. Through a focus on traces, one can identify stories of obsession and desire, featuring people as well as objects, and stories of consumer capitalism and its wastage. Explored here are the details that give away dark secrets and psychological traumas, the gestures that reveal social, cultural and historical perspectives on crime, violence, gender and sexuality.

The changing face of crime and violence – beautiful or ugly – is something that presses upon us aesthetically, socially, politically and morally. The more difficult questions posed by the films may seem incongruous to their sensual detail: the close-up of skin or fabric, or the focus on magnified gestures. However, film has always allowed vicarious and wonderful pleasures, given warnings, and depicted horrors that one would never want to experience. Artists, like forensic investigators, know that to ignore the detail is to miss everything: danger and wonder alike.

Notes
1. *Co-conspirators* was curated by Louise Clarke and myself, with thanks to Marketa Uhlirova, Christel Tsilibaris and Stuart Comer for their suggestions and consultation. The programme was generously funded by Arts Council England, with further contribution from University of the Arts London, Oasis, Arts & Business, Kirin and John Prenn. All quotes from artists are taken from my own interviews.
2. The "mugshot" was standardised widely for identification purposes after the publication of Alphonse Bertillon's *La photographie judiciaire* (1890) in France; the first publication to be used by police officers, Sir Francis Galton's *Fingerprints*, was published two years later.

Elizabeth McAlpine, Slap, 2008. Courtesy the artist and Laura Bartlett Gallery

Carrion
Eloise Fornieles

Eloise Fornieles' performances combine sensual and immersive installations with an uneasy voyeurism to create dramatic environments of heightened meaning. In *Carrion,* the film made for *Co-conspirators,*[1] we see a carpet of used clothing, at the centre of which stands a skeleton house, made of scaffolding. Fornieles populates this space with the carcass of a dead calf, whose flesh she cuts and inserts in it notes of apology or thanks from the spectators. She alternates these acts of cutting with equally repetitive and monotonous acts of dressing and undressing in the discarded clothes spread around her, juxtaposing two kinds of cyclical consumption – eating on the one hand, and buying, dressing, wearing and wasting on the other. As Fornieles says of the clothing, lent by the recycling company LMB: "Britain throws away over a million tonnes of textiles a year and I wanted the excess of clothes in the installation to trigger the audience into thinking about their own material waste." The artist involved two cameramen who, rather than simply documenting her 72-hour performance, became part of it, capturing footage which became the raw material for the film work.

Fornieles researched early war photography in the development of her film and performance, considering the questions raised in Susan Sontag's *Regarding the Pain of Others.*[2] The cameramen were dressed in military-style uniforms, specially designed by the artist and costume designer Kirstie MacLeod and inspired by Mexican uniforms worn during the Mexican-American war (1846-48), one of the first wars to be documented by photographers. The cameramen resemble vultures as they prowl around the scene, watching and filming it through the "open house", challenging our voyeuristic drive to bear witness to cinematic violence and trauma. All the while, the house is surrounded by a deep growling, throbbing sound, invoking the atmosphere of horror films.

In *Carrion,* Fornieles speaks of the complex dialogue between violence and beauty, one of the central concerns in her practice. As she puts it, "fashion can be used to glamorise violence in film. To an extent, clothing connected with violence, such as military uniforms, and clothing associated with terrorist activity can be iconic in a heroic way, but film sometimes has a tendency to use the language of fashion to 'sex up' violent scenes".

Notes
1. The film is based on a performance the artist staged at Paradise Row Gallery, London, 6-9 March 2008.
2. Susan Sontag, *Regarding the Pain of Others* (Harmondsworth: Penguin, 2004).

Eloise Fornieles, Carrion, 2008. Courtesy the artist and Paradise Row Gallery

Slap
Elizabeth McAlpine

The cinematic slap is often read as a particularly female form of violence, mostly associated with the grande dame character of classic Hollywood film. However, the slap was already a major feature at the centre of early film comedies – the slapstick. The slap can be carried out by, and inflicted upon, many different characters – male as well as female, dominant as well as submissive. Elizabeth McAlpine's film splices together short sequences showing sharp slaps, using found footage from the silent era to the present day. Her cutting is a violent act in itself.

The semiotics of the slap is markedly different to that of the punch: slaps is usually designed to humiliate the "slappee". This strategy was used in artist Phil Collins' project entitled *You'll Never Work in this Town Again* (2008), in which he photographed prominent figures from the art world after he had slapped them in the face. McAlpine's slaps are cut together in a sequence that is led by sound as much as by image – "slap" is, after all, an onomatopoeic term describing skin hitting skin – and the act of slapping and being slapped becomes both rhythmic and ritualistic.

McAlpine's interest in cinematic conventions is focused on highly charged and often violent scenes, which she dramatically reinterprets through her sharp cutting. As she explains:

> [the edit] is often placed at the epicentre of the slap. This means that you almost get a double slap, as the act is described from two different angles. It was this space between the edit/cut that I found interesting. I am also interested in the way that the slap is a collision or impact of some kind. However, through the process of editing it is almost as if the collision slips between the frames and is caught in the edit, heightening the tension. It made me think of the tension that occurs between two images when they are put in a sequence next to each other. The frame of an image seems to talk about what is in the frame as much as what is outside of it, creating a present absence.

In *Slap*, McAlpine's sequences are held together by visual indicators that are tied to each other through styling, lighting, colour or similarities in garments or dress. This creates a collage of combatants which places the viewer in an ideal position to witness the act voyeuristically, seeing the slap from a distance, as well as the close-up reaction from the struck face.

Elizabeth McAlpine, Slap, 2008. Courtesy the artist and Laura Bartlett Gallery

Marnie's Handbag
Paulette Phillips

Paulette Phillips frequently explores the subtleties of deviance, as well as the unconscious human behavioural patterns that indicate psychological aberration or trauma. Since 1999, the artist has worked on a series of film and video installations, *The Secret Life of Criminals*, investigating the internal driving force that leads a person into danger. Phillips explains that her interest lies in seeing "how people undo themselves and seemingly participate in their own misfortune". She says: "I see this behavioural paradox of short-circuiting one's best interests, as the root of my interest and engagement with narrative form."

The "behavioural paradox" upon which Phillips has centred *Marnie's Handbag* is indicated by a system of cinematic signs, which surround a female character as she prepares to commit a crime. Cinema typically indicates both the power and the ruin of the female criminal through her dress, style and accessories. The ritual of dressing in a garment to kill or to be killed in; the hard look of heavy make-up or scraped-back hair; the hiding of the eyes behind dark glasses, hats or hair; or the acting out of unconscious gestures, such as fiddling with clothes or bags – all of these give decisive clues and anticipate what is to come. Phillips' decision to extricate details of garments and divorce them from their original contexts gives them an entirely new significance – they can now stand as independent symbols, effectively replacing the crimes they allude to.

Marnie's Handbag looks at the way these criminal gestures have evolved throughout the history of cinema, investigating the intricacies not only of their changing syntax, but also of society's responses to them during particular periods. As Phillips says of her film: "I am interested in latent subtext in narrative and I see the potential in removing film sequences from the narrative context that they are nestled within and placing these sequences into a new context, one that underscores the psycho/sociology, that reveals the hidden meaning of the sequence."

Paulette Phillips, Marnie's Handbag, 2008. Courtesy the artist and Danielle Arnaud Contemporary Art

Frottage
Derrick Santini

As well as being an artistic technique, frottage is also a deviant behaviour involving the practice of giving and receiving sexual stimulation by rubbing against someone or something. It is a mild form of sexual assault, mostly associated with thrills received in public places or with groping.

Drawing on his experience as a photographer who often works in fashion, music and advertising, Derrick Santini is well-versed in capturing textures of garments that make us want to touch and to own. Embodying this desire in a pair of cursed red gloves, Santini presents us with a distorted adaptation of the Powell and Pressburger classic ballet film *The Red Shoes*[1] and the Hans Christian Andersen fairytale[2] of the same name.

In *Frottage*, we find gloves in principal position rather than shoes, though similarly, they are up to no good. Both shoes and gloves are accessories that clothe the extremities, and both are prone more than other garments to fetishisation. There is also a linguistic connection between the two: the German word for gloves is Handschuhe, which literally translates as "hand shoes". In the story of the red shoes, their wearer cannot stop dancing, and is eventually driven to her own death, but in Santini's film the red gloves cast a spell on the female wearer, causing her to touch and stroke inappropriately. A surrealist element is introduced when the wearer must share the ecstasies experienced by her gloves. The touch, which may be a momentary stroke undetected by the victim, is seen in dream sequences extended to epic proportions, with the wearer entering a state akin to drug-induced euphoria.

The gloves, indeed, are the main protagonists of the film. Like the red shoes, they encapsulate a classic archetypal fear that inanimate objects will take on a life of their own, with sinister consequences. Employing elements of humour, eroticism and horror, Santini presents a sensual piece that imagines a living fetish object: desired and desiring.

Notes
1. *The Red Shoes* (Michael Powell and Emeric Pressburger, 1948).
2. Hans Christian Andersen, *The Red Shoes,* first published in *New Fairy Tales. First Volume. Third Collection* (*Nye Eventyr, Første Bind, Tredie Samling,* 1845).

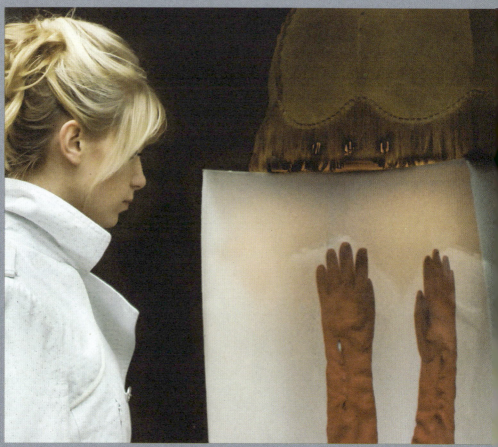
Derrick Santini, Frottage, 2008. Courtesy the artist

Still Framed
Boudicca (Zowie Broach and Brian Kirkby)

Walk along a dried-up creek, to see the cold violet hand reaching from the underworld.

In *Still Framed*, the conceptually-led fashion design duo Boudicca, have created a visual essay, much like a collage, in which each image can be read as a clue. The visual essay is a process that they often employ as designers in research and in the conceptualising of garments, but here this creative process is used with a different aim. Transferring still images onto time-based media, Boudicca play upon our ability to create meaning through the connections between images, through constructing our own narrative. As stories emerge from our imaginations, led down an inevitably dark path, the designers provocatively ask: "is our imagination the criminal?"

Taking as a departure point Guy Debord's classic assertion that "[t]he spectacle is not a collection of images; it is a social relation between people that is mediated by images",[1] Boudicca explore our cultural sensitivity to images, our obsession with them and their capacity to trap entire stories within a single frame. Disassociated fragments of imagery create a crime scene, inviting us to reconstruct, deduce, guess. This is most intriguing when the images shown capture seemingly innocent objects that are, however, loaded with associations to cinematic crime and violence: a bag of oranges,[2] a cup of coffee,[3] a white Datsun.[4]

Memories of these objects, be they real or imagined, capture the truth by way of fiction and lies. As the designers have commented:

> We wonder where the truth is. Are we all within a cabinet of curiosity that just embellishes image upon image, story upon story, one influence upon another, until we understand finally that we are part of a reality of movement that holds still at times and moves at others?

Boudicca's visual puzzle that we attempt to decipher as viewers involves us in a cat-and-mouse game between filmmaker and viewer, reminiscent of Georges Perec's description of the relationship between puzzlemaker and puzzler:

> Despite appearances: puzzling is not a solitary game: each move the puzzler makes, the puzzlemaker has made before, every piece the puzzler picks up … every combination he tries and tries again, every blunder and every insight, each hope and each discouragements have all been designed, calculated, and decided by the other.[5]

Notes
1. Guy Debord, *The Society of the Spectacle,* trans. Donald Nicholson Smith (London: MIT Press, 1995) [1967], p.12.
2. In Stephen Frears's *The Grifters* (1990), the character Lily, played by Anjelica Huston, is threatened with a beating using a bag of oranges, though they spill to the floor before she is brutally kicked and burnt.
3. In Fritz Lang's *The Big Heat* (1953), scalding coffee is thrown in the face of Debby Marsh, played by Gloria Grahame, scarring her.
4. Referring to *Untitled* (1979), Enrique Metinides' photograph of the actress Adela Legarreta Rivas, taken after she was struck and killed by a white Datsun on Avenida Chapultepec in April 1979. The beautiful woman is draped, dead, over railings, with the car lurking menacingly in the background.
5. Georges Perec, *Life: A User's Manual,* trans. David Bellos, (London: Vintage, 2003 [1978]), p.iii.

Boudicca, Still Framed, 2008. Courtesy the designers

El Abuelo
Dino Dinco

Dino Dinco's work is deeply embedded in the "homeboy" and gay Latino gangster aesthetic of South-West America and Texas. His new film, *El Abuelo*, draws on and extends the artist's previous work on LA gangs, especially the *Homeboy Films* project (2002), in which Dinco worked with young gang members, interviewing them and helping shape their stories into a film. Concentrating on their anxiously immaculate attention to detail when dressing, and their tendency to iron their own clothes to sharp perfection, Dinco's film is a loving homage to what has traditionally been women's domestic work. It stands in sharp contrast to the depictions of roughness, macho violence and heavy-handed gun crimes that are traditionally perpetuated in the representations of gang cultures and which are here subtly present through their absence.

In *El Abuelo*, Dinco follows Jo Jimenez, a San Antonio teacher and poet, as he dresses and prepares for an evening out. Jimenez's poem "The Grandfather" (El Abuelo, 1983) from which Dinco's film takes its title, was the artist's inspiration. We hear Jimenez's voiceover whilst watching the modern-day dandy prepare his clothes in a precise way, recognised only by those in-the-know. The shared intimacy, knowledge, experience and passion for clothes creates a bond between the filmmaker and his subject, showing an unexpected tenderness and humour that contrasts with the violence on the streets.

El Abuelo
Jo Jiminez

I'm ironing a shirt. Like chicharras, the starch snaps beneath the hot metal press. Creasing the cotton playera straight down the middle, it's sudden. This flicker, this humming that emanates from the bone.

Over time, I'd forgotten this routine, the gauging of center, the creasing of a camiseta. Misplaced it somehow in the remolino of years since we lived with my Buelo after our pops jammed and my Moms had no place else to go with us and the first time I loved a vato. But it's rheumatic, now, like bone extending itself, morphing slowly into the helix of all I struggle not to forget.

And I recall planchando, watching the bottle fill with spray, the starch boil angrily over a fierce blue kitchen flame. I ironed furiously in my past. Starching up Ben Davis and chones, even. Impressing my first vato with my ability to throw down a rowdy crease. Impeccable lines forged into cloth, sharp and precise, acute enough to splice open envy and captivate a vato's wandering eye.

Dino Dinco, El Abuelo, 2008. Courtesy the artist

Untitled
Wendy Bevan

Wendy Bevan's *Untitled* presents a collection of fashion photographs which have been placed outside their usual context, and imbued instead with darker undertones that drastically change our reading of them. Bevan's photographic signature style tends towards the sinister yet nostalgic, often resembling Hitchcock films, by way of Jurgen Teller and William Eggleston. Employing vintage techniques that reference film and photographic history, and family snapshots from Polaroids or cheap family cameras, her fashion work is notable for its narrative content, and softly menacing tone.

In *Untitled,* the artist has matched her photographic work with sonnets written by her father, Stewart Bevan, who also narrates; a mature male voice giving edge to the photographs of young women. Bevan deliberately chose to work with images that resembled film stills (much like Cindy Sherman's *Untitled Film Stills*, 1977-80). A sonnet called "The Wolf in the Woods", for example, accompanies an image of a young, classically fashionable woman in a trench coat, crouching to feed ducks at a waterside while a small girl plays nearby. We hear the voice of a wolf-like predator watching the two women as if they were lambs, a male figure who – we presume – desires / photographs. Bevan here draws attention to the fashion media's constant surveillance of young women; the words spoken by the narrator constantly reference the violent aspects of a desire to possess (romantically or sexually), and betray an inevitable drive towards death.

Bevan is interested in the power of a still image, and combines this with the spoken word to create a sense of movement and time. Evocative words are superimposed on Bevan's fashion photographs, generating images and memories of their own which interact with the images. The resulting film is the space where personal references, images and words merge and collide.

Wendy Bevan, Untitled, 2008. Courtesy the artist

The Corner
Shannon Plumb

Shannon Plumb has worked as an artist, fashion model, photographer and actress, and so is ideally positioned to satirise the worlds of fashion modelling, film and art. Her funny and perceptive "silent comedies" mix characteristic gestures of early cinema with other, more up-to-date forms of visual representation, such as advertising, fashion and sport. Plumb concentrates meticulously on the detail, etiquette and codes of style and behaviour in the worlds she references, sending them up for ridicule. In filming herself, she has retained control of both the gaze of the camera and the performance the camera is directed at.

At the heart of Plumb's film for *Co-conspirators* is the corner, a place where two streets meet. The corner is also a place where strangers bump into one another, a place where the unexpected occurs, a place that promises all the hazards and delights that a big city can yield (Plumb's corner is located in New York). A figure that hangs out on a corner is one who raises our suspicions almost automatically. The thief, the conman, the woman of uncertain reputation and the rogue are all characters that linger on the corner, on the edge of morality. Familiar from early film, these shady characters get a 21st century makeover in Plumb's treatment. Characteristically, the artist herself plays each of them: loitering, selling or waiting to pick a pocket or two. The clothes these characters wear help us to identify them, although the subtleties of their dress statements differ, depending on whether they want to be easily identified or pass unnoticed. While the gang member marks himself out to his associates (and enemies) through nuanced sartorial coding, a hooker must be recognisable to all, and is so by the way she attractively packages her flesh for consumption.

Whilst one might misread the signals of clothing, or miss them entirely, the need to decode and identify faces in the crowd is vital to the modern city – a theme that early cinema already exploited heavily through its play of costume change, disguise, recognition and misrecognition.

Shannon Plumb, The Corner, 2008. Courtesy of the artist and Sara Meltzer Gallery

Notes on Contributors

Bibliography

Index

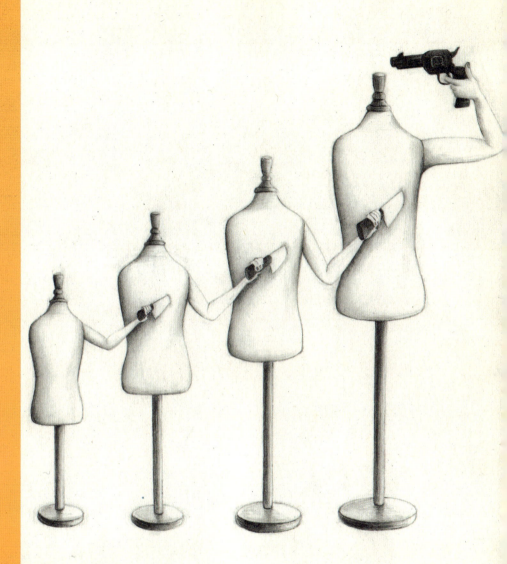

Illustration © Emi Miyashita

Notes on Contributors

Writers

Karen Alexander is a film curator and freelance consultant. She has contributed articles to several books on film, including *British Cinema of the 90s* (BFI, 1997), and as a cinema programmer she has organised numerous film packages for festivals, conferences and exhibitions. Alexander's areas of interest are representation, gender, identity and independent cinema. From 1998 to 2006 she worked at the British Film Institute, with responsibility for the strategic marketing of BFI Distribution and Archive releases.

Rebecca Arnold is a Research Fellow in the History of Design Department at the Royal College of Art. She has lectured internationally, and has published widely on 20th century fashion, including *Fashion, Desire and Anxiety: Image and Morality in the Twentieth Century* (IB Tauris, 2001). Her latest book is *American Looks: Sportswear, Fashion and the Image of Women in New York, 1929-47* (2008).

Anna Battista is a writer, freelance journalist and film lecturer. Her articles on culture, fashion, lifestyle, politics and social issues have been featured in American, British, French, Italian, Portuguese and Spanish publications. She also collaborates with art-house cinemas and film festivals in Italy and the UK, organising courses on Italian films and directors and producing documentaries on a freelance basis.

Stella Bruzzi is Professor of Film and Television Studies at the University of Warwick. Her publications include *Undressing Cinema: Clothing and Identity in the Movies* (1997), *Fashion Cultures: Texts, Theories and Analysis* (co-edited, 2000), *New Documentary* (2000 and 2006), *Bringing Up Daddy: Fatherhood and Masculinity in Post-war Hollywood* (2005), and the BFI Classic on *Seven Up* (2007). Bruzzi's main areas of research interest are fashion and costume; gender and identity in film, particularly masculinity; and documentary film and television.

Roger K. Burton is a former Mod and the founder and director of The Horse Hospital, a unique London venue for avant-garde and underground arts, performance and music, now in its 15th year. Roger is an independent stylist and costume designer. He has designed wardrobe for films including *Quadrophenia* (1979), *Vigo* (1998) and *Stoned* (2005). He also owns the Contemporary Wardrobe Collection (est 1978).

Pamela Church Gibson is Reader in Cultural and Historical Studies at London College of Fashion where she is now developing a new MA in fashion and film, which will call on the expertise of staff from the University of Warwick such as Stella Bruzzi and Stephen Gundle. Church Gibson has researched and written widely on the role of fashion and costume in film and has investigated the links between film, fashion, fandom and the contemporary star system. She co-edited *Fashion Cultures* (Routledge, 2000) and *More Dirty Looks: Gender, Pornography and Power* (BFI, 2004) and is now working on a book on fashion and celebrity.

Barry Curtis is Emeritus Professor of Visual Culture at Middlesex University, a Fellow of the London Consortium and a visiting tutor at the Royal College of Art. He is co-editor of the *Locations* series for Reaktion Books and his book on the "haunted house" in film will be published in 2008. He is working on a book on "Imaginary Architecture" and has contributed to the catalogue for the exhibition "Cold War Culture", V&A (2008).

Hilary Davidson is Curator of Fashion & Decorative Arts at the Museum of London and Network Facilitator for the AHRC Early Modern Dress & Textiles Research Network. She has worked freelance as a dress historian, teacher, lecturer and museum curator. Her core research centres on practice-based clothing study and red shoes, on which she has published in *Shoes: A History from Sandals to Sneakers* (2006).

Bryony Dixon is a curator at the BFI National Archive with a specialism in silent film. She has researched and written on many aspects of early and silent film and co-directs the annual British Silent Film Festival as well as programming for a variety of film festivals and events worldwide.

Petra Dominková is Lecturer in Eastern European Cinema and East and Central European Studies, Charles University, Lecturer in Eastern European and Czech Cinema at the Council of International Education Exchange, and Lecturer in Film Theory and History at FAMU, all in Prague. Dominková has contributed pieces on film to several publications, including the FFF 2006 catalogue. She was awarded a Fulbright Scholarship in 2004-2005 to study Film at the University of California, Los Angeles and is now working on her doctoral thesis on *film noir*. Her main research interests include Eastern European Cinema, Czech Cinema and Feminist Film Theory.

Caroline Evans is Professor in Fashion History and Theory at Central Saint Martins College of Art and Design (University of the Arts London.) She teaches and writes on 20th century and current fashion, and is currently working on a history of early fashion shows and modernism. Her recent books are *Fashion at the Edge: Spectacle, Modernity and Deathliness* (2003, reissued 2007), the co-authored *The London Look: Fashion from Street to Catwalk* (2004), the co-edited *Fashion & Modernity* (2005), and the co-authored *Hussein Chalayan* (2005).

Lorraine Gamman is a Professor and Director of the Design Against Crime Research Centre at Central Saint Martins College of Art and Design, which actively promotes strategies to reduce crime through design. Gamman has expertise in the history and theory of theft, having researched the subject from a variety of cultural studies perspectives. She has organised exhibitions and published widely on the subjects of design, the body, surveillance and crime prevention. She is co-editor of *The Female Gaze: Women as Viewers of Popular Culture* (The Women's Press, 1988).

Adrian Garvey lectures in film at Birkbeck, University of London. He has also taught at Queen Mary, Central Saint Martins, and The Open University. His main research interests are Classical Hollywood and British Cinema. He is currently writing a book on Hollywood melodrama of the 1940s, and is contributing an essay on the sitcom adaptation to a collection on British Film in the 1970s.

Román Gubern has been a guest researcher at the Massachusetts Institute of Technology, Visiting Professor at the University of Southern California (Los Angeles), the California Institute of Technology (Pasadena) and the Venice International University (Italy), Professor at the Universidad Autónoma de Barcelona and director of the Instituto Cervantes in Rome. He has published some forty books on cinema, comic strips, semiotics, popular culture and mass communication. He has also been an active screenwriter for cinema and television.

Tom Gunning is Professor in the Art Department and the Cinema and Media Committee at the University of Chicago. His published work has concentrated on early cinema as well as on the culture of modernity from which cinema arose. He has written on the Avant-Garde film, on genre in Hollywood cinema and on the relation between cinema and technology. Publications include *D.W. Griffith and the Origins of American Narrative Film* (1991), *Pathé 1900: Fragments d'une filmographie analytique du cinema des premiers temps* (ed. André Gaudreault, Presses de la Sorbonne Nouvelle, 1993) and *The Films of Fritz Lang: Allegories of Vision and Modernity* (BFI, 2000).

Kitty Hauser has taught at the Ruskin School of Art and the London College of Fashion; following a Research Fellowship at Clare Hall, University of Cambridge, she is currently Research Fellow at the Power Institute, University of Sydney. In 2004 she won the Alfred Gell Memorial Prize for her article on denim and forensic science, published in *Fashion and Modernity* (Berg, 2005) and the *Journal of Material Culture*. Her book *Shadow Sites* was published by OUP in 2007, and *Bloody Old Britain: O.G.S. Crawford and the Archaeology of Modern Life* is to be published by Granta in May this year.

Tim Lucas is a novelist, critic and film historian whose work reflects a lifelong preoccupation with fantasy and horror. He is the editor of VIDEO WATCHDOG (http://www.videowatchdog.com) and a regular contributor to *Sight & Sound*. His articles and interviews have also appeared in *Film Comment*, *Cahiers du cinema*, *Fangoria* and *American Cinematographer* among others. In 2007 Lucas published the critically acclaimed 1125-page biography *Mario Bava: All the Colours of the Dark*, the most extensive and ambitious monographic project on a film director yet (available from The Cinema Store in London and online at http://www.bavabook.com).

Betti Marenko landed in London at the beginning of the 90s to throw herself into the body art scene. She will never leave. She published two books, got a PhD, had a child. She is now a freelance writer and lecturer who merges theory and personal experimentation in her work. Her field is the metamorphosis of body and identity. She teaches *contextual studies* to future designers at Central Saint Martins College of Art and Design. Currently Marenko is working on the production of subjectivity in the visual discourse of antidepressants. She lives in the East End with her daughter Joy and a (variable) extended family.

Laura McLean-Ferris is an independent writer and curator. She has worked for a number of organisations including Whitechapel Art Gallery, Paradise Row and ArtSway, and projects including a special exhibition at the 52nd Venice Biennial 2007. She is a regular contributor to *ArtReview* and *NY Arts Magazine*, and is currently developing an exhibition on the theme of snags and glitches in a domestic environment.

Claire Pajaczkowska is Senior Research Tutor in the School of Fashion and Textiles at the Royal College of Art, London. Her recent essays in *Textile: The Journal of Cloth and Culture* include "Stuff and Nonsense: The Complexity of Cloth" (2005), and "Thread of Attachment" (2007). She is author of "On Humming: Marion Milner's contribution to Psychoanalysis in Britain", in *Winnicott and the Psychoanalytic Tradition*, ed. Lesley Caldwell (2007); and co-editor of *Shame and Sexuality: Psychoanalysis and Visual Culture* (Routledge, 2008).

Charlie T. Porter is Associate Editor of *GQ* and *GQ Style*. He has also worked at *The Guardian*, *The Times* and *Esquire*, and has contributed to *British Vogue*, *Fantastic Man*, *Pop*, *i-D*, *The Face*, *The Telegraph* and *The Independent on Sunday*.

Roger Sabin is a cultural historian. His books (authored or edited) include: *Comics, Comix and Graphic Novels* (Phaidon), *Adult Comics: An Introduction* (Routledge), *The Lasting of the Mohicans* (University of Mississippi Press), and *Punk Rock: So What?* (Routledge). He is currently working on books on the origins of comics, and contemporary TV crime fiction. He is a Senior Lecturer at Central Saint Martins College of Art and Design, and has a column in the Books pages of *The Observer*.

Jenni Sorkin is a PhD candidate in the History of Art department at Yale University. She is an independent curator and freelance critic who has written for numerous art magazines and journals including *Frieze*, *NU*, *Art Monthly*, *Third Text* and *Art Journal*.

Drake Stutesman is a novelist and Editor of *Framework: The Journal of Cinema and Media*. She is author of the cultural history *Snake* (Reaktion Books, 2005), and is now writing a biography of the milliner/couturier Mr. John. Her articles have appeared in BFI and MoMA collections, *Bookforum*, *The Women's Film Pioneer Source Book* and *Film Quarterly* among others. Co-chair of The Women's Film Preservation Fund, Stutesman also co-programs the WFPF films for MoMA, the Film Society at Lincoln Center and the Tribeca Film Festival. She is Creative Consultant for an upcoming Broadway musical.

Werner Sudendorf is Head of Collections at Stiftung Deutsche Kinemathek – Museum für Film und Fernsehen. He has authored books, articles and talks on German film history, including Marlene Dietrich, Metropolis and S.M. Eisenstein. His forthcoming book: *Erich Kettelhut: The Shadow of the Architect*, will be published by Belleville later in 2008.

Christel Tsilibaris is Co-founder and Associate Curator of Fashion in Film, and Assistant Manager at Think 21, a contemporary art gallery in Brussels. Tsilibaris has worked in numerous art and cultural institutions, including the Courtauld Gallery in London, the Museum of the Moving Image in New York and the Peggy Guggenheim Collection in Venice, Italy. She has also lectured at the International Thessaloniki Film Festival in Greece. Tsilibaris was Visiting Lecturer in Photography at Amersham and Wycombe College in 2006.

Marketa Uhlirova is Research Fellow in Fashion History and Theory at Central Saint Martins College of Art and Design, and Director and Curator of the Fashion in Film Festival. She has worked variously as a researcher, curator, oral history interviewer and writer. She has contributed articles, reviews and interviews to various publications such as *Fashion Theory*, *Art Monthly*, *The Measure* and Scribner's *Encyclopaedia of Clothing and Fashion*.

Cathi Unsworth studied at the London College of Fashion before diverting into music, film and arts journalism and eventually crime fiction. She is the author of two novels, *The Not Knowing* (2005) and *The Singer* (2007), set in the worlds of film and music, and edited the anthology *London Noir* (2006), all published by Serpent's Tail. Her work has appeared in *Sounds*, *The Guardian*, *Mojo*, *Bizarre* and *Nude* and she presents a crime fiction radio show for Resonance FM.

Louise Wallenberg holds a doctorate in Cinema Studies from Stockholm University (2002). Since 2006 she has been involved in the establishment and development of the Centre for Fashion Studies at Stockholm University, where she currently works as Director and researcher. She has published on queer and mainstream film and feminist and queer philosophies, and is currently working on a project dealing with Alfred Hitchcock, film costume and fashion, and transnational and transcultural flows.

Gilda Williams is a London correspondent for *Artforum*, and a Lecturer in contemporary art at Sotheby's Institute of Art, London. From 1994 to 2005 she was Editor and Commissioning Editor (from 1997) for Contemporary Art at Phaidon Press. Williams' most recent publication is *The Gothic* (MIT/Whitechapel 'Documents of Contemporary Art' series); she also writes criticism for *TATE ETC.*, *Art Monthly*, *Parkett* and many other art journals.

Elizabeth Wilson has published several important books on the subjects of fashion, feminism and cultural history, including *Adorned in Dreams* (1985, 2003), *The Sphinx in the City: Urban Life, the Control of Disorder and Women* (1992), and *Bohemians: The Glamorous Outcasts* (2000). She has also co-edited several collections of fashion essays. Her novel *The Twilight Hour* appeared in 2006 and a second, *War Damage*, will be published early in 2009. She is currently Visiting Professor of Cultural Studies at the London College of Fashion, University of the Arts, London.

Artists

Wendy Bevan's photography draws on antiquated methods of image-making, deliberately choosing to use the traditional media of film and the Polaroid as a formal statement. Bevan works regularly on photographic commissions *for i-D, Russian Vogue, Exit, The Independent, 10 Magazine, Nylon, V Magazine, POP, Tank* and *Wig*.

Zowie Broach and **Brian Kirkby** are the British designer duo behind the fashion label **Boudicca**, which they founded in 1997. Producing couture and ready-to-wear collections shown internationally, Boudicca have participated in a number of exhibitions including *Lost and Found* (1999), *Skin Tight* (2004), *Malign Muses: When Fashion Turns Back* (2004), and *The Fashion Architecture* (2005).

Dino Dinco is an LA-based artist, photographer and filmmaker. He has shot collections for Bernhard Willhelm, Levi's and American Apparel, as well as undertaking editorial commissions including *V, i-D, Dazed & Confused* and *BUTT*. Dinco's work has also been featured in publications such as *Archeology of Elegance 1980-2000: Twenty Years of Fashion Photography*, and *Sample – 100 Fashion Designers, 010 Curators*.

Eloise Fornieles' practice includes performance, installation, photography and film. Her work explores loss and intimacy, often by exploiting the close relationship between beauty and violence. Fornieles has participated in group exhibitions at Haunch of Venison, Paradise Row and Madder Rose in London, and has also exhibited in Seoul, Albania, Israel, Paris and New York.

Elizabeth McAlpine is an artist working with installation and time-based media to test and highlight repetitions and gestures inherent in popular media. Her recent exhibitions and screenings include *Imaginary Solution*, Spacex, Exeter; *Sedimentary Sight*, Ballina Arts Centre, Ireland; *The Air is Wet with Sound*, Rekord, Oslo; *Smoke and Mirrors*, Mac, Birmingham; and *I Love Cinema and Cinema Loves Me*, Camden Arts Centre, London.

Paulette Phillips' video and installation work employs the sinister and sensitive as she explores "how people undo themselves". Phillips is Associate Professor of Integrated Media at the Ontario College of Art and Design, Canada, where she is based, and recent solo exhibitions include *Monster Tree* at Diaz Contemporary, LA (2006), *Dying to Make a Living* at Sparwasser, Berlin (2005), and *The Secret Life of Criminals* at Danielle Arnaud, London and the Cambridge Art Gallery, Ontario (2004).

Shannon Plumb is a New York-based artist who has had solo exhibitions in New York, Paris, Germany and Austria, and at the Aldrich Museum of Contemporary Art in Ridgefield, Ct. Plumb's work has been included in many group shows, including *Human Game*, curated by Francesco Bonami, Maria Luisa Frisa and Stefano Tonchi, Florence, Italy; *Torino Triennial*, curated by Francesco Bonami and Carolyn Christov-Bakargiev, Torino, Italy; *i-Dentity*, Fashion and Textile Museum, London, UK, and *Greater New York 2005, PS1*, Long Island City, NY.

Derrick Santini is a London and New York-based photographer and filmmaker. His work explores notions of subtext and the "underneath" in relation to the surface. Frequently appearing in magazines such as *Flaunt, i-D*, and *FHM Collections*, Santini's advertising work includes campaigns for clients such as Nike, Reebok, Levi's and Heineken, and his music photography includes editorial spreads of Muse, Lil' Kim, Lily Allen, Jamelia, Finley Quaye and The Cardigans.

Illustrators

Aganovich was conceived in 2005, and has since become a creative standout in British fashion. A collaboration between Nana Aganovich and Brooke Taylor, Aganovich are recognised for their cerebral and complex approach to fashion. In 2006, Aganovich staged an event at the Great Easter Hotel entitled "Murder in Room 158", a rare fusion of fashion, entertainment and performance.

Francesca Coombs received an MA from the University of Westminster in 2007, and is particularly involved in sensitive conceptual projects exploring memory and archiving. She recently documented the City of London Lunatic Asylum, in a project involving photography, documentation, and the creation of artist books.

Veronika Jiroušková is an up-and-coming Czech artist and designer. Since gaining a BA degree in Arts and Design at Central Saint Martins College, she has worked as a freelancer, developing a personal way of connecting various creative fields, mostly in the areas of interior design, illustration and performance.

Amélie Labarthe graduated in 2006 from the School of Applied Arts Duperré in Paris, France and is now finishing her MA degree at Central Saint Martins College, on the Textile Futures course. She is a colourist, specialising in print, but is also attracted to a variety of other design fields and aspects.

Emi Miyashita is a Japanese artist, currently studying fine art at Central Saint Martins College. Her work explores the relationship between male and female, human existence, dominance and submission, and the aesthetics of birth and death. She recently took part in the *Pecha Kucha* event at the Japanese Embassy in London.

Phillip Osborne's intricate drawing style is born from an inquisitive mind inspired by beat writers, lost civilisations and playing his Miguel Rodriguez guitar. Last summer he graduated from the Ruskin School of Drawing and Fine Art, University of Oxford. He is currently working on a collaborative book project with artist Merlin Ramos and writer Damian James Le Bas.

Art Direction and Graphic Design

Seán O'Mara is an artist, writer and designer. He is currently Creative Director of STUFF ID, London and a long-time collaborator with DAC, MAID and MA Textile Futures at Central Saint Martins College. Currently he is working on three books for the OMARARCHIVE called *Flake (2005)*, *Fez (2005)* and *Fast (2005)*. *Flake* is a major publication exploring his ideas and collections from the exhibition "Dirty Washing" at the Design Museum London (2001). www.omaraspace.com.

Selected Bibliography / Compiled by Susie Cole, Eve Dawoud and Felice McDowell

Books and Book Articles

Abel, Richard, *The Ciné Goes to Town: French Cinema 1896-1914* (Berkeley and London: University of California Press, 1994).

Abelson, Elaine S., *When Ladies Go A-Thieving: Middle-Class Shoplifters in the Victorian Department Store* (New York and Oxford: Oxford University Press, 1989).

Arnold, Rebecca, *Fashion, Desire and Anxiety: Image and Morality in the 20th Century* (London: I. B. Tauris & Co. Ltd, 2001).

Barthes, Roland, Camera Lucida: Reflections on Photography (London: Vintage, 1993).

Berry, Sarah, *Screen Style: Fashion and Femininity in 1930s Hollywood* (Minneapolis: University of Minnesota Press, 2000).

Bordwell, David, *On the History of Film Style* (Cambridge, MA: Harvard University Press, 1999).

Bronfen, Elizabeth, *Over Her Dead Body: Death, Femininity and the Aesthetic* (Manchester: Manchester University Press, 1992)

Bruzzi, Stella, *Undressing Cinema: Clothing and Identity in the Movies* (London: Routledge, 1997).

Bruzzi, Stella, "Desire and the Costumer Film: Picnic At Hanging Rock, The Age of Innocence and The Piano" in Graeme Turner (ed.), *The Film Cultures Reader* (London: Routledge, 2002).

Callahan, Vicki, *Zones of Anxiety: Movement, Musidora and The Crime Serials of Louis Feuillade* (Detroit, MI: Wayne State University, 2005).

Chibnall, Steve and **Murphy, Robert** (eds.), *British Crime Cinema* (London: Routledge, 1999).

Church Gibson, Pamela and **Hill, John** (eds.), *Film Studies: Critical Approaches* (Oxford: Oxford University Press, 2000).

Church Gibson, Pamela (ed.), *More Dirty Looks: Gender, Pornography and Power* (London: BFI Publishing, 2004).

Clarens, Carlos, *Crime Movies* (New York: Da Capo Press, 1997).

Clover, Carol, *Men, Women and Chainsaws: Gender in the Modern Horror Film* (Princeton, NJ: Princeton University Press, 1992).

Cohan, Steven, *Masked Men: Masculinity and the Movies in the Fifties* (Bloomington, IN.: Indiana University Press, 1997).

Cook, Pam, *Fashioning the Nation Costume and Identity in British Cinema* (London: British Film Institute, 1996).

Cotton, Charlotte and **Verthime, Shelly** (eds.), *Guy Bourdin* (London: V&A Publications, 2003).

Crowther, Bruce, *Film Noir: Reflections in a Dark Mirror* (London: Columbus, 1988).

Didi-Huberman, Georges, "The Index of the Absent Wound (Monograph on a Stain)" in: Rosalind Krauss, Annette Michelson, Douglas Crimp and Jean Copjec (eds.), *October: The First Decade, 1976-1986* (Cambridge, MA and London: MIT Press, 1987).

Doane, Mary Ann, *The Desire to Desire: The Woman's Film of the 1940s* (Bloomington and Indianapolis: Indiana University Press, 1987).

Doane, Mary Ann, *Femmes Fatales: Feminism, Film Theory and Psychoanalysis* (London & New York: Routledge, 1991).

Doherty, Thomas, *Teenagers and Teenpics: The Juvenilization of American Movies in the 1950s* (Philadelphia: Temple University Press, 2003)

Doyle, Peter with **Williams, Caleb**, *City of Shadows: Sydney Police Photographs 1912-1948* (Sydney: Historic Houses Trust of New South Wales, 2007).

Elms, Robert, *The Way We Wore: A Life in Threads* (London: Picador, 2005).

Evans, Caroline, *Fashion at the Edge: Spectacle, Modernity and Deathliness* (New Haven and London: Yale University Press, 2003).

Gaines, Jane and **Herzog, Charlotte** (eds.), *Fabrications: Costume and the Female Body* (London: Routledge, 1990).

Gallant, Chris (ed.), *The Art of Darkness: the Cinema of Dario Argento* (Guildford: FAB Press, 2000).

Gamman, Lorraine and **Makinen, Merja**, *Female Fetishism: A New Look* (London: Lawrence and Wishart, 1994).

Gamman, Lorraine, *Gone Shopping, the Story of Shirley Pitts, Queen of Thieves* (Harmondsworth: Penguin, 1997).

Gelder, Ken (ed.), *The Horror Reader* (London: Routledge, 2000).

Genet, Jean, *The Thief's Journal*, trans. Bernard Frechtman (Grove Press: New York, 1987 [1949]).

Gingeras, Alison M., *Guy Bourdin* (London: Phaidon, 2006).

Grieveson, Lee; Sonnet, Esther and **Stanfield, Peter** (eds.), *Mob Culture: Hidden Histories of the American Gangster Film* (Oxford: Berg, 2005).

Gunning, Tom, "The Intertexuality of Early Cinema: A Prologue to Fantômas" in Robert Stam and Alessandra Raengo (eds.), *A Companion to Literature and Film* (Oxford: Blackwell Publishing, 2004).

Gunning, Tom, "Tracing the Individual Body aka Photography, Detectives, Early Cinema and the Body of Modernity" in: Vanessa R. Schwartz and Leo Charney (eds.), *Cinema and the Invention of Modern Life* (University of California Press, 1995).

Hales, Barbara, "Woman as Sexual Criminal: Weimar Constructions of the Criminal *Femme Fatale*" in: Sara Friedrichsmeyer & Patricia Herminghouse (eds), *Women in German Yearbook*, Vol.12, 1996.

Hardy, Phil (ed.), *The BFI Companion to Crime* (London: Cassell, 1997).

Hauser, Kitty, "The Fingerprint of the Second Skin" in: Chris Breward and Caroline Evans (eds.), *Fashion and Modernity* (Oxford: Berg, 2005).

Hebdige, Dick, *Subculture: The Meaning of Style*, London: Routledge, 2007 [1979].

Hill, John, *Sex, Class and Realism in British Cinema 1956-1963* (London: BFI Publishing, 1986).

Howarth, Troy, *The Hanuted World of Mario Bava* (Godalming: FAB Press, 2007).

Kaplan, E. Ann (ed.), *Women in Film Noir* (London: BFI Publishing, 2005).

Krutnik, Frank, *In A Lonely Street: Film Noir, Genre, Masculinity* (London: Routledge, 1991).

Larcher, G.; Grabner, F. and **Wessely, C.** (eds.), *Visible Violence: Sichtbare und verschleierte Gewalt im Film*, (Münster: Lit Verlag, 1998).

Lavery, David (ed.), *Reading The Sopranos: Hit TV from HBO* (London: I.B Tauris, 2006).

Leitch, Thomas, *Crime Films: Genres in American Cinema* (Cambridge: Cambridge University Press, 2002)

Lucas, Tim, *Mario Bava: All the Colors of the Dark* (Cincinnati, OH: Video Watchdog, 2007).
Mason, Fran, *American Gangster Cinema: From Little Caesar to Pulp Fiction* (London: Palgrave Macmillan, 2002).
Medovoi, Leerom, *Rebels: Youth and the Cold War Origins of Identity* (Durham: Duke UP, 2005).
Moda/Cinema, catalogue for the 1998 Florence Biennale (Milan: Electa, 1998).
Modleski, Tania, *The Women Who Knew Too Much: Hitchcock and Feminist Theory* (London: Routledge, 1988).
Moseley, Rachel (ed.), *Fashioning Film Stars: Dress, Culture and Identity* (London: BFI Publishing, 2005).
Mulvey, Laura, *Visual and Other Pleasures* (London: The Macmillan Press, 1989).
Munby, Jonathan, *Public Enemies, Public Heroes: screening the gangster from Little Caesar to Touch of Evil* (Chicago: The University of Chicago Press, 1999).
Murphy, Robert, *Sixties British Cinema* (London: BFI Publishing, 1997)
Naremore, James, *More than Night: Film Noir in its Contexts* (Berkeley, CA: University of California Press, 1998).
Neroni, Hilary, *The Violent Woman: Femininity, Narrative and Violence in Contemporary American Cinema* (New York: State University of New York Press, 2005).
Pomerance, Murray (ed.), *Bad: Infamy, Darkness, Evil and Slime on the Screen* (SUNY Press: Albany, 2004).
Pullen, Melanie, *High Fashion Crime Scenes* (Tucson: Nazraeli Press, 2005).
Rabinowitz, Paula, *Black and White and Noir: America's Pulp Modernism* (New York: Columbia University Press, 2002).
Rafter, Nicole, *Shots in the Mirror: Crime Films and Society* (Oxford: Oxford University Press, 2000).
Rich, B. Ruby, "Lady Killer: A Question of Silence" in: *Chick Flicks: Theories and Memories of the Feminist Film Movement* (Durham: Duke University Press, 1998).
Rugoff, Ralph, *Scene of the Crime* (Cambridge, MA. and London: Armand Hammer Museum of Art and Cultural Center in association with MIT Press, 1997).
Sabin, Roger, *Comics, Comix and Graphic Novels: A History of Comic Art* (London: Phaidon, 1996).
Shadoian, Jack, *Dreams and Dead Ends* (New York: Oxford University Press, 2003).
Silver, Alain and Ursini, James (eds.), *Film Noir Reader* (New York: Limelight Editions, 2003).
Skal, David J., *The Monster Show: A Cultural History of Horror* (London: Plexus, 1994; revised edition 2001).
Steele, Valerie, *Fetish: Fashion, Sex and Power* (Oxford: Oxford University Press, 2003).
Straayer, Chris, *Deviant Eyes, Deviant Bodies* (New York: Columbia University Press, 1996).
Tropiano, Stephen, *Rebels and Chicks: A History of the Hollywood Teen Movie* (Washington, DC: Backstage, 2006)
Uhlirova, Marketa and Tsilibaris, Christel (eds.), *Between Stigma & Enigma* (Fashion in Film Festival exhibition catalogue) (London: Fashion in Film Festival, 2006).
Vincendeau, Ginette, "Max Linder: The World's First Film Star", *Stars and Stardom* (London: Continuum, 2000).
von Ankum, Katharina (ed.), *Women in the Metropolis: Gender and Modernity in Weimar Culture* (Berkeley, Los Angeles and London: University of California Press, 1997).
Wager, Jans B., *Dangerous Dames: Women and Representation in the Weimar Street Film and Film Noir* (Athens : Ohio University Press, 1999).
Williams, Gilda (ed.), *The Gothic: Documents of Contemporary Art* (London: Whitechapel and Cambridge, MA: The MIT Press, 2007).
Williams, Michael T., *Ivor Novello: Screen Idol* (London: BFI, 2003)
Wilson, Elizabeth, *Adorned in Dreams: Fashion and Modernity* (London: I.B. Tauris, 2003).
Wilson, Elizabeth, *The Twilight Hour* (London: Serpent's Tail, 2006).
Wollen, Peter, "Spies and Spivs: An Anglo-Austrian Entanglement", *Paris Hollywood: Writings on Film* (London: Verso, 2002).
Wride, Tim B.; with Bratton, William J. and Ellroy, James, *Scene of the Crime: Photographs from the LAPD Archive* (New York: Harry N. Abrams, 2004).
Žižek, Slavoj (ed.), *Everything You Always Wanted to Know about Lacan (But Were Afraid to Ask Hitchcock)* (London and New York: Verso, 1992).

Journal Articles

Abelson, Elaine S., "The Invention of Kleptomania", *Signs*, vol.15, no.1 (Autumn 1989).
Allen, Jeanne, "The Film Viewer as Consumer", *Quarterly Review of Film Studies*, vol.5, no.4 (1980).
Bruzzi, Stella, "F for Fashion (the alphabet of cinema)", *Sight & Sound* (November 1996).
Deutelbaum, Marshall, "Costuming and the Color System in *Leave Her to Heaven*", *Film Criticism*, Vol. II, No.3 (April 1987).
Eckert, Charles, "The Carole Lombard in Macy's Window", *Quarterly Review of Film Studies*, vol.3, no.1 (1978), reprint. in: Jane Gaines and Charlotte Herzog (eds.), *Fabrications*, (New York: Routledge, 1990).
Gunning, Tom, "A Tale of Two Prologues: Actors, Detectives and Disguises in Fantômas, Film and Novel" *The Velvet Light Trap* 37, 1996.
Gunning, Tom, "Attractions, Detection, Disguise: Zigomar, Jasset and the History of Genres in Early Film" *Griffithiana* 47 May, 1993.
Gunning, Tom, "Lynx-eyed Detectives and Shadow Bandits: Visuality and Eclipses in French Detective Stories and films before WWI", YaleFrench Studies no. 108 (2005).
Mandel, Ellen, "Les Vampires", *Film Quarterly*, vol.24, no.2. (Winter 1970-71).
Persellin, Ketura, "'A High-Heeled Army of Furies': Shoplifting in Marleen Gorris's A Question of Silence" *Spectator*, Vol.16, No.1 (Fall/Winter 1995).
Round, Julia, "Fragmented Identity: The Superhero Condition", *International Journal of Comic Art* (Vol.7, No.2, Fall/Winter 2005).
Wilson, Elizabeth, "A Note on Glamour", *Fashion Theory*, vol.11, no.1 (March 2007).
Wilson, Elizabeth, "Magic Fashion", *Fashion Theory*, vol.8, no.4 (Dec 2004).

Index / Compiled by Rita Revez, Felice McDowell and Dorcas Brown

4 mosche di velluto grigio (see *Four Flies on Grey Velvet*)
5 bambole per la luna d'agosto (see *Five Dolls for an August Moon*)
10th Victim, The: 40-51

À bout de souffle (see *Breathless*)
Abel, Richard: 100-102, 116
Abuelo, El (see "The Grandfather"): 244
Adler, Alfred: 34
Adventure, The: 40
Adventures of Giacomo Casanova: 170
Agent secret, L': 28
Agnès B: 220
Al Capone: 218
Alabama 3: 224
Alba, Jessica: 216
Aldrich, Robert: 72
All Quiet on the Western Front: 174
Allain, Marcel: 26, 28
Allen, Woody: 82
Almodóvar, Pedro: 78
Alraune: 126
Altman, Robert: 154
Amann, Betty: 126-130
Amazing Dr. Clitterhouse, The: 218
Ambassadors, The: 70
American Gangster: 22
Andersen, Hans Christian: 144, 146, 150, 151, 240
Andress, Ursula: 40-51
année dernière à Marienbad, L' (see *Last Year in Marienbad*)
Antefatto – Ecologia del delitto (see *A Bay of Blood*)
Anton, Karl: 108-112
Antonioni, Michelangelo: 17, 40, 194
Aoki, Devon: 216
Apocalittici e integrati: Communicazione di massa e teorie della communicazione di massa: 36
Aragon, Louis: 24
Aranda, Vicente: 194-201
Arden, Mary: 178
Argento, Dario: 52-59, 74, 170, 179, 184
Arlen, Michael: 16
Arliss, Leslie: 16
Arnold, Rebecca: 220
Asher, Robert: 142
Asphalt: 126-130
Assassin, The: 40
assassin sans visage, L' (see *Follow me Quietly*)
assassino, L' (see *The Assassin*)
Assayas, Olivier: 24
atelier della morte, L' (see *Blood and Black Lace*)
Atonement: 78
Austen, Jane: 16
aventura, L' (see *The Adventure*)
aventura di Giacomo Casanova, Le (see *Adventures of Giacomo Casanova*)
Ayres, Lew: 174

Bacon, Francis: 34
Bailey, David: 220
Banton, Travis: 132
Barbarella: 48, 194
Barlow, Ray: 210
Baron Blood: 174
Barthes, Roland: 32, 38, 74
Bartok, Eva: 38, 174, 179
Barton, Mischa: 68
battaglia di maratona, La (see *The Giant of Marathon*)
Baudelaire, Charles: 96
Bava, Mario: 32, 39, 40, 156, 170-179, 182, 192
Bay of Blood, A: 172, 174
Bazin, André: 62
Beatles, The: 194
Becker, Jacques: 164
Beebe, Ford: 34
Benedek, László: 204
Benet, Marianne: 196
Berger, Augustin: 108
Bergman, Ingmar: 170, 182, 194
Bergman, Ingrid: 190
Berlin: die Sinfonie der Grosstadt: 126
Bernard, Susan: 210
Berry, Sarah: 112, 132, 134, 137
Bevan, Stewart: 246
Bevan, Wendy: 246

Beyond the Forest: 140
Big Heat, The: 64, 138, 140,142
Bigger Splash, A: 154
Billard, Pierre: 196
Billitteri, Salvatore: 34
Bird, Antonia: 222
Bird with the Crystal Plumage, The: 52-59, 184
Birds, The: 70
Björk, Anita: 172, 188
Black Sabbath: 34, 170, 176
Black Sunday: 174, 176
Bladh, Hilding: 170, 172, 179
Blahník, Manolo: 148
Bleierne Zeit, Die (see *The German Sisters*)
Blonde, Didier : 28
Blonde Venus: 132
Blood and Black Lace: 32-39, 40, 156, 170-179, 182, 184
Blue Angel, The: 134
Blue Velvet: 212
Boetticher, Budd: 218
Body and Soul: 138
Body Double (X): 94-97
Bogart, Humphrey: 218
Bolton, Andrew: 142
Bonifassy, Luce: 46
Borden, Lizzie: 76
Borges, Jorge Luis: 194, 196
Born in Flames: 76
Borzage, Frank: 126, 132, 136
Boston Herald American: 68
Boudicca: 242
Bourdieu, Pierre: 132, 134, 137
Bourgeois, Gérard: 100
Bowery, Leigh: 38
Boys, The: 204-209
Bracco, Lorraine: 224
Brando, Marlon: 204, 210, 164
Breathless: 62
Breton, André: 194
Breward, Chris: 220
Brittain, Vera: 124
Broach, Zzowie: 242
Brontë, Charlotte: 92
Brooks, Richard: 82, 164
Browning, Tod: 34
Bruckheimer, Jerry: 72
Brunel, Adrian: 120
Brunskog, Bengt: 172, 184
Brute Force: 138, 140, 142
Bruzzi, Stella: 218
Bulgakov, Mikhail: 136, 137
Bunhongsin, (see *The Red Shoes*)
Buñuel, Luis: 196
Burroughs, William: 68
Burton, Richard: 218
Bush, Kate: 214

Cagney, James: 218
Caillois, Roger: 26
Caine, Michael: 218, 220
Calefato, Patrizia: 96
Callahan, Vicki: 24, 30
Calvert, Phyllis: 16
Cameron, James: 214
Capellani, Albert: 104
Carangi, Gia Marie: 156
Carpenter, John: 36, 92
Carrie: 74, 84
Carrion (see *Eloise Fornieles*): 234
Castle, Irene and Vernon: 124
Cat on a Hot Tin Roof: 164
Caught: 138, 140
Cavani, Liliana: 164
Chanel, Coco: 154
Chase, David: 224
Cheung, Maggie: 24, 214
Chomette, Henri: 104
Christie, Agatha: 14-18, 170
Citizen Kane: 78
Clair, René: 104
Clarke, Ossie: 154
Clément, René: 164-168
Cleopatra: 178
Clewell, Tammy: 226

Clover, Carol: 90
Co-conspirators: 230-249
Coen brothers, Joel and Ethan: 72
Cohan, Steven: 164, 168
Cohn, Bernard: 196
Collier, Constance: 118
Collins, Phil: 236
Collins, Wilkie: 192
Colombo, Joe: 44
Coltellacci, Giulio: 40-51
Connell, Betty: 212
Cooper, Gary: 134
Copjec, Joan: 138, 142
Coppola, Francis Ford: 62, 218
Coppola, Roman: 40
Corberó, Xavier: 196
Corman, Roger: 218
Corner, The: 248
Corte, Carlo Della: 36
Courrèges, André: 40, 44, 46, 196
Cramps, The: 212
Craven, Wes: 36, 92, 176, 179
Cristofer, Michael: 156
Cronaca di un amore (see *Story of a Love Affair*)
CSI: 72, 74, 227
Cunningham, Sean S: 36
Curle, Richard: 160
Curtiz, Michael: 138
Cutpurse, Moll: 228
Cutts, Graham: 118

D'Asta, Monica: 24
d'Ursel, Henri: 104
Dahl, Roald: 82
Dahl-Wolfe, Louise: 160
Dalbés, Alberto: 196
Dalí, Salvador: 196
Damen i svart (see *Lady in Black, The*)
Danger: Diabolik: 36, 40, 48
Dangerous Spring: 182
Danton, Ray: 218
Dark Adapted Eye, A: 14
Dark Water: 150
Darrieux, Danielle: 16
Dassin, Jules: 138, 164
Date With Elvis, A (see *The Cramps*): 212
Davis, Bette: 16, 140
Davis, Fred: 14
Dawson, Rosario: 216
de Beauvoir, Simone: 17, 18, 78, 162
de Lorde, André: 102, 104
de Mateo, Drea: 226
de Niro, Robert: 224
De Palma, Brian: 22, 52, 74, 78, 170
Dean, James: 204
Debord, Guy: 242
decima vittima, La (see *The 10th Victim*)
Decleir, Jan: 192
Del Toro, Benicio: 216
Delerue, George: 94
Dellsperger, Brice: 94-97
Delon, Alain: 164-168
Demenÿ, Georges: 24
Demme, Jonathan: 38-92
Deneuve, Catherine: 82
Desire: CE (whole article), 126
Det kom en gäst (see *A Guest is Coming*)
Devil is a Woman, The: 132
Devil Wears Prada, The: 156, 184
Dick Tracy: 34, 36, 64
Dick Tracy vs. Cueball: 64
Dickens, Charles: 16
Didi-Huberman, Georges: 74
Dietrich, Marlene: 72, 126, 132-137, 190
Dinco, Dino: 244
Dior, Christian: 70, 72
Dishonoured: 132
Ditko, Steve: 36, 38
Diva: 16
Dolce & Gabbana: 96
dolce vita, La: 40, 44, 52
Doane, Mary Ann: 142, 158, 162
Donna Scarlatta, La (see *The Scarlet Woman*)
Don't Look Now: 148, 150

ouble Indemnity: 16
ouglas, Gordon: 64
owne, Allison Louise: 212
oyle, Sir Arthur Conan: 26, 170
racula: 34
ressed to Kill: 52, 78
ue occhi diabolici (see Two Evil Eyes)
 Maurier, Daphne: 92
ung fong saam hap (see The Heroic Trio)
uring, Simon 137
urran, Jacqueline: 78

astwood, Clint: 212
bert, Roger: 214
co, Umberto: 36, 196
conomist, The: LG
deson, Arthur: 174
dmond, Allen: 224
kman, Hasse: 182, 192
ggleston, William: 246
jiofor, Chiwetel: 22
ricsson, Annalisa: 170, 182, 190
vangelista, Linda: 156
yes of Laura Mars: 156
yes without a Face: 36

ace: 222
agot, Georges: 102
alco, Edie: 226
antômas: 22, 26, 28, 110, 118
arlig vår (see Dangerous Spring)
arnham, Marynia F: 160, 162
aster, Pussycat! Kill! Kill!: 210-217
at Joe: 224
ata Morgana: 194-201
atal Woman, The (see Fata Morgana)
ellini, Federico: 40, 44, 46
emme écarlate, La (see The Scarlet Woman)
errandis, Antonio: 194
errara, Abel: 82-85
euillade, Louis: 22, 24, 28, 100, 104, 110, 118, 196
éval, Paul: 26
acre de nuit, Le: 28
iala, Eman: 108, 110
incher, David: 150
ight Club: 150
ingered: 212
iore, Maria: 174
itzgerald, F. Scott: 194
ive Dolls for an August Moon: 184, 192
laiano, Ennio: 40
leischer, Richard: 32-39
leming Victor: 14
licka och hyacinter (see Girl with Hyacinths)
lügel, J.C: 64, 220
lynt, Larry:82
ollow Me Quietly: 32-39
onda, Jane: 82, 84
ondato, Marcello: 172, 179
ontaine, Joan: 64
ontana, Zoe, Micol and Giovanna: 40-51
ord, Glenn: 196
ord, Tom: 48
oreign Correspondent: 70
ornieles, Eloise: 234
our Flies on Grey Velvet: 184
our Horsemen of the Apocalypse, The: 124
oyle's War: 16
ranju, Georges: 13, 36
rankel, David: 156, 184
rankenstein: 34
rank, Jesus: 192
reud, Sigmund: 74, 138, 140, 142, 143, 146, 151, 222, 226
reund, Karl: 34, 174
riday the 13th: 36, 172
rissell, Toni: 160
rom Here to Eternity: 164
rottage: 240
röhlich, Gustav: 126
umetti, I: 36
urie, Sidney J: 204-209
urnas, J.C.: 142

"G" Men: 218
Gabin, Jean: 164
Gaboriau, Emile: 26
Galeen, Henrik: 126
Gamman, Lorraine: 151
Gance, Abel: 104
Gandolfini, James: 224
Garbo, Greta 126, 134
Gaskell, Elizabeth: 16
Gaudí, Antoni: 196
Gautier, Jean-Paul: 78
Geddes, Barbara Bel: 140
Gee, Cecil: 206
Gentleman Thief, The: 100-105
German Sisters, The: 76
Get Carter: 218, 220
Gia: 156
Giant of Marathon, The: 174
Gibbon, Monk 151
Gilda: 196
Gimpera, Teresa: 194-201
Giovannini, Giorgio: 172
Girl with Hyacinths: 182
Girl Who Knew Too Much, The: 170
Glazer, Jonathan: 222
Godard, Jean-Luc: 62
Godfather, The: 62, 218, 220, 224
Gold Diggers, The: 76
Goldstein, Max: 190, 192
Gone With the Wind: 14
Goodfellas: 218, 222, 224
Gordon, Douglas: 94
Gordy, Berry: 184
Gorris, Marleen: 76-81
Granger, Stewart: 16
Granhagen, Lena: 172, 188
Grant, Cary: 196
Grant, Lee: 142
Great Gatsby, The: 194
Green Hat, The: 16
Greene, Anna Katherine: 26
Griffith, Melanie: 86, 88
Griffith, D.W.: 22, 120
Grishi: 164
Grudge, The: 150
Grune, Karl: 126
Guerra, Tonino: 40
Guest is Coming, A: 182
Gycklarnas afton (see Sawdust and Tinsel)

Haber, Peter: 192
Haji: 210
Hallberg, Nils: 172
Halliday, John 134
Halloween: 36, 92
Hamlet: 196
Happy Birthday to Me: 179
Harmon, Robert: 212
Harrison, Evangeline: 220
Harrison, Susan: 140
Harron, Mary: 84
Harvey, John: 220
Hawks, Howard: 196
Hayworth, Rita: 196
Hazan, Jack: 154
Head, Edith: 66
Hebdige, Dick: 68, 220
Heckroth, Hein: 144, 148
Hedren, Tippi: 74, 194
Helm, Brigitte: 126
Heroic Trio, The: 214, 216
High Plains Drifter: 212
Highsmith, Patricia: 164, 168
Histoires Extraordinaires: 48
Hitchcock, Alfred: 17, 18, 52, 64, 70-72, 74, 78, 154-156, 170, 176, 194, 196
Hitcher, The: 212
Hjelm, Keve: 192
Hockney, David: 154
Hodges, Mike: 218
Holbein, Hans the Younger: 70
Holdaway, Jim: 194
Holden, William: 64, 164
Hollander, Anne: 16

Holmsten, Karl-Arne: 170, 182
Homeboy Films (see Dino Dinco)
homme aux gants blancs, L' (see The Man With White Gloves)
Hon dansade en sommar (see One Summer of Happiness)
Honogurai mizu no soko kara (see Dark Water)
Hooper, Tobe: 36
Hopper, Edward: 214
Horowitz, Anthony: 16
Horseman in Blue: 179, 192
House of Hate, The: 110
Hubert, René: 126
Hughes, Claire: 14
Hugnet, Georges: 104
Hugo, Victor: 194
Hush ...Hush, Sweet Charlotte: 72, 74
Huyghe, Pierre: 94

I Shot Andy Warhol: 84
Ibsen, Lillebil: 170, 184
Imitation of Life: 158
Imperioli, Michael: 224
Important c'est d'aimer, L' (see The Important Thing is to Love)
Important Thing is to Love, The: 94-97
Ingram, Rex: 124
Invasion: 194
Invasion (see Invasion)
Invisible Man, The: 34
Invisible Man's Revenge, The: 34
Irma Vep: 24
It's My Life: 62
Iler, Robert: 226
Izquierdo, Pelayo: 194

Jack the Ripper: 34
Jackson, Samuel L.: 220
Jacobsson, Ulla: 182
Jameson, Fredrick: 110
Jane Eyre: 92
Jasset, Victorin: 22, 100
Jeans, Isabel: 118
Jimenez, Jo: 244
Johns, Jasper: 44
Jordà, Joaquim: 194
Ju-on (see The Grudge)
Julian, Rupert: 32
Jurassic Park: 64
Jürss, Ute Friedrike: 94

Kafka, Franz: 194, 196
Karina, Anna: 62
Kazan, Elia: 164, 210
Keaton, Diane: 82, 84
Kelly, Grace: 194
Keighly, William: 218
Kennedy, Jackie: 68, 74
Kern, Richard: 212
Kerr, Deborah: 164
Kershner, Irvin: 156
Kettelhut, Erich: 126
Kidnapping of Fux the Banker, The: 108-117
Kill Bill Vol. I: 216
Killer 7: 74
Kim, Yong-gyun: 144, 146
Kim, Yu-Shin "Mue": 38
Kipling, Rudyard: 150
Kirkby, Brian: 242
Klein, William: 48
Kloepfer, Eugene: 126
Klute: 82
Knightley, Keira: 78
Koestenbaum, Wayne: 68
König, René: 18
Kristeva, Julia: 226
Krugher, Lea: 178
Kubrick, Stanley: 174, 182
Kundun: 179
Kyrou, Ado: 194

Lacan, Jacques: 70
Lack, Christiane: 94
Lady in Black, The: 170, 182
Lady in White: 192
Laforêt, Marie: 166
Lamač, Karel: 108-110

Lancaster, Burt: 140, 164
Landis, Deborah: 94
Landström, Eivor: 172, 188
Lang, Fritz: 64, 126, 138, 196
Larson, Cedric: 142
Last Year in Marienbad: 17
Lau, Damian: 214
Leander, Zarah: 190
Leave Her to Heaven: 158-163
Leblanc, Maurice: 102
Left-Handed Fate (see *Fata Morgana*)
Leg, Lung: 212
Leigh, Janet: 176
Leone, Sergio: 218
Léotard, Jules: 22
LeRoy, Mervyn: 22, 64, 218
Lesbian Vampires: 192
Lester, Richard: 194
Lewis, Herschell Gordon: 212
Lichtenstein, Roy: 48
Light, Alison: 14
Lindberg, Lennart: 172, 184
Linder, Max: 102
Lindstedt, Carl Gustaf: 192
Lindström, Bibi: 172
Liotta, Ray: 222
Little Caesar: 22, 64, 218
Litvak, Anatole: 218
Livia, Bronislava: 110
Lloyd-Wright, Frank: 160
Lodger, The: 154-156
Lockwood, Margaret: 16
Logan, Joshua: 164
Loggia, Robert: 227
Lollobrigida, Gina: 170, 174
Long Good Friday, The: 222
Longfellow, Henry W: 194
Look!: 44
Looking for Mr. Goodbar: 82
Losey, Joseph: 194
Lost: 74
Lubitsch, Ernst: 134
Lucas, Tim: 182, 192, 38
Lunch, Lydia: 212, 216
Lund, Zoë Tamerlis: 82
Lundberg, Ferdinand: 160, 162
Lynch, David: 212

Mackendrick, Alexander: 138, 140
Mackenzie, John: 222
MacLeod, Kirstie: 234
MacMurray, Fred: 16
Made in Paris: 184
Madonna: 148, 214
Magistretti, Vito: 44
Mago (see Goldstein, Max)
Mahogany: 184,192
Malkovich, John: 164
Mallarmé, Stéphane: 194
Man in Grey, The: 16
Man with White Gloves, The: 100-105
Man Without Desire: 120
Mannekäng i rött (see *Mannequin in Red*)
Mannequin in Red: 170-172, 182-193
Mankell, Henning: 182
Mankiewicz, Joseph L.: 178
Marey, Étienne-Jules: 24
Margheriti, Antonio: 170, 172
Mariachi, El: 216
Marklund, Liza: 182
Marnie: 70, 78
Marnie's Handbag: 238
Marsh, Mae: BD118, 120
Martí, Marcos: 196
Martin, Marcel: 196
Martinelli, Elsa: 46
Martino, Sergio: 170
maschera del demonio, La (see *Black Sunday*)
Mason, James: 16
Masque of the Red Death, The: 32
Master and Margarita, The: 136
Matroianni, Marcello: 40-51
Mattsson, Arne: 170-172, 182-193
Maturin, Charles: 92

Mauss, Marcel 137
May, Joe: 126
Mayer, Johannes: 126
McAlpine, Elizabeth: 236
McLaren, Malcolm: 38
McQueen, Alexander: 96
Méliès, Georges: 24
Mellvig, Folke: 182, 192
Melmoth the Wanderer: 92
Menken, Adah Isaacs : 24
Mercier, Michèle : 176
Messac, Régis: 26
Metropolis: 126
Metz, Christian: 62
Meyer, Nicholas: 74
Meyer, Russ: 210-217
Miglietti, Alfano, Francesca: 96
Mildred Pierce: B&C, 138, 140, 142
Milestone, Lewis: 174
Miller, David: 142
Miller, Frank: 214-217
Milner, Martin: 140
Milton, John: 28
Minghella, Anthony: 164, 166
Miró, Joan: 196
Misery: 90
Miss Marple (series): 16, 170
Mitchell, Cameron: 174
Modleski, Tania: 18
Modesty Blaise: 194
Molloy, John T: 86,88
Momento Sera: 46
Momma Don't Allow: 62
Mondrian, Piet: 48
Monroe, Marilyn: 196
Moore, Alan: 34, 38
Morgan, William: 204
Morley, Karen: 22
Morley, Robert: 206
Morocco: 132
Ms .45: Angel of Vengeance: 82-85
Moseley, Rachel 137
Moskowitz, Gene: 200
Mui, Anita: 214
Mulvey, Laura: 140, 142, 220
Mummy, The: 34
Muni, Paul: 22
Murder is Announced, A: 16
Murderer Invisible, The: 36
Murnau, F.W.: 64
Murphy, Brittany: 216
Musidora: 24, 104, 110
Musketeers of Pig Alley, The: 22
mystères du château de Dé, Les (see *The Mysteries of the Chateau de Dé*)
Mysteries of the Chateau de De, The: 104

Nakata, Hideo: 150
Nation, Marty: 212
Nelson, Kay: 158
New Nightmare: 176
New Women's Dress for Success: 86
Newman, Barnett: 44
Newman, Oscar: 218
Newman, Paul: 164
Nichols, Mike: 86
Nick Winter and the Case of the Famous Hotel: 100-102
Nick Winter et l'affaire du célèbre hôtel (see *Nick Winter and the Case of the Famous Hotel*)
Noland, Kenneth: 44
North by Northwest: 70, 196
North Soho 999: 14
Nosferatu: 64
Notorious B.I.G.: 224
Novak, Kim: 17-19, 164, 194
Novello, Ivor: 154, 194
Nude ... si muore 172
Nugent, Frank S: 134
Nykvist, Sven: 170

O'Brien, Geoffrey: 224, 227
O'Connor, Patrick 137
O'Donnell, Peter: 194
Office Killer: 86-93

Oldenburg, Claes: 44
On the Waterfront: 210
Once Upon a Time in America: 218
One Summer of Happiness 182
Ondra, Anny: 108, 110
Ophüls, Max: 138
Owen, Clive: 216

Pacino, Al: 62, 224
Pakula, Alan J: 82
Panton, Verner: 44
Perec, Georges: 242
Pastore, Vincent: 224
Pearl, The: 104
Perle, La (see *The Perle*)
Petré, Gio: 170, 184
Petri, Elio: 40-51
Phantom, The: 48
Phantom of the Opera, The: 34, 178
Phillips, Paulette: 238
Piattelli, Bruno: 40, 44
Picasso, Pablo: 196
Pichel, Irving: 138
Picnic: 164
Pitts, Shirley: 228
Place, Janey: 158, 162
Plan 9 from Outer Space: 204
Planet of the Vampires: 40
Plato: 22
Plein soleil: 164-168
Plumb, Shannon: 248
Poe, Edgar Allan: 22, 32
Poell, Christian, Carol: 96
Poiret, Paul: 108-117
Polanski, Roman: 82
Pollock, Jackson: 74
Polsca, Julia: 224
Pommer, Erich: 126
Poston, Pat: 212
Potter, Sally: 76
Powell, Michael: 144, 146, 151, 240
Prawitz, Elsa: 172, 184
Preminger, Otto: 78
Presley, Elvis: 204, 212
Pressburger, Emeric: 144, 146, 240
Prêt-à-Porter: 154
Pretty Woman: 88
Princess Diaries, The: 88
Proust, Marcel: 16
Psycho: KH, 170, 172, 178, 179
Psychology of Clothes, The: 64, 220
Pucci, Emilio: 40
Pugh, Gareth: 38
Pulp Fiction: 72, 218, 220
Purple Noon (see *Plein Soleil*)

Quant, Mary: 194
Question of Silence, A: 76-81
Qui êtes-vous, Polly Maggoo? (see *Who Are You, Polly Maggoo?*)
Quicksand: 138

ragazza che sapeva troppo, La (see *The Girl Who Knew Too Much*)
Rand, Ayn: 38
Randone, Salvo: 44
Rat, The: 118-125
Ray, Man: 104
Ray, Nicholas: 204
Reagan, Ronald: 82
Rebecca: 64, 92
Rebel Without a Cause: 204
Red Shoes, The: 144-151, 240
Reed, Carol: 64
Reeves, Steve: 170
Regarding the Pain of Others: 234
Reiner, Rob: 90
Reiner, Thomas: 174
Reisz, Karel: 62
Rendell, Ruth: 14
Republic, The: 22
Repulsion: 82
Reservoir Dogs: 218, 220

esnais, Alain: 17, 196
chardson, Tony: 62
der in Blue 192
fifi: 164
fifi chez les hommes, Du (see Rififi)
ng: 150
ngu (see Ring)
ngwald, Molly: 86
pley's Game: 164
se and Fall of Legs Diamond, The: 218
ttau, Guenther: 126
bards, Jason: 218
bbe-Grillet, Alain: 196
binson, Edward G: 22, 64, 218
cky Horror Picture Show, The: 84
drigvez, Robert: 216
eg, Nicolas: 148
entgen, Wilhelm Conrad: 26
net, Maurice: 164
rschach, Ivy: 216
ss, Diana: 192
ossen, Robert: 138
ssi, Alfredo: 40
sson, Richard: 22
th, Philip: 68
urke, Mickey: 216
stichelli, Carlo: 176, 178
utherford, Margaret: 170
ttman, Walter: 126

ttare I blatt (see Horseman in Blue)

cher-Masoch, Leopold von: 138, 142
gal, Boris: 184
llert, Ulla: 190
lvioni, Giorgio: 40
unt el qusur (see The Silences of the Palace)
ndberg, Gösta 151
ntiago, Hugo: 194
ntini, Derrick: 240
ssoon, Vidal: 46
stana, Tura: 210-217
wdust and Tinsel: 170, 190
yers, Dorothy L: 162
arlet Empress, The: 132
arface (1932): 22
arface (1983): 22
arlet Woman, The: 56
hirripa, Steven R.: 226
hneider, Romy: 94, 96
henk, Walter: 210
hoenen Tage von Aranjuez, Die: 126
hroeder, Barbet: 150
hwarzenegger, Arnold: 214
orsese, Martin: 176, 218, 222
ott, Ridley: 22,78
ream: 36, 92, 179
berg, Jean: 62
cret Life of Criminals, The (see Paulette Phillips): 230
gal, George: 44
gal, Steven: 214
i donne per l'assassino (see Blood and Black Lace) 170-179
iter, George: 110
iter, Willam A.: 142
erandrei, Mario: 178
rvais, Jean: 164
tte vergini per il diavolo (see Seven Virgins for the Devil)
ven Virgins for the Devil 172
xy Beast: 222
anghai Express: 132
e-Devils On Wheels: 212
eckley, Robert: 40
herman, Cindy: 53, 58, 86, 93, 246
imizu, Takashi: 150
lence, The: 194
lence of the Lambs, The: 38,92
lences of the Palace, The: 76
n City: 214-217
natra, Frank: 174
ngle White Female: 88, 150
k, Douglas: 158
öwall, Maj: 182
kal, David J: 32, 34
ap: 236
ell of Female (see The Cramps): 212

Smit, Howard: 74
Smith, Maggie: 190
Smith, Richard: 74
Snow Queen, The 151
Solanas, Valerie: 84
Sopranos, The: 218-229
Sontag, Susan: 234
Souvestre, Pierre: 26, 28
Spears, Britney: 68
Spider-Man: 36
Spielberg, Steven: 64
St Valentine's Day Massacre, The: 218
Stage Fright: 70-72
Stahl, John M: 158
Stallone, Sylvester: 214
Stanwyck, Barbara: 16
Star Trek II: The Wrath of Khan: 74
Stefano, Joseph: 172
Steiger, Rod: 218
Steinbeck, John: 210
Sternberg, Josef von: 132, 134
Stilte rond Christine M., De (see A Question of Silence)
Stiller, Ben: 156
Storaro, Vittorio: 56
Storm Fear: 138, 140, 142
Story of a Crime, The: 182
Story of a Love Affair: 17
Straayer, Chris: 166, 168
Street, The: 126
Streetcar Named Desire, A: 164
Stutesman, Drake: 134, 137
Suárez, Gonzalo: 194
Sudden Fear: 142
Sunset Boulevard: 64-67
Swann, June 151
Swanson, Gloria: 64
Sweet Smell of Success: 138, 140
Swift, Jonathan: 68

Talented Mr. Ripley, The (see Patricia Highsmith): 164
Talented Mr. Ripley, The (see Anthony Minghella): 164
Tàpies, Antoni: 196
Tarantino, Quentin: 72,216, 218, 220
Taylor, Lili: 84
Telefono, Il (see Telephone, The)
Telephone, The: 170, 176
Teller, Jurgen: 246
Ten Little Indians: 172
Tenth Victim, The (see 10th Victim, The)
Terminator, The: 214
Terrore nello spazio (see Planet of the Vampires)
Terzano, Ubaldo: 174
Testament of Youth: 124
Testi, Fabio: 94, 96
Texas Chainsaw Massacre: 36
Thelma and Louise: 78
Third Man, The: 64
Thompson, J. Lee: 179
Thurman, Uma: 216
Tierney, Gene: 158, 160
Tilson, Joe: 44
Tlatli, Moufida: 76
To, Johnny: 214
Todd, Richard: 206
Touchez pas au grisbi (see Grisbi)
Tourneur, Jacques: 174
Travolta, John: 220
tre volti della paura, I (see Black Sabbath)
Trenter, Stieg: 182
Trouble in Paradise: 134
Tuchner, Michael: 218
Two Evil Eyes: 179
Tystnaden (see The Silence)

Ungaro, Francesca: 174
Únos bankéře Fuxe (see Kidnapping of Fux the Banker, The)
Untitled (see Wendy Bevan): 246
Untitled Film Stills (see Cindy Sherman): 246
Untouchables, The: 218
Uther, Hans-jörg: 150, 151

Vadim, Roger: 48
Valentino, Rudolph: 124
Vampires, Les: 22-31, 104, 110, 118

Van Damme, Jean-Claude: 214
Van Zandt, Steve: 226
Vasarely, Victor: 44
Venanzo, Gianni Di: 44
Venus in Furs: 138
Verna, Jean-Luc: 94-97
Vertigo: 17-18
Vidor, Charles: 196
Villain: 218
Vine, Barbara (see Ruth Rendell)
Violent Years, The: 204-209
Vitti, Monica: 194
Vivre sa vie: Film en douze tableaux (see It's My Life)
voleur mondain, Le (see The Gentleman Thief)
voleurs des visages, Les : 28
Von Trotta, Margarethe: 76

Wahlöö, Per: 182
Wallace, Edgar: 36, 170, 172
Warhol, Andy: 44, 196
Washington, Denzel: 22
Watchmen: 38
Welles, Orson: 78
Wells, H. G: 22, 24, 26, 28
Whale, James: 34, 196
What Ever Happened to Baby Jane?: 72
Whirlpool: 78
White Face: 36
White Heat: 142
Who Are You, Polly Maggoo?: 48
Wild Boys: 68
Wild One, The: 204
Wilde, Cornel: 138, 142, 158
Wilder, Billy: 16, 64
Willetts, Paul: 14
Williams, Ben Ames: 158
Williams, Lori: 210
Willis, Bruce: 216
Wilson, Elizabeth 137
Wilson, Richard: 218
Winehouse, Amy: 68, 70
Winter, Georges: 100
Wiseguy: 222
Wizard of Oz, The: 144
Woman in White 192
Woo, John: 214
Wood, Edward D. Jr: 204
Working Girl: 86-93
Wright, Joe: 78
Wylie, Philip: 36

Yellow Car, The: 192
Yeoh, Michelle: 214
You'll Never Work in this Town Again (see Phil Collins): 236
Yves Saint-Laurent: 96

Zinnerman, Fred: 164
Žižek, Slavoj: 70
Zoolander: 156
Zulawski, Andrezej: 94

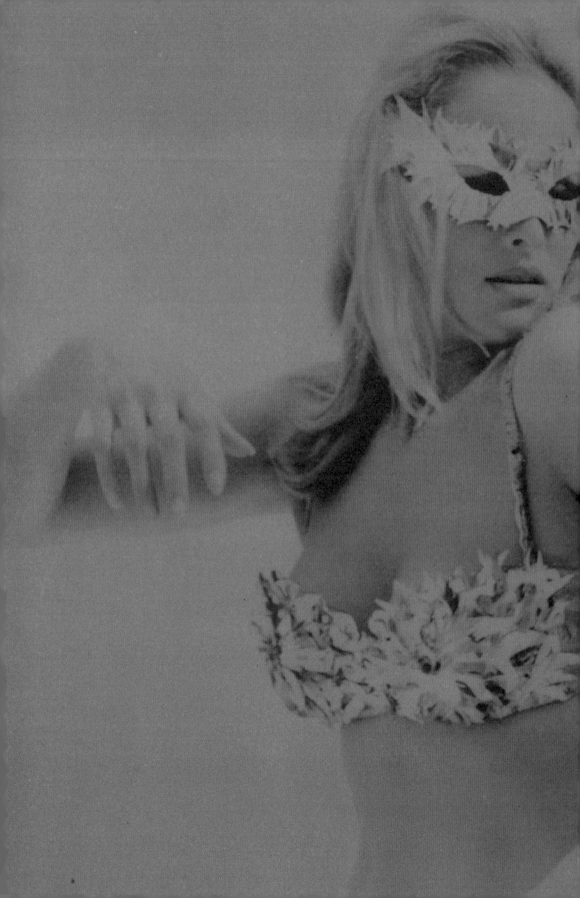